C000144024

MUNCH AND PHOTOGRAPHY

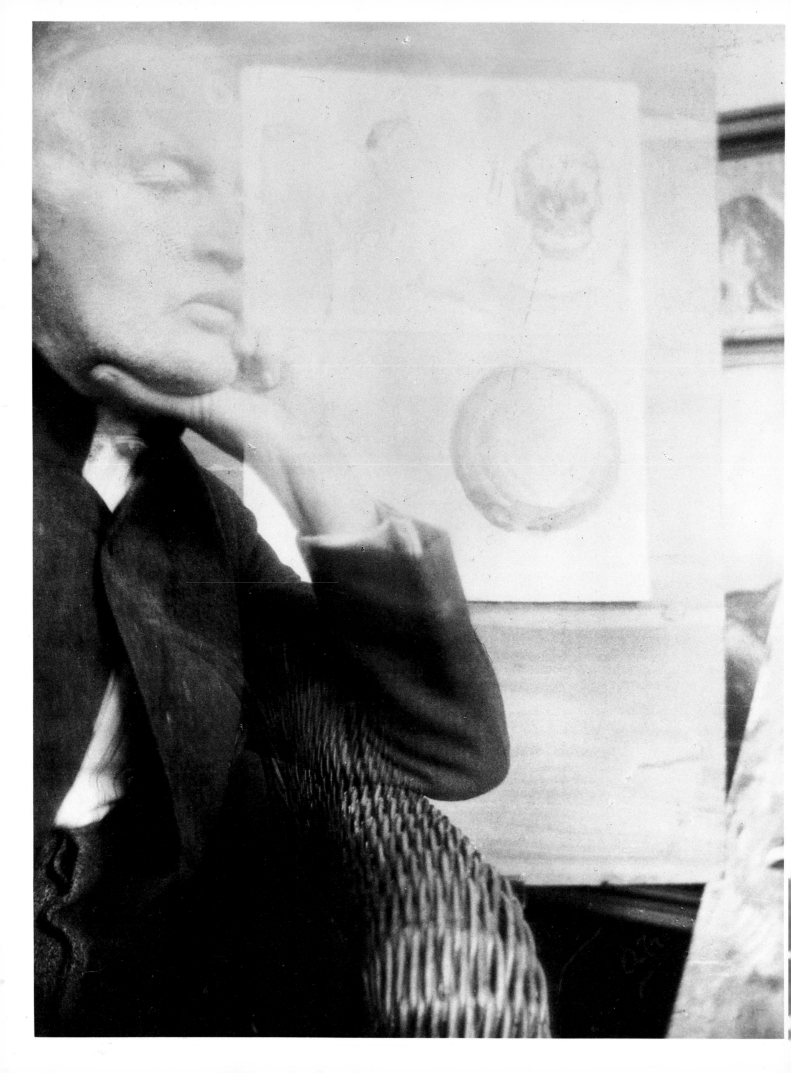

MUNCH AND PHOTOGRAPHY

ARNE EGGUM

TRANSLATED BY BIRGIT HOLM

YALE UNIVERSITY PRESS · NEW HAVEN & LONDON · 1989

© Gyldendal Norsk Forlag A/S 1987
First published as *Munch og Fotografi*, Oslo 1987

Copyright © 1989 by Yale University

All rights reserved. This book may not be reproduced,
in whole or in part, in any form (beyond that copying
permitted by Sections 107 and 108 of the U.S. Copyright
Law and except by reviewers for the public press),
without written permission from the publishers.

Typeset in Hong Kong by Best-set Typesetter Ltd
Printed in Spain by Graficas Estella, S.A., Estella

Library of Congress Catalog Card Number: 89-50652
ISBN: 0-300-04548-4

CONTENTS

Preface

The camera cannot compete with brush and palette – as long as it cannot be used in Heaven or Hell.

This is the best-known of Munch's aphorisms, which predate the debate on the relationship between art and photography that has taken place in a comprehensive literature, not least in recent years.

Munch made several drafts of this sentence in the year 1929 and published it in a booklet, *On the Creation of the Frieze of Life*, that same year, but he maintained that it originated in 1904. However, thoughts about art and photography were already present among his notes from the 1880s, thoughts which might well have been expressed in such an aphorism.

Even if Munch did not consider his camera as a competitor to his brush and palette, he made use of it throughout his life, using photographs as an aid to his art, both as a basis for his portraits and as an inspiration for a new concept of reality. Such a use of photography was quite legitimate to Munch; and he was later in his life to state: 'I have learnt a lot from photography'. However, he held in contempt some of the ways in which photography was used as a norm for painting.

Munch also photographed himself at various times of his life, achieving some fascinating results. His photography has in recent years become a topic of increasing interest, especially among modern photographers. Some of his photographs are constantly displayed at exhibitions, and his photography has been discussed in writing as well. In my opinion it deserves a more elaborate treatment.

It has been my intention to show how contemporary photography was integrated into Munch's artistic work, how it inspired his creative imagination. By relating his work to the contemporary world of photography in which he moved, a better understanding of the special quality of expression of his art can be achieved.

Part of the material important for an appreciation of Munch's relationship with photography, such as portrait photographs and Munch's own photographs, is still in private hands, and I hope that this book will encourage its publication.

I should like to thank Alf Bøe, director of the Oslo Kommunes Kunstsamlinger, who has shown great interest in this project throughout and has given me his fullest support.

In addition my thanks go to Sven Andersen, who has rephotographed the photographic material, making it clear to me how Munch must have experimented with the camera, and to Robert May, the historian of photography, who during the writing gave me much food for thought and who also read my manuscript, correcting important details.

Above all I thank Sissel Biørnstad, librarian of the Munch Museum, who made available and arranged the comprehensive photographic material from the collections of the Munch Museum and assisted me during the long writing process, demanding clear argument and explanation throughout the ever-lengthening manuscript, when the enthusiasm of the author made him blind to faults.

A.E.

Edvard Munch's First Encounter with Photography

2. Edvard Munch, 1864. Detail from illustration (3).

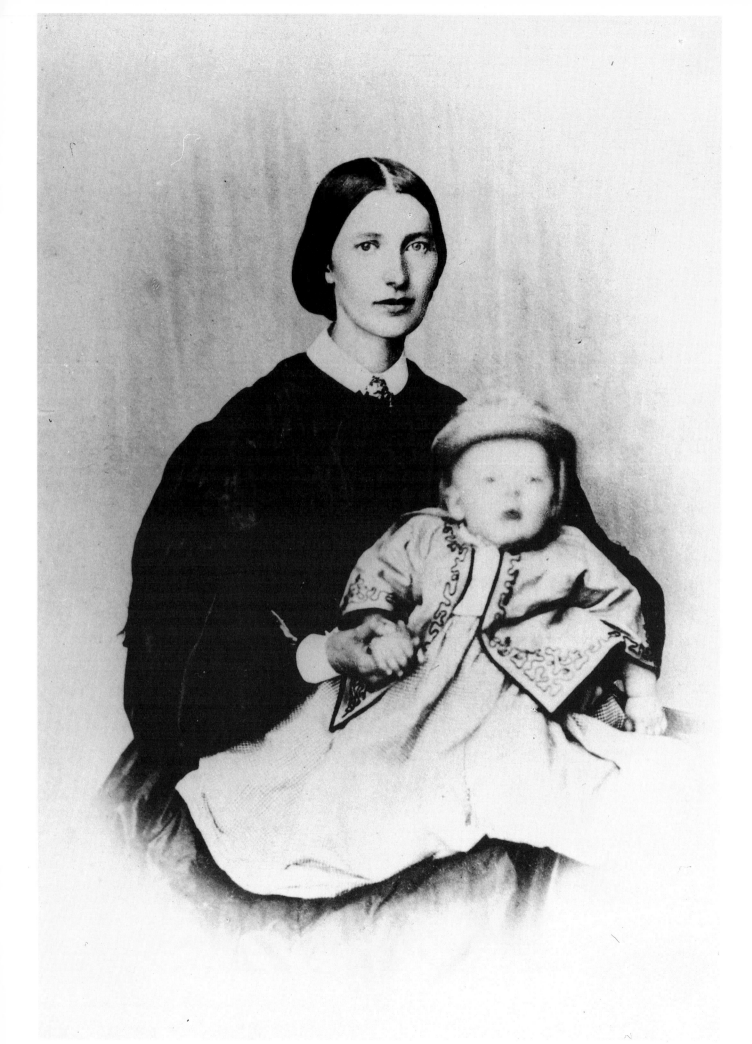

3. Laura Cathrine Munch with little Edvard on her lap. Edvard's features are blurred; he moved during the relatively long exposure time which photography of that period required. Presumably, this was the reason why his father judged the picture 'useless'. The photograph was taken by H. Lunde, who had his studio on Østre Torv in Hamar. The family then lived at Engelhaug farm at Løten, while the father stayed at Gardermoen.

The sensational discovery of photography, 'the pencil of Nature', which draws its own picture – either direct as in the daguerreotype or indirect via the negative – led to a stream of photographs for more than a decade before Munch was born in 1863. Being a child of good family, both he and his brothers and sisters were frequently photographed, singly or in groups. Thus the features of his mother and of his sister Sophie, who both died when Munch was a child, were preserved in the family.

Some of the portrait photographs were, according to fashion, mounted and hung in well-ordered, symmetrical patterns on the wall, the dead among the living. The photograph of his mother with her children around her (9), taken shortly before she died, was later used by Munch in several of his drawings recording memories from childhood (10).

The photographs have been preserved, and the way they were displayed has been recorded in some of the young Edvard's small and meticulous drawings of his homes at 48 Thorvald Meyersgate and 7 Fossveien in Grunnerlokka (in Oslo). One of these shows four photographs of female figures, in dark frames, arranged over a desk containing a bookshelf. On the desk is a handsomely bound book; judging from the size either the family's illustrated Bible or a photograph album (14). Such an album has

survived and contains more than a hundred carte-de-visite photographs of friends and family arranged in its frames. In such a manner photography democratized portraiture; one's portrait could survive without having to have been painted by professional painters.[1]

Likewise, photographs of works of art democratized the world of art, as one could get a fair likeness of a work of art. In contrast to the copperplate etching or xylograph, the photograph could give one the illusion of standing in front of the actual work of art.

As a Christmas present from his aunt Jette, who was a sister of the artist's father and was married to the artist Carl Fredrik Diriks, Munch received in 1878 what he describes in his diary as 'a book with copies of the greater Nordic artists'. The book in question can hardly be any other than the *Nordic Artists' Album, 1879: Newer Nordic Works of Art*, which was already on sale by Christmas 1878.

This book contained twenty-one mounted photographs of paintings from the Nordic section of the World Exhibition in Paris in 1879. The photographs were taken by court photographer Johannes Jaeger, who was employed at the National Museum in Stockholm. Realistic scenes like Albert Edelfelt's *Duke Charles with Flemming's Body* and Gustav Cederström's monumental *The Dead Body of Charles XII is Carried Over the Norwegian Border*

appeared in the monochrome photographic reproductions as if they were pure documentary photographs.

The most important art historians of the time, Lorentz Dietrichson, professor at the University of Kristiania (Oslo), C. G. Estlander, professor at the University of Helsingfors, and Julius Lange, lecturer at the University of Copenhagen, had written the introductory chapters for the participating Nordic countries. In these they stressed the importance of colour and brushwork, which was precisely what the photographs could not show. However, they were addressing a public whose taste was already influenced by photography.

Already from the 1850s photographs of well-known paintings of every style and period had been on sale in bookshops, and they were used, among other things, as extra prizes in Art Society lotteries. Munch must have seen many of them at the homes of friends' and relatives', as well as in exhibitions at the Kunstforeningen, which he was already as a young man visiting often.

However, the sepia photographs in the *Nordic Artists' Album* would have given Munch his first survey of the new and dynamic Scandinavian painting represented in the Paris Exhibition. Nevertheless, the texts made it clear that the photographs were merely abstractions; the most important artistic expressions could be studied only in the original paintings.

4. Carte-de-visite photograph of Edvard at eighteen months, taken by photographer J. Lindegaard. At the right of Edvard the mother can faintly be seen through the veiled framing of the vignette. Her black dress and her left hand are visible, whereas her right hand is barely seen as a white spot.

THE PHOTOGRAPH AS A PICTURE AND AS A NORM

As a medium for the reproduction of portraits, landscape paintings or other works of art, photography immediately became the subject of discussion at many levels, espeically that of theoretical perception. The camera produced pictures that, in a mysterious way, seemed to be drawn by light, by Nature itself. These pictures possessed a truth different from that of paintings. They appeared to be more objective and acquired – by analogy with the concept of reality – a kind of indisputable authority.

Concepts such as these first arose around the daguerreotype, which was developed directly on to a prepared metal plate, and later around photography, which, by means of the negative, could produce several positives. The Danish existentialist philosopher Søren Kierkegaard showed concern about the potential conformist influence of the new invention. In 1854 he wrote in his ironic, ambiguous style:

By means of the Daguerreotype everybody can be portrayed – which was earlier a privilege for only the few; and at the same time there is a strong tendency to make us all look alike – so only a single portrait will be needed.[2]

The aesthete and scientist Hans Christian Ørsted, a compatriot of

Kierkegaard, had in 1843 treated the analogy of the ways in which reality is captured by photography and by the human recollection in 'Two Chapters on the Nature of Aesthetics', in which he maintained that the process of photography reflects the activities of the senses.

From research we now know that the light provokes a change in every surface on which it produces the picture in such a manner that the picture-creating element keeps functioning for a while after the light has stopped and can be made visible by means of certain steam condensation. In the optic nerve a similar picture processing takes place, the duration of which the sense itself tells us. If we do not limit the chemical process to be applied only on apparent changes or separations of the substance, but include all our interior changes of mind, we can conclude from this that a chemical reaction must be taking place in our optical nerve during the creating of a picture.[3]

Theories of a similar kind were taken up by professional psychologists later in the nineteenth century, and, as a model for man's picture-creating activities, they had profound significance at many levels. They also led to a drawn-out debate on perception theory concerning the relation between photography and painting.

In his comprehensive and influential work on the theory of art, *The World of Aesthetics* (1873), Lorentz

Dietrichson wrote at length a description of the human senses, as a basis for an idealized art.

By seeing, the subject became fixed in my interior life – such as happens in reality with all its occasional defects; the object itself had gone, but the shape of it is still fixed, 'built-in', in my mind.

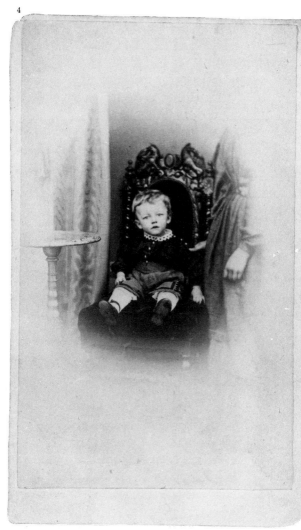

4

5. Carte-de-visite photograph of Munch's mother in a black gown, taken in 1865. The photographer, J. Lindegaard, had his studio at 12 Kongensgate, a stone's throw from 9 Nedre Slottsgate, where the Munch family lived when the father, promoted to captain, had to work at the Akershus fort. She is approaching the end of her life. The way she is standing leaning on the chair is repeated in several of Munch's drawings from around 1890.

6. *At the Double Bed*, 1891–2. The mother is saying good-bye to the two small siblings, Sophie and Edvard, who are crouched at the end of the bed, and she is leaning against it. 'They were sitting close together on two small children's chairs at the end of the double bed; the tall figure of the woman was standing next to them, big and dark against the window. She said she was going to leave them – had to leave them and asked if they would be sorry when she was gone – and said that they must promise her to turn to Jesus, then they would meet her again in heaven – they did not really understand, but finding it so awfully sad they both burst into tears' (E. Munch 1889).

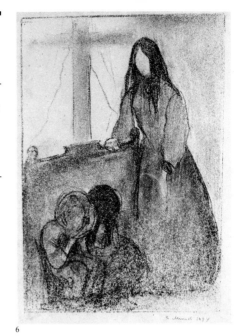

6

The portrayed has until now been standing in front of the interior camera, and this has, by looking, taken the picture; but after the portrayed has gone the picture is fixed on to the prepared plate.[4]

In 1873 Hippolyte Taine's *The Philosophy of Art* was translated into

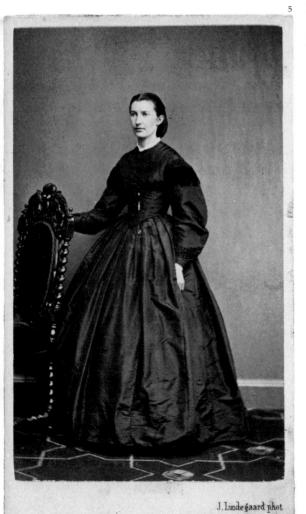

5

J. Lindegaard phot

Danish in an easily read edition, which became of great importance to the spread of Taine's philosophy of art throughout Scandinavia. Taine also discussed the issue of photography versus painting, which was simplified in his rationalistic philosophy. It does not make sense, he said, for a painter to reproduce every detail in a painting, as does photography. The artist should not make a literal delineation, he should bring out something thematic, 'the mutual dependencies and relations of all items within it'. The important thing is a meaningful concentration of the 'construction, composition, and effect' of the motifs, a total painting which makes the work of art a 'product of thought and not just hands'.[5]

The art historian Julius Lange added an interpretation to the debate in his article 'The Aesthetics of Photography' (1865), also published later in his collected articles, *Art of Today* (1873), a bestseller in Scandinavia. His point of view was, briefly, that, whether the artist took photography or nature itself as his base, the task remained the same: 'to draw lines', to sum up and accentuate in such a way that the result included both an interpretation of the subject and an adaptation to the style of the time.

William Henry Fox Talbot had already maintained in his famous book on photography, *The Pencil of Nature*[6] (1844–6), that most of man's field of vision is encompassed in a

blurred light. In contrast to the lens of the camera, the eye sees clearly only that on which it is focussing. Julius Lange argued his ideas for the first time in a letter to Georg Brandes, the cultural giant responsible for introducing many new ideas from the rest of Europe to Scandinavia.[7] Lange's main idea was that the artist, by being an intermediary, added a value to the original subject, a value which in the end became identical with the artistic value. Those ideas were pubished in *Tidskrift för Bildande Konst och Konstindustri* (1875 and 1876), which was edited by Lorentz Dietrichson, and in which photography was discussed as being especially good for reproducing freehand drawings.

According to Dietrichson's ambitious ideas for this first big and fashionable art magazine in Scandinavia, the illustrations were to appear in the four main categories of printing: etching, lithography, woodcut and photography. Etching was intended to reproduce 'the effective nuances of the painter's brush', and the colour lithograph was intended for watercolours, because this medium, in Dietrichson's view, was especially suitable for bringing through 'lots of shade and light'. The woodcut, the strength of which lay in the force of contour, was to be used for reproducing decorative patterns, vignettes and the like.

Photography was reserved for copying Old Master drawings, since

7. *The Dead Mother and the Child*, 1899–1900. The subject is linked to Munch's childhood memory where his family said farewell to his mother. The girl in front is Munch's sister, Sophie. The way she stands holding her hands over her ears, as if to protect herself against the silent scream of fear, is derived from the figure in *The Scream* (50).

8. Carte-de-visite photograph of Sophie when three years old, also taken by J. Lindegaard. She is standing by the chair on which Edvard is sitting in (4). Munch's memories of Sophie are reflected in many of his works, and this photograph brings to mind the many paintings of the subject *The Dead Mother and the Child*.

the force of photography lay in its 'completely true reproduction of lines with the finest accuracy in every detail'. Dietrichson was obviously well aware of the danger of making art banal through the spread of popular and inexpensive photographs. However, the intelligent use of different methods of reproduction would provide a suitable vehicle by which to present art to the public.

After his dynamic influence in the world of Swedish art, Dietrichson was in 1875 appointed professor at the newly established Institute for Art History at the University of Kristiania. Besides creating a base for research into Norwegian art and building up various public collections, he took it as his task to pave the way for an educational establishment for artists, and, furthermore, to educate the public into a better understanding of art. He was popular with the public,

7

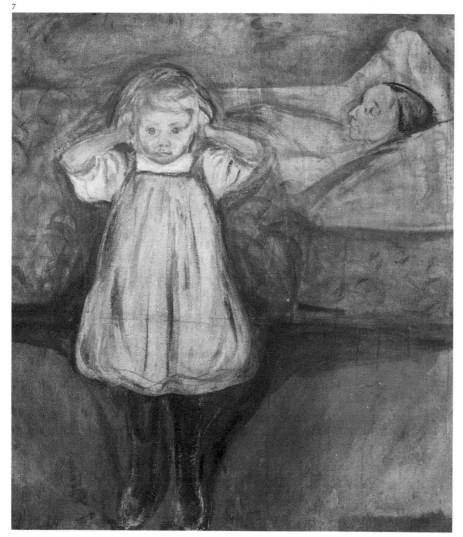

8

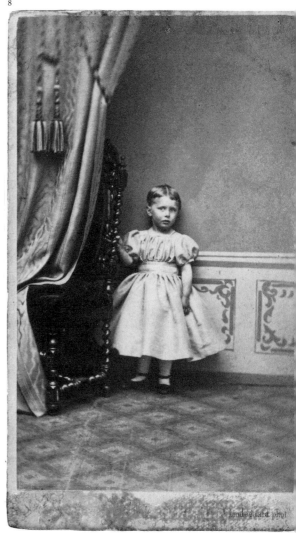

9. The carte-de-visite photograph of Munch's mother with all her children gathered around her was taken in the summer of 1868, six months before she died, and may thus be considered a farewell photograph. To the right of the mother is six-year-old Sophie, with little brother Andreas on the chair in front of her. To the left of the mother is four and a half year old Edvard standing behind little Laura, and on the mother's lap is the baby, Inger. The atmosphere is clearly serious. Already before giving birth to Inger, the mother had written a good-bye letter to the children, in which among other things was written: 'having confidence in our Lord who has promised to listen to my prayers, I will beg for your souls as long as the Lord will let me live. And now my beloved children, my loveliest little dears, I am saying good-bye to you. Your beloved father will teach you the way to heaven, where I shall wait for you all. Oh, Give, that we for Jesus' sake have our souls saved, all of us.'

10. *Childhood Memory*, c.1895. 'She was sitting quiet and pale in the middle of the settee in her heavy black dress which seemed even darker in this flood of light. Around her all five of them were either sitting or standing. The father walked up and down the room, then sat down beside her on the settee, and they whispered close together. She smiled and a tear ran down her cheek. Everything was quiet and bright . . . She, on the settee, looked at every one of us, stroking our cheeks with her hand' (E. Munch 1889. Berta was Munch's name for his sister Sophie).

but he came into immediate conflict with artists about, among other things, the function of photography as an intermediary between the public and the fine arts.

As part of his pedagogic task Dietrichson had taken a positive stand on a purchase for the Nasjonalgalleriet of a collection of 300 watercolours, copies of major works of art from the great museums of Europe, painted by Hans Bergh. Dietrichson thought that these watercolours would make good, complementary material for art education, but he met with unexpected and severe opposition from the Norwegian painter Otto Sinding, who, in an article in *Dagbladet*, maintained that it was better to buy a collection of the 'excellent photographs' now on the market, which 'would give a more comprehensive, truer and much better representation than the watercolours in question'. And he finished by stating that his point of view was shared by 'artists of all ranks'.[8]

The watercolours were none the less acquired and later transferred to the library collection of the University, which mainly consisted of neatly mounted photographs of well-known works of art. It was this collection that Munch was studying exactly a month after he had taken his final decision to become a painter. He wrote about it in his diary notation of Wednesday, 8 December 1880:

Yesterday I went to the reading room in the University where I was shown a lot of plates of the most well-known

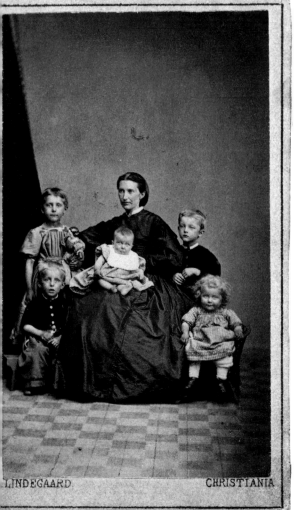

LINDEGAARD CHRISTIANIA

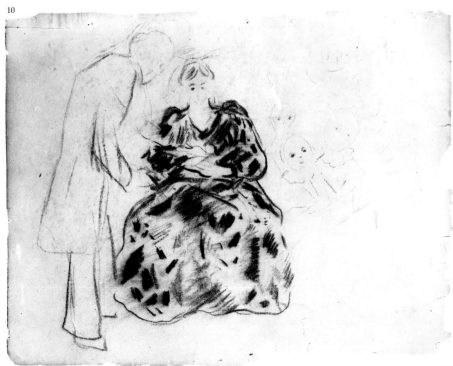

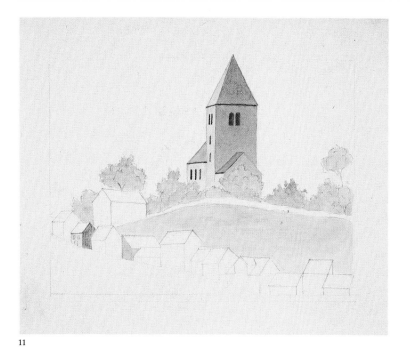

11

11. *Gamle Aker Church*, 1877. View from a window in the family's flat at 7 Fossveien. The drawing had been made as part of Munch's preparation for architectural studies.

12–13. Two drawings from 1878 of the interior of 7 Fossveien: the living room with the interesting portraits of the great-grandparents, vicar Peter Munch and his wife Christine, painted by Peder Aadnes, and a corner of the boys' room with a framed portrait of Christ over the sofa. The precise lines of these studies indicate that Munch had used a drawing device, a camera obscura or a camera lucida.

14. Desk with framed photographs around a portrait of Christ, probably painted at 48 Thorvald Meyersgate in 1877. According to his sister Inger's notes, the bookshelf with fretwork was made by Edvard.

paintings. I have now expressly started studying the history of art.

THE CAMERA OBSCURA AND THE CAMERA LUCIDA

A pair of optical drawing devices, the camera obscura and the camera lucida, were much used by artists throughout the whole of the nineteenth century. The camera obscura, which had been in use among artists and architects since the Renaissance, was now mainly constructed like a photographic box with a glass plate on which the subject could be copied directly. Like the camera it was equipped with lenses for focussing.

The less complicated camera lucida, invented in the early nineteenth century, has no box, but consists of a prism mounted in such a way that the subject is projected directly on to a piece of paper or canvas. For artists and others who aimed at a precise reproduction of reality, such devices had the advantage over the monochrome photography of the time in that they reproduced the subjects in colour.

The camera obscura and the camera lucida were much used by Munch's generation, the young stormy Naturalists of the 1880s, both in their studios and in the open air.

It is difficult to determine to what extend Munch himself made use of such instruments. The many drawings from the interior of the family's flats in Grunerlokka, first at 48 Thorvald Meyersgate, in 1877, and later at 7 Fossveien, in 1878, are completed in a common style which might be explained by the assumption that Munch made use of an optical drawing device. The many studies of the view from the window of the flat in Fossveien of Gamle Aker church, with the wood buildings of the picturesque Telthusbakken, have a similar feel indicating that a drawing device was used. The same can be said for the finely nuanced studies of *The Hill at St Olav's Church* (18).

Possibly, Munch also made studies with drawing devices as a preparation for the entrance examination to Kristiania's Technical College, where he intended to study architecture. In the autumn of 1878 these studies were augmented by others, among them mathematics. Munch was to spend the following summer, 1879, at Gardermoen, where his father served as an Army doctor during the summer, in order to build up strength for the demanding entrance examination. After establishing himself at Gardermoen the father wrote to his bookworm son: 'Do not bring too many books with you, but you must have your paints and drawing devices.'

Judging from the many precise and sure drawings of architectural subjects Munch made that summer, it must be assumed that there was a camera lucida and/or a camera obscura among his drawing tools. The peculiar, blurred edges of many of his drawings from a trip to the east of Norway that same summer indicate that he used the lightweight camera lucida while travelling, the oblong prism of which produces exactly such an effect.

At Technical College Munch had drawing lessons, which also included instruction in the use of optical drawing devices. Munch's knowledge of and skills in using technical devices must have been a contributory factor in his rapid development as a painter. As the construction of one-point perspective presented no difficulty to him, Munch could early concentrate on what was more important for him, and this gave him an initial advantage over other artists who had learned to reproduce nature by freehand drawing.

Moreover, Munch also knew of the 'magic lantern' at an early age. According to his own diary he assisted the Rev. Johan Storjohann, Norway's most influential and popular church leader, who was a friend of Edvard's father, by placing the plates in a magic lantern during a public showing of pictures from Palestine. Such photographic glass plates were often coloured with transparent enamel paint, creating a striking and illusory effect of colour. The magic lantern was also used to project photographs on to canvas, which could then be traced and painted.

At the end of February 1880 Munch contracted a violent influenza. He

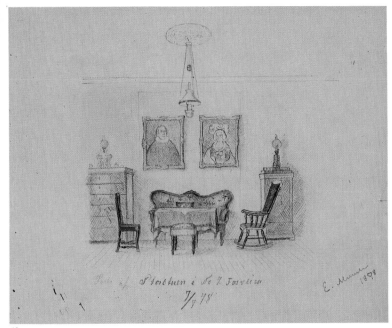

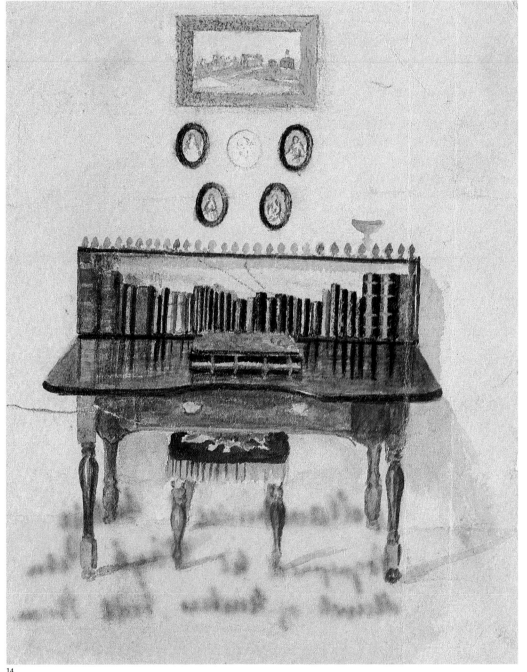

remained in bed for more than a month and had to stay at home for several more weeks, which made him miss his studies at the Technical College. At the end of his convalescence in the month of May he acquired paints and brushes and began his first oil painting, a picture of the Gamle Aker church. Even if he did not make a definite decision to become a painter until some months later, the plan must have been maturing in his mind along with the realization that he would not be able to finish his education at the Technical College because of ill health.

Just at the time of Munch's illness, a long and intense debate was taking place in the Kristiania newspaper *Aftenposten*, in which it was unambiguously stated that the leading Naturalists Christian Krohg and Fritz Thaulow both used the camera obscura and the camera lucida as quite natural devices in their profession as painters.[9]

This debate was started by the art critic Jonas Rasch, who, in a critique of the paintings exhibited at the Kunstforeningen, had maintained that Christian Krohg's painting *The Net Mender* (now in the Nasjonalgalleriet) did not have a correct perspective. According to Rasch this was caused by Krohg's lack of art education. Professor Dietrichson countered Rasch in a series of articles, maintaining that *The Net Mender* strictly speaking did have a correct perspective, and that

15. The living room at 7 Fossveien. The cabinet to the left is also in (12). Most of the furniture survives and is today in the Munch Museum.

16. A watercolour of Munch's left hand, most likely done by means of a drawing tool at the same time as many other studies of small objects in his home. After Munch's death, the drawing and a later X-ray of the same hand (143) went to Munch's friend and professor of anatomy Kristian Schreiner and ended up at last in the Munch Museum.

17. Carte-de-visite photograph taken on the occasion of Munch's confirmation. Edvard is sixteen years old and a student at Kristiania Technical College. The photograph was used as late as 1883 as an admission card to the Exhibition for Art and Industry, where Munch exhibited a painting for the first time.

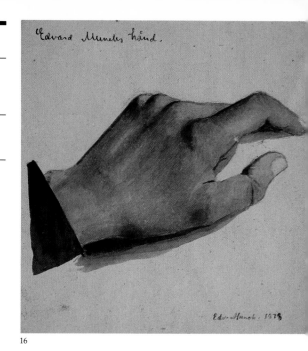

16

this could be proved by use of a camera obscura. Krohg had merely placed his device (which was in fact a camera lucida) so close to the subject that the nearest objects seemed abnormally large compared with the background. In Dietrichson's view Krohg had not broken any of the rules for the drawing of perspective, but he had broken with the conventional use of such a camera. It is therefore interesting to see that in his interiors from Skagen, in which he

has also placed his camera lucida 'wrongly' – i.e., too close to the figure in the foreground – Christian Krohg created some of his most striking works of art.

The debate about *The Net Mender* was ended by a contribution by the landscape painter Fritz Thaulow, who maintained that both the camera obscura and the camera lucida were in daily use by contemporary artists, both in the studio and outside.[10]

17

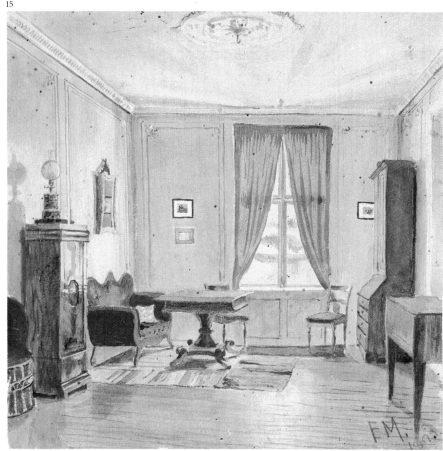

15

It is very likely that Munch followed this newspaper debate, which must have made it clear to him that when Krohg and Thaulow made studies based on their own observations, outside the realms of the academy, it could be considered legitimate to use optical drawing devices. Such drawing devices also allowed the artist to choose the most difficult angles of perspective in order to show a 'corner of reality'. Without the use of such optical devices the artist invariably had to cling to available stereotypes.

Thus the leading Norwegian

16

painters of the time in a reaction against the brownish studio painting, which had such an obvious resemblance to sepia photography, made frequent use of the camera obscura and camera lucida as devices to assist them. This enabled them to concentrate on liberating the palette, which resulted in a new approch to painting of light and colour. As will be seen later, the contrasting use of sharp, detailed photographs as a basis led to the opposite result – dry, monochrome painting.

In the light of this episode it is very likely that some of Munch's earliest, meticulously worked out interiors, which exactly illustrate 'corners of reality' – for instance, the portrait of his father reading in the settee (1881) and *The Sick-Room at Helgelandsmoen* (1882) – were constructed under the control of a drawing device. In any case, such an assumption would

18

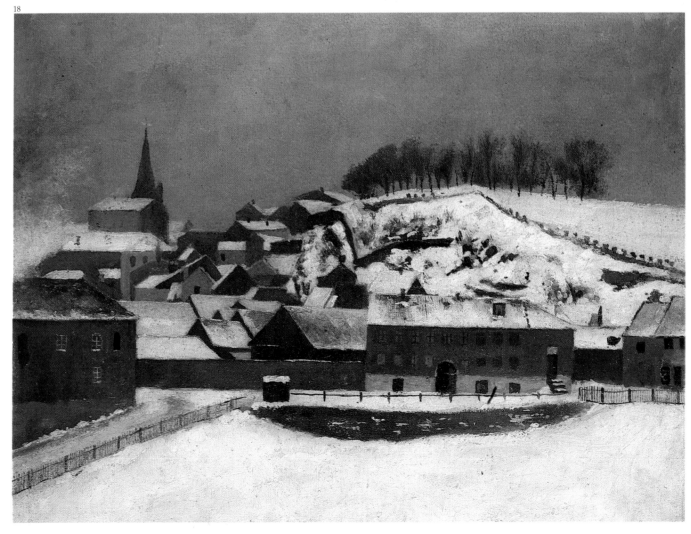

19. Christian Krohg's *The Net Mender*, 1879–80. In the spring of 1880 perspective as an artistic means was a topic for discussion in the press, and Krohg was accused of having used his camera lucida incorrectly by placing it too close to the model. As seen in Munch's painting *At Dawn* (20), he did not let the critics prevent him from continuing in Christian Krohg's style three years later.

19

explain why the very young Munch, without any visible difficulty, mastered the most intriguing perspective constructions and at the same time was able to capture the most refined images of his own eyes.

In some of his paintings created during the first half of the 1880s, Munch was so close to his model that he seems to have been inspired by the unorthodox use of the drawing device by Krohg in his principal works, *A Woman Cutting Bread* (1879) and *The Net Mender* (1879). This can be seen in, among others, *At Dawn* (1883) and *Morning*, the first paintings Munch exhibited at the Autumn Exhibition in Kristiania.

On the back of the painting *At Dawn* (20) Munch has painted three partly overlapping studies of his aunt Karen Bjølstad's head, seen from different angles (21). The studies are so precise and their perspective so difficult to achieve that the paintings on this side of the canvas, too, must have been projected on to the canvas by a camera lucida. There is absolutely no reason to believe that these studies were based on photographs, as it was quite unusual to be photographed from such angles.

From the moment photography was generally known, in 1839, the relation between painting and photography was a constant issue for debate. Would the painter now become superfluous or did he have a new device for use in his art? There were those, led by

Eugène Delacroix, who feared that painting would become a mechanical form of art.

As early as February 1839, the scientist H. C. Ørsted had given a lecture at the Society for the Advancement of the Natural Sciences in Copenhagen on 'Daguerre's invention ... the invention which allows the fleeting projection created in the so-called camera obscura to produce a lasting trace of material structure'. As the photography historian Robert Meyer pointed out, the report of his lecture was printed in full in *Morgenbladet* on 4 March 1839, only a few months after Daguerre had made public his invention.[11]

After discussing the technical aspects of photography thoroughly, Ørsted added:

The Fine Arts, the real creator, have of course nothing to fear from an art that just reproduces by similarity, but cannot create.

Already in the 1840s and especially during the 1850s, painters experimented with using photographs to capture the outlines of their subjects. A photograph could be projected on to the canvas and traced from there, or the canvas could be prepared in such a way that the projected picture could be fixed on to the canvas and painted over. The methods were many and the results just as varied.

The Pre-Raphaelites Dante Gabriel

Rossetti, John Everett Millais and Ford Madox Brown used cut-out photographic figures in their compositional preparation, whereas French artists associated with Jules Bastien-Lepage used complete photographs of the model posing in nature. To what extent Norwegian painters made use of photography before the 1880s is difficult to gauge.[12] But with the emergence of Naturalism in Norway, which compelled the artist to paint reality without adding or subtracting anything, there was an obvious temptation to use photography just as the French Naturalists had done.

Towards the middle of the 1880s there are also indications in Munch's art that he used photography as an aid and support. There are, for example, two painted portraits of his father (23) from around 1885, which can be seen in relation to a pair of portrait photographs of carte-de-visite size that his father had had taken by the fashionable photographer C. G. Rude (22). One of Munch's portraits reveals a severe and reticent expression similar to one of the photographs, even if the glasses have been omitted.

It became common practice in portraiture at the end of the nineteenth century that portrait photographs were used as the basis for further work on the canvas. Most artists stuck very closely to the basic photographic picture, whereas others – such as Munch – went the opposite way. Already in the second portrait of his

20. *At Dawn*, 1883. There is an influence from
Krohg in this painting, but also typical
characteristics of Munch: the sensitive atmosphere
and the fine reflections of light interplaying between
the dawn and the matches in the hands of the girl.
The painting was the first exhibited by Munch, at
the Autumn Exhibition of 1883, where it caused a
great deal of critical comment.

21. Portrait studies of Karen Bjølstad, 1883 (back of
20). These studies were painted over by the artist
and reappeared during restoration in the 1930s.

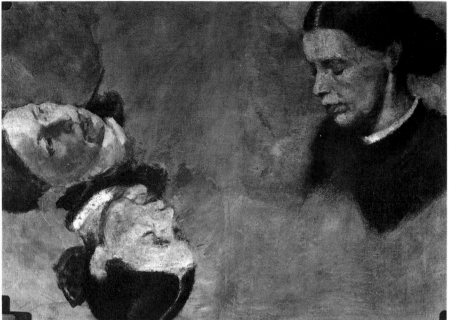

21

20

father, *The Artist's Father with a Pipe*
(1885), Munch seems to have freed
himself from the restraints of the
photograph by creating a psycho-
logically analysed portrait of his
brooding, nervous father.[13]

It was not only portrait painters
who would use photography in their
work. An existing photograph shows
how Christian Krohg had his models
photographed in a composition like
that in his main work, *Albertine in
the Police Doctor's Waiting Room*.
Later he made corrections directly on
the photograph with oil paint.[14]

This photograph has traditionally
been considered the basis for Krohg's
monumental and realistic depiction of
his theme. It also shows that photo-
graphy could function as an aid in the
very construction of a theme; a theme
the author Hans Jaeger, by the way,
criticized for having been constructed
in the studio from professional models
and not observed in reality.

For the Zola-inspired Naturalists,
who were the leading artists in Kris-
tiania when Munch entered the field,
the aim was to change the awareness
of the public by showing matter-of-
fact pictures of reality. The artist
should not edit reality; he should
neither add nor subtract. The main
aim was to find a subject and to frame
it in such a manner that the 'message'
was obvious. In that sense photo-
graphy became, logically, an equal to a
study of nature.

By this time there were well-tried

22. Carte-de-visite photograph of Christian Munch from the middle of the 1880s, taken by C.G. Rude, one of Kristiania's best photographers of that time. Munch's father was a deeply religious man with a literal belief in heaven and hell, and with his convincing stories about spirits and ghosts he could have a frightening effect on his children. No photograph showing the father with his wife and children has ever been traced.

23. *The Artist's Father*, c.1885. It is apparent that Munch had been glancing at the photograph when painting this portrait. However, the simple strokes lie as audacious colour spots giving an excellent, illusionist effect when seen at a distance.

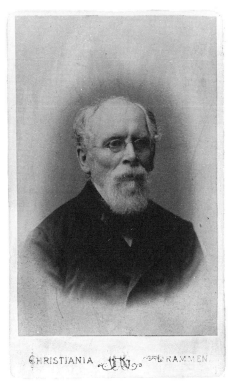

22

techniques of transferring a photograph to the canvas in such a way that the photograph became the outline drawing of the painting. This could be done by means of mechanical projection, which enlarged the photograph on the canvas. And, according to English photography magazines from around 1885, prefabricated canvases, called linographs, on which projected photographs were easy to fix, were available. However, it is uncertain if this technique was used by artists.[15]

In the catalogue of Norwegian works at the World Exhibition in Antwerp in 1885, at which photo-

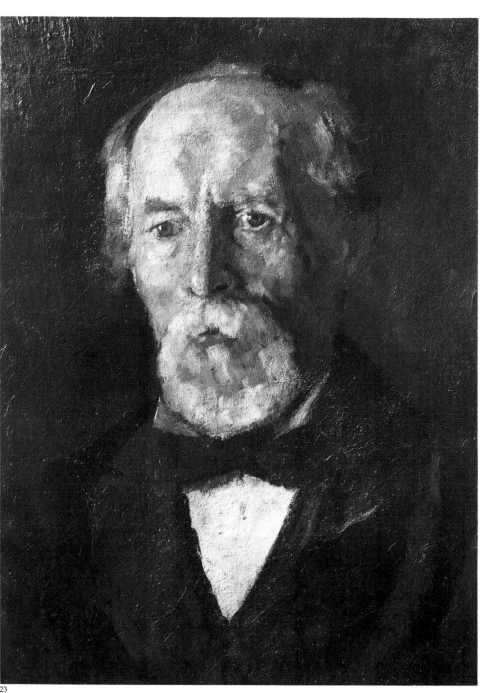

23

24. *Charlotte (Meisse) Dörnberger, c.1889.* Munch had a romance with the sister of his painter friend Karl Dörnberger in 1889, when Munch had to spend a month in the Dörnberger family's home because of a sudden illness. The picture was painted after the stay and was based on a photograph. A note in the Illustrated Diary, written in the spring of 1889, shows that Munch asked his friend for the photograph of the sister: 'Please, let me have the photograph as I cannot any longer recall her features.'

25. Carte-de-visite photograph of Charlotte (Meisse) Dörnberger found among Munch's effects, which has an obvious similarity with the portrait of her from 1889 (24). Notice how closely the mouth, the ear and the hair have been depicted. Munch's style is, however, so emancipated from the photographic original that the differences are just as interesting as the similarities.

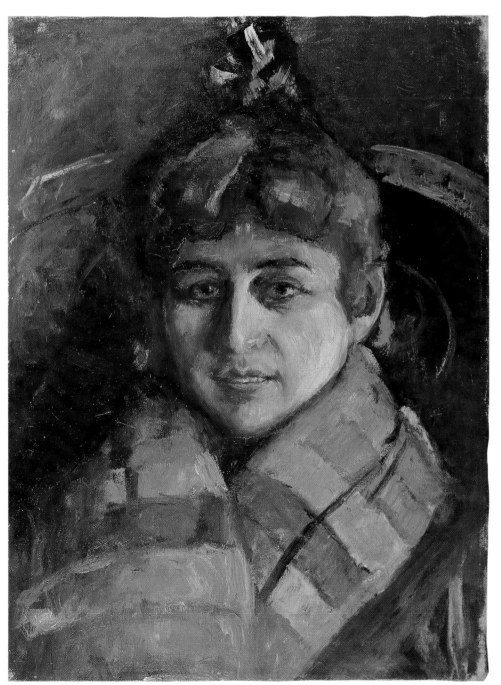

25

graphs were exhibited along with books, the following text was to be found among the listings for the Department of Industry: 'Misses Jørgensen: Oil Painting from Photography'. The sisters Alette and Nicoline Jørgensen were also known for painting portraits from photographs. It is obvious that such an industrial development is the clearest reason why an artist's eventual use of photography was kept a secret both from his contemporaries and from posterity.

The increasingly popular style of photographic realism, the painting inspired by photography, was to

24

dominate Norwegian Naturalism more and more in the 1880s with its monochrome and detailed style. This is the simplest explanation of why Munch's exhibited paintings – which were totally free of such characteristics – were received with aggression and suspicion not just from the bourgeois public, but also from his artist colleagues, such as Gustav Wentzel, who himself had practised photographically inspired painting. However, in radical circles Munch became the very image of the artist liberated from all conventions.

Photography
and Perception

26

26. Portrait photograph of Edvard Munch used as an admission card for the World Exhibition in Antwerp in 1885.

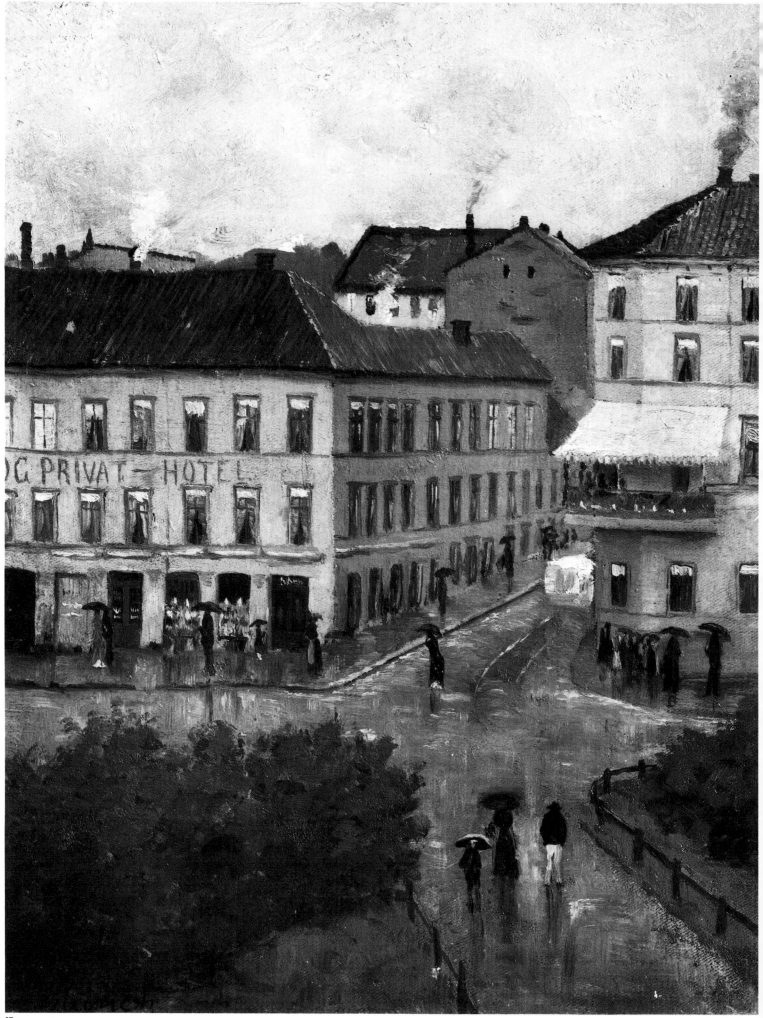

27. *Rainy Day on Karl Johan Street, c.1883.* The subject is apparently seen from a room or the balcony in the Freemasons' Lodge in Stortingsgaten. The heavy rain is appropriate for a radical Impressionist. The supposedly casual framing of the subject, inspired by photography, is also typical of the time. The bird's-eye perspective is only apparent, since the perspective lines are orientated towards a point at the horizon, at the level of the viewer's eye, which has been the classical way of drawing perspective from the Renaissance onwards.

MUNCH'S IMPRESSIONISM AND PHOTOGRAPHY

Munch was early accused of searching for Impressionist effects. The *Portrait of the Painter Jensen-Hjell* (1885) was characterized as 'the extremity of Impressionism, the wrong side of art'. Impressionism to the critic meant radical avant-garde art.

Munch's acquaintance with this new manner of painting arose mainly from the discussions in the press, artists' circles, studios and cafés. In the article 'The Impressionists' in the periodical *Nyt Tidsskrift* (autumn 1882), Erik Werenskiold wrote about this new movement in art. Werenskiold, who had attended both the independent Impressionist Exhibition in Paris in 1881 and the more selective one in 1882, maintained that the Impressionists often used unusual, oblong picture formats, unnatural colours, and an exaggerated bird's-eye perspective, and, for instance, that rolling wheels were painted blurred in the same way as a landscape seen from a moving train. Werenskiold wrote, furthermore, that the use of the pure, deep, black colour was typical of the Impressionists, who were opposed to the sepia tones of studio painting.

The art historian Andreas Aubert maintained for his part that the Impressionists had created a new expression of reality, which was of indisputable importance. Close by, the canvas seemed filled with a chaotic mess of brush strokes, like a cacophony of colours divorced from any recognizable subject. However, what the great public apparently did not realize was that the supposed mess was due to a complicated basic system. According to Aubert, their paintings were built up by means of complementary colour contrasts, a colour system that gave the viewer a complete illusion of nature when seen at a distance.[1]

Lorentz Dietrichson's contribution to this debate was a long article called 'Impressionism'. He maintained that from having been an excellent means by which the artist could modify and state his concept of nature, photography had become a tyrant to the Naturalism of the time. The new kind of photography, documentary photography, had 'sharpened the eyesight, sharpened it incredibly well so as to comprehend immediately'. And, he also wrote, 'Impressionism is the child of documentary photography: the first Impressionist undoubtedly got his first inspiration in front of a documentary photograph'. To Dietrichson there was also a convincing connection between documentary photography, the immediate appreciation of paintings at the great exhibitions where the audience were exposed to a lot of works of art in succession, and the artist's quick instantaneous brush strokes. He contended that Impressionism partly arose as a direct consequence of the great art shows of the time, for example, the many World Exhibitions.[2]

The Naturalistic painting of the nineteenth century could more and more easily be explained by its identification with photography, whereas Impressionism caused perceptual problems of a theoretical nature. Such problems belonged philosophically and traditionally to the faculty of aesthetics at a university, and Professor M. J. Monrad, who held such a chair, took part in the debate. In his book *Movements of Art*, which was published in 1883 and presumably written at the same time as Dietrichson's article, he claimed that all art is merely an imagery of senses, 'just an image created in our eye, an impression of the nerve impulses transmitted to our mind . . . Impressionism depicting the most fleeting of the fleeting moments' leaves behind 'only the impression of a quickly passing vision'.[3] As an art form of realism, Impressionism contradicts itself, according to Monrad. 'Because', he says, 'a realism which sticks strictly to experience ends up by becoming sensuality'.

However, Reinhold Geijer, who criticized Monrad's *Movements of Art* in the *Ny Svensk Tidskrift* in May 1884, thought that the Impressionists' manner of treating sensuality points beyond itself. Since an Impressionist work of art implies a total impression which also carries the artist's own impression, it becomes at long last 'a

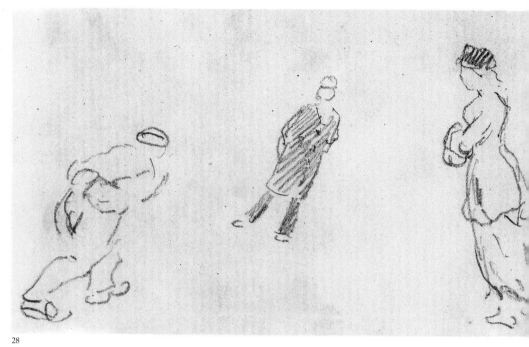

28. The skaters on the ice outside Akershus are drawn in a posture where they are really off balance. Such effects are perhaps best known from documentary photographs of street life where people are 'frozen' in unusual positions.

29–30. Two sketches from the Artists' Ball, which were to lead to the painting *The Dance Party*. The two pictures on the wall in (29) represent *Morning* and *At Dawn* (20). The drawing of skeletons shows that Munch was also able to make fun of death.

painting of moods'. The function of a work of art is, according to Geijer, to arouse the same mood in the viewer as the subject originally did in the artist.

That overheated debate about supermodern Parisian Impressionism – an art movement the Nordic audience had scarcely had any chance to experience directly – apparently stimulated the young experimenting Edvard Munch. The thoughts provoked by this debate we are to meet again and again in Munch's later

theoretical reflections on the perception of art. Such thoughts about the truth of art and photography surely motivated him to create works of art which interpreted as well as reflected the original visual subject. No one else of his generation in Norwegian art attached such importance to theoretical perception and psychological problems.

Before his first visit to Paris in 1885 Munch had seen hardly any modern French Impressionism or French

avant-garde art, apart from a few paintings by Paul Gauguin shown at the Autumn Exhibition in Kristiania in 1884. However, already in 1883 and for the next ten years Munch was constantly painting in different styles, all of them inspired by Impressionism, which showed nature through a blur of light and atmosphere. The finest example is *Olaf Ryes Plass* (1883, signed 1884). The exaggerated high perspective and the extreme oblong format bring to mind

29

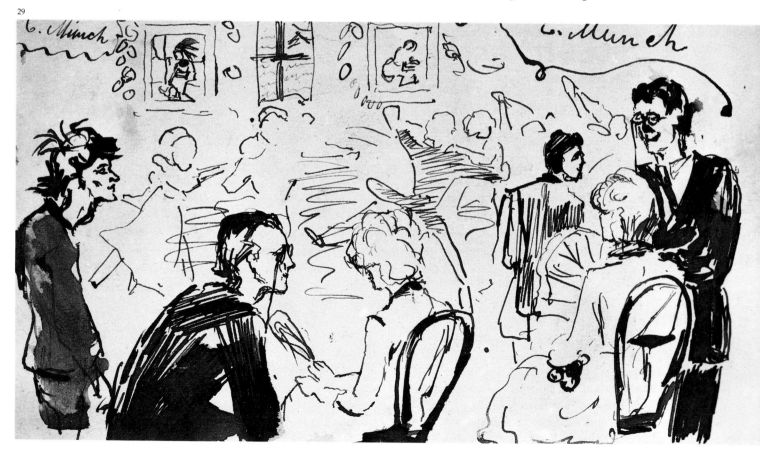

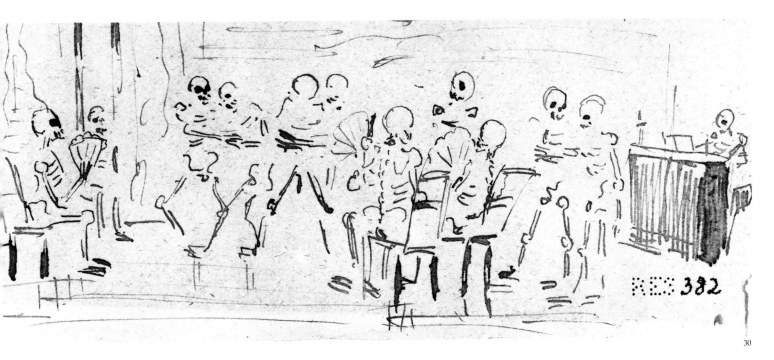

Werenskiold's article, whereas the style is closer to Aubert's concept of Impressionism.

Another line in Munch's Impressionist experiments leads on to the painting *The Dance Party*, a blurred view of a party of dancing couples in dizzy movement. The painting is traditionally dated 1885; and the style is what he himself called an 'Impressionist blur', partly caused by his own drunkenness. Several drawings from this party predate the painting, among them parodies depicting the dancers as skeletons.

Apart from those he drew at Technical College, hardly any of Munch's drawings from these years are thoroughly worked out. They are attempts at fixing the instantaneous moment, as can be seen in a study of skaters on the ice outside Akershus, a meeting place for people who also often met in Karl Johan Street. Munch made sketches of the activity on the ice in February 1882, and he considered these so interesting that he tried to sell them to *Illustreret Tidende* that same afternoon. Such a drawing has been preserved (28) (and judging from its style, it was drawn at that same time, not in 1880 as dated on the paper), and it shows the skaters in that particular frozen movement which instant photography had been the first medium to capture. In painting, this kind of movement was first shown by J. F. Willumsen and Max Klinger at the end of the 1880s. Munch's

light but sure strokes indicate extraordinary drawing talent and an ability to capture an instantaneous impression.

It became problematic for Munch, however, when he tried to combine complicated painting constructions like those of streets with an impression of the instant, as seen in his first depiction of Karl Johan Street. It is a very small picture, painted on cardboard sometime between 1881 and 1883 (27).

The supposedly casual framing of the façade, which was typical of the time, is seen from Stortingsgaten, very likely from a window of the Freemasons' Lodge (Losjebygningen), about 200 metres away. Every detail has been reproduced, from the curtains to the painted letters on the wall. The subject may even have been studied through binoculars.

The quality of the painting is, however, convincing. The rainy weather has created interesting contrasts and fine reflections, which Munch expresses in a sensitive way. People who are hurrying along under their umbrellas seem to be captured in their movement. The tram disappearing into Rosenkrantzgaten is seen as a white spot. In his treatment of the subject Munch seems to be inspired by the aesthetics of documentary photography, which may have led him astray into painting a complicated perspective without help from any drawing tools or photography.

When Munch several years later – in 1885 or 1886 – again painted Karl Johan Street (31) he attacked the subject in a totally different manner. Instead of choosing a section of the street, as was typical of the time, he painted all of it, just as it was known from popular photographs, such as picture postcards. There were at least three different picture postcards in circulation using exactly the same framing and perspective as the painting (32–4). Most likely, Munch painted from the same window in Stortinget (the Parliament) used by photographers before him.

When such a reflective artist as Munch paints a subject so often photographed – with the Royal Palace at the vanishing point and Uranienborg church at the centre line of the picture, just as it has been reproduced on postcards – there is already implied a differentiation between the artist's and the photographer's aims: the photographer should reproduce subjects that are interesting for most people, reproductions the viewers might consider their own souvenirs; in contrast, the artist should deepen these in an artistic and emotional way.[4]

In Munch's treatment of Karl Johan Street we find the same impeccable perspective as in the existing photographs; the depiction of people as dim dots also has clear reference to the photographic originals. But the way Munch has painted the buildings

31. While the vibrating light in Munch's painting blurs all details, the photographic picture postcards are in comparison crystal clear. The clear sunshine of the photographs has been replaced in Munch's painting by a far more diffused and artistic light. Munch has apparently been studying the subject from the same place as had so many photographers before him. None of his contemporary Naturalist colleagues made serious attempts at such a banal view of Karl Johan Street.

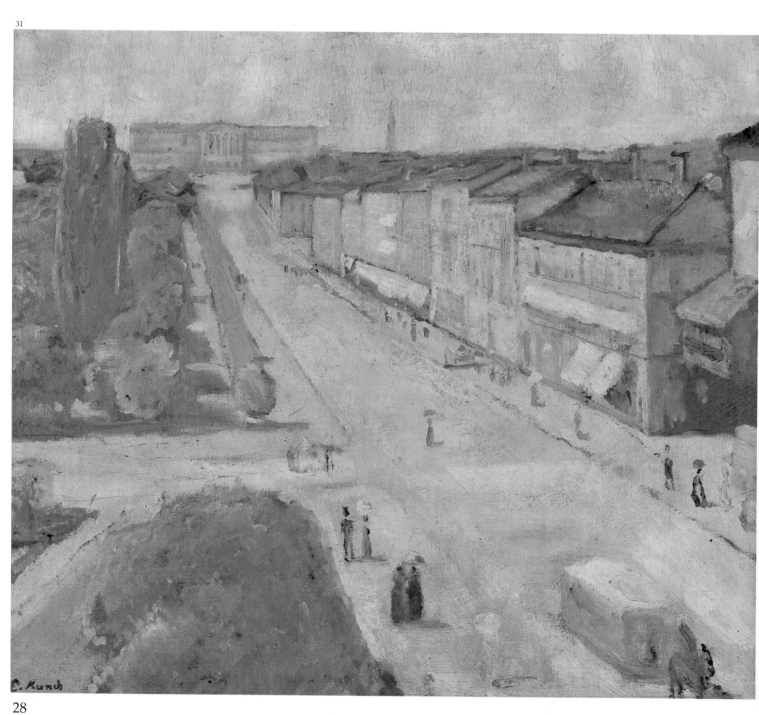

31

C. Munch

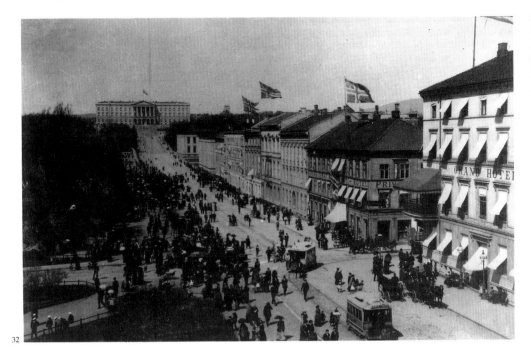

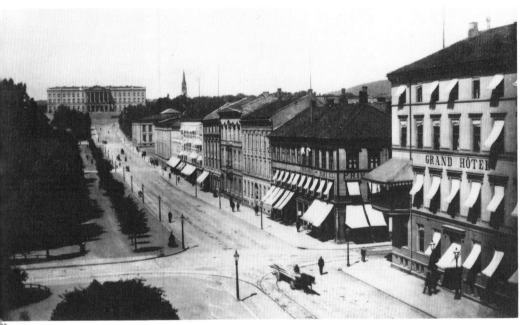

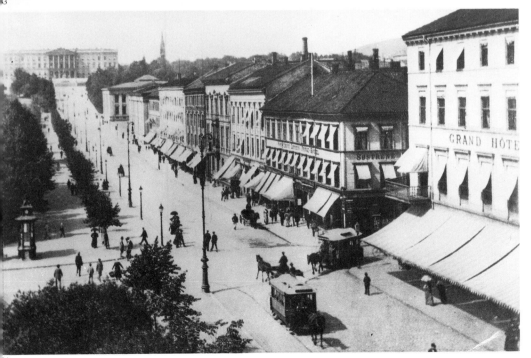

is clearly simplified, compared both with his first painting of Karl Johan Street and with the existing photographs.

The row of houses in the painting has weight and firmness of construction which reminds us of Paul Cézanne's Post-Impressionist style. The buildings are firm cubes bathed in blurred light which dissolves all details of no importance to the impression as a whole. The painting seems built up with the spatula, and together with the soft grey tones it relates to Gustave Courbet's paintings. Courbet had been introduced into the Norwegian debate as an artist who had managed to create paintings of unsurpassed pictorial strength from photographic originals.

THE SICK CHILD AND SPIRITUALIST PHOTOGRAPHY

An early photograph exists (36) of Munch's main work from the 1880s, *The Sick Child*. The painting, entitled *Study*, was exhibited for the first time at the Autumn Exhibition of 1886. The photograph, taken when the painting was exhibited in Berlin in 1892–3, reveals that to a certain extent it was painted over later.

The photograph shows a painting much more dim and atmospheric than the one known today (37). There are indications that Munch had sprayed fluid colours directly on to the canvas,

29

35

35. *Self-Portrait*, 1886. In this painting Munch has used the same technique as in the painting *The Sick Child*, scraping and scratching in the surface of the oil colours.

36. On Munch's initiative a photograph was taken of *The Sick Child* (*Study*), when it was exhibited in Berlin in 1892–3. The photograph shows the painting before parts of it were painted over at the end of the 1890s. When the painting was first shown at the Autumn Exhibition of 1886 it was received by the audience as an insult, causing an emotional outcry as never before witnessed in Norway as a result of a work of art.

37. *The Sick Child* as we know it today.

letting the colours run, thereby creating a pattern of parallel, vertical lines. The first stages of the etching of the same theme relate to the original painting, whereas later stages of the etching are influenced by the over-painted version.

When the Autumn Exhibition opened on 18 October 1886, the painting elicited open aggression, even among artist collegues. The painting clearly represented something new and sensational. A comparison with Christian Krohg's painting *Sick Girl* (39) is the most obvious way of clarifying the new elements in Munch's art that rebelled against tradition. Whereas Krohg's style could be characterized as a realism of many details, based on the school of the German painter Wilhelm Leibl, it is the lack of detail in Munch's painting that is conspicuous. The model in Krohg's painting may have been studied through a camera obscura, at a close, but correct, distance. It is, however, so refined in every detail that it also raises a suspicion that he used a professionally made portrait photograph as its model. Such photographs of sick girls were already by then an established photo-graphic genre.

Munch's *Study*, on the other hand, was painted in an almost abstract style by accentuating the lines as well as the picture plane, but focussing on the central subject, the girl's sensitive and almost transparent profile against the

pillow. Munch seemed to want to demonstrate that the subject is seen by the human eye in a concentrated moment: what the eyes have focussed upon has been reproduced relatively sharply, whereas the surroundings, which are out of focus, are reproduced as blurred. In Krohg's painting the air is crystal clear, without any atmos-phere. In Munch's painting the atmos-phere is concentrated and almost tactile.

The closest parallels to Munch's *Study* among other works of art are to be found in the works of the sculptor Medardo Rosso and the painter Eugène Carrière, especially the latter, whose monumental and remarkable *L'Enfant malade* is a peculiar grisaille interior, which, however, has more similarities with Munch's *Spring* than with *Study*. In Carrière's many typical composi-tions of mother and child, the subjects are painted in a misty atmosphere with a hint of the 'soft focus' of photography, which also relates to Munch's *Study*. Carrière seems to have been influenced by the photo-graphy of the time in his own way; and as Robert James Banten wrote:

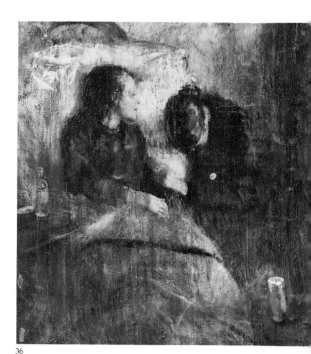

36

Though his palette may have been sug-gested by contemporary albumin prints or by his study of the Old Masters' technique of laying-in a painting, it may be that Carrière chose to continue to work in monochromatic brown throughout his mature career for symbolic reasons … This artistic

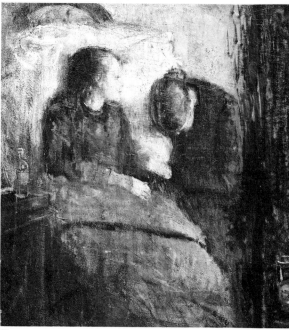

37

38. This Spiritualist photograph, taken in St Petersburg in January 1881, was one of the best known of its kind around the end of the nineteenth century. Among the papers left by August Strindberg there is an article entitled 'Science Occultes', from *La Revue des Revues* (1896), in which this photograph was printed and described as a treasure in itself. The photograph was taken by a stereoscopic camera (a camera in which two lenses simultaneously take photographs of the same subject), which was intended to reinforce the authenticity. As the materialized hand was not like the medium's (Mrs Pribikow's), this photograph became the very proof of the possibility of photographing spirits.

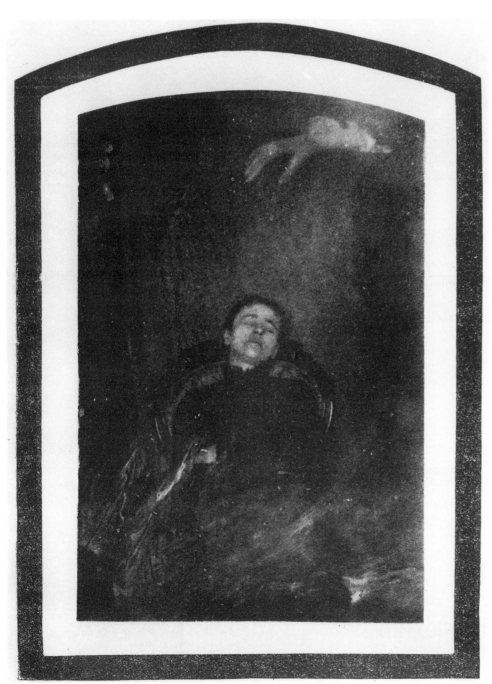

device immediately isolates his images from those of normal perception, and in effect, suggests a realm of existence other than the normal physical world.[6]

This feeling of a 'realm of existence other than the normal physical world' is expressed even better by Munch's *Study*, where, in Jens Thiis's words, 'The real world, which was the original subject, has withdrawn into itself, leaving the effect to the cobweb thin cocoon of spirit which *is* the surface of the painting'.[7]

While Munch was working on *The Sick Child*, the Symbolist Manifesto was published in Paris in *Le Figaro* on 18 September 1886. Here, and in Gustave Kahn's 'La Réponse des Symbolistes' in *L'Événement* of ten days later, it was contended that the highest aim of art was 'to objectivize the subjective'. Summed up in such a phrase this view can be applied to what Munch does in such a radical manner, starting from a naturalistic base, in *Study*.

According to later descriptions, while working on *Study* Munch was so overwhelmed with feeling that he saw his subject, through tears and trembling eyelashes, turning into stripes on the canvas; he left it like that without any alternative explanation than that it was the artist's reaction to his subject. The artist's subjective feelings could thus be said to have 'become objective'. In this way, Munch radically expanded the

39–40. Christian Krohg's meticulous depiction of *Sick Girl*, 1881, was exhibited for the first time at the Kunstnerforeningen in 1881. The depiction of death beds had a function as a kind of devotional picture which aroused the viewer's compassion and sympathy. Innumerable artists tried out the genre, which became the most popular of the time. What, however, seems to be almost forgotten in art history is that such motifs were also tremendously popular as photographs as early as the 1850s.

concept of themes in painting, and this made of *The Sick Child* a new phenomenon in Norwegian art, and perhaps in the whole history of modern art. The model is sitting in the same chair in which his mother and his sister – and he himself – had been awaiting death and longing for 'light and summer', a chair Munch kept all his life. Did he think that the chair – in a spiritualist sense – had 'photographed' these occasions? Spiritualism, the belief in the possibility of establishing a connection between the living and the dead, arose from the middle of the last century and spread from the United States to England and the Continent. Scientists of different kinds subjected Spiritualist phenomena to all sorts of research, and a comprehensive literature on Spiritualism was published.

The person who introduced Spiritualism in Norway was language teacher H. Storjohann. He was in charge of a 'Scientific Public Library' at 14 Stortingsgaten, just opposite 'Pultosten', where the young painters, including Munch, gathered at the beginning of the 1880s. In a letter to the *Spiritual Record* in London, dated 19 July 1883, H. Storjohann explained his missionary work as a Spiritualist since 1878, first in Bergen, and from the spring of 1882 in Kristiania. He wrote, 'I will do all I can to promote our glorious cause', and he intented 'to start a spiritual paper and library'. During the years 1883–6 he translated

several books from English into Norwegian, which suggests an increasing interest in the phenomenon by the public.[8]

A month before the opening of the Autumn Exhibition on 18 October 1886, when *The Sick Child* was exhibited, an intense debate about occult phenomena took place in the newspapers. The actual cause was the appearance of the American medium Dr Henry Slade, who after working for more than ten years in England and Germany held a seance in Kristiania. Among the Spiritualist phenomena the press focussed on were the so-called spirit photographs, i.e., photographs of people together with the spirits of their beloved dead relatives (41–4).[9]

This phenomenon related to the Spiritualist belief that the spirit is a misty substance which, divorced from the human body, could communicate with the living. It was also partly explained by the idea that individual imagination could materialize and be projected into a room. In both cases such phenomena – spirits – could be photographed.

Vicar E. F. B. Horn (45), who was a central person in the intellectual life of the time, described such spirit photographs in his article 'On the so-called Psychic Force' in *Aftenposten* of 14 September 1886:

Abroad one will often find photographs, originals or copies, of the following: a

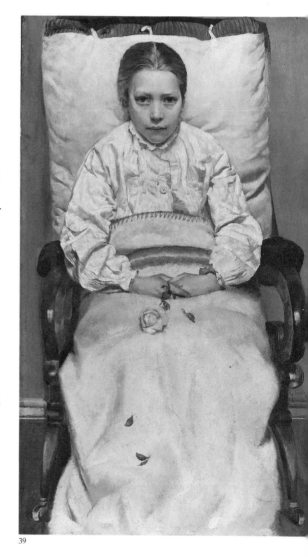

39

lady or a gentleman sitting in an armchair, and next to them a figure, often standing, in a light transparent robe, often full size, sometimes only half-length ... There is no other explanation than imagining a hidden 'force' to have produced these pictures, acting on the chemical base in the same

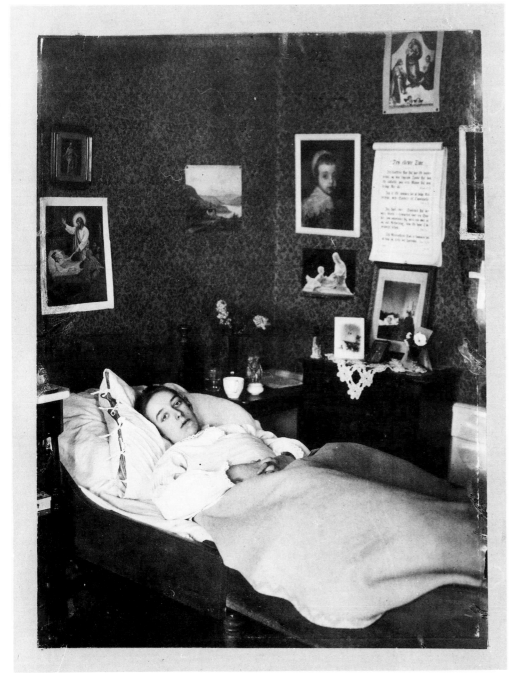

way that light does, i.e., by affecting the cornea of the human eye.

Already in the spring of 1886, Horn had been the first person to explain the history of Spiritualism in an article entitled 'On Spiritualism' in *Luthersk Ugeskrift*. He also explained the different ways in which the spirit can materialize, and, he wrote, 'many of them are even photographed'. He described quite vividly how a hand, for instance, materializes while the medium lies 'in a trance, i.e., an intensified sleep, at a level deeper than the usual night sleep'. A hand, floating in the air, is at first 'pale as the hand of a dead body, but later it looks warmer, totally alive'.

Horn thought that Spiritualism numbered more than thirty million among its followers, and that it ought to be taken seriously by the Church: Spiritualism could lay the ground for modern theology. Horn especially mentioned the Spiritualist author Allan Cardec who, with Emanuel Swedenborg, maintained that spirits were the souls of the dead, just like angels in the Bible. Horn also referred to Mrs Houghton's *Chronicles of the Photographs of Spiritual Beings and Phenomena* (1882), containing fifty-four phototypes of spirit photographs, and he mentioned several Spiritualist periodicals, such as the *Spiritual Record* and *Sphinx*.

Horn, who here revealed himself as a confirmed Spiritualist, was a col-

41–4. Spiritualist photographs, taken in 1872, from Giorgiana Houghton's *Chronicles*. The author is sitting in the chair and behind her is the materialization of her deceased mother, whose right hand touches her shoulder. The photograph is just like the 53 others in the book taken by the photographer Mr Hudson. (42) shows Miss Houghton in conversation with her deceased sister, taken in May 1872. The light shade between the two women was interpreted by another participant as, 'a ray of coloured light, flowing from her to you . . . it is a link binding you to each other; it flows from the heart, but also from all other regions below the heart.' The first Spiritualist photograph was taken ten years earlier by the etcher William M. Mumler, when he was taking a photographic self-portrait on 5 October 1862, and which he described in *Spiritual Magazine* in December of the same year. This caused a plague of similar experiments, primarily designed to demonstrate contact with deceased people.

41

42

43

44

league of Munch's father: he was the Army Chaplain of the same regiment in which Munch's father served as an Army doctor. Horn was also the vicar of the congregation to which the Munch family belonged, and he confirmed both of Munch's sisters, Laura and Inger, as well as conducted the funeral of Munch's father in 1889 (46). Furthermore, Horn was well known and respected in radical circles. Hans Jaeger had had the task of taking down his sermons of 1884–5 in shorthand, with the aim of having them published, and he had also given 'him' much space in the final chapter of his (banned) book *From the Kristiania Bohemian*, in which Horn served as a model for the vicar who conducts Jarmann's funeral. It is very possible that Munch knew of the Rev. Horn's views, and eventually also his writings, such as *Fantasy and Imagination* (1885), in which Horn, in a popular manner, explained most of the occult phenomena known to psychology and folk belief. He was convinced that they are part of reality and that they are in fact the basis of religion – the very same thoughts which became so popular half a decade later through the flowering of Neo-Romanticism.[10]

Shortly before the First World War – when Munch again wanted to combine his major themes into a frieze of life – he created a new subject, *The Sacrament*, in which the vicar portrayed is the Rev. Horn, seen together with the Munch family at the father's

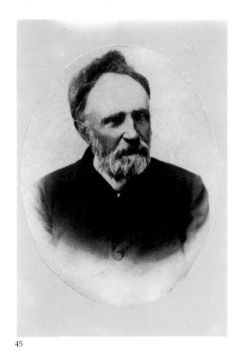

45

45–6. The Rev. E.F.B. Horn was closely connected with the Munch family. He confirmed Edvard's sisters, Laura and Inger, and he was present when their father died, an occasion which is reflected in *The Sacrament*. When Munch painted the subject around 1915 he must have had a photograph of the vicar on hand. Munch himself was absent when his father died, and the scene could be regarded as a recollection created by imagination, just as with the painting of *The Death of the Bohemian*.

deathbed; a scene Munch himself could not possibly have recalled, since he was staying in Paris when his father died.

In the autumn of 1886 an undercurrent of mysticism and religiosity broke through at a time which had otherwise mainly been characterized as rationalistic. For instance, the first Spiritualist magazine, *Morgendaemring*, was published in September. Bjørnstjerne Bjørnson gave a lecture about Spiritualism to the Workers' Society on 20 September, in which he pleaded for the creation of a society for psychic research after the example of a similar institution in London; and the

respected professor of aesthetics M. J. Monrad spoke on 'Spiritualism and Related Topics' in the ceremonial hall of the University some weeks later. The lecture was published in *Morgenbladet* on 6 October, ten days before the opening of the Autumn Exhibition. Monrad, who had experienced a reaction against rampant Naturalism and materialism, maintained that there were certain aspects of the mind that did not reach consciousness in the normal ways.

In Spiritualist literature it is often pointed out that it is the nervous, hypersensitive individual with artistic talents and a well-developed imagin-

ation who is more disposed to see and sense supernatural phenomena. Painters like William Blake and Dante Gabriel Rossetti were – so it was often noted – among those artists who at an early stage had used such phenomena as a subject.

A Spiritualist painter within the tradition of pure photorealism of the 1880s was the well-known Munich painter Gabriel Max (who was the protégé of Albert Kollmann, a role Munch was to take over in 1902). One of his best-known paintings shows a materialized hand guiding a woman playing a piano. In addition, there existed a more obscure tradition of the artist–medium, which language teacher Storjohann took a special interest in. The theory was, in brief, that a medium in a trance, without any previous knowledge of his or her subject, was able to depict correctly people who had lived generations earlier.

When Munch himself twenty years later took what he called his Fatal Destiny Photographs, the transparency and mistiness of which bring to mind the most expressive Spiritualist photography, he wrote the following lines, which show that the Spiritualist mode of thought was not far removed:

Do spirits exist?
We see what we can see – because we have such eyes –
What are we?
A collected force of movement – a burning candle – with its wick – now

46

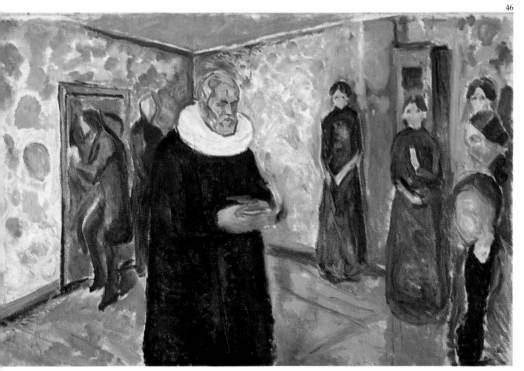

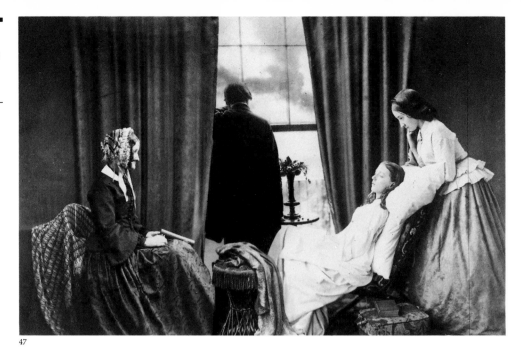

47. H. P. Robinson's *Fading Away*, 1858. The photograph shows a family gathered around a dying young woman, who, in a traditional arrangement, is sitting in a chair leaning against a big pillow. The picture had a great influence on the treatment of such motifs in art from the 1850s onwards.

47

*the inner warmth – now the outer flame
– and another invisible ring of flames –
If we had had different eyes – we could
see our wick, as with X-rays – a con-
struction of bones –
Had we had even more different eyes –
we would have been able to see our
outer rings of flames – and beings of
other shapes –
Why should not other beings of easily
soluble molecules exist around us and
in us –
The spirits of the dead –
The spirits of our beloved – and evil
spirits.*[11]

In the light of the above quote it makes sense to consider Munch's *Study*, or the *The Sick Child* in any case, partly a result of this first debate about Spiritualist phenomena, in respect to both the subject itself and the misty, totally unreal atmosphere surrounding the figures of his dead mother and sister Sophie. The convincing similarities between the typical Spiritualist photography of the time and Munch's *Study* are hardly due to coincidence.

Even if Munch had scratched out and repainted the subject several times – and he was working on the painting for perhaps more than a year – the debate about spirit photographs and medium-inspired paintings can explain the final visual expression of the 'cocoon of spirit', as Thiis described it, and also the fact that Munch was not only motivated, but dared to exhibit such a work at that time.

THE MEMORY AS PHOTOGRAPHIC RECOLLECTION

Many of Munch's notes explain his work on *The Sick Child* (*Study*), how he noticed that the subject gradually lost the original atmosphere of the underlying sketch, and how he scraped into the overlaying paint, almost searching in the oils for this original expression. At the same time he was trying to recall the contours and colours he 'had recorded in his inner eye – on the cornea', imprinted at a moving moment in his youth. He reworked the painting many times in order to make 'the emotion vibrate'.

Munch's struggle with this painting was thoroughly described by Hans Jaeger in a newspaper article dealing solely with this painting, while it was still being exhibited at the Autumn Exhibition. Jaeger clearly realized that *Study* represented quite a peculiar artistic achievement, founded in the conscious wish to recall a significant childhood event and recreate it on the canvas in such a manner that the artist's feelings were accurately conveyed to the viewer.

Painting pictures of impressions received in moments of emotion may seem to be far from the Naturalistic style of the nineteenth century and its detailed depictions of reality. But such new ideas had already appeared; ideas which might have caught Munch's interest. For instance, the Rev. Horn described, in his book *Fantasy and*

Imagination (1885), the inner pictures 'which lie in our mind like photographs', and the peculiar 'ability of our mind to renew such almost forgotten memories', an ability with which 'artists, poets and sanguine people are specially provided'.

The complexities of recollection had been presented in detail the previous year in the periodical *Tilskueren* in an enthusiastic article, 'On Recollection and Imagination, in which the young medical doctor Holger Mygind, together with the philosopher and psychologist Harald Høffding, discussed the distinction between memory and recollection.

The memory is the ability to preserve impressions once received, whereas recollection is analogous to printing photographs, or to bringing the preserved impressions into consciousness. Every impression of the senses leaves 'a consistent material mark, the sum of which creates the image of memory'. Quoting Horn, in this way the interior images of our mind's camera are created.

In his article Mygind also mentioned the fact that people often complained about 'not having the ability to recall the images of a beloved dead relative'. He referred to Francis Galton's *Inquiries into Human Faculty* (1883), a book that presented many points of view on the problem of the artistic use of inner images, 'mental images'. Galton

48. *Spring*, 1889, is one of the many paintings inspired by the style of *Fading Away*. The similarities were originally even more convincing. An X-ray photograph taken by Leif Pather has revealed that at an earlier stage there were several standing figures in the painting.

maintained that there is a force which, without much effort, can be trained to 'project mental pictures upon a piece of paper, and hold it fast there so that it can be outlined with a pencil'. For instance, it is obvious to him that the painter William Blake created his universe of images from projections of his mind. Galton also discussed some occult observations of psychological interest.[13]

The book was written in an easily read style which also made it popular outside research circles; and at the same time it had so scientific a profile and such gravity that so eminent an authority as Harald Høffding took it very seriously. It can thus be said that this book presented a theory that embraced the experiences hinted at by Munch while working on *Study*; that is, the ability of a human being to project inner images like a magic lantern.

Another popular scientific author, T. A. Ribot, wrote the following in his work *The Diseases of Memory* (1882, Danish translation 1892) about the human ability to search for the images of recollection:

If we compare our past life on to an unrealistic hypothesis – the way we subjectively imagined it – we would realize that the image consists of its own system of projection; each one of us is at ease with this because he creates it himself.[14]

Elements of recollection, such as images from memory, also occupied a central position in Harald Høffding's standard work, *Psychology* (1882), in which he describes the phenomenon by referring to how he, after having stared at a photograph in an oval frame, visualized a negative on his cornea. This negative dissolved, and then the positive reappeared as a copy in the field of vision of the closed eye. According to Høffding, this was really a copy of a copy.[15]

He also refers to Brierre de Bois-mont, who in his book *Des halluci-nations* talks about an English painter who, after a short study of his model, completed his painting by visualizing the model, whom he projected three-dimensionally 'more alive in colour and contour than in real life'.[16]

It can thus be stated that during the very period in which Munch was painting *The Sick Child (Study)* a fundamental debate took place, dealing with pictorial depiction in connection with both Spiritualist phenomena and the complexities of recollection in psychology. Recol-lection, which by Høffding among others was characterized as the basic mental phenomenon, gave a new di-mension to artists who were occupied by the fundamental problems of psychology, be it Ibsen in *Rosmers-holm* (published in September 1886) or Munch in *The Sick Child*; and, whereas memory was seen as being analogous to the manner in which 'the pencil of nature' creates its images on a photosensitive plate, recollection was described as a development of pictures in consciousness, corres-ponding to the printing of the photo-graph from negative to positive.[17]

Photographic Realism and Recollection

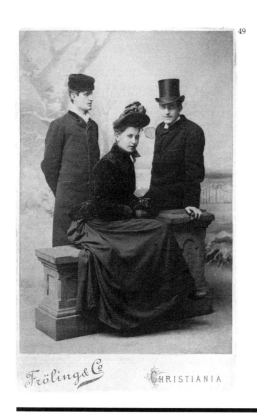

49. Edvard Munch, Åse and Harald Nørregård, 1889.

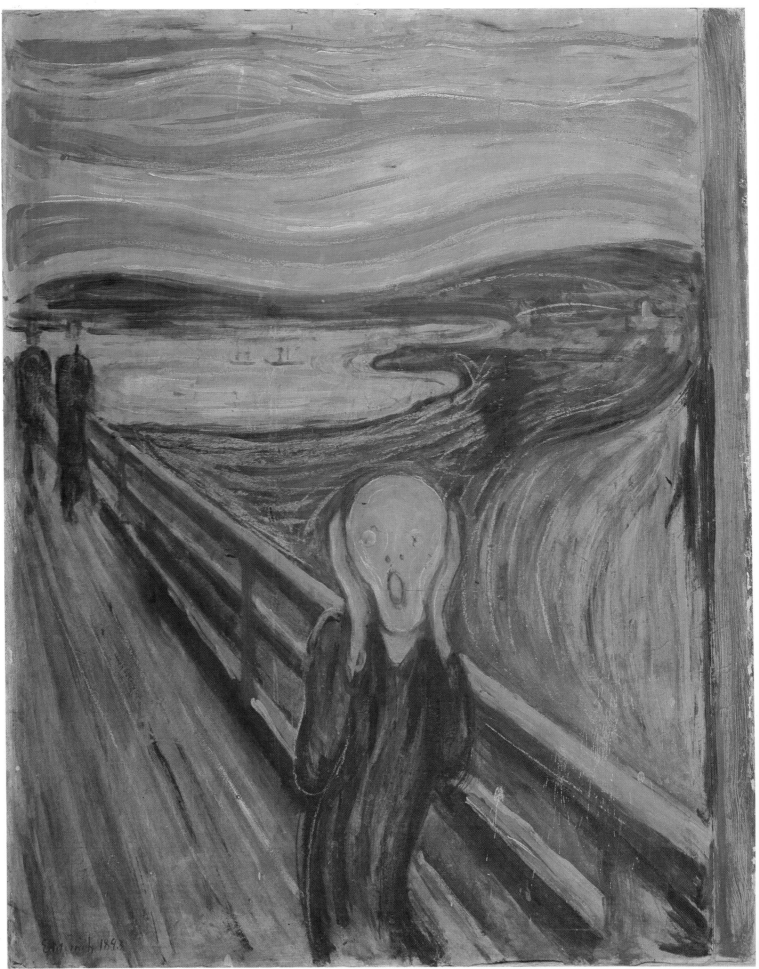

50. *The Scream*, 1893. 'I walked along the road with two friends – the sun was setting – I felt a breath of sadness – Suddenly the sky became red as blood. I stopped, leaned against the railing, tired to death – seeing the flaming skies like a bloody sword – the blue-back fjord and city – My friends walked on – I was left standing there trembling with fear – feeling one tremendous eternal scream going through nature' (E. Munch, Nice, 22 January 1892).

In the chapter 'Art and Photography' from his book *From Naturalism to Neo-Romanticism* (1934) Leif Østby comprehensively described the photographic style that characterized most of Norwegian painting during the second half of the 1880s:

From the 1880s the relation between photography and art entered a new phase. Naturalism was driven into a blind alley. The competition with photography to show realism in its truest form ended up with artists, at any rate the most important of them, withdrawing into tunnels where photography could not reach them, leaving the battlefield to the competitor.

The photographic style, 'the blind alley', was characterized by Østby as 'an almost colourless, grisaille, or monochromatic green or brown, like the tones of photogravure. All details are overdone, the surface thin and lacking substance, the brushstrokes completely invisible.'

To Østby this photographic style was particularly dominant in the works of Ludvig Skramstad, Oluf Wold-Torne, Theodor Kittelsen and Lauritz Haaland; and towards the end of the 1880s Christian Krohg became its most prominent representative. Whereas this cautiously coloured style was to the taste of the general public, the taint of photography was received as a drawback by the more qualified art critics.[1]

In the summer of 1886 the painter Christian Skredsvig gathered some like-minded artist friends together at his new home, his farm at Fleskum, in Daelivannet, Kolsåstoppen, out at the western part of Baerum. This so-called Fleskum Group is generally said to represent a reaction to the Naturalistic painting of their time. Their common aim was to achieve international recognition – i.e., Parisian – while painting typical Norwegian subjects.

Erik Werenskiold worked on his illustrations for Norwegian tales; Harriet Backer painted the people and milieu of a typical farmworker's house, and Eilif Peterssen, Kitty Kielland and their host found inspiration from the summer nights on the waterfront. One of the paintings from this time, Eilif Peterssen's *Summer Night* (1886) has since been recognized as a major work of Norwegian landscape painting (52). However, the painting cannot be said to belong to any tradition, either Norwegian or international; it is an original creation in art on Norwegian soil. Most of the picture-plane is filled with the surface of the water, on which the viewer is looking down, because the horizon is placed extremely high. The sky and the clouds, the blushing light of the horizon, and the pale waning of the moon are reflected in the water. The ridge and the group of trees in the background have been cropped by the frame but they can be seen through their reflections in the surface of the water.

The perspective lines, formed by the tree trunks either leaning over the water or lying on the surface, create a mystical and intense picture space. Both foreground and background are relatively blurred, whereas the large centre is so focussed that every detail and every twig is seen clearly and precisely.

If Munch's *Study (The Sick Child)* can be said to relate to the soft focus of photography, *Summer Night* seems to be painted as if the landscape were seen through a camera focussing on the centre of the subject. Even if the paintings are very different from one another, both seem to attract the viewer's eye towards the centre of the picture space, a centre which seems to radiate its own immaterial source of light.

After Munch's *Study*, Peterssen's *Summer Night* was the most discussed painting of the Autumn Exhibition in 1886. It was not just the subject and the style that attracted attention, but also its broad, silvery frame, which, according to one critic, matched the colours of the painting; to another it was too strong a contrast. The extremely high horizon was the reason the painting was hung unusually low on the wall; and one critic thought that it might as well have been standing on the floor, because it really ought to be seen from above.

Andreas Aubert wrote in his long critique of *Summer Night* that, in spite of the originality of 'the framing of the landscape ... the painting has not escaped a hint of brownish-violet, which does not originate from true

41

51

51. P. H. Emerson's *Gathering Water-Lilies*, 1886. In his photographs Emerson wished to renew the naturalistic landscape painting in the tradition of Millet and Bastien-Lepage; these were no longer to be considered as subordinate to painting, but as an equal art. Several of his photographs typically enclose the subject, this effect achieved by pointing the lens downwards so as to let the water surface fill out most of the picture. He uses the perspective lines of the oars to create spacial tension. The tension, the vegetation, and the reflection of the sky in the water's surface create a lyrical atmosphere, like the one in Eilif Peterssen's *Summer Night*.

nature'.[2] The characteristic 'hint of brownish-violet' was equivalent to a taint of photography in the language of the time.

Aubert also referred to a small landscape painting by Gustave Courbet which was hung in the entrance hall of the exhibition. He argued against an opinion expressed by Lorentz Dietrichson in his biography *Adolph Tidemand: His Life and Works* (1878) that Courbet's paintings were 'painted, glittering photographic pictures of everyday life, lacking poetry'. Aubert thought, on the contrary, that the exhibited painting by Courbet was 'filled with Romanticism, expressing an enthusiastic mind carried away by a lonely and sombre nature'.

Both Aubert and the other critics found Peterssen's *Summer Night* very realistic and filled with poetic atmosphere.[3] The illusion of genuine nature was said to make one critic want to dip his fingers into the water, and Aubert to want to go and stand by the tree in the foreground. Before painting this unique work in Norwegian landscape painting, Eilif Peterssen had painted hardly any landscapes; in the main he had painted historic subjects. Perhaps that was why it was natural for him to consider a reflective element once he started landscape painting. He probably knew of Dietrichson's treatment of water as a poetic-reflective pictorial symbol in his book *The World of Aesthetics*:

The ability of the water to reflect surrounding nature is of special significance to us; a symbol of the reflection of one nature in another nature, a reflection of itself in itself. Water is the lifegiving element of nature – the eye of nature; it recalls the soul of nature.[4]

The illusory and photographic touch of *Summer Night*, and the peculiar fact that the painter of historic subjects, Eilif Peterssen, could have executed such a landscape painting, make one wonder if there is not a similar photographic subject that might have influenced it.[5]

In May 1886 the English photographer P. H. Emerson had a sensational success with his photograph *Gathering Water-Lilies* (51), which was exhibited and immediately published in an issue of one thousand signed photogravures, enlarged to 28.5 × 38 cm (250 copies were sold, mounted on cardboard in the size 44.5 × 61.5 cm). After printing, the plate was destroyed. This was the first time a photograph copied directly from the glass plate was presented and distributed as a work of art. In the spring of 1886 Emerson had maintained in a number of articles in the *Amateur Photographer* that it was possible to create works of art by means of photography of equal artistic value to painting. As a photographer he considered himself within the tradition of the painters Corot, Millet and Bastien-Lepage.

Gathering Water-Lilies has many surprising similarities with Peterssen's *Summer Night*: the high perspective, which makes the viewer look down on the surface of the water; the water in turn filling up most of the photograph; the sharp lines of the water-lilies and the rushes in the crystal clear surface, in which the sky is reflected; plus the perspective reinforced by the lines of the rudders and the tree trunks. The focussing of the broad centre – which is also found in *Summer Night* – is precisely the photographic effect Emerson is known to have used. What made *Gathering Water-Lilies* so popular was the combination of a realistic depiction of nature with a highly poetic atmosphere, which is also the characteristic of *Summer Night*.[6]

Whether Eilif Peterssen had seen Emerson's photograph is an open question. But it can be noted here that Frithjof Plathe, the father-in-law of Christian Skredsvig, a prosperous businessman and well-known art collector, had close connections with England. It was he who had lent the above-mentioned picture by Courbet to the Autumn Exhibition in 1886.

The combination of an extremely high horizon and the effect of moonlight was to be a formula Munch made use of throughout his life. However, crystal clear and detail-filled realism was never Munch's trait. On the contrary, in the eyes of his contemporaries he went to extremes of

52. Eilif Peterssen's *Summer Night*, 1886. The subject is seen from a small spit at the south end of Daelivannet at Fleskum farm in West-Baerum. The hill reflected in the surface of the water has the characteristic profile of Kolsåstoppen. Today, the bay is a little more overgrown by water-lilies, and the group of trees has expanded, otherwise the motif is still 'photographically' correct.

53. *Inger on the Beach*, 1889. The model is painted on the shore of Åsgårdstrand. When Munch exhibited the painting for the first time at the Autumn Exhibition of 1889, he entitled it *Summer Night*.

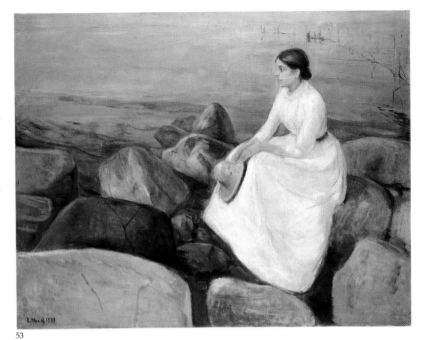

53

expression in his abstracted simpli-fication of nature.

The first momentary appearance of this was in the lyrical, musical painting *Inger on the Beach* (first called *Summer Night*, 1889), in which the horizon lies above the frame (53), and the row of mooring posts creates a picture space similar to the space created by the birches in Peterssen's *Summer Night*. All Munch's erotic landscape paintings, such as *The Mystery of Night* (1892), *The Voice* (1893) and *The Dance of Life* (1900),

express in common a poetic sensual atmosphere, which derives from a rather high perspective in the reflected light of the moon – sometimes doubly reflected – in the surface of the water.

Munch's particular use of these elements seems to refer to *Summer Night*; but it may also be inspired by Theodor Kittelsen's landscapes from the second half of the 1880s. However, it was Munch who had the talent to interpret the mysticism of nature in works of major importance in the history of art.

52

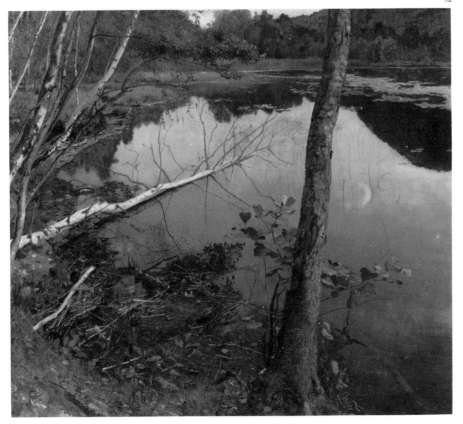

MUNCH'S MANIFESTO AGAINST PHOTOGRAPHIC REALISM IN ART

When Munch visited Copenhagen in the summer of 1888 he could, besides seeing a collection of Scandinavian art, also have been exposed to modern French art at the comprehensive French Exhibition which was on at the same time in the Danish capital. At the Scandinavian Exhibition photo-graphs were also exhibited. Even if the Danes were predominant, the Nor-wegians showed to their advantage, since three of the four participating Norwegians received prizes.

In contrast to the photographs exhi-bited at the Arts and Crafts Exhibition in Kristiania in 1885, photographs had by now become esteemed aesthetic objects. In the wake of this exhibition photography shops were established in all Scandinavian countries, and several photographic magazines appeared.[7]

In Copenhagen Munch also made contact with the painter Johan Rohde, the first spokesman in Scandinavia for van Gogh and Gauguin and their revo-lutionary art. The previous year Rohde had become fascinated by El Greco's art during a visit to Spain. In the December 1888 edition of *Kunst-bladet* he published a long article in which he maintained that El Greco, 'when he considered it relevant, sacrificed colour, drawing and com-position in order to capture the exact mental life he wanted to express'; in this he has 'many points in common

54. Portrait photograph of Edvard Munch, used as an admission card for the Kristiania Theatre.

54

with artists of the most recent times'.

Rohde used the same terms to praise El Greco that Christian Krohg had used earlier in the same magazine in a damning criticism of the young Norwegian artists at the exhibition in Copenhagen, a criticism generally considered to have been aimed at Edvard Munch.

Referring to El Greco, Rohde continued that it was fully legitimate to paint unnatural, distorted features and oversized eyes, and to use clumsy, unharmonious colouring. What makes up for these 'technical offences' is the fantastic atmosphere which, even if it is revolting, creates 'a treasure of the deepest and most honest understanding of the human soul'.

The visit to Copenhagen, with its multitude of influences, must have contributed to the insight Munch acquired into his own art. Here he was able to study all that was new and innovative in painting, and all that broke with photographic realism in art, from Delacroix to Manet. And the knowledge of El Greco gave him a historical reference point for expressive painting that could not fit in with the classic construction of single-point perspective pictorial space.

This is the time when Munch formulated his own characteristic approach to painting which was diametrically opposed to photographic realism. The first notes were taken down on the occasion of the Autumn Exhibition that same year (1888).

According to one of these, he found the exhibition 'mild, matt and harmless'; the audience were neither 'horrified nor annoyed', but just 'gaping sluggishly and foolishly at the many paintings which they have seen a hundred times before'. Munch characterized Jacob Bratland's painting *After a Watchful Night* as a subject 'for which the sick child had simply been sleeping nicely and quietly throughout the night, serving as a model. The painter had never really seen this, in any case he had not painted what he saw.'[9]

Another note carries Munch's first comment on photography and art. It is a manifesto and a banner for the young artists to follow, the young artists who must arm themselves against the banality of art:

We want something more than just a photograph of nature. Nor is the aim to paint neat paintings to hang on walls of a living room. We will try if we can to reach an art that captures the human being – and if we cannot fully succeed, then just to do the foundation. We want an art that grasps. Art created by life blood.

The note indicates that Munch considered himself the representative of a new generation of artists. Perhaps, he was thinking of uniting the young artists who were complaining about not being given enough space for their art at the Autumn Exhibition. Several of them were still being refused, among them Munch. The idea of

Secession Exhibitions – communal exhibitions for young radical artists who wanted to break with tradition – was in fashion at the time. But the outcome was for Munch his own first one-man exhibition at the Student Society's Hall in April 1889.

It is quite likely that Munch wrote the diary, later known as 'The Illustrated Diary' and partly based upon earlier notes, in the period leading up to this one-man exhibition. Here are long theoretical reflections in which he argues against photographic realism in art. He imagines a new form of art that is not just based upon recollection, but that also must appear to the viewer in such a manner that a painting in the end becomes the recollection of the viewer, and this is the basic criterion. Considering the importance of the note in this regard it is quoted here in its entirety:

The fact is that we see differently at different times. We see differently in the morning from in the evening. The way we see is also dependent upon our moods. That is the reason why a subject can be visualized in so many ways, and that is what makes art interesting.

Coming from a bedroom into the living room in the morning we will, for instance, see everything in a bluish light. Even the deepest shadows are lightened. After a while we will get used to the light, the shadows will become deep, and everything will then be seen sharply.

If we want to paint such an atmos-

44

55. At the easel in Åsgårdstrand, July 1889. Munch is standing in front of a study of the stones for *Inger on the Beach* (53). According to a contemporary letter, dated 18 July 1889, from his sister Laura, the study was painted 'around 9 to 11 in the evening'. Laura describes also how the photographer C. T. Thorkildsen, whom she characterized as 'very nice, but a little boring', took the photograph of them: 'I am standing at the coffee table; the hostess, her daughter and the little child are standing near the house. Grønstad is by the stairs, a cup in his hand. Edvard is painting at the easel, and Inger is holding the kitten.'

55

phere – say, this blue morning light has moved you – then it will not do just to sit gaping at each thing, painting it 'exactly as we see it'. We will have to paint just as it has to be, the way it looked when the subject moved us. And so if we cannot paint according to our recollection, but have to use models, then we are bound to do it wrong.

The painters of details call this dishonest; to paint honestly is to paint with photographic accuracy this or that chair and this or that table, just as it is seen in that moment. They consider our attempt to capture a mood dishonest painting.

In a drinking bout we see in another way: the outlines merge, everything becomes chaotic. As is well known, you can also see wrongly, and then you must – that is logic – also paint in a wrong fashion. If we see double, we will have to paint, for instance, two noses. And if a glass is seen slanting, it has to be painted as such.

If we want to express something we have felt in an erotic moment when we were excited and amorous, and we have found a subject at such a time, then we cannot capture it by painting it as we see it a second time, when we have cooled off. It is obvious that the first image we have seen must look different from the second.

We perceive differently when we are warm and cold. And this is the element – the only one – that makes art interesting. It is the human being, life, that must be portrayed. Not lifeless nature.

A chair may attract just as much interest as a person, I think. But the chair must be seen by a person. It must

in one way or another have moved you and it must move the viewer in the same way. It is not the chair that is the essence of the painting, but the response of the human seeing it.

A parody of the craftsman concept of art has been written by one who is in the front line of the detailed method – Wentzel: 'A chair is a chair and it cannot be painted in more than one way', and this is why the followers of that style feel such contempt for the painting of atmosphere. They cannot comprehend that a chair can be seen in a thousand ways: 'A chair is like that, of this or that colour, so it has to be painted like that.'

Their skill can be admired; it can be said that it is not possible to paint better – so they may as well stop painting, as it cannot be done any better! But it leaves one cold. The blood does not flow any faster. We are not moved. It has not given us anything to remember, something which might be recalled later. The painting is forgotten in the moment you no longer look at it.[11]

It is tempting to think that Munch must have known of van Gogh's distinctive *Chair*, painted in December 1888, when he wrote his note. He may have heard of van Gogh's latest works from Johan Rohde in Copenhagen. There were also Scandinavian links with van Gogh via Gauguin. Fritz Thaulow was Gauguin's brother-in-law and it might have been from him that Munch heard a description of the painting, which later became so renowned.

Among the sketches in the Illustrated Diary (1889) are several sketches of very Impressionist style, some of which have an unusual concentrated single-point perspective of the same subject as the painting *Evening on Karl Johan Street* (1892). However, the exaggerated perspective is more *outré* than in the painting and may relate to the way single-point perspective is used in *The Scream* (1893).

Such a high perspective, which gives the viewer the impression of the sloping floor of a stage, was already seen in paintings of the 1870s, in works by Edgar Degas and Gustave Caillebotte, and it was to become a characteristic of van Gogh's expressive painting towards the end of the 1880s. It is not quite clear whether their use of this perspective was influenced by Japanese woodcuts, the unusual perspective of which fascinated artists at that time and was the subject of much discussion.

Even if Munch had not seen any Japanese prints at the art dealer Bing's in Paris during his short visit in 1885, there were many opportunities to study Japanese woodcuts at the exhibition in Copenhagen, where Bing showed a selection from his Japanese works. The editor of *Kunstbladet*, the art historian Karl Madsen, who himself owned a large collection of Japanese art, had already in 1885 written a book about Japanese painting, which had been well received by

both the public and the press. In this book is illustrated, among others, the woodcut by Hiroshige *From the Outskirts of Yedho*, where the foreground is dominated by a wooden bridge, on which people are hurrying along under their umbrellas in the rain. In the centre is the citadel, and in the background Fuji Yama. Karl Madsen wrote in connection with this major work in Japanese woodcut:

Without knowing the rules for the construction of perspective the Japanese know very well the effect of perspective. The lack of theory may well be the reason why they audaciously tackled the phenomenon of perspective which the European painters had earlier avoided.

They did not follow the principle of leaving a distance of 20 feet from the foreground of the picture, but gave it a scale, which seems out of proportion, but which in reality is exact. The chambre-clair instrument shows that they were right, and the latest European painting has followed their practice so as to produce a surprisingly effective perspective.[12]

The 'chambre-clair' in the second quotation is the French word for the Italian 'camera lucida'. The use of such a perspective then follows in the book, and it is described as providing an opportunity for the modern artist. For an experimenting artist like Munch it must have been obvious that he would consider the possibilities

46

56

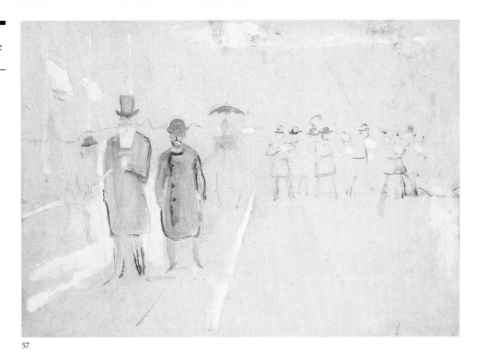

57

opened up by the young Japanese artists' primitive use of exaggerated perspective. Another characteristic of these artists is the tradition, carried over from Japanese ricepaper painting, of leaving great areas of the surface unpainted. They could not understand why 'one has to keep on painting on the same canvas for such an unreasonably long time', as Madsen put it. He also reported that the foremost of Japan's young artists were studying at Bonnat's in Paris, where Munch was going to study later, in the autumn of 1889.

THE MILITARY BAND ON KARL JOHAN STREET

A painting that reflects many of the impressions Munch must have received in Copenhagen is *The Military Band on Karl Johan Street* (59), painted in Kristiania in the spring of 1889. The painting is a milestone in Munch's artistic development; it explodes in light and colour, and the brushwork is executed with a lightness and boldness that presage the future.

Greater parts of the canvas are left unpainted and this is the first time Munch uses perspective as an attractive and exciting element in the composition of a painting, an element otherwise known in several of the works of van Gogh and the Pont-Aven Circle. The composition of the picture

space, as well as the partial use of the new decomposition of the colours, has a basis in Seurat's *A Sunday Afternoon on the Isle of La Grande Jatte* (1886).

Munch also thought – at least he said so later – that *The Military Band on Karl Johan Street* exemplified a kind of colour decomposition. In 1929 Munch had published his booklet *On the Creation of the Frieze of Life*, which was a long account of the experience that led to the painting. The experience is here compared to the experiences behind the themes of *The Sick Child* and *The Scream*. The account was probably based on a note written while painting the subject. A version of the account, written in 1908, has been preserved:

I made the observations while walking along Karl Johan Street one sunny day – seeing the white houses against the light blue air of spring – rows of people passing each other as if in a ribbon running along the walls of the houses – then the military band came down the street – playing a march – and then, suddenly, I saw the colours differently – vibrating in the air – vibrating in the yellowish white façades – The colours of scarlet and white parasols were dancing among the flow of people – yellow spring costumes against blue-black winter costumes. The golden trumpets flickered and sparkled in the sunshine – everything was vibrating in blue, red and yellow – I saw everything differently under the influence of the

music – The music separated the colours – I felt a sensation of joy.[13]

The military band was an institution in the capital, and the marching musicians were the signal for the strollers to meet every Sunday at two o'clock sharp in this, 'Kristiania's living room'. The band is depicted as a many-coloured ribbon – a flickering of colours – across the street. The figures on the outer left and the figures of the children are just cursory, almost abstract dots of colour. The tension between the Naturalist and the Impressionist stylistic elements is concentrated in an almost programmatic manner, with a contrast between the elderly man with a top hat, to the right, painted in an almost sculptural manner in shades of grey, and the woman in front of him with a scarlet parasol, painted in a flat and casual fashion.

James Ensor, Munch's counterpart in Belgian art, set up contrasts in the same way in his work. He populated his Naturalistic interiors with puppet-like figures and masks. As in the case of Ensor, is there any more reason to believe that such elements in *The Military Band* on *Karl Johan Street* are due to later repainting, as has been suggested?

A photograph from the end of the 1880s of the military band on Karl Johan Street has been preserved in the Oslo Bymuseum (58). It is a professionally made documentary photo-

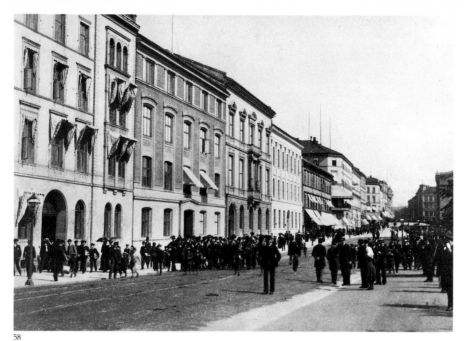

58

58. Cabinet photograph of Karl Johan Street from the end of the 1880s. To the left the military band is on its way to the Music Pavilion around two o'clock on a Sunday afternoon in summer. During the performance this part of the main street became the living room of the city, where everybody who wanted to see and be seen used to promenade along this boulevard.

59. *The Military Band on Karl Johan Street*, 1889. There is every reason to believe that Munch had help from a photograph in painting a music band marching down Karl Johan Street, even if it was meant to be a spontaneous reproduction from memory.

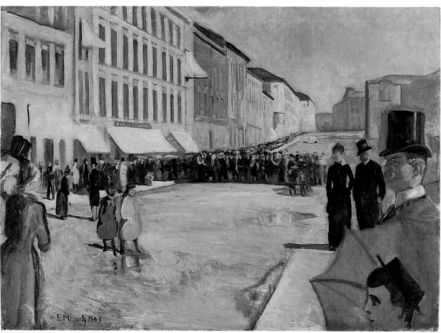

59

'THE SQUARE ROOT OF NATURE'

Munch's Impressionist-inspired landscape painting from a long period can be seen as an attempt at painting, not documentary landscapes, but momentary impressions of landscapes. It was the human aspect of such momentary impressions that occupied Munch, not the mechanical. Whereas many of his artist colleagues still painted under the influence of photography, Munch increasingly called upon his memory to recreate his impressions and 'the boundless feeling of the moment that split the past and the present giving a glimpse of eternity', to quote the philosopher Søren Kierkegaard, in whom there was a great interest at that time.

In this process Munch likened the creation of a work of art to giving birth in agony. He wrote that these momentary impressions were

not humbug done in a slovenly manner ... but they are created in seriousness and agony – they are the results of sleepless nights – they have cost your blood – your nerves.

This note was probably written in January 1891, at a time when Munch's works were in the main completely uncomplicated. Among others in the spring of 1891, he painted a couple of street scenes in Paris, *Rue de Rivoli* and *Rue Lafayette*, using an exaggerated foreshortened perspective

graph taken at street level with such a quick exposure time that every single figure in the crowd is clear. The photographer was the legendary L. Szacinski and the subject is so close to Munch's painting that it is reasonable to ask if he had this photograph at hand while painting it. There would have been an obvious need to use a photograph in such a fleeting situation, even if it was meant to be an image of spontaneous recollection.

In the spring of 1889 photography as a medium was especially topical in Kristiania. The fiftieth anniversary of the invention of photography was being celebrated, and the Photographic Society in Kristiania invited professional photographers as well as amateurs to an exhibition which –

among other topics – would show 'documentary scenes'.[10]

It is obvious that the general excitement stimulated by such an exhibition heightened the interest in photography, and Karl Johan Street, on a Sunday afternoon, with the spring sunshine reflecting in the puddles, and with long shadows and the military band, would have been an obvious subject for photography.

Munch would also later paint scenes from Karl Johan Street with the aid of well-known photographs (for example, picture postcards (60)), such as *Spring Day on Karl Johan Street* (61) from 1890, in an almost Seurat-like Divisionist style and *A Rainy Day on Karl Johan Street* (1891), in an almost Monet-inspired Impressionism.

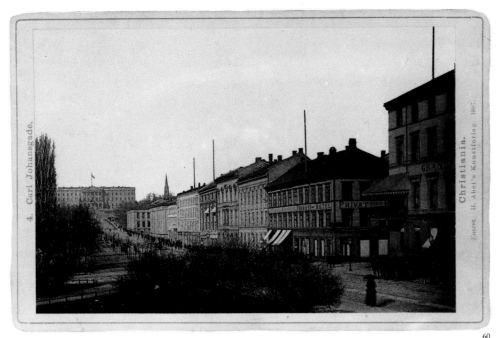

60–1. The picture postcard of Karl Johan Street from c.1887 has approximately the same perspective as Munch's painting *Spring Day on Karl Johan Street*, 1890 (the painting was wrongly signed with the later date of 1891). There are quite a few photographs of Karl Johan Street from around 1890, very often showing one of the lions in front of Stortinget in the foreground. Unlike the earlier picture postcards, these have been taken from street level.

60

in his own interpretation of Impressionist technique as a series of peculiar, parallel brushstrokes.

The themes of these paintings are not very interesting, and the work of Eugène Caillebotte is probably a direct model. But it is interesting to see these paintings in relation to the photography of the time, which little by little had become less conformist, as some photographers tried to copy the style of Impressionism. It also became more usual to have exchangeable lenses, for example, wide-angle lenses or telephoto lenses, which familiarized people with the many possibilities of perspective. So it is not

always simple to track down which one inspired the other, the painter or the photographer. The photographer E. Puyo claimed, for instance, that he was inspired by Munch's *Rue Lafayette* to take a photograph of this street in the same dynamic perspective.[17]

The most expressive use of perspective in Munch's art is found in *The Scream* (50). Munch painted a study for this painting called *Sunset Atmosphere*, later entitled *Despair* (63), in the winter of 1892, while he stayed with Christian Skredsvig in Nice. Skredsvig described in detail in *Days and Nights amongst Artists*

(1908) how for a long time Munch had wanted to paint 'the recollection of a sunset' which literally had appeared as clotted blood. Munch thought that nobody would ever have the same sensation as he had had and was sad because the limited means of expression through painting was never sufficient. Skredsvig wrote: 'He is aspiring to the impossible and he is desperate enough to turn religious, I thought, but I advised him to paint it – and he painted his strange painting *The Scream*.'[18]

Munch himself summed up his experience in retrospect in the following note, dated 22 January 1892:

I walked along the road with two friends – the sun was setting – I felt a breath of sadness – Suddenly the sky became red as blood. I stopped, leaned against the railing, tired to death – seeing the flaming skies like a bloody sword – the blue-black fjord and city – My friends walked on – I was left standing there trembling with fear – feeling one tremendous eternal scream going through nature.

It was at this time that Munch's sister Laura was diagnosed as insane and was admitted to Oslo Hospital. Munch feared that his own despair could also be transformed into madness, and his painting may be understood as a disturbed mind's compressed expression of fear.

The landscape in the background of *Sunset Atmosphere* is a view of

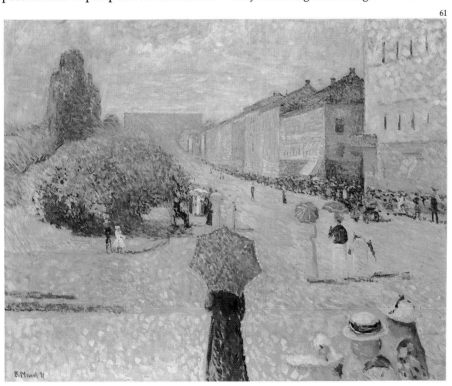

61

62

Kristiania seen from Ekeberg. After Karl Johan Street it was the best-known Kristiania view, varied and repeated in many drawn, painted and graphic versions from the end of the eighteenth century (62) until it was reproduced as a picture postcard in 1890. Munch, who at this time lived out at Nordstrand, must have passed the place many times. And he may also have known that just below the spot on Ekebergveien where he painted his view, was Oslo Hospital, the insane asylum for women, surrounded by slaughterhouses. Both the screams of animals and those of women must have carried the short distance to the ridge where Munch heard the screams of nature and saw clouds 'red as blood'.

It is important to note that this most abstract of Munch's landscapes is basically a correct depiction of a generally known location, which, theoretically, could be verified by a camera. But Munch's simplified style clearly shows the possibilities of painting as opposed to photography. In *The Scream* Munch transformed a given landscape as much as possible without rendering it free abstract painting. In his own words he captured 'an extract of nature – the square root of nature'.[20]

In October 1892, just before Munch took the train to Berlin to arrange the one-man exhibition which was going to shake the art life of the Emperor's capital and give Munch a European

succès de scandale, Christian Krohg interviewed him for his book *Artists*, which was published the same year. Krohg summed up Munch's attitude as follows:

His concept of art has basically always been the same, concentrated in his hatred of Realism. He gets angry when hearing somebody talk about this or that work of art being 'honest' and starts talking about the big storeroom 'Honesty', where all pictures of which neither good nor bad can be said shall be stored.

One shall not paint the way one sees the subject, but the way one saw it, he says, for one's state of mind will never be the same today as yesterday, or the same in the evening as in the morning, so one will never be able to recapture the nuanced mental impression if one sets out to paint the way in which it is seen now.

Therefore, he says, it is of no use to continue a painting for long, as one has to be careful not to spoil a refined successful work by a later, different mood – and that is why he prefers to leave a picture unfinished in cases where something might be ruined.

It is psychic impressions, and only those, he wants to show, not a picture of some part of nature.

If, for instance, clouds seemed like blood when you were in an excited mood, he says, it is not good to paint normal, realistic clouds. You must go the direct way – paint clouds like blood.

He thinks it must be a relief for painters to realize this, so we can never again be overtaken by photography.

And he cannot understand how one can be so idiotically ambitious to think that one can paint something which approximates nature.[21]

It is in Munch's rejection of Realism that Krohg sees his artistic originality, and that, strangely enough, at a time when Krohg's own painting became more and more tainted by photography. The following reflections, which were probably written before Munch went to Berlin in 1892, give the quintessence of Munch's long-held thoughts about art and nature.

As such, art is one person's need to communicate something to another – All means are equally good – In painting as in literature the means is often taken for the aim – Nature is not the aim – If one can obtain something by changing nature – it must be done –

When you are in an emotional mood a landscape will have a certain effect on you – by depicting this landscape you will recall your emotion – it is the emotion that is the main thing – Nature is just the means – Whether the painting looks like the nature in question is of no importance. – It is impossible to explain a picture – The point is that it has been painted because there is no other way of explaining – You can just hint what you have been thinking of.

I do not believe in art that has not been forced out from a human being's need to open up the heart. All art, literature as well as music, must be created by your life blood – Art is your life blood.[22]

63. *Despair* is the first painting of the theme of *The Scream* (50), which was painted the following year in a hotel room in Berlin.

64. *Death in the Sick-Room (The Moment of Death)*, 1893. The painting may be considered a family portrait showing Edvard Munch's sister Sophie, sitting in the cane chair with her back to the viewer, surrounded by all her relatives. The bed is the same one we know from (6), where the mother says her farewells to Sophie and Edvard. The portrait of Christ on the wall was also shown in Munch's small study from the boys' room from 1878 (13). Munch's painting could be said to crystallize a memory. The process of developing and copying photographs was at that time being used as a model for psychological analysis of the manner in which the mind creates and recalls memories.

63

THE MOMENT OF DEATH

The subject known as *Death in the Sick-Room* (1893) was originally exhibited as *The Moment of Death* (64), and it was understood to be analogous to the manner in which death scenes were traditionally portrayed on stage, where the actors 'froze' the scene in a tableau vivant. Few if any of his contemporaries knew that Munch's painting was a family portrait produced from the 'recollection' of one of the 'actors' on the sloping stage floor.

According to Munch's own notes the subject is his sister Sophie's own moment of death. She died of tuberculosis at the age of sixteen, when he himself was fifteen. She is not visible, sitting in the cane chair, with her back turned to the viewer. Munch writes that she had just asked to be put back to bed, after which she fell back into the chair, dead.

The sloping perspective of the floor causes a sharp distinction between foreground and background. In the background stand Munch's aunt Karen, bent over the dying young

woman's chair, and his father, who is praying, his hands folded. Munch's brother, Andreas, is leaving the room. In the foreground are Edvard and his two other sisters. He is facing his dying sister, while Laura is sitting, hunched up and melancholy, in profile. Inger is standing in a frozen pose, *en face*, with big staring eyes, as an intermediary of the drama to us, the viewers.

The effect of this compressed perspective is a totally new element of intensity and expression, even if it has antecedents in the interiors of Degas, van Gogh and Toulouse-Lautrec. The group in the foreground is seen at such close quarters that if Laura were to get up, she would burst out of the picture. It is thus an extreme development of the use of perspective first represented in Christian Krohg's pictures from Skagen in 1879.

If this picture were to be considered by photographic standards, in the sense that Munch, having 'photographed' the event with his cornea, painted it exactly like that several years later, the composition would become somewhat meaningless. The living members of the family are here shown of the age when Munch painted the picture, and not as the children they were when they together experienced the death of their sister. Munch has, furthermore, painted his own figure in this 'recollection', which he really could not have seen or photographed. This apparent

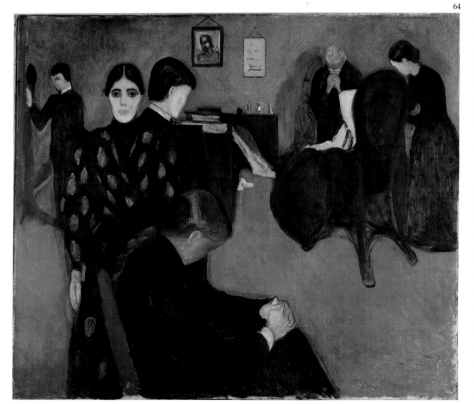

64

contradiction can be explained by a certain understanding of recollection in psychology at that time.

Francis Galton, the person who has written most clearly about memory, maintained that some people have the habit of 'recalling scenes from a distance, not from the point of view where they were observed, and they visualize their figures as actors on the mental stage'.[23] T. A. Ribot wrote in *The Diseases of Memory* that the individual creates his own projection when recalling from his past. Referring to Ribot's explanation, the scene of Munch's painting can be interpreted as a subjectively projected recollection and not a 'photographic' recollection. Such a projected recollection may well have contributed such a personal and expressive touch to Munch's art. Munch himself expressed it as follows:

I painted picture after picture of the impressions I had had in my mind in emotional moments – painted the lines and colours I had imprinted there at my inner eye – the cornea. – I just painted what I recalled without adding anything – without the details I no longer kept in mind. – Thus arose the simplicity of the paintings – the apparent emptiness.[24]

Strindberg and Photography

65

65. Edvard Munch, 1890–2.

A short time after Munch and Strindberg met for the first time in Berlin at the beginning of December 1892, Munch painted a portrait of the Swedish author in an Impressionist grisaille, a snapshot-like painting far from the stylish author portrait Strindberg had wanted.

The fact that Munch painted Strindberg was reported in the press both abroad and at home. Munch's famous one-man exhibition in Berlin was reopened in December at the Equitable Palace. During the exhibition the portrait of Strindberg was placed on a separate easel, which probably led to that particular corner of the exhibition being photographed.

Munch and Strindberg moved in the same circles of authors and artists in the café which Strindberg had named 'Zum Schwarzen Ferkel' (The Black Pig). During this period Munch had become acquainted with Strindberg's *tachistische* painting and experimental photography.

In March 1893 Munch painted the bluish portrait of Dagny Juel. The canvas was painted with a peculiar flattening of the picture space. In spite of all the other differences, this flatness brings to mind the characteristic flatness of Strindberg's landscape paintings. The portrait of Dagny Juel, in any case, brings a new dimension into Munch's art, a dimension of almost immaterial or psychic character. Strindberg, who saw the painting materializing in Munch's studio, described it to his fiancée, Frida Uhl, as showing 'more of a mental than a physical seduction'.

It was Munch who introduced Dagny to the Ferkel group. She was for a short period Strindberg's mistress and married Stanislaw Przybyszewski in August 1893.

Strindberg's and Munch's common interests were of many facets, but they were mainly painting and literature. Perhaps they also had a common hope of being in the front line of what Strindberg called a Scandinavian Renaissance. The art historian Jens Thiis, whom Munch introduced to Strindberg in Berlin in December 1892, thought that a rich 'exchange of ideas must have taken place between them' during this first period in Berlin.[1]

Parts of Munch's contribution to this exchange of ideas have been published in Ola Hansson's article 'Von Künstlerischen Schaffen' in *Der Zukunft* in May 1893, in which opinions, very close to those of Ribot, Galton and Høffding, were ascribed to Munch. Hansson maintained that Munch did not paint pictures of nature, but subjective 'pictures of recollection', pictures that 'have burnt or etched their images in his mind; they spring out in bold colours from the black behind his eyelids as soon as he closes his eyes'. According to Hansson, Munch's choice of colours relates to the colours of recollection. And Hansson asked for a general psychological law or rule which would define the difference between recollection and outer reality. To him it was important to be able to define this difference, because recollection is the basic point of all new, creative enterprise.

Similar opinions about Munch's art were expressed by another of the central personalities of the Ferkel group, the author Richard Dehmel, in a posthumously published manuscript on Rembrandt:

The enthusiasm over the light arising from the inner world has now become focussed by all the painters who are going to light up the future: Marées, Munch, van Gogh, yes, even the late Cézanne, have all rediscovered this dimension which has been lost for centuries.[2]

In the spring of 1893, in Berlin, Christian Krohg, too, painted a portrait of Strindberg. This painting has a surprising similarity to a photographic self-portrait of the author standing in front of a closed door, in an overcoat with the collar up (66). Strindberg is known to have sat for Krohg a couple of times, and he kept his old overcoat as a prop in Krohg's studio. All in all, Krohg's portrait of Strindberg carries an expression and artistic finish which indicate that in Berlin he was inspired by Munch and/or Strindberg to try something more than the photo-

67. Munch's exhibition in the Equitable Palace at the turn of the year 1892–3 with the portrait of Strindberg centrally situated. Strindberg wrote in a letter to Birger Mørner on 26 December 1892: 'Munch has promised me to paint the picture as quickly as possible.' The freshly painted portrait was probably the reason the photograph was taken.

67

graphic style then dominant in his painting.

If Strindberg's photograph was the basis for Krohg's portrait, it is an example of the use of photography resulting, not necessarily in lifeless images, but in stimulating and concentrated colours and brushstrokes.

In Berlin Strindberg was more preoccupied with photography than with writing. In order to understand the depth of his interest in photography as a device for theoretical perception, it is important to recall some of his background as an amateur photographer.[3]

In the summer of 1886 Strindberg travelled to France with a hired photographer in order to photograph French peasants in their milieu as part of an anthropological study. The Naturalist Strindberg planned to collate photographs of interest from the different places he was going to visit. He purchased a 'blixtapparat' for 'Momentaufnahmen' (a flash unit for snapshots), so as to be able to take photographs from the windows of the trains, among other things. He had many ambitions, as he wished to exhibit at the World Exhibition in 1889, when the fiftieth anniversary of photography was to be celebrated.

In the late autumn of 1886 Strindberg moved to an idyllic health resort, Gersau, in Austria, where he photographed himself and his family. Strindberg seemed to wish to use the camera as a way of analysing his models, and he acted in front of the camera as if he were directing himself in a part in a play. In November 1886 Strindberg sent eighteen 'Impressionist photographs' to his editor, Bonnier, to have a collection of phototypes published with his own text.

It may be assumed that Strindberg knew of Victor Hugo's peculiar photographs from his forced exile on Jersey in 1853–4. Those were photographs of moods and subjects, to which Strindberg's own images relate. And a direct and acknowledged inspiration came from the most important photographer of the nineteenth century, Gaspar Félix Tournachon, known by the name of Nadar. He had just published his famous photography interview with the influential colour theorist of art and photography M. Chevreul on his one hundredth birthday. Nadar was in the photographs himself, since it was his son Paul, his successor in his famous studio, who released the shutter. Modelling his own work accordingly, Strindberg had his wife, Siri von Essen, release the shutter to make the exposure of his own photographs.

The publication of his album of photographs from Gersau was never realised, but Strindberg kept the photographs together regarding them as important. Five years later, on Värmdö, in 1891, he took another series of photographs, creating a kind of continuation to or commentary on the photographs from Gersau. These also bring to mind the Victor Hugo photographs, in particular, those of himself and the children against a closed door, but also a photograph taken by the veterinary professor John Lundgren, who was a clever amateur photographer, showing Strindberg in a mackintosh leaning against a rock in the skerries.

As explained later, it is mainly this self-regarding tradition from Victor Hugo and Strindberg to which Munch related when he started photographing in 1902.

Strindberg's painting and photography are two methods of visual expression which are often interwoven. In 1890–1 he experimented in photography by means of a so-called pin-hole camera, i.e., a camera obscura without a lens. This type of camera, which today is almost ignored in photographic writing, gave a picture with a clear perspective at the edges and a slightly distorted middle, and as such it was particularly good at reproducing the atmosphere of Impressionist painting.[4]

Although Strindberg did not succeed in printing colours in the photographs from his pin-hole camera, in a peculiar series of grisaille paintings,[5] which he himself mounted in oval frames (a popular framing for photographs of the time), he created an illusion of colour photography. Perhaps Strindberg simply painted over the photographs in order to

68. Munch's studio in Berlin in 1894. The seated figure resembles Adolf Paul whom Munch used as a model for the male figure in *Vampire*. *The Day After* is seen on the easel.

69. August Strindberg's *Solitary Flower on the Beach*, 1893, was said to have been painted on Munch's palette and given as a present to Adolf Paul by Strindberg.

69

capture the colours? According to Adolf Paul, Strindberg believed, at the time of the Ferkel group, that from the results he had obtained in colour photography he was going to make a living as a photographer.

Strindberg may have derived the idea of recreating nature in blurred 'atmospheric' photographs from the reproductions of J. M. W. Turner's paintings, which had been very popular since the 1850s. John Ruskin, Turner's biographer, maintained in his well-known work *Modern Painters* (1841–60) that Turner's paintings looked like blurred photographs which had been rejected by the photographer, but that they in fact captured nature better than detailed realistic photographs.[6]

In the summer of 1892 Strindberg took a series of portraits with his pin-hole camera, which he himself called 'soul photographs'. During the long exposure necessary, Strindberg had the model adopt different expressions. The final photograph was intended to display a total picture of the model's personality. The pinhole camera managed to assimilate the changes without disturbance to the photograph; the picture plane had just a hint of Impressionist blurring.

Several of Strindberg's paintings from this period have been preserved. Whereas he had painted before in the open air, in front of the subject, in Berlin he painted from memory and called himself a Symbolist. Possibly under the influence of Munch, Strindberg's paintings seem to have obtained a psychological depth, and Strindberg scholars appear to agree upon that. He gave his paintings titles such as *The Night of Jealously, The Solitary Thistle, The Solitary Flower* and *The Solitary Toadstool*.

Strindberg gave one of these small pictures to their mutual friend Adolf Paul. According to Paul, the painting was executed on one of Edvard Munch's palettes and contained a typical Strindberg subject, *Solitary Flower on the Beach* (69). For his part, Strindberg may well have stimulated Munch into expressing himself even more spontaneously than before, such as can be seen in *The Hands*, as well as into clarifying for himself psychological, philosophical and literary possibilities.

In the conservative, bourgeois artistic circles of Berlin, both Munch and Strindberg were solitary, avant-garde artists. However different they were, their common position led Strindberg's biographer to make this statement, quite rightly: 'In essence it can be said that this was the time the Ferkel brothers brought German-Scandinavian Symbolist Expressionism into the world.'[7]

We must assume that the paintings Munch brought with him to Berlin were discussed by Strindberg and

68

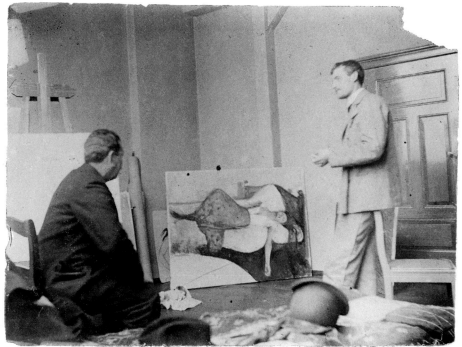

Munch. Two paintings are of particular interest because they contain thematic as well as technical similarities to Strindberg's paintings.

In *The Mysticism of a Night* (1892) the evocative stones and the stump give an illusion of living creatures as does the toadstool in Strindberg's *The Solitary Toadstool* (1893). The beach, the sea and the sky painted as horizontal strata also remind us of Strindberg's painting. However, in Munch's painting the horizon is placed so high that the viewer looks down on the beach and the sea. Where the waves break on the shore, the column of moonlight is reflected up into splashes of light which float towards us like the waves.

Another of Munch's landscapes, *Moonlight on the Shore* (1892), is also composed of horizontal strata (70). The light of the moon is reflected through a rainy forest, casting its image no fewer than four times on the wet shore. It is as if the moon is giving birth. When the painting was exhibited in Kristiania in 1892 a critic wrote in *Aftenposten*: 'There are moons reflecting on the shore four times looking like a chain of gold coins over strange formations of stones, which the sharp eyed Impressionist has discovered.'[8]

This chain of reflections from the moon, fading successively in colour and intensity, shows a physical phenomenon that has scarcely before been depicted in painting. The repeated shapes can almost be compared to photographs taken for a scientific purpose, in order to verify an unusual phenomenon.

The best-known photographs of repeated shapes were at that time Eadweard Muybridge's studies of motion, which in series of from 12 to 24 photographs documented the movement of an animal or a human, revealing the correct limb positions, for example, of a galloping horse. Muybridge's studies of movement have influenced artists from Mesonnier and Rodin to Francis Bacon, as well as many others today. A further development from Muybridge's studies of movement were Etienne-Jules Marey's famous chronophotographs, well known since the end of the 1880s, in which he portrayed movement in a ribbon of repeat forms, taken by means of several revolving cameras.[9]

It is possible that Marey's recording of movement in particular inspired Munch a year later, in 1893, to render several drawings of erotic themes, which border on caricature. Some of the drawings show two men following a woman, presumably a prostitute, through the streets of Berlin (71–2). The men are walking close together, and Munch showed their excited mood by doubling the lines of their legs. A third drawing, the subject of which Munch in 1895 made into a lithograph, shows the cabaret 'Moore's Academy of Music' in Friedrichstrasse, in which the kicks of the cancan girl are drawn in repetition (73) in analogy with Marey's chrono-

70
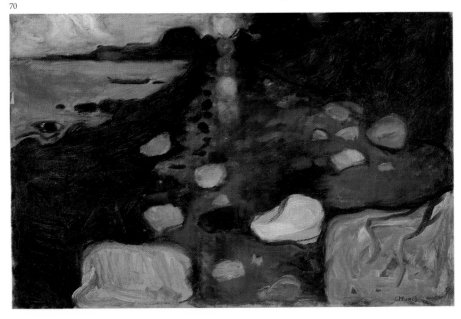

71–3. In these drawings Munch wants to illustrate movement by repeating the lines of the shape of the legs. He seems to have been directly inspired by Marey's photographic studies of movement, tracing the development of a movement in a sequence of photographs. In (71) one of the figures seems to separate itself from the other; is this perhaps the first version of a theme which later became central in Munch's art – the split personality of mankind?

71

photographs.[10] The chrono-photographs, which would become the most important source of inspiration for the Futurists, together with spirit photographs and atmospheric photographs, were thus assimilated at an early stage into Munch's art, in order to give an adequate pictorial expression to some of his ideas.

Neither Munch's nor Strindberg's paintings were understood by the conservative Berliners. Both exhibited at Freie Berliner Kunstausstellung in June 1893, when their works were characterized by one critic as 'incredible daubs', and another critic stated that the so-called works of art by the Norwegian (sic) Strindberg were 'even inferior to the colour dots of Munch, whom Strindberg seems to have learnt from'.[11]

According to Stanislaw Przybyszewski, the author Laura Marholm (pseudonym), Ola Hansson's wife, collected dozens of photographs of Strindberg from different stages of his life. So at Ola Hansson's, whom Munch often visited, he must have had a good opportunity to study the photographs from Gersau and Värmdö.

Munch's famous painting *Self-Portrait with a Cigarette* (75) from 1895 has obvious similarities with some of Strindberg's photographic self-portraits from Gersau from 1886, in the peculiar intense atmosphere and special lighting from below. In Berlin Strindberg had had taken a

72

73

59

74–5. The striking resemblances between Munch's *Self-Portrait with a Cigarette* and Strindberg's carte-de-visite photograph is hardly a coincidence. Strindberg used one of his own photographs, taken in Gersau in the autumn of 1886, for this carte-de-visite which he acquired in Berlin at the beginning of the 1890s. So there is good reason to think that Munch knew Strindberg's photograph well from the time they spent together in Berlin.

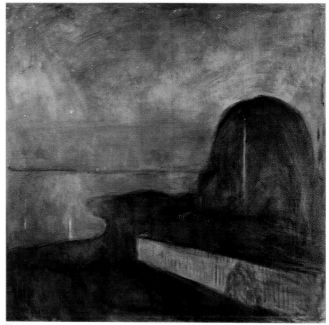

76

74

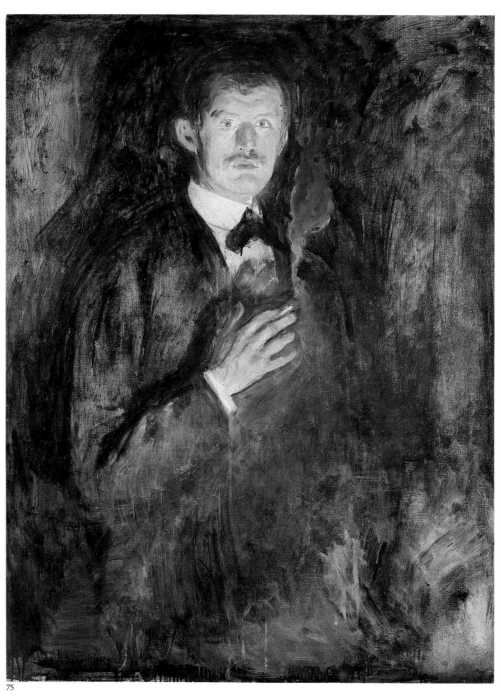

carte-de-visite photograph of the same motif, with which Munch must have been familiar.

Strindberg stands holding the cigarette before him as Munch does, and the subject is lit from below. The light distorts the features of both figures in such a manner that even moustaches, mouths and eyes appear surprisingly alike. The diffuse and ghostlike touch in both the photograph and the painting invariably recall the Spiritualist photographs, discussed earlier in this book.

Przybyszewski reveals that Munch's knowledge of contemporary literature was 'excellent' and that he

60

75

77

had 'literary culture'. He also writes that Munch 'apart from that was interested in occultism'. He mentions, as an example, that when he gave Munch the book *Spiritismus und Animismus* by Alexander Aksakow, he 'positively devoured it in an evening'.[12] Aksakow's book was a comprehensive work in two volumes, which dealt thoroughly with the phenomenon of Spiritualist photography, showing several of these in photograveur.

Whereas he considered Munch open to such thoughts, Przybyszewski saw Strindberg as a rationalist opposed to metaphysics and occultism. It was not until Strindberg's so-called inferno crisis in Paris in 1896, that he became involved in occult circles. He started his occult diary and became obsessed by Albert de Rochas's *L'Extériorisation de la sensibilité* (1896), a richly illustrated book on the hidden forces, showing patterns of aura around a man's head among the illustrations.[13]

The theory of photographic recording of supernatural beings fascinated Strindberg. He owned, for instance, a photograph showing the dead Paul Verlaine, on which he considered certain irregularities a proof of the existence of spirits and demons. He even thought that the photograph itself could retain occult forces, and in his belief in mysticism and magic went so far as to try to cure his children's illnesses by taking 'curative' photographs of them.[14]

At approximately the same time the occultist Dr Baraduc published a comprehensive work, *L'Ame humaine et l'iconographie de l'invisible fluidique* (1896). Most of the photographs in the book look like Strindberg's so-called celestographs, taken during his stay in Dornach, Austria, in 1893–4. Strindberg's celestographs were produced by placing the film directly in a pan filled with developer and exposing it by placing the pan out of doors under the starlit sky. By doing so he meant to create natural photographs that were not falsified by the optical systems of the eye or the camera. Both Strindberg's celestographs and Baraduc's artificial photographs can be said to have inspired Munch's treatment of the sky in his painting *Starry Night* (76) from 1893, as well as in a graphic work of the same subject, called *Attraction* (77) from 1895.

Among the illustrations in Baraduc's book are many photographs that were also taken without the use of a camera – for example, a picture taken by placing a hand charged with static electricity directly on to a photographic plate. One of the many ideas engaging photography at the end of the 1890s was to make visible the invisible. To his contemporaries there was no clear difference between science and the occult, even if each explained phenomena in very different ways.

Forms and lines in several of Munch's pictures from these years have such obvious resemblances with psychic signs and patterns from the occult, that there is good reason to ask if Munch derived inspiration from these sources. The strange forms surrounding the heads in the lithograph *Man's Head in Woman's Hair* (c.1896) gain new and enlarged significance by being viewed in relation to them. The apparently detached, ornamental shapes floating around in the air are best understood in relation to the occult as so-called thought forms, ideas that would

61

78

become significant in Kandinsky's non-figurative form language a decade later.[15]

The frame surrounding Munch's lithographic portrait of August Strindberg (79), made in the spring of 1896, may also be influenced by such ideas. The aggressive, jagged border on the left, where Strindberg's name is inscribed, contrasts with the soft, sweeping lines that successively take the form of a naked woman on the right. At any rate, in the occult literature there, are schematic drawings of aura types showing geometrical patterns of convincing similarity with the border around Strindberg's portrait. These drawings show precisely how the aura could change from aggressive masculine to soft feminine lines. However, to my knowledge they were not published until 1901 in A. Marque's article 'Die menschliche Aura' in *Neue Metaphysische Rundschau*. But if he knew of such ideas, it would have been obvious for Munch to make use of them, especially for a portrait of Strindberg during his inferno crisis.

When Wilhelm Conrad Roentgen published his article about the so-called X-rays or 'new rays' (Roentgen-rays) in *Ueber eine neue Art von Strahlen*,[16] in January 1896, in which he also described photographs taken by means of these invisible rays, Strindberg reacted spontaneously by claiming that he had done the same earlier with his 'dark rays of light'. On

24 January 1896 he wrote to his friend the scientist Torsten Hedlund:

Two years ago I was to be put in a lunatic asylum by lunatics – because I had photographed the sky without a camera or a lens – and now one can photograph through wood! – without a camera or lens![17]

Strindberg's reaction to the article shows his interest in the phenomenon just a few days before he again had contact with Munch. He also began writing the essay 'On Lighting Effects and Photographing: Thoughts on the Occasion of the X-Rays', which reflects, in an almost Munch-like manner, on the concept of light and sound as waves that in a remarkable way penetrate material.[18]

In his article Roentgen also de-

80

79

81

62

78. *Man's Head in Woman's Hair.* In this lithograph from *c.*1896 the floating, ornamental shapes seem to illustrate different kinds of psychic aura.

79. *August Strindberg,* 1896. Lithograph. The border around Strindberg's head seems to have been inspired by the ornamental illustrations of human 'aura' published in occult and pseudo-scientific writing (80–1). Strindberg was furious with the first version in which the border includes a female figure and Munch had misspelt his name 'Stindberg' (stind = fat). Munch did not change the border until after he had printed a considerable number.

80. Illustration of an 'aura' in Albert de Rochas's *L'Extériorisation de la sensibilité* (Paris 1895). Around 1895 several books were printed with photographic experiments pretending to show human aura or animal magnetism.

81. The scheme shows geometrical 'aura' shapes which surround every human being, according to theosophical beliefs. The aura patterns are different on either side: they go upwards on the left-hand side and downwards on the right-hand side, characterized respectively as the positive and the negative side. Sharp pointed patterns mean vitality and strength, soft rounded patterns mean feminine passivity. Breaks in the geometrical pattern mean a sick point in the personality. The patterns are constantly changing, but within certain limits which characterize the personality. Dr A. Marques continued these thoughts and presented them in a series of articles in *Neue Metaphysische Rundschau,* from which these patterns are taken. As for the portrait of Strindberg, the naked woman would mean a sick point in his character; it is not strange that Strindberg, who knew these theories, was furious.

82–3. *The Kiss,* 1897–8 and 1902. Woodcut. In Munch's different versions of the theme *The Kiss* in woodcuts we can follow a process from radiation around the couple, a surrounding aura (82), to a kind of transparency, where the couple are seen as a shadow through the grains of wood.

84. *Melancholy (Solitude, Jappe on the Beach, Jealousy),* 1896. Woodcut. The woodcut has been printed using two blocks, each divided into two. The grains of the overprint wood block are especially clear, and this contributes to the etherial character of the woodcut. The effect is related to double exposure as well as to X-ray photography, which was demonstrated at amusement parks and market places all over Europe at that time, among other ways by photographing the object through thin wooden planks.

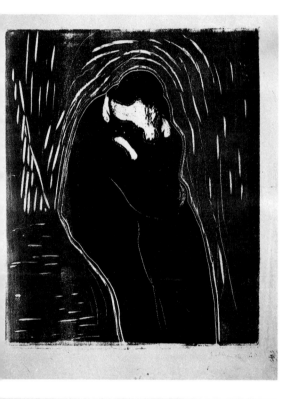

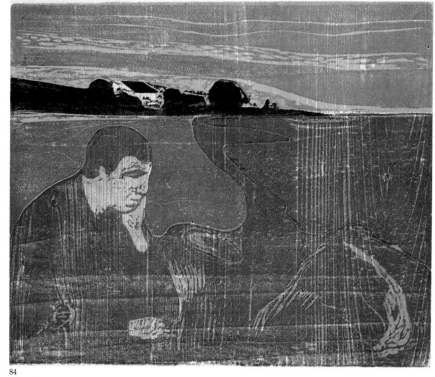

84

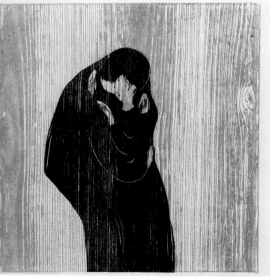

scribed photographing through wood. This manner of photographing became one of the big sensations in the market places and amusement parks of the time. The X-rays, which were used for photographing, allowed the rings and knots of the wood to show through. And here Munch found an important inspiration for his special use of the basic material in his woodcuts.

A characteristic of his finest work is the manner in which the striations have been used to show the pattern of the wood exactly as it would have been seen had the subject been photographed by X-rays through a wooden plate. It is the use of striations that gives a woodcut such as *The Kiss* (82) the character of an unreal shadowy existence. And in the woodcut *Melancholy* (84) it is obvious how Munch, by means of overprinting several different woodcuts, achieves a kind of transparency that mimics the double exposures of photography and the use of X-rays. On a unprimed piece of wood, which is still preserved and which is just like the one he used in his early woodcut, Munch painted the same couple that were shown naked in the etching *The Kiss* in a naturalistic outline that he probably intended to

transfer to woodcut. Through the many later, well-known versions of the subject there is a logical development from showing radiation around the couple to depicting them as transparent. At first he surrounded the couple with an aura of lines, then in the final version the total pictorial effect is achieved by using the structure of the wood itself in such a way that the couple are seen as a shadow against the pattern of its fibre (83).

Portrait Painting and Photography 1896–1908

85

85. Edvard Munch 'à la Nietzsche', *c.*1906.

86. Edvard Munch and Tulla Larsen had their picture taken by a street photographer just before the turn of the century. Tulla Larsen seems to be triggering the exposure by pressing the mechanism – a rubber balloon – linked to the camera via a cable.

Munch had close relationships with authors, musicians and occult circles in Paris. He was, for instance, engaged to illustrate some of the poems in a planned de luxe edition of Baudelaire's *Les Fleurs du mal*, a project never realized, however, because of the death of the publisher.

Munch had several extensive exhibitions in Paris, which were well received by the press. Their climax was his comprehensive exhibition in the new and fashionable Galerie L'Art Nouveau in 1896, where he followed exhibitions by Eugène Carrière and Constantine Meunier. Strindberg came out with an interpretation of Munch's art in the *Revue Blanche*, describing him as an artist of visionary power, who captured the most profound instincts and longings of man.[1]

STÉPHANE MALLARMÉ

Munch certainly used a photograph to help him with his lithographic portrait of the poet Stéphane Mallarmé (1896) during these years in Paris (87).

After Paul Verlaine's death Stéphane Mallarmé had become the undisputed leader of the Symbolist writers in Paris. The circle around him were also mostly Munch's friends, from Julius Meier-Graefe, who was connected to Galerie L'Art Nouveau, to the musician William Molard, who took care of Gauguin's works while he was in Tahiti. Mallarmé's weekly

reception was the meeting place for the circle. Munch wrote about this time in Paris as follows:

Strindberg joined in, and our circle consisted of friends of Gauguin, who was in Tahiti, plus van Gogh – There were also some friends of the now dead Verlaine and of Mallarmé; also people from the Mercure de France Circle – Merrill, too, came there. – For a time Oscar Wilde attended – Mollard in Rue Vercingetorix.

We used to go to Café Lila and to Harcour's – We strolled along Boulevard Michel, and often went to Bullier's – At that time I had my studio in Rue de Santé.[2]

It was probably not a coincidence that Mallarmé wanted to have his portrait done by Edvard Munch, whose graphic masterpieces, which included the *Self-Portrait with Skeleton Arm* and the lithograph of Strindberg, showed what Munch could achieve by way of magic-symbolic portraiture. Gauguin had earlier made a graphic portrait of the poet, an etching from 1891 in which a raven symbolically peers from behind Mallarmé's head. And James McNeill Whistler had produced a somewhat more matter-of-fact lithograph and also painted a portrait of the poet in 1892. However, neither of these, nor any other portrait, gave a complete image of Mallarmé's faunal personality.

As Georg Brandes remarked in his introduction to Mallarmé in *French*

Poetry (1899), there was a clear distinction between the private person, 'the common gentleman', and the poet, 'the sphinx-like hierophant of artistic mysteries'. Munch was clearly conscious of this dual personality. Several years later he wrote in a draft letter to Thiis: 'I drew him in half-shadow which matched his character.'

Munch's work on the portrait started in the autumn of 1896, and some time afterwards Mallarmé gave Munch a photograph, referred to in a draft of a letter from Munch to Mallarmé dated 25 March 1897:

Please excuse me for having kept your photograph for such a long time. A lot of work and other business have prevented me from applying sufficient attention so as to finish this lithograph sooner.

I won't forget that you have lent me your photograph, and I hope everything will be finished in a few days' time.

Two photographs exist, either of which may be the one in question. One was taken by Paul Nadar and shows the elderly, sick Mallarmé, a rug around his shoulders and a pen in his hand (88). The other photograph projects a more official image and was used as a postcard portrait of the poet, presumably somewhat later.

Shortly before Munch and Mallarmé became acquainted, Degas had taken some photographs of Mallarmé. One was given to Paul Valéry, who

87–9. *Stéphane Mallarmé*, 1896. Lithograph. While the famous photographer Nadar took a naturalistic photograph as his portrait of the Symbolist poet Mallarmé in 1895, Munch concentrates on the mystical aspect of the poet; his face appears as Christ's in a sudarium in the lithograph as well as in the etching, both from 1896.

88

wrote: 'I have here the nicest portrait of Mallarmé that I have ever seen, apart from Whistler's admirable lithograph.'[3]

This photograph shows the painter August Renoir sitting and Mallarmé standing near a mirror. The reflection in the mirror shows Edgar Degas with the camera positioned on a table, and Mallarmé's wife and daughter sitting next to him. The light was provided by nine paraffin lamps and the length of exposure was fifteen minutes, all of which must have given taking part a real feeling of being involved in a process of creation. It was also in part such events that motivated Strindberg's experiments with his pin-hole camera for portrait photography. And Mallarmé himself may have considered photography a medium of many possibilities.

Mallarmé's daughter Geneviève, who is in the photograph mentioned above, received the lithographic portrait from Munch when he finally finished it in May 1897, and she wrote to her father, who was staying in the country:

It is really good, but it looks like one of these portraits of Jesus on a holy sudarium, on which is written underneath: 'If you contemplate this for long you will see how the eyes close'.[4]

Munch probably first made an etching on a smaller plate before he executed the lithograph of Mallarmé; this

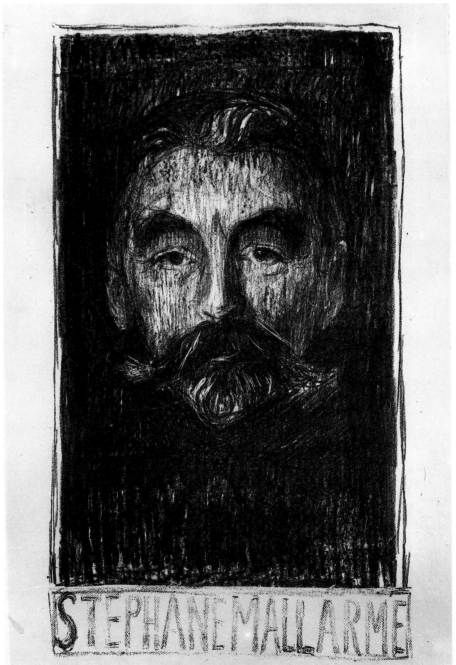

STÉPHANE MALLARMÉ

87

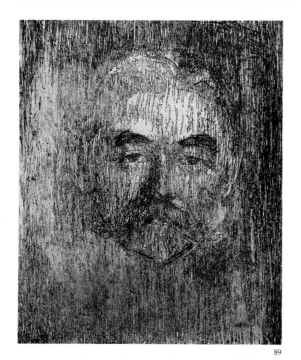

89

etching is known, however, only from later reprints (89). But the etching has so many similarities with the lithograph that it must be assumed that they have the same photographic basis. Both in the etching and in the lithograph the head is seen isolated against a dark background, which is dominated by strong, parallel vertical lines. This use of lines corresponds to Munch's use of striations in the woodcuts, such as *The Kiss*, and illustrates a kind of psychic-wave pattern.

It is not known if the portrait of Mallarmé was a commissioned work. But judging from the ways in which Mallarmé had earlier used artistic portraits of himself as frontispieces for several of his editions, it is very likely that Munch's portrait was intended as an illustration for the complete works of Mallarmé, which were published in 1897. The plan might have failed because Munch as usual was slow in finishing a commissioned work.

The poet died the year after, and Munch's lithograph was published for the first time in 1938 in a biography of the poet. At any rate, Mallarmé seems to have been very satisfied with the result and thanked Munch in several letters from the summer of 1897. In one of the letters he characterized the lithograph as a 'gripping portrait, which gives me an intimate sense of myself'. In the subsequent letter he elaborated his satisfaction, admiring 'its openness and strength'.

A note, which Munch wrote after meeting Mallarmé, shows how he studied his features thoroughly before making the portrait, aided by the photograph:

The two eyebrows – enormous – and dark as the wood – underneath the eyelids, a little tired – two eyes in the depths of which the clear day is reflected – the quiet water beneath a ridge – The beard and the hair are grizzled – a little bristly like the beard of a pig – The smile is kind and a little pensive. The colour of his small study is faded green – a Japanese chair – old faded carpets – A mirror in Louis XIV-style – a symphony of colours – Behind the faded green tapestry, from a light lilac to dark brown – emerald. The pottery is largely greenish – He writes here in a heavy silence – only interrupted by a voice from a room next door – with these little moods and unfinished poems – which later are captured in an essence – these poems however elegant they are – are only understandable for the few – every word is weighted so that they arouse a whole world of sensations – like the tiny recording elements in a phonograph disk – which look like nothing – but in a phonograph become the spoken word.[5]

One can conclude that Munch used the photograph of Mallarmé to secure the likeness. But it should equally be said that Munch also saw it as his task to pierce the mask of this poetic giant, to breathe life into the portrait photograph and so release the image of the genius.

MARCEL RÉJA

Among the people Munch met in Paris was the young author, and later psychiatrist, Marcel Réja. He wrote the preface to the French edition of Strindberg's *Inferno* (1898), in which, referring to Mallarmé, he characterized literature as the science of art, just as philosophy is the science of thought. He saw *Inferno* as an expression of mysticism and religious occultism, showing 'the terrible stages of religious thought'. 'What we systematically reject from our consciousness', Strindberg 'constructs into a frightening ensemble'.

Réja also collected drawings and primitive art made by insane people and published his views on this work in the book *L'Art chez lez fous* in 1908. Among the illustrations are fetish-like sculptures similar to those that would become so central to the development of modernism.[6]

Munch did Réja's portrait in woodcut around 1896/7 (91). The portrait seems clearly experimental, executed in a spontaneous and unsophisticated manner. The result is a classic example of Munch's new experiments with the effects of waves in woodcut, such as in the woodcut versions of *The Kiss* and *Melancholy*.

Munch kept a photograph of Réja in the same pose as in the portrait, which suggests that he used the photograph as an aid. But even if the features are like those of the photograph, Munch

90. Photograph owned by Munch of the author and later psychiatrist Marcel Réja. From Munch's notebooks we know that he always kept Réja's address in Paris. Munch is also supposed to have painted a portrait of him; its whereabouts, however, is not known.

91. *Marcel Réja*, 1896. Woodcut. Notice how Munch lets the vertical strands of light from the wooden plate shine through Réja's head. The sharp gouges of light are due to Munch's work with the cutting tool in the wood.

has portrayed Réja as if he were X-rayed through a wooden plate. The light around him suggests radiation – an aura. Using Réja's words about Strindberg from the preface of *Inferno*, Munch can be said to concentrate in this portrait 'what we systematically reject from our consciousness'.

HENRIK IBSEN

After finishing the portrait of Mallarmé, Munch was commissioned in the autumn of 1897 by the theatre director Lugné-Poë to produce a poster for Ibsen's new play *John Gabriel Borkman* for the performance at the Théâtre de l'Oeuvre (93).

90

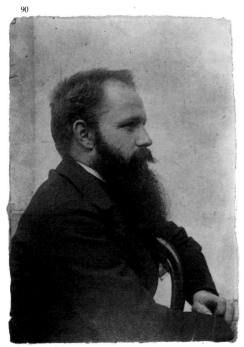

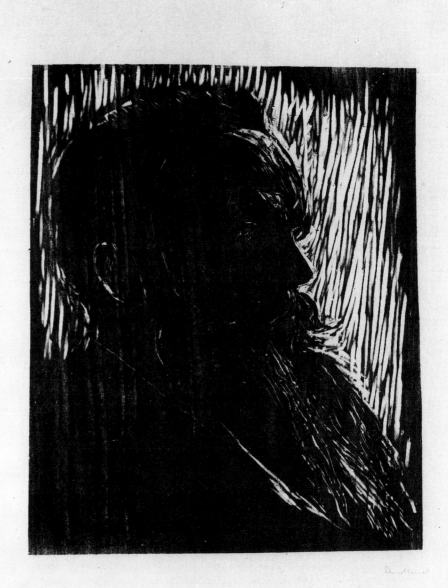

91

92. Cabinet photograph of Henrik Ibsen which was in Munch's possession. The name 'cabinet photograph' indicates the size of the picture, around 12 × 16.5 cm, and also a higher technical quality than the smaller carte-de-visite photograph. The fact that Munch chose to portray the author so like the 'official' portrait may be interpreted as a wish to appeal to a broader audience.

93. *Poster for the Performance of 'John Gabriel Borkman' at the Theatre de l'Oeuvre in Paris, 1897,* 1897. Lithograph. The poster, which at the same time functioned as a programme, was enclosed as a free copy in the magazine *La Critique* on 20 April 1896.

L'Art et la Scène
REVUE ILLUSTRÉE D'ART DRAMATIQUE PARAISSANT LES 10 ET 25 DE CHAQUE MOIS
Le Numéro : 50 centime

DISTRIBUTION

Wilhem Foldal : M. Henri BURGUET.
Erhart Borkman : M. LUXEUIL.
Jean Gabriel Borkman : M. LUGNÉ-POE.
Gunhild Borkman : Mᵐᵉ J. BRINDEAU.
Ella Rentheim : Mᵐᵉ Marguerite MAUPAS.
Madame Wilton : Mᵐᵉ Blanche DELIAU.
Frida Foldal : Mᵐᵉ Hedwige MOORE.
Hanna : Mˡˡᵉ DELLAC.

Piano de la maison WACKER.

Jean Gabriel Borkman, 4 actes et 5 tableaux par HENRIK IBSEN
Traduction de M. le Comte PROZOR
Causerie de M. LAURENT-TAILHADE

93

Munch chose to let Ibsen's portrait stand out against a typical Norwegian fjord landscape, illuminated by a dominating lighthouse. The dramatist's expression is somewhat sphinx-like. One eye is staring ahead, whilst the other is clearly not seeing at all. Munch seems to have wanted to show Ibsen as a lighthouse 'that illuminates everything around', analogous to his characterization of Rembrandt, 'a lighthouse that illuminates everything – even brighter than French Art'. But a question arises as to why Munch chose a portrait of the playwright as the subject of the poster.

During the years 1894–6 there had already been some contact between Ibsen and Munch. The relationship

92

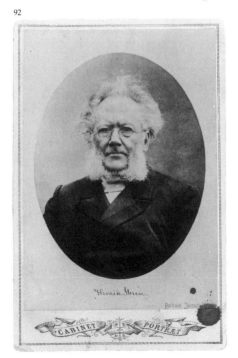

had begun by Munch conveying regards from Dr Julius Elias, Ibsen's translator in Berlin. Munch then showed Ibsen his exhibition at Blomqvist's in 1895, and they later met at the Grand Café, where they would talk in the small study where Ibsen worked every day. Munch, the young unappreciated artist, regarded this as a gesture of acceptance from the elder, established artist, believing that Ibsen and he felt a mutual sympathy for one another.

In 1910, according to Ludvig Ravensberg's diary, Munch, while showing him in Kragerø 'some excellent drawings' of John Gabriel Borkman, told him that Ibsen had prepared him for his new play *John Gabriel Borkman* with the words, 'Something new and diabolic as usual will come from me, something of interest to you'. Munch also related that he considered this, a play about the lonely and isolated, as a play in which Borkman is Ibsen himself. Munch said to Ravensberg, 'John Gabriel Borkman is Ibsen; first he felt like writing about such a man, then he meant himself.'[8]

This may be the way to understanding why Ibsen's portrait is on the *John Gabriel Borkman* poster: Borkman was Ibsen's alter ego. The portrait of Ibsen has many similarities with Felix Vallotton's portrait of the author, made for the same theatre two years earlier. In spite of the different media the similarities were probably caused by the artist relying upon the same

cabinet photographs (92). But, equally, Valotton was one of those artists whose graphic work had been a model for Munch ever since he began working in graphics in 1895. This would further explain the eventual resemblance in their way of translating a photograph into a graphic work.[9]

Munch painted a portrait of Ibsen, more or less as a commissioned work by Julius Elias, in which Ibsen's head is in the same pose as on the poster for *John Gabriel Borkman*, but this time enveloped in a fog. The background is replaced by the smoke-filled study at the Grand Café with the window facing Karl Johan Street 'in sunshine, crowded with people'. The lithograph of the same subject – first printed in 1902 – was not a new creation, but was made by transferring one of the studies to a lithographic stone. When Munch, while working on the Nietzsche portrait in 1906, wanted to paint another thematic portrait of Ibsen, he wrote from Germany to Ludvig Ravensberg in Kristiania: 'Would you do me the favour of going to a bookshop and ordering four postcards of Ibsen (the best ones, all different, but full face). I intend to paint a decorative portrait of Ibsen.'

What has here been discussed about the portraits of Marcel Réja, Stéphane Mallarmé and Henrik Ibsen shows that the subject of photography versus portrait painting in Munch's art is a many-sided one. There is also good reason to ask if Munch used photo-

graphs as a basis for all his graphic portraits of famous people. Such a view could be confirmed or modified through collecting and studying photographs of the men Munch portrayed in the 1890s, such as Holger Drachmann, Gunnar Heiberg, Knut Hamsun, Stanislaw Przybyszewski and Sigbjørn Obstfelder.

It is, however, easier to conclude that in those cases where there are both lithographs and paintings of the same subject the general rule is that he transferred the lithograph on to the canvas as a basic drawing. In this manner Munch was able to achieve an artistic distance from the photograph through abstraction and graphic printing, creating a language of his own.

This procedure explains why Munch, after the turn of the century, habitually painted several portraits of the same person: in this way his treatment could be developed from one version to the next.

DOUBLE-PORTRAIT OF EDVARD MUNCH AND TULLA LARSEN

In a couple of photographs from around the turn of the century Munch posed so self-consciously that he must be considered at least as responsible for the composition as the photographer.

In a small ferrotype – a so-called street photograph, which, just like the daguerreotype, produced a positive

94–5. Behind the double-portrait of Edvard Munch and his fiancée Tulla Larsen a set piece showing a paradisal, tropical vegetation is visible as a naive paraphrase of a modern Adam and Eve story. In a draft letter to Tulla Larsen, Munch wrote: 'You have got the gospel of the pleasures of life – I have the one of agony.' Indeed the photograph has something in common with the Adam and Eve theme of *Material Transfer*, 1899–1903, showing Adam with the obvious features of a Munch self-portrait, even if there is no actual photograph used as a model.

95

image on a metal plate – Tulla Larsen, Munch's woman friend from the turn of the century, stands out as a dashing and elegant woman, whilst Munch seems somewhat reserved by her side (86 and 95). Upon closer examination, Tulla Larsen's left hand suggests that she is holding a balloon-like exposure trigger.

The photograph brings to mind the painting *Material Transfer* (1899–1903), in which the male figure has the characteristics of a self-portrait (94). The two pictorial compositions are relatively contemporary and have an evocative touch in common, even if the painting is far from being directly inspired by the photograph.

In another portrait photograph Munch is posing in the snow in his winter coat. The photograph was taken during his stay in 1900 at Kornhaug Sanatorium, where he painted *Golgotha*. In this painting he casts his artistic vocation as a passion story. And in a letter to Tulla Larsen he wrote: 'My paintings are the children of agony and sorrow – and I have never celebrated the gospel of pleasure.'

Both photographic portraits, with their melancholy and introversion, seem to be a comment on such a situation. He is standing, lonely, at the 'entrance' to the new century – and he is, at the same time, the only important Norwegian artist not represented at the World Exhibition in Paris that year.

PHOTOGRAPHS OF MUNCH

Several carte-de-visite photographs of Munch from the 1880s and '90s, generally used as passes or admission cards to exhibitions and for other such practical purposes, show a handsome young man of pronounced features. The photographs were all taken in the Naturalistic style of the time.

There is also a series of three photographs of a different and sensitive character, which seem to have been taken for *Aftenposten* around 1890, perhaps on the occasion of Munch's first big one-man exhibition in the Student Society in 1889. Munch had by then acquired a moustache and posed with a certain relaxed elegance. The soft light reveals the sensitive features of an artist in contrast to the rather lifeless reproductions on the carte-de-visite photographs.

Rather few amateur photographs have been kept of Munch from around the turn of century. In a letter to his aunt Karen Bjølstad from Berlin on 29 April 1894, he wrote: 'I enclose myself and my whole studio'. This is probably the photograph showing Munch together with an unknown person in his studio. In the photograph there is, alongside several unpainted canvases, a newly started painting, *The Day After*, in front of the subject *Madonna*. Munch, who is standing at the door to the right, is wearing a light suit and gesticulating with his left hand. The visitor, wearing his coat, sits on a

chair, presumably listening to Munch and studying the painting. In the foreground is a hat – a trilby – probably Munch's, since he wears such a hat in two other photographs taken that summer.

These photographs were taken on the platform of Nordstrand station, outside Kristiania. The train has stopped and people are walking to and fro. In one of the photographs Munch is seen in profile; in the other he is looking away. The framing of the pictures may indicate that he was unaware of being photographed. The photographer was the landscape painter Wilhelm Peters, the only painter in Kristiania who at this time was a member of the Society of Amateur Photographers.[10]

Around the turn of the century photography became rapidly popularized. It is indicative that seventeen percent of the visitors at the World Exhibition in Paris carried portable cameras. So on days when 300,000 visitors were admitted, the best part of 51,000 cameras were being used in the exhibition area. Partly in order to satisfy the needs of such amateur photographers, photographic paper made into postcards, on which the negative could be printed directly, was introduced at the turn of the century. Very soon atuomatic photographing and developing machines were installed in hotel foyers and other public places, in which such photographic postcards could be produced. Every-

96

97

98

99

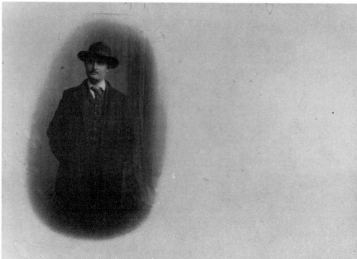

100

96–100. Postcard photographs taken in hotel foyers during the years 1902–4. Such photography machines showed up after the turn of the century, when a copying paper that could at the same time serve as a postcard was invented. Some of the photographs exist in several copies in Munch's documents. (97) is somewhat different from the other postcards. Unlike them it does not carry any details about the print or the photographer. The height of the photograph is the same as Munch's own photographs. Assuming that it has been reduced in width Munch could have copied the postcard himself using a negative from his own camera, which was a usual method of that time. In that case it can be concluded that the big shadow of his own head is a calculated pictorial effect.

body could now take his own photograph.

In the Munch Museum there are many such photographs of Munch, which must have been among the first to be produced by means of these machines. They show him either alone or with two other figures whom it has not been possible to identify. In one he is seen behind an Art-Nouveau-style fence with two other men (99). Munch's bandaged hand indicates that the photograph was taken in the autumn of 1902, after he had shot himself in the hand on the occasion of his final break with Tulla Larsen. Another photograph shows the artist and two other men, in which Munch's shadow, grotesquely oversized, is cast on the wall behind them (97). In a third Munch is seen with a plump, almost conceited, man in a porter's uniform holding a beer mug in his hand (96). This photograph seems to be the result of an incident related in Hugo Perls' book *Why is Camilla so Lovely?* Once when Munch was staying at the Hotel Nordland at the Stettiner Station he became very irritated with the porter, who was very arrogant and not devoting any time to him. Munch therefore asked him if he wanted to earn three marks, and as the porter said yes, he was taken by Munch to a street photographer around the corner, where they were photographed together. When leaving the hotel Munch gave the porter the three marks and an envelope with the photograph on which Munch had written, 'This is what the artist looks like. That is what the porter looks like'.[11]

In the following years Munch would use postcard photographs as the starting points for his own portraits, often shown in the oval vignette typical of the time (98). Most of them were taken in Berlin and show Munch casually dressed, often with his shirt collar open, his coat unbuttoned, his tie askew and his hands in his pockets (100). As a human document the volume of postcard photographs is a good supplement to the photographic self-portraits he took with his own camera.

EVA MUDOCCI, *THE VIOLIN CONCERTO* AND *SALOME*

Two of Munch's double-portrait lithographs, *Salome* (1903) and *The Violin Concerto* (1903), are very good examples of Munch's new and freer use of photographs as a basis for portraits (104). *Salome* is a double-portrait of Munch and Eva Mudocci; *The Violin Concerto* (101) depicts Eva Mudocci and Bella Edwards. In both works, created at the same time, Munch plays with the elements of the basic photograph. An analysis of them provides a key to a better understanding of these works.

The English violinist Eva Mudocci was an unusually attractive and exotic woman who fascinated her audience by temperamental interpretations of the works of Christian Sinding and Edvard Grieg. She toured every year in Norway with the older pianist Bella Edwards as accompanist. They lived together as an artist couple. Munch first heard about Eva Mudocci in an undated letter from his friend Jappe Nilssen:

Here in Paris are two ladies, the pianist Bella Edwards and the violinist Eva Mudocci. Eva. M. is unhappy. Bella Edwards has totally got her in her power. They live together in a relationship. I have a suggestion and request for you. They are coming to Norway on tour. Could you not take care of Eva, court her a little, so, perhaps, her emotions could become natural?[12]

However, Munch and Eva Mudocci did not meet until the spring the 1903 in Paris, half a year after his break with Tulla Larsen. He had a letter of introduction to Eva Mudocci from the couple's Danish impresario, Rulle Jørgensen. His next step was to call on her at the small flat she shared with Bella Edwards in Rue Las Cases carrying a huge lupin and announcing that he had come for 'tea o'clock'.

After spending the spring with Eva Mudocci in Paris Munch travelled to Lübeck in order to paint a group-portrait of Dr Max Linde's sons. An exchange of letters started at this time and continued from Åsgårdstrand,

where Munch stayed that summer. Munch sent a photograph of himself 'badly photographed', probably taken with his own camera, and Eva Mudocci repaid him by sending her photograph, which Munch thought was good and pretty, but, he wrote, 'Your expression and character are missing – I will paint you some time'. In another letter Munch told her that he had pinned her photograph over the bed, and she looked as if she were going to protect him against evil powers.

Munch wrote several times from Åsgårdstrand that he wanted to paint her portrait and otherwise filled the letters with verbal caresses. In one letter he wrote, 'You are all music'; in another he remarked, 'Sometime I should like to bathe my sick soul in your music – that will do me good'. However, when they met again in Berlin their behaviour was artificially cool. They wrote letters to each other even though living in the same city, and she addressed him in the polite *Sie*-form. The correspondence reveals that Munch had been commissioned to paint a double-portrait of Eva Mudocci and Bella Edwards.

Munch then filled their room in the Hotel Sans Souci with lithographic stones and other painting materials, but, according to the exchange of letters, he did not really start working on the portrait. He kept breaking appointments, and they would become infuriated waiting in vain in a room

filled with stones and canvases; at last they demanded that he move his equipment out. It was under these circumstances that Munch created the two double-portraits *The Violio Concerto* and *Salome*.

For the commissioned double-portrait Munch seems to have started out with a cabinet photograph which the two women employed as their official artist portrait (102). The photograph shows Eva Mudocci standing, with her violin bow resting on the strings, while Bella Edwards is sitting

101

at the piano ready to begin playing. Both women are wearing dark dresses, which visually create a common shape. They were also bound together in a fateful relationship which was to last their lives.

In the lithograph *The Violin Concerto* Bella Edwards is seen with one hand at the keys of the piano, whose lamps are lit. She is wearing a dark dress as in the photograph. The couple are captured at the end of playing, as Eva Mudocci lowers her bow and holds her precious Stradivarius up

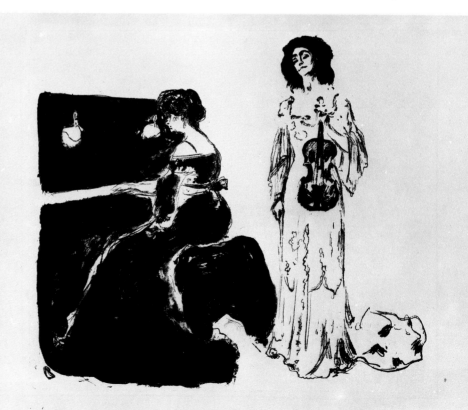

102. The official photograph of the artist-couple Eva Mudocci and Bella Edwards taken a short time before they met Edvard Munch. The photograph was taken at Harald Patz's Successor in Copenhagen. Bella Edwards was Danish and Eva Mudocci spoke Danish relatively well. However, her long exchange of letters with Munch was in German; and by birth she was English. According to her passport she would have been around twenty years old in 1902, but she was probably ten years older.

103. Cabinet photograph of Eva Mudocci taken at Ludvig Forbech's who had a studio at 35 Karl Johan Street in Kristiania. He specialized in portraits and took many for well-known policitians and artists.

104. *Salome*, a lithograph from 1903 showing a symbolic double portrait of Eva Mudocci and Edvard Munch, in which Munch again varies the theme 'man's head in woman's hair' (78).

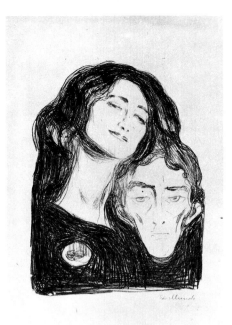

104

for the audience. Munch did not use the figure from the double-portrait photograph for the depiction of Eva Mudocci, but a photograph in which she is seen alone in a long white dress holding the violin in front of her (103).[13] In this manner Munch breaks up the dark common shape of the women in the photograph into light and dark figures, thus separating them. Eva Mudocci stands to the left in the photograph, but to the right in the lithograph. Whereas the two musicians together face 'the audience'

in the photograph, they seem separate from each other, absorbed in themselves, in the lithograph.

Compared with the basic photograph, the differences between photograph and lithograph end up by being more interesting than the similarities. Munch does not just abstract, but also manipulates the singular elements in the photographs and in so doing adds an intensity and musicality to create a new theme in the lithograph.

The lithograph *Salome* shows a symbolic double-portrait, partly a

caricature, of Eva Mudocci and Edvard Munch. Munch seems to have used the photograph of Eva Mudocci in her black dress with Bella Edwards. Where Eva Mudocci holds her Stradivarius he has drawn his own head.

On 17 May 1904 Munch explained to Louise Schiefler that his hand had 'gone wrong' while working and instinctively he had created a Salome theme by placing a man's head in her hands. Eva, for her part, said in retrospect that this representation of Salome was the reason for their one and only disagreement. *Salome* clearly released the underlying tension which was only hinted at in the letters.

A third lithograph Munch made of Eva Mudocci was entitled *Madonna*. It was later entitled *The Lady with the Brooch*, after the piece of traditional Norwegian peasant jewellery given to Eva by Jens Thiis during one of her tours in Trondheim, a year before she met Munch. Was the brooch in this portrait perhaps an expression of the jealously Munch seemed to have felt for Eva Mudocci at this time?

In *Madonna* Eva Mudocci has an ethereal dreamy expression which relates to 'the Pre-Raphaelite expressive features and attitudes which were in vogue in the idealism of the nineties', to quote Thiis. According to Eva Mudocci, Munch brought the heavy lithographic stone to her room in the Hotel Sans Soucis, and on it was a piece of paper on which was written: 'This is the stone which fell from my heart'.

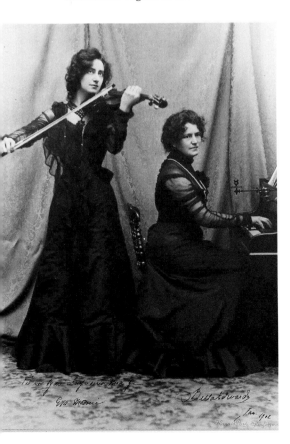

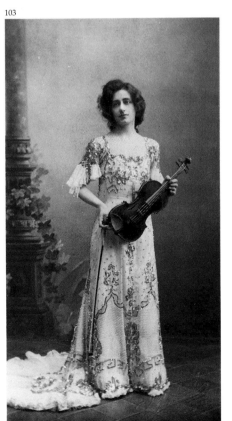

103

105

A PORTRAIT OF HENRIK LUND

The development of wide-angle lenses did not advance for almost ten years until the German firm Goerz introduced the new Hypergon-Dobbelana-stigmat after the turn of the century. The old wide-angle lens produced a somewhat indistinct picture of a 100 degree angle, whereas the new pro-

duced a clear picture of around 135 degrees. This lens was primarily intended for photographing architecture – and in the following years its traces can be seen in picture postcards, where the perspective of the street could be reproduced with an extraordinary effect.

This new lens was demonstrated in *Photographische Rundschau* in the

spring of 1902 in an illustration showing a man's head photographed with the usual 45 degree angle compared to the same man's head taken with the new lens (106). This was presented as a previously unknown kind of distortion which gave the face 'Aztec-like features'.[14]

The comparison with Aztec art indicates that the distortion was seen

106

105. *Double-Portrait of the Painter Henrik Lund and his Wife, Gunbjør*, 1905–6. According to Munch he painted his artist-colleague at a distance of only 10 cm. Munch did not have much respect for Lund's art, which he characterized in a letter as 'sweetened'.

106. Two photographs of the same person taken by means of a normal lens and a new extremely wide-angle lens. The photographs were published in *Photographische Rundshau* (1902), in which was written: 'Because of the short focus, a peculiar distortion appears which gives the face Aztec-like features.' Perhaps this is the common basis for Munch's extreme close-up pictures and for Picasso's first Cubist studies?

as primitve and ritualistic. The angular head, the extremely enlarged nose and the accentuation of the eye provide a certain Cubist character. The eye, placed in the centre of the face, gives the face the abstract simplicity of a primitive sculpture.

The distorted photograph has interesting features in common with Picasso's early Cubist paintings from 1906 and 1907, which led to one of his main works, *Les Demoiselles d'Avignon* (1907).

In the next issue of *Photographische Rundschau* the painter and photographer Edward Steichen was featured with eleven full-page illustrations of his photographs, among others, close-up photographs that were so close to the object that parts of the head could not be seen. Steichen's photographs with their hazy touch of mezzotint represent a fashion that was fading, seen in an art historical context. His pictures express an aesthetic attitude which relates to Munch's etchings of Obstfelder and Mallarmé from 1896. Another photographer, Alvin Langdon Coburn, became famous for similar close-up photographs, often combined with deliberate indistinction. As will be seen later, Munch took some interesting close-ups of himself in this period – for example, the peculiar portrait taken in his small house in Åsgård-strand in 1904 (174).

Munch also used such effects in his painting. The first known example is a grotesquely painted face, which can be identified as a portrait of the painter Henrik Lund (105), because of a note in one of Munch's sketchbooks from the 1920s. He wrote retrospectively:

Henrik Lund was living with his family one floor below me at the Palads Hotel – He wanted to draw me – Very reluctantly I agreed – He stands at a distance of 2 metres in front of his easel – He screws up his eyes – takes a measure with his charcoal – and starts drawing. The eye's camera is moving – eyelids screwed up and measuring, he finishes the drawing – It was very good.

Why do you have to draw at a distance of 2 metres

One sees other people at that distance, he says

You set up the conditions of a photographer, I say, but perhaps one sees another person better in other situations – casually – Perhaps one may have a better impression of a person at only 10 centimetres . . . – Now, I am going to paint you –

Yes, where do you want me to pose, he said –

Unnecessary – I noticed you when passing through your room – Do you remember that you were sitting a little away. I passed by you at a distance of only 10 centimetres.

The next day I painted the picture – It was unnaturally big – as the subject had been so close to me – and his wife, in a scarlet dress, who had been sitting further away, was rather small – The colour of his face was apple-green against the cinnabar red.[15]

The enormous head, which almost bursts out of the picture space, makes one think of an exaggerated photographic close-up; the shape of the head is dissolved, the features distorted and blurred. The apple-green face with the sensual, red lips reminds one of a pig's snout. The cinnabar figure of his wife is seen as a silhouette-like appendix to Lund's head – a head of which the brutality of feature and expression is unusual, even in Munch's multi-faceted art.

The painting was probably executed in 1905 or 1906. There are certain similarities with the paintings *Christmas in the Brothel* (1905) and *Around the Table* (1906) with regard to both the highly exaggerated intensity of the colours and the formularized presentation of the figures. The figure in the centre of *Around the Table* seems to be a portrait of Henrik Lund.

The Palads Hotel, which Munch mentioned in his note, was in Copenhagen. Henrik Lund lived in the Danish capital during the years 1905–9, and perhaps he and his family stayed at the hotel temporarily before settling in.

Through his extreme proximity to his subject Munch found a new manner of expressing a forceful intensity, which almost explodes the picture space. A development of this close-up effect is seen in a series of paintings of the title *The Green Room*, which Munch made in Warnemünde in 1907. The appalling scenes have

107–8. Respectively, Ellen Warburg and Edvard Munch next to his portrait of her. The photographs were taken by the beautiful young woman's mother, who was present as chaperone when Munch was painting her daughter.

109. Amateur photograph taken in the late summer of 1905 at Chemnitz at stocking manufacturer Herbert Esche's, where Munch was painting some portraits of the family. He is posing for the photographer in the same way as he visualized himself when painting *Self-Portrait with Brushes* the previous year. The damage to the middle finger of the left hand from 1902 is covered by a broad ring.

110. *Self-Portrait with Brushes*, 1904. It has wrongly been supposed that Munch used a photograph as the basis for this self-portrait. However, the photograph was taken half a year after Munch had painted the portrait over Christmas 1904, while he was staying at Dr Linde's in Lübeck. Munch had just completed a trial hanging of a frieze of paintings in the children's room, about which he writes in a letter of 11 December 1904 to Ludvig Ravensberg: 'The frieze for Linde has been hung, and the effect is like that of a bomb in his French Empire room – it creates flames of red and blue.'

been painted as if the subjects were studied at close quarters through a short-focus lens, which has given the paintings the character of unpleasant proximity.

SELF-PORTRAIT WITH BRUSHES

It has often been repeated in the literature on Munch that he used a certain photograph as a model for the painting *Self-Portrait with Brushes* (1904). The photograph has often been printed reversed in order to make the brushes point in the same direction and thus make the similarity more obvious. It can be proved, however, that the photograph succeeded the painting and not vice versa.

Self-Portrait with Brushes (110) was painted during Munch's stay at Dr Linde's home in Lübeck during Christmastime 1904. It was exhibited at Cassirer's in Berlin in January 1905, when it was also mentioned in the press. In the painting Munch appears self-confident and vital, set against an almost abstract background, his broad brushes in his right hand. The brushes are saturated with strong, pure colours. In the photograph Munch stands in a similar pose, his brushes in his hands, in front of a bookshelf.

The photograph (109) was taken in the library of Herbert Esche's house in Chemnitz in the autumn of 1905, when Munch was painting some portraits of the family. There are no

indications that Munch visited the manufacturer and his family earlier. So the similarities between painting and photograph are not due to the photograph having been used as a basis for the painting.

In Berlin just a week after finishing *Self-Portrait with Brushes* Munch painted a full-size portrait of the young Ellen Warburg, whom he described as a 'black-eyed goddess' in a letter to Ludvig Ravensberg. In a biographical note written in the early 1930s, Munch summed up the contrast between the atmosphere of the painting and his own state of mind at this time:

In the morning I painted the young Miss Warburg – the banker Warburg's daughter – A full-length painting in a white dress – The hands folded in front – Big beautiful eyes – a calm picture – calm in colours and style – In the evening, hallucinations.[16]

Two photographs show respectively Ellen Warburg and Munch next to the newly painted portrait. Munch wears the same coat and stands in the same pose as in *Self-Portrait with Brushes*. The photographs were presumably taken by Miss Warburg's mother around 15 January 1905, when the painting was finished. Munch considered the portrait one of his best paintings, whereas the woman who commissioned it – the very rich, beautiful and blasé Mrs Warburg – recounted to Gustav Schiefler that

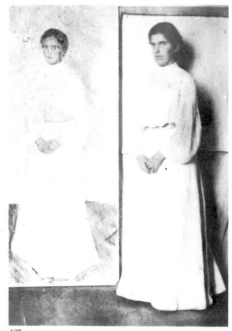

107

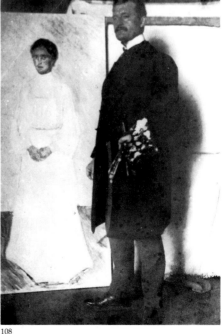

108

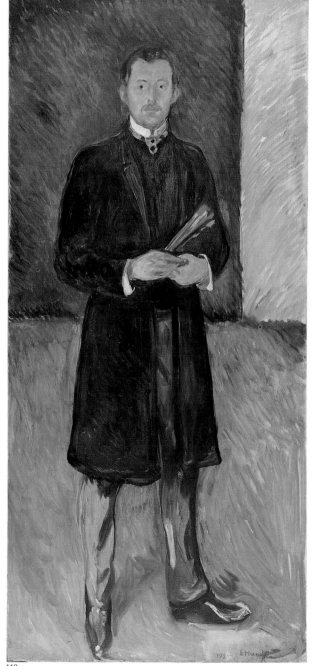

109 110

111. *Herbert Esche's Children*, 1905, is a painting in the series of Munch's many interesting portraits of children. Munch was also a very good friend of the Swedish author Ellen Key, who, in her book *The Century of the Child* (1900), maintained that the world of the child had great value in itself.

'the creation of the portrait was fun, whereas the possession has been less pleasing'.

These two photographs are the first of the kind in which Munch has respectively himself and his model photographed next to the portrait.

HERBERT ESCHE'S CHILDREN

While Munch was trying to recover from his frayed nerves in Klampen-borg, outside Copenhagen, in the summer of 1905, he received two commissions. The Swedish banker and admirer of Nietzsche, Ernest Thiel, wanted a portrait of the deceased Friedrich Nietzsche, and the manufacturer Herbert Esche in Chemnitz wanted a portrait of his children. As Munch needed money he immediately went to the Esches'. Here he recharged himself for three whole weeks, during which he drank the family's good

brandy and did not touch his brushes. Presumably, this was the reason Henry van de Velde was sent for, in order to straighten Munch out.

Some photographs were taken during van de Velde's visit. One of these shows the previously mentioned photograph of Munch with the brushes in his hand in front of a bookshelf, with the children's toys scattered about on the floor. This could indicate that he had started painting the portrait.

The story goes that, once started, he painted in an explosive manner without sketches or studies. The result was a major work among Munch's portraits of children, a peculiar, intense picture of the young Hans Herbert holding his sister Erdmute, younger by three years, by the hand, against a bare wall on a slanting floor, without any props (111). The Esche family were also very pleased with the results.

A photograph exists showing the children posing as in the painting (112). It was taken with the same camera as the others from van de Velde's visit to Esche's, and it is therefore likely that the photograph was taken just after Munch had started painting and that it supported his work in progress.

In the photograph, however, the children pose in an arranged manner, in a slack and artificial pose without tone, whereas the little couple in the painting stand out with a contrasting lively suppleness. One can really sense

111

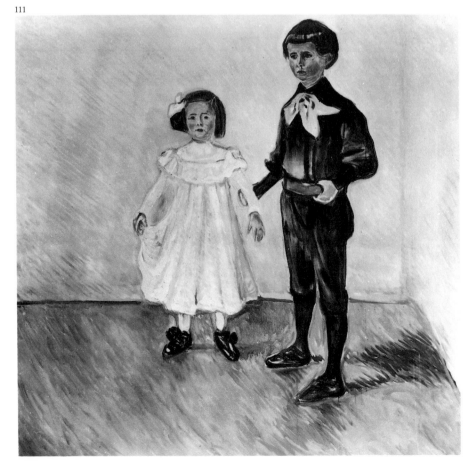

112. Hans and Erdmute Esche in their home in Chemnitz in 1905. The pattern of the tapestry was designed by the architect Henry van de Velde, who had also designed the family's house. The photograph was presumably taken after Munch had started his portrait of the children (111), and he most likely made use of it during the further progress of the painting.

113. The architect and designer Henry van de Velde and Munch, photographed in Herbert Esche's house in Chemnitz. The furniture was designed by Henry van de Velde. The photograph was probably taken at the same time as the one of Esche's children, since the proportions and the colour of the photographs are the same.

113

how the boy leads his little sister on to the stage and into life. The children are seen at their own eye level, which gives them a certain dignity not evident in the photograph.

Munch had received the commission on the recommendation of both Dr Linde in Lübeck and the architect Henry van de Velde, who had designed Esche's new house in Chemnitz. The design of the interiors was of a simplicity and formal purity that showed Munch's dynamic colours to their best advantage.

Among the photographs from van de Velde's visit to Esche's while Munch was there are two double-portraits of Munch and van de Velde. In one they both sit on a sofa designed by van de Velde; in the other van de Velde sits in one of his chairs while Munch stands next to him.

It is the manner of formal portrayal of two well-known persons that relates to Degas's legendary photo-graphic double-portrait of Mallarmé and Renoir, a formula Munch later used in a double-portrait of Jappe Nilssen and Dr Lucien Dedichen in 1926. So it is very likely that the double photographic portrait was not just meant to document the visit of Munch and van de Velde to Esche's house, but was also meant to act as a study for an eventual double-portrait.

Van de Velde recounted to Mrs Esche, 'It is one of my ardent wishes to leave my portrait, made by Munch, to my children', and Ernst Thiel had

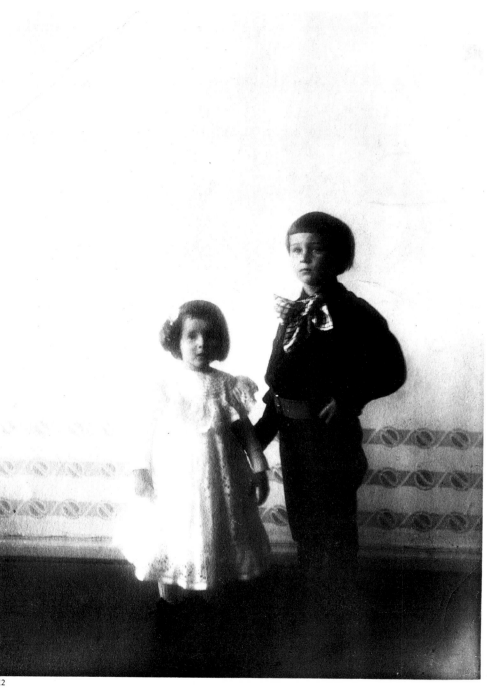

114. Picture postcard of Nietzsche and his house in Weimar. As Nietzsche had been dead for several years, Munch had to rely on the photographic portrait alone, when he was painting his portrait. This photograph was clearly the basic model for (115), in which we also see the flat Weimar landscape in the view from the windows.

115. Sketch for the portrait of Friedrich Nietzsche, sitting in a room of his house in Weimar towards the end of his life. Munch has here shown him as a melancholic, situated in a yellow room against a red cloth in an analogous manner to the way in which he painted his sister Laura in *Melancholy* (see 162).

already in his first letter to Munch advised him of the eventual commission to paint van de Velde in Weimar. A portrait painting was, however, never made; but the following year in Weimar Munch created a fine lithographic portrait of van de Velde. It would have been a good starting point for a portrait painting if transferred to canvas, and it was probably intended as such.

FRIEDRICH NIETZSCHE

Ernest Thiel commissioned Munch to paint Friedrich Nietzsche, because, as he wrote to Munch on 6 July 1905, 'he was the man to whom I owe a greater debt of gratitude than to any other human being'. The task necessarily had to be done from already existing representations of the poet-philosopher, as Nietzsche had been dead for five years when Munch received the commission.[17] It was therefore logical for Munch to go to Weimar to research at the Nietzsche Archive, managed by Nietzsche's sister, Elisabeth Förster-Nietzsche.

Thiel defined in a subsequent letter that he wanted 'a work which shows your Nietzsche – *my* Nietzsche, that is another matter'. However, it is questionable whether Munch really attempted to paint *his* Nietzsche. As in the other cases where Munch portrayed famous personalities whose portraits were known to the public,

84

there is also good reason here to believe that Munch primarily aimed at capturing the so-called general concept of the poet-philosopher.

Munch's first reflections concerning the task were expressed in a letter to Thiel:

I think it must be executed in a high decorative style – It is somewhat difficult to paint a dead person – although it is easier with a personality who is still alive through his works . . . I

have an idea – Nietzsche sitting at the window in his study in Weimar – as you may know there is a rather melancholic landscape outside, which is very appropriate for him.

In Munch's first sketches Nietzsche is shown sitting in front of a window, through which a broad landscape is seen. These sketches developed into a composition in which Nietzsche is sitting at a small round table in the corner of a room (115), a composition

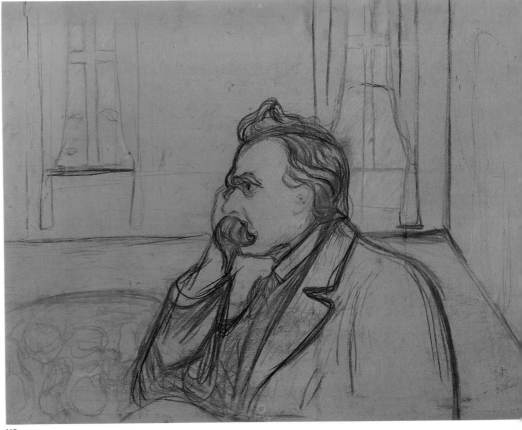

115

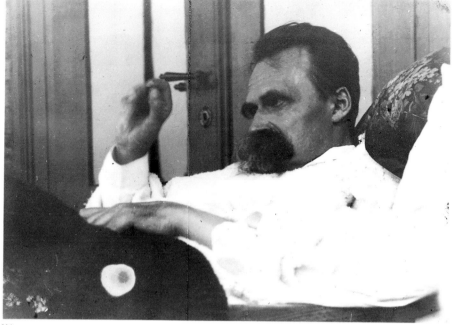

116. Photograph of Friedrich Nietzsche, taken by Hans Olde in 1899 as one of a long series of studies of the then insane poet-philosopher, planned and used for a feature article in the magazine *Pan*.

116

that has clear precedents in *Melancholy/Laura* (1900), which portrayed Munch's insane sister.

Munch has thus used an already proven representation, which expressed a melancholy close to psychosis. He has also obviously relied upon the best-known portrait photograph of Nietzsche, published as a postcard in several versions. It shows Nietzsche, his hand under his chin, in a medallion in the sky above his house in Weimar, where later the Nietzsche Archive was established.

Munch's first idea was the most obvious: to place Nietzsche at the window in a room in his own home, based on the best-known photograph of him. Munch knew this house very well from his visit to Weimar the previous year, and he wrote in his first letter to Ernest Thiel:

I spent some unforgettable days in Weimar, not least at Mrs Förster-Nietzsche's, in whose house the great brother's ideas were felt all over.

During his study of Nietzsche, Munch probably became aware that the postcard photograph had not been taken in Weimar, but in Naumburg in 1882, when his ideas about the Zarathustra character were taking shape. Munch explained his work on the portrait in another letter to Thiel, in the spring of 1906:

I have made studies for the two pictures – I intend to paint Nietzsche first – and

have already made a promising study – As I have hinted I have chosen to paint him in a monumental and decorative style. I think it would not be right of me to portray him in an illusory manner – as I have not seen him with my outer eyes – So I have made my point by painting him somewhat larger than life-size – I have depicted him as the author of Zarathustra in his cave between the mountains. He stands on his balcony looking down into a deep valley, and over the mountains a radiant sun is rising – One may think of the point where he talks about standing in the light, but wishing to be in the dark – but of many others as well.

This description largely corresponds to the portrait finished by Munch half a year later (117), after he had produced a lithograph of the head as an intermediary stage. The head no longer relates to the photographic portrait of Nietzsche from 1882, but must be considered a stylized version of Hans Olde's etching from 1900.

Hans Olde, a graphic artist and photographer, had had the task of making an etching of Friedrich Nietzsche for the journal *Pan*. In 1899, the year before Nietzsche died, Olde took a series of twenty photographs (116) of the poet-philosopher, at the initiative of Elisabeth Förster-Nietzsche. Nietzsche was photographed sitting either on his bed or in an armchair with a rug around him. Olde transformed one of these photographs almost directly into an etching

of Nietzsche. Olde played an important part in the Weimar circle, in which Munch also became a central figure during his stay, so it is impossible for Munch not to have been aware of these photographs.

The photograph of Nietzsche from 1882 was also used as the frontispiece to the last volume of Elisabeth Förster-Nietzsche's biography of her brother, on which she was working during Munch's first stay in Weimar in 1904. Under the photograph she had her brother's signature from 1885 printed. In chapter 27 of *The Will to Power*, she explains why she considered 1885 such a significant year in Nietzsche's life: it was then that her brother gained full insight into his concept of the Will to Power, which carries the main ideas of his work. And – almost in the manner of Munch – she describes an experience in nature which she thought more or less started the process of recollection that awakened Nietzsche to the fundamental significance of his ideas:

Perhaps, I can allow myself a recollection which might give a clue to how the idea of the Will to Power first arose . . . I have already recounted the sad, but none the less wonderful, walks in the valleys around Naumburg in the autumn of 1885. Just like this, my brother and I walked over the hills up to what had been a resting place for hunters; the path up there offers a wonderful, wide view and just on this day – when night was falling – it was

117. *Friedrich Nietzsche,* 1907. Munch has
undoubtedly used Hans Olde's photograph and
etching of the poet-philosopher for the portrayal of
the head in this great portrait, commissioned by the
Swedish patron Ernest Thiel.

*particularly beautiful: the heavens were
yellowish red with deep black clouds,
which created a strange atmosphere of
colour in nature.*[18]

It is possible that Elisabeth Förster-
Nietzsche did not attach any impor-
tance to this experience until after
conversations with Munch during his
stay in Weimar in the spring of 1904. It
is not unlikely that Munch had ela-
borated his most subjective experi-
ences in nature, which had been a
starting point for his works, such as
the major work *The Scream.* It is, at
any rate, the only time in her bio-
graphy of her brother where an ex-
perience in nature is considered
of importance. And the incident
kept occupying her thoughts. In the
comprehensive Pocket Edition of
Nietzsche's work, of which she was in
charge, she extracted sections of her
full biography to serve as prefaces to
the different volumes, often without
much change.

In the preface to *The Will to Power,*
which she completed in August 1906,
after Munch had finished her brother's
portrait, she featured the same recol-
lection from Naumburg, but in a
much more detailed version. She
explained that they were wandering in
the environs of Naumburg 'in order to
see the locations of our childhood
again', and she mentions the place
where the experience took place as
'the hills between Naumburg and
Pforta at the river Saale'.

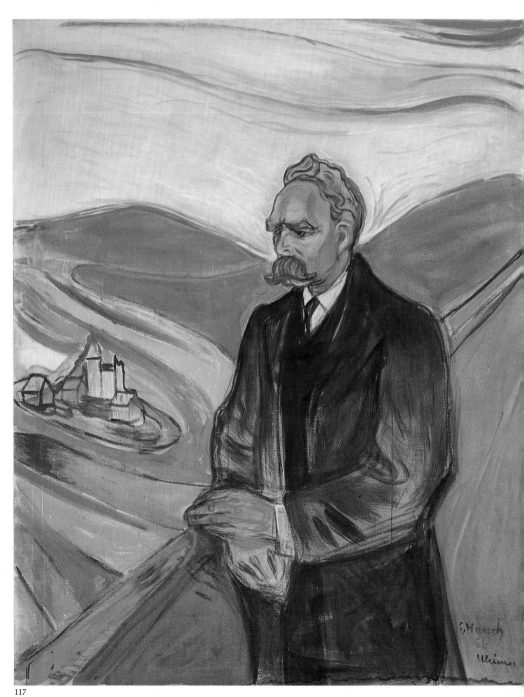

RUDELSBURG u. SAALECK.

Dort Saaleck, hier die Rudelsburg
Und drunten tief im Thale,
Da rauschet zwischen Felsen durch
Die liebe alte Saale.

Und Burgen hier u. Burgen dort
Zur Rechten u. zur Linken.
Die Rudelsburg, das ist der Ort
Zum Schwärmen u. zum Trinken.

118

118–19. Munch owned several postcards showing the landscape around the river Saale and Rudelsburg and Saalecksburg. It is in front of this landscape, however stylized, that Munch paints Nietzsche in the final version (117), and the same scenery is to be found in the naively painted tapestry, in front of which Munch poses in a small ferrotype.

The landscape in Munch's portrait of Nietzsche has been considered a purely imaginary landscape. In form it relates to the landscape of the drawing *In the Land of Crystals* (1893), to the poster for *Peer Gynt* (1896), and to the lithograph *Funeral March* (1897). My hypothesis is, however, that Munch has shown Nietzsche at the exact hill between Naumburg and Pforta at the very moment the concept of Will to Power becomes fixed in his mind as his main message. In the valley below, the river Saale, with its characteristic bends, is seen flowing past the castle Rudelsberg. Far back in the landscape, to the left, a tower can vaguely be seen; it is quite likely one of Saalecksburg's typical towers. Gustav Schiefler described how he and Munch wandered in the countryside around the river Saale, how they followed the river downwards, passed Rudelsberg and Saalecksburg with its large flocks of crows, and then headed for the hills on the other side of the valley.

Among Munch's documents are two postcards of exactly this landscape. One shows Rudelsburg and Saalecksburg and the river Saale winding in soft curves through the flat valley (118); the other depicts Saalecksburg seen from Rudelsberg. These postcards almost certainly prove that the landscape in the final Nietzsche portrait is the same landscape in which Nietzsche and his sister were wandering in 1885, with the difference that Munch's version is stylized.

In November 1906 Munch was again 'in Saaleck in a quiet inn'. In his letter to Gustav Schiefler he interprets his own situation in Nietzsche's landscape:

119

Once again my life's river is winding like the quiet river of Saalack, and my life's storms stand like the old towers surrounded by black ravens.

A preserved ferrotype shows Munch at

120

121

120–1. This photograph of Elisabeth Förster-Nietzsche appears to be a snapshot taken at random, but it is probably a planned pose, taken at the same time as Munch was painting her portrait in 1907. She is most probably standing in the Nietzsche Archives, which she directed.

122. Munch's etching of Gustav Schiefler, 1905, compared to a photograph of him, published in *Das Kunstblatt* (1930).

a railing in front of an old cloth backdrop (119). This prop, so typical of a street photographer, shows both Rudelsberg and Saalecksburg, to the left and to the right in the picture. It is not known when this ferrotype was taken, but it was presumably made in connection with the work on Nietzsche's portrait, perhaps as an ironic comment on his own identification with the Nietzsche figure.

A series of postcard portraits of Munch, also from this period, relate invariably to the portrait photograph of Nietzsche from 1882. The coiffed hair, the long moustache, the sharp gaze and the almost aggressive expression indicate that Munch identified himself with the poet-philosopher.

Both Ernest Thiel and Elisabeth Förster-Nietzsche were very enthusiastic when the portrait was finished. Thiel wrote to Munch:

I am absolutely moved by his impressive portrait, in which prophet and human being melt into one. It was exactly like this I wanted to see him! You could not have succeeded better.

The portrait managed to generate similar enthusiasm later. But another tradition, leading back to the first viewing of the picture, sees it as a failure as a heroic portrait of the writer, explaining this by the fact that Munch had only a photograph of the deceased philosopher on which he could base his image.

88

Ernest Thiel also asked Munch to paint 'my revered friend, Mrs Elisabeth Förster-Nietzsche. Regardless of her being a woman, I admire her as his sister, apprentice, and biographer.'

In the Munch Museum there is a photograph of Elisabeth Förster-Nietzsche standing in a long full dress in front of some archive shelves (120). In her hands she holds a long, thin object. The photograph has the character of a snapshot, showing an active woman at her prime. It has generally been assumed that Munch used this photograph as a model for his two paintings of her (121). From the correspondence it is evident that Mrs Förster-Nietzsche posed for Munch several times, but this does not prevent the photograph from having played an important role in the conception of the portrait.

GUSTAV SCHIEFLER AND 'THE LITTLE ANGEL'

Just before Munch received the commissions to paint Friedrich Nietzsche and the Esche family he suggested to his friend Gustav Schiefler that he should etch the portrait of Schiefler's little daughter, Ottilie, whom Munch called 'the little angel'. He wrote from Åsgårdstrand in 1905:

I would like to have etched the Little One – Perhaps you would be so kind as to send a photograph – By means of this

and my memory I may be able to manage something.

Munch was sent some photographs but had great difficulty in finishing the etching (124). The many commissions probably absorbed most of his powers of concentration.

He was asked to return the photographs, but obviously allowed himself to keep the one later found among his documents (123). Supposedly this is the one he wanted to use as a model. He still complained about not being able to start and wrote to Mrs Schiefler in January 1906: 'I am sorry that The Little Angel has not been finished – It is difficult from a photograph – but it will come eventually.' Here Munch gives expression to the actual difficulty of using a photograph as a starting point, indicating that the transformation was far from automatic.

In the mean time Schiefler visited

122

GUSTAV SCHIEFLER

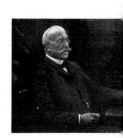

124

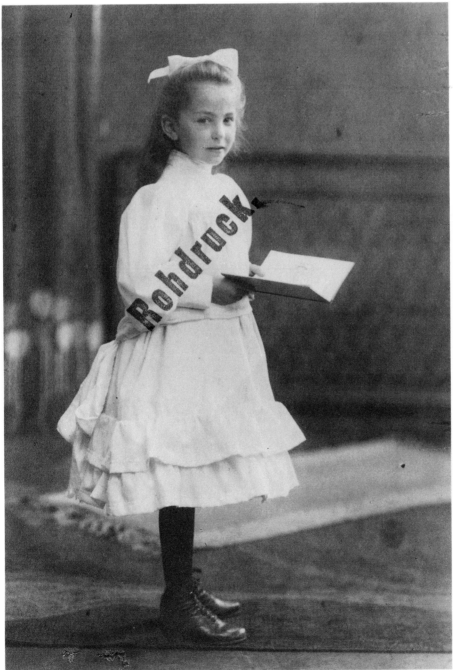

123

Munch in Elgersburg over Christmas 1905 in order to continue his work on the catalogue of Munch's graphic works, the first volume of which was published in 1907. During this visit Munch made an etched portrait of him, which, according to Gustav Schiefler's diary (21 December 1905), 'was finished in an hour'. He also described how the etching, which was completed in bright sunshine reflected in the snow, captured the spirit of their conversation. Surprisingly, this portrait bears a striking resemblance to a contemporary photograph of Schiefler, so striking that the portrait and the photograph were published together in *Das Kunstblatt* in 1930 in connection with the first exhibition at which artistic interpretations were systematically presented with photographs of the same model (122).[19]

FELIX AUERBACH

In the same period in which Munch was painting the Nietzsche portrait he also made a portrait of Professor Felix Auerbach in Jena, in January and February 1906.

Auerbach was in Munch's eyes a very interesting person. His theories of how sound waves could affect a human being physiologically interested Munch so much that he attended his lectures in Jena, frequently taking notes. Auerbach's theories were in line with the problems which

125–6. The photograph of Felix Auerbach was taken by his wife, Anna, at Munch's request after the painting was finished, since Munch wanted to improve the hand. However, this did not happen, as he, according to a draft, wrote to Mrs Auerbach: 'I feared that I might ruin the picture – and the picture is very good – but all my portraits are *outré* – it cannot be otherwise.'

125

occupied Munch. In one of Munch's literary drafts from that time is the following:

A man comes in and sits down at a table – a woman stands stifly – cold – and pale behind him – She utters a word – is otherwise careless – the man suddenly collapses – grasps his revolver and shoots himself – She kills the man by one little word – It was not the word, though – it was the sound which made it happen – maybe, not the sound either – it was the vibration of her vocal cord – and the fact that this vibration happened at that very moment.[20]

In the portrait Auerbach is standing in a mass of colours and floating objects, almost an aura of thought- forms, gesturing with the cigar in his left

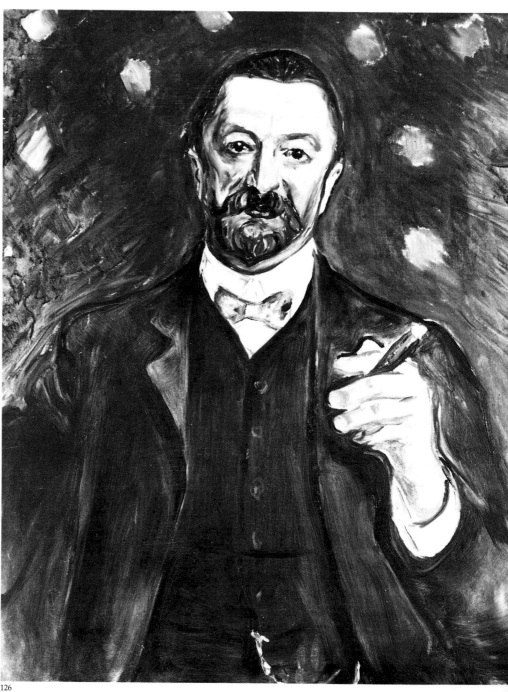

126

127

from the end of the year 1906) there is talk of improving the hand. Munch asked if he could borrow the portrait for a month for the exhibition at Cassirer's in Berlin and wrote: 'Would it be possible for your wife to photograph you in the same pose? I could then improve the hand in Berlin.'

Felix Auerbach's wife, Anna, did photograph her husband in the same pose as in the painting, but Munch did not alter the hand. He himself photographed the portrait during the exhibition at Cassirer's in January 1907.

In a far later letter to Munch from the painter Charles Crodel, a friend of the Auerbach family, it is revealed that Mrs Auerbach also took a portrait photograph of Edvard Munch. There are no other details about this photograph; perhaps Mrs Auerbach was the photographer of the portrait in which Munch is standing with a stick of charcoal in his hand in an unidentified room?[21] The photograph (333) seems to have been taken with the same camera, considering the measurements, and was probably taken in Jena or Weimar.

hand (126). A photograph of Auerbach with exactly the same pose and gesture (125) gives the immediate impression that this photograph was the basis for the painting, but correspondence between Munch and Auerbach reveals that it was not. In a letter from Munch (undated, but presumably

DR DANIEL JACOBSON

In early October 1908 Munch was admitted to Dr Daniel Jacobson's clinic in Copenhagen for treatment for a nervous disorder and alcoholism. Dr Jacobson specialized in helping Scandinavian artists with such

problems. Munch soon transformed his sick-room into a studio, where he painted his doctor.

There is a series of photographs from the clinic of a peculiar, oblong format, which seems specially suited to full-length portraits. Portraits of Helge Rode and Dr Jacobson are the main subjects of these photographs. The photographer is not known, but it is assumed that they were developed in a professional studio since they are mounted on cardboard.

In one of the photographs Dr Jacobson is standing in the same pose as in Munch's portrait of him, with legs far apart and hands by his sides, 'as a pope among his nurses, clad in white, and us, the pale sick ones', as Munch expressed it. But in this case, as with Auerbach's, the photograph was not the point of departure for the portrait. In another photograph is the finished portrait of Jacobson, 'big and broad in a fire of the colours of hell'.[22]

And a third photograph in the same series shows Dr Jacobson and Munch, posing self-consciously with brush and palette, standing on either side of the painting (127).

The photograph can be seen in connection with Munch's later remark: 'I painted a life-size portrait of the doctor. When I was painting, I was the master. I felt that I controlled him as he had controlled me.'

The figure's dynamic interaction with his surroundings is underscored by the atmosphere which is as tangible

91

as the figure. This intense atmosphere surrounding Dr Jacobson has an equivalent in the atmosphere around the dark-clad nurse in a photograph which Munch took with his own camera at the same time.

Munch also took a series of photographs of himself while staying at the clinic. He literally recorded his own convalescence by means of the camera – how his personal hell gave way to a sensation of health and strength, which immediately led to the appearance of sunlight in his works as a dominant feature. However, these photographs mark an end to a process that had started in Berlin six years earlier, in 1902.

Munch's Experiments as an Amateur Photographer 1902–1910

128. Ferrotype of Edvard Munch, probably c.1902.

129. Munch's photograph of his model Rosa
Meissner in the Hotel Rôhne, Warnemünde, 1907.
It is an evocative photograph which inspired Munch
to develop the theme of the weeping Psyche in
paintings, graphics and sculpture.

It came as a surprise at the exhibition *Painting after Photography* in Munich in 1970 that such a spontaneous and intuitive artist as Munch had used photographs as a basis for some of his subjects. Munch's own work as an amateur photographer was of only peripheral interest on that occasion, even if Professor J. A. Schmoll gen. Eisenwerth remarked in his introduction to the exhibition catalogue:

Munch's photographs, so technically imperfect and at the same time so unconventionally magnificent as pictures, bear witness to a psychological ability to see, in a manner not at all witnessed elsewhere in photography at the time.[1]

Eisenwerth deemed such qualities gratuitous, although necessary, results of Munch's manner of 'seeing' with his camera. However, an analysis of all the material shows that it is likely that many of Munch's own photographs must be understood as deliberate experiments.[2]

In spite of (or perhaps because of) a totally impossible situation in Kristiania, where he did not sell anything and instead was obliged to pawn his paintings, Munch went to Berlin in November 1901, in order to create a base for himself and his works. There he spent his remaining funds to rent a respectable studio in which he could both work and receive his friends and eventual clients and other persons interested in art. A studio would give him the possibility of both painting commissioned portraits and using models. Also, collectors of modern art liked to visit studios to experience the direct contact with artists. With Fridtjof Nansen himself as guarantor, Munch had his works released and sent to Berlin, in order – his wish and hope – to exhibit immediately at Cassirer's fashionable Exhibition Rooms, which had specialized in modern French Art.

Munch was convinced that his works, through their power and intensity, could in this way provide him with a definite breakthrough as an international artist, and that this could compensate for the negligence he had received at the hands of the buying public in Kristiania.

It must, therefore, have been quite a disappointment to him that the Exhibition Rooms were not available and that the paintings, after arriving in Berlin on 27 January 1902, were brought instead to Munch's large studio. It is in this tense situation – so filled with the spectre of both fiasco and success – that Munch acquired a camera and started photographing himself and his milieu.

The small camera Munch used in the years 1902–10 has not been preserved, but he mentioned his 'Kodak camera' in letters to Ludvig Ravensberg, who more than once would have to search for the forgotten camera for him in restaurants and cafés. It was quite likely a small Kodak camera with a roll of film containing four, six or twelve pictures of the size 9 × 9 cm. According to the advertisement, the square format was well suited to 'producing magic lantern pictures easily'. It is possible that Munch chose this type of camera to aid him in his work on commissioned portraits.[3]

The standard type of Kodak camera worked either by time adjustment or by an instant exposure of 1/20 second. An automatic release was generally an extra piece of equipment. It was not necessary to have a dark room or other technical equipment for developing and printing, just suitable pans, and water and chemicals from commercially available packs.

All the photographs taken by Munch's Kodak camera were developed as contact prints. The prints are often 'signed' with fingerprints. Most likely, Munch developed and printed his photographs himself. However, no negatives have been preserved from before the spring of 1907.

The first preserved series of Munch's own photograph are from his studio in 82 Lützowstrasse in Berlin, from early February 1902. A letter of 14 February to his aunt Karen Bjølstad helps to date these first photographs. Munch wrote, 'Enclosed are two photographs taken by a small camera I have acquired. You see, I have shaved off most of my moustache.'

One of those two photographs

130–1. Edvard Munch sitting on his trunk in the studio in 82 Lützowstrasse in Berlin, 1902. He had just acquired his first camera, a small Kodak camera. The paintings behind him were intended to contribute to his breakthrough at the Berlin Secession in 1902. The rich palette hanging on the wall behind him indicates that he is working on new paintings.

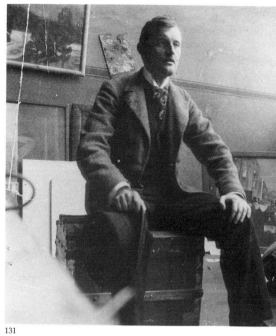

131

130

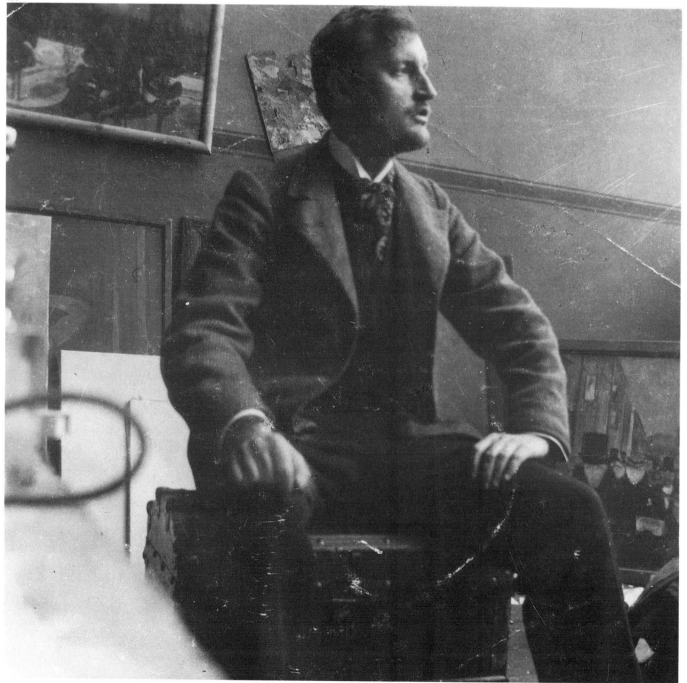

132. A glance into Munch's bedroom in the studio flat in Lützowstrasse. Apparently, he was photographed in a casual moment while sitting on the bed putting on his shoes. The painting leaning against the stove to the left, *Girls on the Bridge* (1900), is today in the Nasjonalgalleriet in Oslo.

132

the moment he considered the film sufficiently exposed. If his camera possessed a shutter this could be opened automatically, but he had to stop the exposure himself.

One of the reasons Munch took two photographs of the same subject was probably that he was experimenting with different exposure times. The full-face self-portrait is slightly over-exposed compared to the profile view.

Another five photographs preserved from the studio in Lützowstrasse show that Munch photographed his new surroundings almost systematically. All the photographs show walls, floors and table filled with his recently unpacked paintings and graphic works.

From a room filled with canvases, he is seen through the doorway sitting on a bed, photographed against the light (132). To the left of the door is the version of *Girls on the Bridge* (1901) which became his most popular and sought-after painting that spring. The photograph has the same low vantage point. The exposure time was probably around 20 to 30 seconds and a helping hand has presumably ended it.

Two other, almost identical, photographs show a naked model with long hair and black stockings, prob-ably a professional model, who, ac-cording to Munch, would came daily from 10 to 12 during this period (133–4). She is standing behind a table and in front of the painting *The Three*

probably refers to the picture in which Munch is sitting on a trunk, the one Gustav Schiefler mentioned in his diary on 30 December 1904 as being filled with the best of Munch's graphic works. A palette is hanging on the wall behind his head. The low pers-pective and the blurred area, which helps concentrate the composition, indicate that the camera was placed on a table.

Two almost identical photographs exist of this subject. In one, Munch holds a broad-brimmed hat in his right hand. Some blurring around the hat indicates that Munch has moved it. In the other, where he is shown in profile, the hat is hardly seen. Such a photograph has probably been taken with an exposure of around half a minute, and Munch may therefore have used the hat to cover the lens at

133–4. The model in Munch's studio has previously been identified as Tulla Larsen, his fiancée from the turn of the century. The large painting, placed on end, *The Woman*, 1894 (also called *The Three Stages of Woman*), is today in Rasmus Meyer's collection in Bergen. On the left in the photograph can be noticed a fingerprint, which reveals an amateur's developing, probably done by Munch himself.

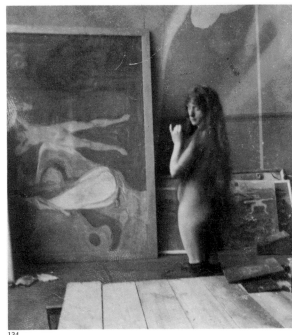

134

133

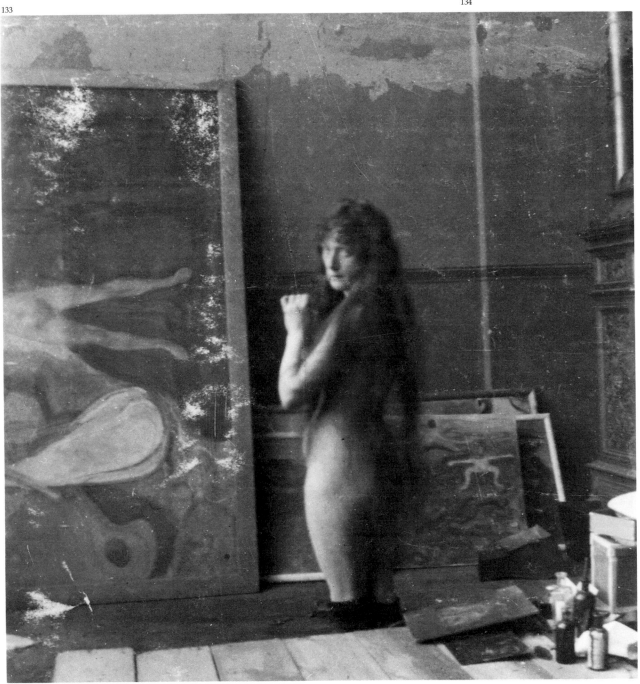

135. *Naked Woman*, 1902. Compared with photography it is obvious how Munch eliminates all unnecessary material, condensing the solidity and volume of the body in contrast to the more ethereal depictions of woman of the 1890s. Notice how Munch, in an almost primitive ritual manner, has scratched on the body of the woman with a pointed tool.

136. *Sin*, 1902. Lithograph. The young features of the model have here been handled in a much more naturalistic way than those of the painting. Traditionally, the lithograph has been dated to Berlin, 1902.

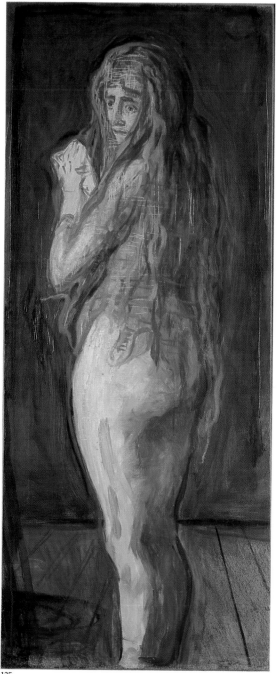

135

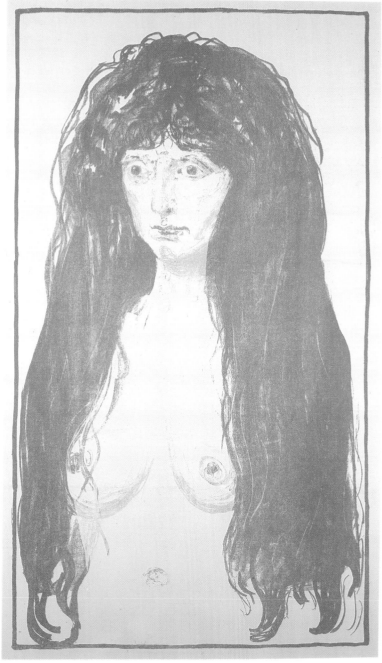

136

137

138

Stages of Woman (1894). These photographs undoubtedly relate to the painting *Naked Woman* (135) and the lighograph *The Sin* (136). In spite of the intimacy of the photographs they contain little of the special intensity of the lithograph and the painting.[4]

Another photograph shows a woman in hat and coat, an umbrella in her hand, in another corner of the studio (137). It is uncertain who she is. However she bears some resemblance to the singer Marta Sandal, whose portraits Munch made at this time. In both the painting and the lithograph she seems a very proud and erect woman, whereas the woman in the photograph seems more modest. In a letter to his aunt, Munch wrote that he occasionally saw 'Miss Sandal with two Shadows – Wieck and his brother, who is a musician. I think Wieck looks thin and pale and I believe that he is perhaps suffering from unrequited love.' Presumably, the two figures in the last photograph of this series are the two brothers Wieck (138). The photograph was not taken at exactly the same time as the previous one, since the paintings in the background have been arranged differently, although the graphic works lying on the floor have not been shifted.

Munch also used his camera to create portraits that winter in Berlin. There is a photograph of the painter Walter Leistikow sitting in a chair against a background of his own land-

scape paintings (140). In the double-portrait lithograph of the painter and his Danish wife, Anna Mohr, his profile is seen at exactly the same angle (139). Anna Mohr had translated Maurice Maeterlinck's play *Pelléas and Mélisande* into Danish in 1894, the publication of which had originally been planned with illustrations by Edvard Munch.

Leistikow, who, under the pseudonym Walter Selber, had defended Munch at the so-called Scandal Exhibition in Berlin in 1892, was now one of the administrators of the Berlin Secession, and he was probably the person to whom Munch was indebted

for the extensive showing of his works at the exhibition in 1902. In collaboration with Munch, Leistikow supervised the mounting of his Frieze of Life in one continuous frame of white fabric along all four walls in the Sculpture Room.

Munch's first photographs show a full command of the medium in all its aspects, from lighting to framing to the portrayal of the subject. He must also have had a definite idea of what he wanted before every single exposure. It is clear that Munch mastered the basics of this new medium before he tried out further experiments.

Many of the photographs are easily

139

100

140

137–8. Friends visiting Munch's studio. The woman is probably the singer Marta Sandal of whom Munch was painting a portrait at the time, and the two men may be her 'two shadows', the rich brothers Wieck. The photographs are taken almost at the same time: even if some of the paintings have been moved, several of the graphic works are lying on the floor in identical positions. The guests probably had to remain standing, as Munch did not have a single chair in any of his rooms.

139. *Anna Mohr and Walter Leistikow*, a lithograph, done in 1902 on the basis of Munch's own photograph (140). There is reason for believing that this double-portrait of the artist couple inspired the photographer August Sander to make his photographic double-portrait of the painter Otto Dix and his wife.

140. The painter Walter Leistikow in his studio in the late winter of 1902. In the lithographic double-portrait of Leistikow and his wife, Anna, Munch has depicted Leistikow exactly as we see him in the photograph; the light–shade effects are almost identical. It is possible that Munch later also took a photograph of Leistikow's Danish wife.

141–2. Edvard Munch and Albert Kollmann photographed each other in front of a display of tombstones in a back yard in Berlin. Kollmann, a mystic interested in art, was Munch's protector in Germany. According to Munch himself, Kollmann worked 'indefatigably at obtaining better conditions for Munch in Germany – and it is mostly due to him that he obtained the position he did'.

dated or at any rate placed in a relative chronology. However, some problems with exact dating have arisen, and some indications of dates can be very uncertain and will probably be the subject for verification when more documentary material comes to light.

This insecurity of dating affects two complementary photographs of, respectively, Munch and the mystic and art enthusiast Albert Kollmann against a row of tombstones covered with snow, presumably lined up at a stonemason's yard in Berlin. The photographs may be interpreted as a memento mori – life in the perspective of death. Kollmann's photograph of Munch (141) is more traditional in terms of composition than Munch's portrait of Kollmann. The depth of the perspective is cut off by the wall in the background. Munch, however, has placed Kollmann at the point of intersection between the light and the dark walls of the buildings, in an almost symbolic manner (142).

These photographs are probably among the very first taken by Munch's new camera, at the beginning of February 1902. This was when Munch and Kollmann began the friendship they both thought of as a fateful fellowship, in which Kollmann, this 'ghost from Goethe's time', assisted Munch as a modern Mephistopheles and tempted him to seek fame and fortune in the German art market through portrait painting.

The great display of *The Frieze of Life* at the Berlin Secession was in reality the breakthrough Munch had hoped for, and Berlin – the stronghold of conservatism in Europe – accepted him and his art. In the late summer, when the exhibition had ended, he went to Kristiania to consolidate his new position. During the preparation for an exhibition at Blomqvist's gallery his situation became rather complicated, as his woman friend Tulla Larsen demanded a clarification

141

142

143. X-ray photograph of Munch's left hand taken before the operation at Riks Hospital in 1902. The small revolver bullet, probably 22 calibre, is visible in the fractured middle finger. The journal is still at the hospital today.

144–5. From Munch's exhibition at Blomqvist's in the autumn of 1902. The photographs seem to be deliberate references to Blix's caricatures (146). The reflections and the blur contribute to a particular, intense atmosphere which indicates that Munch intended more than just documenting the exhibition. Besides, all of the works depicted by Blix can be identified in the photograph.

146. Ragnvald Blix's *Edvard Munch's Exhibition*. Caricatures in *Tyrihans* in 1902 dealing with the fact that Munch's exhibition was hardly visited until a boycott was proposed in *Aftenposten*; then the audiences flocked to the exhibition.

of their relationship. She found their situation so unbearable and desparate that she was driven to the verge of suicide. They went together to Munch's small house in Åsgårdstrand and in this tense atmosphere Munch fumbled with a small calibre revolver in desparation and shot himself in the hand, in a more or less reflex action. This ended their relationship, and Munch went to Riks Hospital to have his hand operated on.

The X-ray taken of the damaged hand at Kristiania Roentgen Institute before the operation is preserved and shows the hand with the bullet embedded in the smashed finger (143). Notes written some years after the incident show Munch's despair over what he later came to call his 'fatal hand', when the bandage was removed:

– *The bandage on the hand was removed*
– *a shudder passed over him*
– *a monster*
– *a crippled limb*
– *was once his well-formed hand*
– *his precious aid in his work*
– *crippled, awful and useless.*[5]

This incident developed little by little into a trauma for Munch, who used it as an explanation for all his difficulties all the way through to his breakdown and his admission to Dr Jacobson's clinic for nervous disorders in 1908. In notes, plays, series of lithographs,

paintings, and – as we shall see – in photographs as well, he dwelt on his degradation.[6]

Two days after he left hospital the extensive exhibition of his latest works opened on 24 September at Blomqvist's in Kristiania. This exhibition was sparsely attended until an anonymous letter appeared in *Aftenposten* on 2 October 1902 under the headline 'We call a strike' requesting the public 'to boycott the daub and filth of this exhibition'. Then the audience flocked to it out of curiosity.

In the satirical magazine *Tyrihans*, of 17 October 1902, the cartoonist Ragnvald Blix (an artist very much influenced by Munch at this time) recorded the incident in a double caricature (146). One half shows the empty galleries with the artist's shadow as the only viewer. The other half shows a crowd of people struggling to get into the exhibition after the demand for a boycott. In two complementary photographs of the same part of the gallery, Munch seems to echo Blix's caricature with his camera. One photograph shows the empty rooms; the artist's shadow is seen moving across the prominently placed portrait of Åse Nørregard, perhaps Munch's closest woman friend through the years (145). In the other photograph the audience is seen passing along the paintings as faint ghosts (144). A long exposure can explain the evocative effect of the first picture. The camera was probably placed on a polished

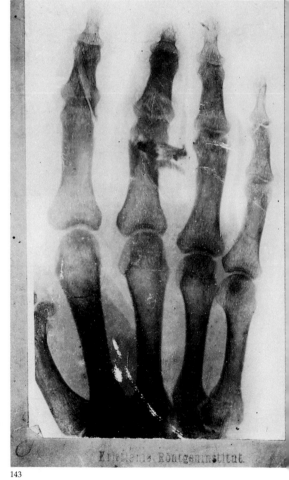

143

table that reflects both paintings and the roof construction, which contributes to the strange evocative lighting. Furthermore, Munch seems to have passed a light object in front of the lens, such as a piece of paper, presumably in an attempt to manipulate the light. These two photographs were placed side by side in a photograph album so as to create a double picture like Blix's caricature.

144

Edvard Munchs Udstilling.

„Wasteson trænger lidt Reklame"! „r." i „Aftenposten".

146

145

147. This photograph is one of the most unusual among Munch's Fatal Destiny Photographs; the face is just faintly to be seen deep down in the shadow of the room. The subject relates to both *The Sick Child* (37) and *The Day After* (see 68). The blurred parts show that Munch has been in and out of bed during the exposure. The light parts to the right of the picture may indicate that he has moved a white piece of paper or the like in front of the lens before closing it.

147

On that occasion Munch was unusually bitter about the way he had been treated in *Aftenposten*. In a subsequent interview in another newspaper he said that he wanted to paint a picture 2 × 1 metre large showing how the stinking manure of the distinguished editor of *Aftenposten*, Amandus Schibsted, was spread by his mean assistants over the garden of art. Apart from several drawings of this subject there is a lithographic caricature *Double Rotation Press* (1902), made in the spirit of James Ensor and in the manner of Blix's *Simplicissimus* caricatures, in which the artist himself is seen in the background vomiting, his hat in his hand.

Munch's teacher Christian Krohg followed his pupil's progress attentively, and he supported him in a long article in *Verdens Gang* entitled 'Edvard Munch: An Analysis' on the occasion of the exhibition at Blomqvist's. Krohg maintained that the audience could not accept Munch because they could only accept purely photographic concepts; their minds worked in 'black and white'.

Already by their first criterion, the photographic resemblance with nature, he lets them down to such an extent that there is no question of appreciation by any other criteria.[7]

Perhaps the constantly repeated criticism of lacking 'resemblance with nature', which Krohg referred to, inspired Munch to try out his subjective way of seeing the world with a camera. At any rate the results were quite subjective documents.

A motif representing himself lying stretched out on a bed – in a mental sense castrated – was to be a major theme in Munch's art until his nervous breakdown in 1908. A photograph showing him lying on a bed, hardly visible in the darkest corner of the room, with beer bottles lined up on his bedside table (147), may be one of the photographic models used for the theme he later called *Marat's Death*.

There are so many similarities between this and the other photographs Munch took in the autumn of 1902 that it makes sense to suppose that they were taken at approximately the same time. They have the same framing and similar colouring and have been printed on the same kind of paper. Also the peculiar lighting – especially to the right on this photograph – indicates a similarity of technique. Perhaps Munch also in this case passed a white paper or the like in front of the lens during exposure. The fact that he printed two photographs reveals his interest in the subject and makes it clear that he had experimented during the printing process. Munch's fingerprints, evident in different places, reveal the marks of his own activity that arose during printing.

In the photograph Munch lies like a shadow, wrapped in the white sheet, staring out into the room towards the camera. Such a photographic subject has the same predecessors in the history of photography as, for example, Degas's photographs taken in half-light at Mallarmé's, which were experiments Munch undoubtedly knew of. The melancholy mood of this photograph has, however, an introverted touch, indicating that the artist deliberately used the photograph to document his situation.

In the album that contains the photographs from Blomqvist's there is another shot of both photographic and iconographic interest containing the following words, written in the hand of Munch's sister Inger: 'Window in Pilestredet. Photographer: Edvard Munch', and on the back of the photograph: 'A swan on the wall' (148). Such a 'swan' can be distinguished with a little effort on the wall to the right, just below Munch's own fingerprint.

The swan is an often repeated symbol in Munch's art from the 1890s. The artist has to dive down into life's filthy depths, while the ideal of art, the swan, stays pure. The lighting in this peculiar photograph has been achieved either by means of double-exposure or by Munch's having moved the camera slightly during exposure. In this way the blurring, which gives the subject a strange, intense and anxious touch, can be explained technically. But it was here in 30b

148. This may be Munch's most peculiar photograph. It is taken in the yard of 30b Pilestredet, where the family was living when Munch's mother died at Christmas 1868. The atmosphere of fear is understandable. On the back of the photograph Munch has written, 'A swan on the wall'. Using one's imagination the beak of a swan may be seen as a shadow on the lower part of the wall at the right-hand side.

148

149. The entrance door and the windows to the family's apartment in 30b Pilestredet. The photograph was also published in Jens Thiis's fine biography of Edvard Munch in 1933. The photograph has a close resemblance to Eugène Atget's documentary photographs.

150. The entrance to 30a and 30b in Pilestredet. The Munch family lived in both places, first facing the yard in 30a (1868–73) and then facing the street in 30b (1873–5).

149

150

Pilestredet that Munch's mother had wasted away and died when he was five years old; these were painful memories of his childhood that were to become basic themes in his art.

At the same time Munch took two photographs of the entrance to his childhood home. One was taken at an angle at relatively close range concentrating on the entrance and the windows on the floor above, where the family lived (149). The other was taken from the opposite side of the paved street showing an unidentified elderly couple talking together in front of the gateway (150). The empty street in the foreground and the windows with the white curtains in the background bring to mind many of his paintings, from *The Storm* and *Evening on Karl Johan Street* to *Virginia Creeper*, in which the windows literally 'gaze' out into the picture space.

The matter-of-fact manner in which Munch chose these subjects and the manner in which he, so to speak, emphasized sections of the façade relate to the unpretentious photographs from little-known parts of Paris by Eugène Atget, who was active for several decades. His photographs were highly esteemed by the painters of Montmartre, where Munch, too, had a studio around the turn of the century.

Munch also photographed the back garden where he played as a child. The photograph expresses a very melancholy mood through the bare trees and

scattered dead leaves on the ground (152). Far later, in the 1930s, he used the same scenery for a study of himself as a young man, sitting on a bench with his doomed sister (151). The scattered dead leaves in the photograph also relate to the watercolour *Madonna in the Churchyard* (1896) and the painting *Inheritance* (1897–9), in which dead leaves are strewn over the woman's skirt.

These photographs from his childhood home in Pilestredet convey a realistic attitude which also recalls Heinrich Zille's photographs, taken in the years 1895–1910, of unpopulated street scenes and back gardens in Berlin.

A photograph from the same period shows his aunt Karen Bjølstad sitting and his sister Inger standing in front of his childhood home at Olaf Ryes Plass, where the Munch family had lived in 1882 (153). The bare trees of the park suggest a cold autumn mood. The cornice of the building in the background marks the ground floor entrance to the pharmacy in the house where the family had rented a flat on the floor above. The foreground, a greyish oblong expanse, which takes up a third of the picture space, frames and unites the two women into one silhouette. The best explanation for the expanse in the foreground is that the camera has been placed on the opposite wall at the side of the steps from that upon which the aunt is sitting. As the camera must have been

151

151–2. The photograph depicts the back garden of 30b Pilestredet, where the crystal clear details of the autumn leaves and the bare trees contribute to an atmosphere of melancholy. Munch used this back garden as a model for a series of drawings from childhood memories, in which he shows himself as an overgrown thin lad in too narrow clothes sitting on a bench with a slim young girl, who is leaning against him, presumably his mortally ill sister, Sophie (151).

152

153-4. In the photograph his aunt Karen Bjølstad and his sister Inger are sitting on the steps in front of 2 Olaf Ryes Plass. From 1883 to 1885 Munch's family lived at 4 Olav Ryes Plass. Munch has placed his camera so far over on the opposite wall that it has created a pale grey shadow in the foreground which artistically unites the two female figures in a common form, an analogy to the two female figures in the woodcut *Two Women on the Beach* from 1898 (154).

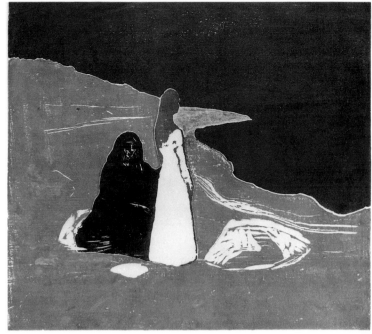

154

placed far from the edge of the wall, there is good reason to believe that the effect was calculated. The same effect, although not quite as exaggerated, could be seen in Munch's first self-portrait photographs sitting on his trunk in Lützowstrasse (130–1). And calculated uses of shade as a means of composition are found not only in Munch's art but in paintings and photographs by artists such as Pierre Bonnard and Edouard Vuillard.

The shape created by the figures of the two women in Munch's photograph relates to a similar closed form of the same models in the painting *Mother and Daughter* (1897) and in the woodcut *Two Women on the Beach* (154) from 1898. Munch also seems to have wanted to try out in photography this silhouette-like common shape, which has antecedents in Japanese and Chinese art. He had also used such a shape

earlier in the subject *Death in the Sick-Room* (64) and developed it in the fusion of the figures of the mother Åse and Solveig in the poster for Ibsen's *Peer Gynt* at the Théâtre de l'Oeuvre in Paris. Later Munch went to see his childhood homes at Pilestredet and Grünerløkka at regular intervals in order to 'wander about' in the memories of his own upbringing.

In a photograph from an unidentified yard Munch positioned his latest version of *Girls on the Bridge* (1902), which is a good example of his new vibrant use of colour dating from the start of the century. It is a neutral, almost anti-romantic, photograph, and it is strange that Munch wanted this painting photographed in these surroundings. Was it to prove how his new use of colours had an explosive effect in an architecturally neutral and impoverished environment?

In the first half of November 1902 Munch went to Lübeck in order to make a series of graphic works for the eye specialist Max Linde. The series was to depict Dr Linde's house and family. During Munch's visit Linde finished his well-illustrated monograph *Edvard Munch and the Art of the Future* (1902), printed with several colour illustrations using different advanced techniques. Before Linde contacted Munch in Berlin, on Albert Kollmann's initiative, he had acquired some very important sculptures by Auguste Rodin for his large collection of modern art. So it

153

155

155. Edward Steichen's photograph of Auguste Rodin, 1901, printed in *Photographische Rundschau* (1902). Ernst Juhl, who was responsible for the wonderful reproductions of Steichen's works in *Photographische Rundschau*, later lost his position partly because he favoured such a controversial artist as Steichen, but also because he wanted to promote 'amateur' photographs taken by artists instead of technically superior photographs by professional photographers.

156. The photograph for this book cover was taken by an unknown photographer at Dr Linde's in Lübeck in December 1902. The marks around the head have probably arisen by scraping on the negative plate during retouching. By referring to (157), the thin oblong object under the tie can be identified as an etching needle.

157. Edvard Munch in Dr Linde's garden in Lübeck in front of one of Rodin's sculptures apparently sketching a subject directly on to the copperplate.

157

was natural that he would compare Munch with Rodin.

On the front cover Munch is portrayed in half-profile (156), and the plate has been marked in a mezzotint-like manner in the same way as it can be observed in the highly fashionable American painter and photographer Edward Steichen's portrait of Munch's relative and teacher Fritz Thaulow (1901). The thin object appearing in the right-hand lower corner must be an etching tool which Munch is holding in his hand. A contemporary photograph of Munch clarifies this (157). Here the bandaged left hand with its damaged fingers is emphasized by being placed in the foreground.

156

158. In Edward Steichen's *Self-Portrait* from 1901 we see that Steichen has made scratches in the glass plate so as to give the photograph the character of a graphic work, as did the unknown photographer in the portrait of Munch in (156). Steichen's *Self-Portrait* also reminds us of Munch's *Self-Portrait with Brushes* (110).

158

Behind Munch is Rodin's sculpture *The Age of Bronze,* just as the sculpture of Victor Hugo is seen dimly behind Rodin himself in several of Steichen's famous portrait photographs of him.

It is possible that this photograph of Munch was intended as a symbolic portrait of the artist for the front page of Dr Linde's book, a portrait photograph which, like the text, seeks connections between the works of Munch and Rodin. Munch's pose is fascinatingly similar to Steichen's pose in his by then well-known photograph *Self-Portrait with Palette* (1901).

It is sensible to suppose that Steichen's photographs were an inspiration for Munch's experiments with creative photography. In September 1901 five of Steichen's photographs were shown in *Art et décoration,* and in the spring of 1902 eleven of his major photographic works were printed as a full-page art supplement in *Photographische Rundschau.* The photograph which was most thoroughly discussed in the text was, apart from *Self-Portrait with Palette,* the portrait of Auguste Rodin with the marble sculpture of Victor Hugo seen dimly in the background (155). Ernst Juhl wrote about this: 'It is as if you were looking at a technically perfect, graphic print in mezzotint.'[8]

Among the other printed photographs was the portrait of Fritz Thaulow, who had introduced

Steichen to Rodin, and the portrait of the painter Alphonse Mucha in front of one of his works. Mucha was himself an experimental artist and photographer, who moved in the same circles as Munch in Paris towards the end of the 1890s.

Edward Steichen, who was twenty-four years old, had ten photographs accepted for the graphics section at the Paris Salon in the spring of 1902, and submitted several paintings as well. Even if this acceptance was later sabotaged by the hanging committee, this incident showed that photography was beginning to be accepted as a graphic medium in line with etching, lithography and woodcut. It does not need further comment to see that Munch, who had already created masterpieces in the other graphic media, would try this new modern medium. Munch took some photographs himself during his stay in Lübeck, which is also documented from a letter at the beginning of 1903 from Dr Linde to Munch:

Your amateur photographs are excellent. What a shame you forgot to roll the film on, because now Danaide and Burgthor are on the same negative.

The double-exposure photograph mentioned by Dr Linde is lost. The Danaid refers to a sculpture by Rodin in Linde's large collection, which Munch etched in one of the Linde portfolio etchings. Burgthor, the famous sculpture on the gate to the

walled Hanse town of Lübeck, is also in one of the etchings from the same period.

Among the photographs preserved from Lübeck is one of the city hall and another of people strolling about, probably taken in one of the many parks in Lübeck. Both photographs are snapshots, with an empty foreground and sloping lines, which are elements that will appear in several of Munch's landscapes in the following years. Another snapshot, taken in Dr Linde's house, shows Munch's painting *On the Operating Table* (1902–3) in which the artist is lying naked while the revolver bullet which damaged his left hand is being removed. The photograph was taken from an angle that emphasizes the painting's perspective with its strong foreshortening of the naked body.

Among those amateur photographs which Dr Linde mentioned may also have been the one showing Linde with his sons and two maids at the garden side of the house (159). The photograph has the typical characteristics of a snapshot; only the maids seem to be aware of being photographed. It was the ability to photograph instantly in the sunshine that made the natural atmosphere and the casual poses possible. Both a lithograph and an etching from the Linde portfolio show the same part of the garden, but they are deserted, like night photographs without actors other than Rodin's sculptures.

159

160

There is no resemblance between the pose of the children in this snapshot photograph and the way Munch depicted them in his famous group portrait *The Four Sons of Dr Linde's*, which he painted a short time afterwards. But there are less well known paintings of children in Dr Linde's garden, which show the way children group naturally during their everyday play.

161

One has to be just as cautious about a photograph of Linde in front of the same door as seen in the painted portrait of him. It is not known when Munch took the photograph – before or after the painting, or for that matter the many graphic portraits of his first important patron.

Whereas the painting *On the Operating Table* reflects the real operation on his damaged hand, the painting entitled *Fisherman in a Green Meadow* can be seen as a contemporary paraphrase of the same theme. A Tolstoy-like character, marked by life, stands in a frozen pose against a greenish background. The red blood on the bandaged hand contrasts with the green background. Munch seems to express the essence of his own situation via this figure: wounded, but in his prime.

This painting is centrally positioned in a photograph taken in one of the rooms of Paul Cassirer's fashionable art salon in Berlin (162). The proprietor, who stands in an elegant pose in front of a van de Velde sofa, was the art dealer who stood out from the others as the main presenter of the new avant-garde art. To the right in the photograph, on the wall, is the painting *Melancholy* (1900), which shows Munch's insane sister Laura sitting hunched up in a static pose in a corner of a room. It is hardly a coincidence that Munch shows his own depression and loneliness, both in photography and in painting, as a

figure sitting hunched up and lonely in a bare room.

The selection of paintings and graphics on the walls indicates that this was taken in January 1903, when Munch was preparing for his exhibition, which went on to Cassirer's showrooms in Hamburg some months later.

From this period – also on the initiative of Linde – Munch developed a colourful and optimistic style of painting that could embellish the light walls of modern architecture of the type designed by van de Velde in those years. One epoch was ending and a new one was about to start.

Dr Alfred Lichtwark, who was director of the Kunsthalle in Hamburg and a friend of Dr Linde, was at this time occupied in advancing the prestige of photography. In many people's view he had profaned this most respectable museum by holding annual exhibitions of photography from 1893 and for a decade thereafter. Dr Lichtwark believed that the renewal of painting would come from amateur photography. He was, moreover, an admirer of Munch's art, and Munch most likely knew of his ideas.

Photographs taken in Munch's garden at Åsgårdstrand in the summer of 1903 show him with his latest paintings. Munch was apparently preparing for the big exhibition at Blomqvist's in September. In one of the photographs the artist is wandering in the garden, wearing a dark,

broad-brimmed hat, among some unfinished paintings, such as *Women on the Bridge* and *Four Girls at Åsgårdstrand* (165). In another photograph some of his other recently begun works are placed against the studio wall and among the trees and bushes.

There are also two prints of a photograph in which Munch stands naked, with his right hand stretched out towards the light and his left hand, clenched, resting at his hip, against a background of dense vegetation (166). His body is pale, but his face is tanned from the sun. His hair is relatively long compared with his crew-cut the following year. So it is likely that the photograph was taken that same summer of 1903. The contrast be-

tween light and shade and the position of his arm akimbo establish the connection of the photograph with the self-portrait he exhibited at Blomqvist's that same autumn, which later became entitled *Self-Portrait in Hell* (167).

Munch's new position on the Continent was clearly marked by the invitation to go to Germany to paint a portrait of Harry Graf Kessler, who was director of both the Academy and the Ducal Museum in Weimar. Together with van de Velde he was working to initiate a new renaissance in German art. In the portrait Graf Kessler is seen in front of a bookshelf in his study. The brushwork in this portrait probably results from the

sitter's own interest in and theories about pointillism as an important force in modern art.

Furthermore, the painting has captivating similarities with André Derain's and Matisse's pointillist works, their so-called pre-Fauvist paintings from the summer of 1904. A photograph of the finished painting documents this important commission for Munch, which was to pave the way for many future portrait commissions.

During the summer of 1904, which Munch again spent in Åsgårdstrand, he made frequent use of the camera. He was working on the frieze for the children's room at Dr Linde's home, but primarily he was painting a huge

162

163

164

165

164. Beginning in the 1880s, when Munch was given a boat by his grandfather, Andreas Bjølstad, he was an eager sailor. Through the years he would own a number of boats. Here his is probably seen at Åsgårdstrand in the summer of 1903.

165. Munch among his paintings in the garden of his small house at Åsgårdstrand in the summer of 1903. To the left can be seen the beginnings of *Women on the Bridge,* and to the right the Munch Museum's version of *Four Girls at Åsgårdstrand.*

166. The way Munch is posing in the photograph, naked and with his right hand stretched out towards the light, was to become a theme he employed in painting as well as lithography. In photographic literature this nude pose is found from the 1890s onwards as a symbol of photography seen as the art of light. Munch's highlighted torso, contrasting with the dark background, leads to *Self-Portrait in Hell.*

167. *Self-Portrait in Hell*, 1903, reflects, and is reflected in, many posed photographs Munch took in Åsgårdstrand in the summers of 1903 and 1904. Among other things, a comparison with these photographs shows that the contrast between his reddish face and his pale body is due to the fact that his face is sunburnt – even if he has used this fact to create a particular expression of fear.

166 167

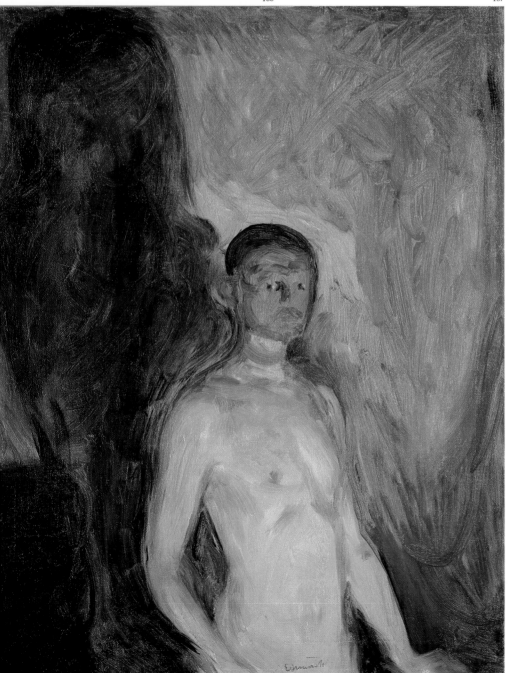

picture of bathing men (which after Munch's death was entitled *Bathing Boys*); this was for Munch's part probably intended for the ducal collections in Weimar, where such large canvases were among the most desirable. There are two photographs of Munch naked in the sunshine (168–9), one full-length, another cut off at the waist, and both of clear resemblance to the foreground figure in the painting. The unfocussed object in the foreground indicates that the camera had been placed on a table.

A photograph of Munch's friend and relative Ludvig Ravensberg also shows him with a naked torso (170). This is probably a model study for the above-mentioned painting and, as in the other photographs, the trees and bushes in Munch's garden are seen in the background. Ravensberg also appears in two other photographs: one with Munch and an unidentified person in front of the large, as yet unfinished, bathing subject (171); the other in which he looks out from behind the edge of this painting (173).[9]

Christian Gierløff wrote about that summer:

The sun had been scorching all day, and we just enjoyed it. Munch painted for a short while on his bathing scene; but most of the day we were lying down, overwhelmed by the sun, in deep sandpits at the edge of the water, between the big stones, absorbing all the sun we possibly could. Nobody asked for a swimsuit.[10]

115

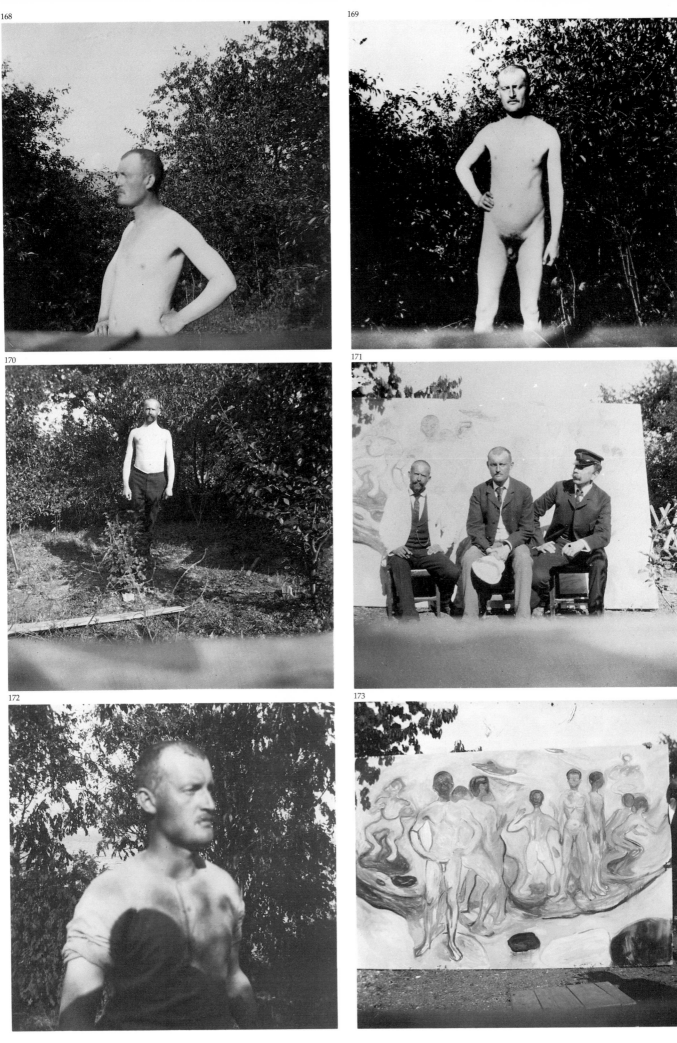

168–9. Nude self-portrait taken in the garden of Åsgårdstrand, 1904. The short hair can be explained by a military fashion: an outcome of sabre rattling in Norway in 1904, the year before the Union between Norway and Sweden was dissolved. The photographs are probably model studies for the painting *Bathing Boys* (173), which Munch painted that summer.

170. Munch's friend and relative Ludvig Ravensberg, Åsgårdstrand 1904.

171. Munch with Ludvig Ravensberg and an unidentified person in front of the painting *Bathing Boys*. The painting, part of which is visible to the left, is from the Linde Frieze.

172. Munch in a workshirt in the front garden of the house at Åsgårdstrand. Ludvig Ravensberg may be the one who held the camera, in which case it is his shadow on Munch's shirt.

173. *Bathing Boys*, 1904, photographed in the front garden of Munch's house at Åsgårdstrand. Ludvig Ravensberg can be seen standing at the right of the canvas.

174. This peculiar self-portrait is taken in Munch's small house at Åsgårdstrand. The camera catches Munch's blurred profile against a clear and detailed background. The composition seems deliberately calculated, a kind of self-expression for the artist. Munch used the same effect later in, for instance, *Man and Woman II* (255), where the figure of the man in the foreground is blurred and dissolved, whereas the woman in the background is in focus.

The model for the main figure in the bathing scene seems to be Munch himself, judging from the photographs, yet depicted without any portrait likeness. *Bathing Boys* can thus be considered a development of earlier nude self-portraits such as *Self-Portrait with a Lyre* (1896), *The Flower of Pain* (1898), *Golgotha* (1900), and *On the Operating Table* (1902).

One of the nude photographs preserved seems to be the one Munch mentioned jokingly in a letter of 23 June 1904 to Ludvig Ravensberg:

When I saw a photograph of my body in profile I decided after consulting my vanity to prolong the time spent tossing stones, throwing the javelin and bathing.

In this 'photograph in profile' (168) Munch poses in a manner similar to that in *Self-Portrait in Hell*, which, however, according to the newspaper review, was completed the previous year. In the photograph Munch is seen with a pale body, but suntanned face and crew-cut hair, against a bushy background. The special light in the painting, coming from below, parallels the effect of this photograph in which the sunlight is probably reflected from some bright or shiny plate. The tense atmosphere of fear is, however, expressed only in the painting.

Self-Portrait in Hell might as well have been Munch as 'Adam in

174

Paradise' instead of 'The Artist in Hell'. The portrait's expression of fear might in that case have related to the fear Adam felt through being put into a close relationship with nature; this was a central theme in Søren Kierkegaard's philosophical work *Angst*, a work which in many cases was an influence in Munch's art.

One of Munch's most fascinating portrait photographs, taken indoors at

Åsgårdstrand, also probably dates from this summer, as Munch has the same short haircut as in the previously mentioned photographs (174). He is photographed in profile in a close-up which has made his features indistinct. The camera was probably positioned on a table at the foot of the bed. Although the window was covered with a curtain, which moved a little during exposure, the fact that the

175. The portrait of Ingse Vibe, 1903, may have been painted behind the railing seen in the background of (177).

176. Cabinet photograph of Ingse Vibe, provided by the Vibe family, corresponding to Munch's portrait painting of her.

177. Ingse Vibe was a very sought-after young woman who spent her holidays at Åsgårdstrand at the beginning of the century. She is here embroidering a rug, surrounded by unidentified friends. When Munch once slapped her bottom in public because she was making fun of him, he was confronted by a crowd of indignant youngsters, and that was one of the reasons he left Norway immediately in the summer of 1905.

178. Edvard Munch with an unknown young woman in front of the studio in the garden at Åsgårdstrand. Perhaps she was the model for the young woman in *Dance on the Shore*, 1904, which can be seen to the right of the photograph.

179. The painting from the so-called Linde Frieze in Munch's garden at Åsgårdstrand, probably set up as part of his planning for the great exhibition at Blomqvist's in the autumn of 1904. The central painting, *Dance on the Shore*, was later painted over twice. Without this photograph we would not know what the original painting looked like. The two canvases with paintings of flowers at either side have subsequently disappeared. We can see them, however, in the photograph from Cassirer's in January 1907 (188 and 189), where they were hung at either side of a version of the same theme for the Reinhardt Frieze.

177

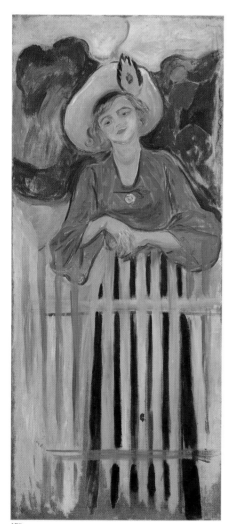

175

176

the 'poodle', Sigurd Bodtker, while the 'enemy', among others Tulla Larsen, and 'the frog', Gunnar Heiberg, are applauding in the background.

Munch clearly wanted to comment on his own situation by means of private iconographic symbols, which is something that also characterizes his other autobiographical works. The lighting and the almost aggressive close-up effect create a peculiar relationship between the figure and the interior. The hazy, indistinct expression relates to the famous contemporary American photographer Alvin Langdon Coburn's portrait

picture was taken against the light has created varied and fascinating lighting effects. On the wall, above the wonderfully carved chest which Tulla Larsen had given him, is a lithographic caricature, dated 1903, from the series *The Bohemian's Heroic Deeds*. It shows how Munch was attacked by

photographs from the same year. His portrait of Gilbert K. Chesterton, for example, was described by G. B. Shaw in 1906:

You could say that the head is not placed correctly in the picture space, that the focus is not right, that the exposure is wrong, if you wanted to, but Chesterton is right, and it was a genuine picture of Chesterton Mr Coburn wanted to make.[11]

These words could also be applied to Munch's self-portrait. Such close-up portraits were in vogue; for instance, Strindberg, assisted by a professional photographer a couple of years later, cultivated similar deliberately unfocussed portrait photographs by means of his self-made 'Wunderkamera'.

The clear pose in profile, the indistinct features, and the total effect from having photographed against the light in Munch's self-portrait relate to other self-portraits, for example, a painting which Johan H. Langaard entitled *In Profile to Life* (c.1904).

Another photograph showing four figures seated on a lawn is probably also from Åsgårdstrand (177). The fair young woman in the middle, who is embroidering, is Ingse Vibe, one of the most sought-after young women at Åsgårdstrand. Munch painted a full-length portrait of her, in which can be

recognized the hat, the fair hair underneath, and her charming light smile (175). A photograph that corresponds to the painting has been preserved by Ingse Vibe's family (176).

A correct exposure characterizes a well-composed view from the shore showing the stones and the bathing hut (180). As in the paintings of the beach from 1904 and 1905, it is no longer the curving line of the beach

that interests Munch, but fresh nature bathed in light and air.

Two other photographs from Munch's garden are probably from the autumn of 1904, just before the opening of the exhibition at Blomqvist's on 16 October. We know from the exhibition catalogue that the paintings in the photographs were exhibited. The photographs, both characterized by the same high foreground and the same dense build-up of space,

complement each other. One shows three paintings from the so-called Linde Frieze placed against his studio wall, focussing on the central couple in *Dance on the Beach* (179).

In the other photograph Munch and a young woman can be seen as a paraphrase to this couple, standing arm in arm amid Munch's paintings (178). The young woman was probably the model for the young fair-haired woman in *Dance on the Beach*, to the right in the photograph. There is nothing flattering in this anti-romantic depiction of the artist and his model. Munch is photographed in his work clothes with his left hand bandaged just like the man in the painting *Fisherman in a Green Meadow*. The earlier damaged fingers are protruding from the bandaged 'fatal hand'. This could hardly be the result of the shooting incident in 1902, but must be a new injury. In August 1904 Munch had been in a fight with the author Andreas Haukland in Copenhagen, and this may explain the re-bandaged hand.[12]

From the exchange of letters with Ludvig Ravensberg we know that Munch still carried his small Kodak camera around during these years. He would often forget it in cafés and restaurants. In the autumns of 1904 and 1905 he asked Ravensberg to help him find it and wrote on 9 December 1904:

I forgot to tell you to prepare yourself for a cruise around looking for the Kodak camera, the Andreas Aubert

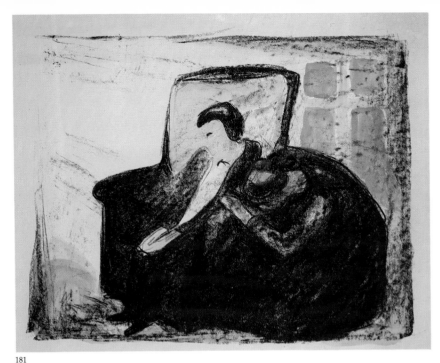

181

182

180. *Beach at Åsgårdstrand*. During the summers of 1904 and 1905 Munch painted a large series of beach studies characterized by strange colours among which the red tones were especially dominant.

181. In 1906 Munch worked on a set design for the performance of Henrik Ibsen's *Ghosts* for Max Reinhardt's new Kammerspeil in Berlin. In the last scene where Oswald says 'Mother, give me the sun', he seems, according to Ibsen's stage direction, 'to shrink in the chair'. Munch intepreted the scene in several paintings and drawings. This lithograph, which is entitled *Oswald*, is from 1920.

182–3. Photographic self-portrait, taken in an unidentified room of spartan furnishing with an untidy bed in the background. The chair, whose image shows through the figure of the artist, as well as the cloudy atmosphere around him, show that he has moved during exposure. It is not an ordinary double exposure. Munch has developed a normal print and a reflected image of the subject. The normal print can be identified by the fractured left hand. Certain clues, such as two circles in the foreground of the normal print were probably caused during the developing. We are led to believe that Munch was fascinated by such coincidences just as he was always anxious to retain artistic expressions that appeared accidently. The pose and the melancholy mood reappear in *Self-Portrait with Wine* (187).

183

184. *The Son*, 1902–4. The painting depicts Munch's alter ego sitting on a settee against a cushion. Behind the artist's head there is a red shadow, not unlike the one found behind his head in (187), but here it binds him symbolically to the family portraits which we know from (12). The painting is also present in (178), and might have been exhibited for the first time at Blomqvist's in the autumn of 1904.

185–7. Together with (183) these two photographic self-portraits elucidate the painting *Self-Portrait with Wine Bottle*, painted in Weimar in 1906. There are many similarities: the atmosphere of melancholy, the weak posture, the feeble hands, and the room pressing around the artist. The misty air in the photograph also has a corrolary in the painting, especially in the blood-red shadow which forms an irrational frame around the head and which, besides being expressive, may remind one of the occult 'aura' patterns and ideas. While the photographs have a rather low vantage point, due to the low siting of the camera, the perspective horizon of the painting lies in the upper frame, which may indicate that the subject was studied through a mirror. The feeling of loneliness is reinforced and even more desperate in the restaurant surroundings, where the waiter, the other guest and the still life with food convey symbolic overtones like those of a dream.

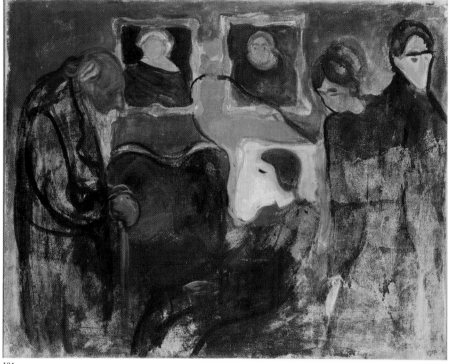

184

books, and God knows what! You will have to console yourself with dinners and cigars.

Most likely two expressive self-portraits, taken in unknown interiors, are from this or the following year. In the first photograph Munch is sitting half-dressed on a stool, his left hand on his thigh (182). His damaged, shortened finger is quite obvious – this was to him the symbol of his despair and loneliness during these years.

Behind him is the bed, an element from several of Munch's paintings usually expressing death and fear, such as in *Death in the Sick-Room* and *Puberty*. The interior behind the artist partly shines through him, which contributes to the touch of unreality. The effect can be explained by Munch having used an automatic shutter and – after an exposure time of around 30 seconds – having got up from the stool to interrupt the exposure. The same effect might also have been obtained if Munch had moved quickly in a co-ordinated manner in and out of the field of vision. To my knowledge there is only one other similar self-portrait among contemporary experimental photography,

namely, one by Alphonse Mucha, taken in America in about 1905, in which Mucha most probably also exploited the time exposure and got up to interrupt the exposure. Alphonse Mucha belonged to the same circles in Paris as Munch at the end of the 1890s, and they might have found their inspiration in the same sources.[13]

Munch's pose in the photograph, the weak position of the body, the pendant hands, and the resigned expression relate invariably to *Self-Portrait with Wine Bottle* (187) painted in Weimar in 1906. In the photograph, as in the painting, the narrow room seems to press around the artist, emphasizing the sensation of unease. Just like the red patch behind the head in the painting there are two irrational circles in front of the head – two spots which were probably caused by Munch's spilling the chemicals.

It is impossible to say whether the photograph was the basis of the painting or vice versa, but it can at any rate be said to be the pictorial expression of – as Munch himself stated (to Ravensberg in August 1905) – 'the small hell which has been pleased to take possession of my inner mind'.

Munch also printed a reversed copy of the photograph, also marked by spilled chemicals during printing (183). He was later to print other negatives both right way round and reversed, showing that he deliberately experimented in this way with his subjects.

In a later period – in Kragerø around

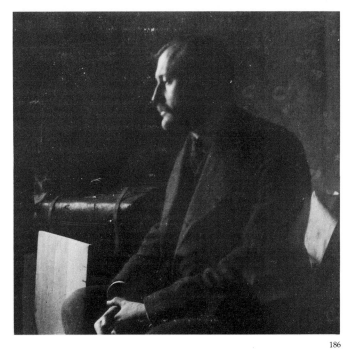

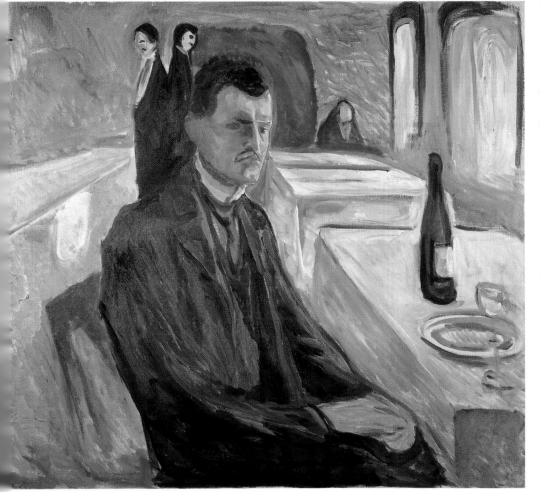

185

186

187

1910 – Munch is known to have studied his own paintings in a mirror. To Munch it was most likely the proof of a satisfactory composition that a picture was well balanced in the reverse as well. In a similar manner Munch would reverse his subjects from drawing or painting in his graphic works. When Munch drew the subjects on to the graphic plates the prints were automatically reversed. There are, however, subjects that are executed in both a normal and a reversed version in the same graphic medium, such as the woodcut *Melancholy* (1896 and 1902). The many evocative, multicoloured versions of this print seem directly inspired by the indistinct prints that characterize double-exposure photographs or photographs produced from overprinting several negatives.

The self-portrait as a lonely person sitting in a sombre interior is repeated in two other photographs, for which Munch probably used an automatic release and got up to stop the exposure. In both photographs he is sitting in a relatively dark room, possibly a hotel room, looking towards the light filtering in through the windows (185–6). The room is filled with objects, which contributes to the claustrophobic feeling of the photograph. This dense atmosphere pressing in on the artist relates again to the manner in which the room is pressing in on him in *Self-Portrait with Wine Bottle* bringing about an intense impression of melancholy and hopelessness. The trunk in the photograph has the same function as the table in the painting. In one of the pictures a circle of light is seen on the wall near the window, which was probably due to a reflection in the camera lens. The large hands are central to the composition. In both, Munch's figure is translucent, which contributes to the peculiar atmosphere.

According to Gustav Schiefler's diary from 15 March 1905, Munch described his melancholy: it would overwhelm him on light, beautiful days in spring, when he could not identify with happy people, which caused further depression. In these photo-

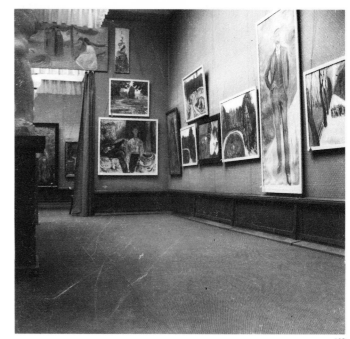

graphs Munch seems to present himself according to the traditional ideas of melancholy. Melancholy was interpreted as the creative mood of the artist in a tradition that leads back to Albrecht Dürer's famous *Melencolia*. Munch also depicted himself in this manner in a painting, *The Son*, in which he is sitting, sick and discouraged, on the sofa, underneath family portraits and surrounded by close members of family.

When, in 1906, he made the stage designs for the performance of Ibsen's *Ghosts* (1883) at Max Reinhardt's new theatre in Berlin, he used the same pose for the draft for the last scene in which Oswald, his health destroyed by congenital syphilis, exclaims, 'Mother, give me the sun!' (181). A note from 1943 makes it clear that Munch, then eighty years old, was quite clear about the symbolism of these photographs:

In the suitcase is a portfolio with the Fatal Destiny Photographs from 1902–1908. Another photograph of me needs to be added: 1943 – the Fatal Hand revealed. The left hand is the crippled. One of the long fingers has been smashed by a revolver bullet.[14]

The photograph that 'needs to be added' must be the one taken by Ragnvald Vaering at Ekely in 1943. Everything indicates that Munch has calculated the effect of the picture, in which he sits with the 'fatal hand'

clearly displayed on his thigh (331); it is a very old man who, fearless but erect, looks death in the face. The same pictorial expression is found in the painting *Self-Portrait at a Quarter Past Two in the Morning* (332) whose real theme is the encounter with death.

The photographs which Munch calls the Fatal Destiny Photographs include the above-mentioned self-portraits, as well as a number of easily datable photographs from Warnemünde in 1907 and from Dr Jacobson's clinic in 1908–9. They are all characterized by an experimental symbolism, in the sense that the artist is more or less transparent against his surroundings. Irregularities in printing have been handled in the same way as in many of August Strindberg's photographs from Gersau in the autumn of 1886.

The Fatal Destiny Photographs are human documents which are a supplement to Munch's many notes from these years. He reflects on 'the spirits from the dead', and on the possibility of experiencing 'another world if our eyes were different'. His many thoughts about life, God and death are to him not theoretical but existential questions. He describes, for example, how he suddenly and 'unconsciously' fired a revolver, which is understood as a kind of answer to his Faust-inspired question:

Are there or are there not powers which rule over us – Is there a God or isn't

there – So I shouted into the room – Are there powers I can talk to, then answer me.[15]

It could also be said that the above-mentioned photographs, in which Munch is sitting in a dimly lit room, might reflect the influence of Spiritualist photography. As mentioned before, the first Spiritualist photograph arose when the graphic artist William H. Mumler took a portrait photograph of himself sitting in a chair in the autumn of 1862.

In his introduction to Symbolism in *Mercure de France* in 1891 Albert Aurier put forward – with reference to Emanuel Swedenborg – the thesis (which Gösta Svenaeus has discussed) that it was now the artist's task to find his theme in Heaven or Hell. So Munch might well have been thinking of Swedenborg when he ascribed the following aphorism to Berlin c.1904 (published in a booklet in 1929):

The camera cannot compete with brush and palette – as long as it cannot be used in Heaven or Hell.[16]

The Fatal Destiny Photographs show, however, that in the years around 1905 Munch experimented with photography by capturing incidents, the recording of which are more than just mere registrations, and that he tried as well to document another dimension in life, his own hell. The Fatal Destiny Photograph are personal documents, in both subject-matter

188–9. When famous, Munch often painted several versions of his themes giving them different titles at different times. It is therefore difficult to identify his paintings according to the limited information in the exhibition catalogues. The only case of which we know when Munch himself photographed an exhibition systematically was at Paul Cassirer's in Berlin in January 1907. The photographs are clear and distinct with a fine grey tone which makes it easy to identify every single painting.

190. Self-portrait from the covered veranda of 53 Am Strom, in Warnemünde. Here, the continual contrast between exterior and interior in Munch's art seems to be eliminated. In front of the transparent head is an easel. The hand with the crippled middle finger is resting on his left thigh. Even if the subject himself appears relaxed and free of the depressive atmosphere in (182), (185) and (186), the peculiar transparency seems to give the photograph an anxious character.

190

and form, commenting on Munch's own situation: his bitterness resulting from the break with Tulla Larsen, and the anxiety and exhaustion from an unsettled life with much night life and alcohol, combined with his disappointment over his lack of acceptance in his own country. Munch wrote in a note from this time:

The artists of a country – the poets – are sensitive phonographs – they have the great and painful ability to record the morals of society – Thus the poets have a primordial power – If an artist is rejected by his own country – the country expels at the same time this electrifying force.[17]

Another set of photographs, on the other hand, merely records Munch's exhibition at Paul Cassirer's in Berlin in 1907, from which almost every work can be identified (188–9). The photographs are clear and distinct with a fine grey tone, even if the light in the rooms cannot have been optimal.[18]

Trying to recover from his hectic life in Berlin, Munch settled down in the summer of 1907 in Warnemünde, a bathing resort on the Baltic Sea. There the lifegiving power of the sun became a major theme in his art and his brushwork became more vital than ever before. A self-portrait photograph shows Munch in a cane chair on the

191

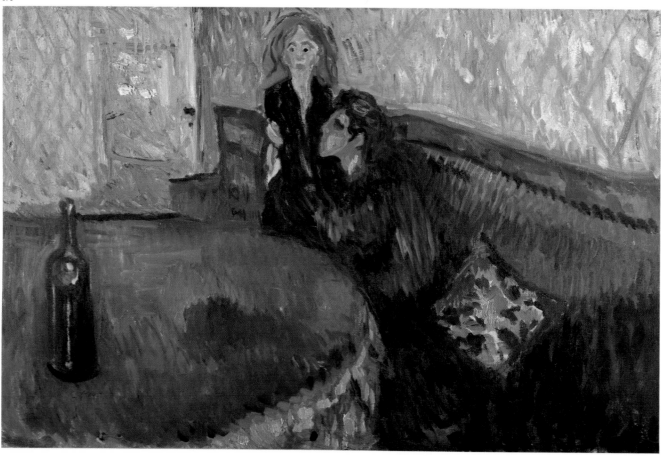

192

192. Munch's housekeeper on the veranda at 53 Am Strom. The severed figure and the stiff gaze seem reflected in *Desire* (191). Stacks of newspapers are piled up on the bench with an edition of the Danish *Politiken* on top; all his life Munch was a passionate reader of news.

193. The manner in which Munch and his housekeeper are almost squeezed into the picture because of the large table with the wine bottle in the foreground brings to mind the painting *Desire*. Presumably, the blurred image of the woman is due to her covering the lens while Munch sat down. His crystal clear transparent head indicates that the exposure must have been interrupted while he moved about.

covered veranda at 53 Am Strom a sea captain's house he rented there (190). He sits in approximately the same pose as in the other Fatal Destiny Photographs, but the contours are much more distinct in the well-lit room. The panelled wall is seen through the artist and the fatal hand is clearly visible, but all melancholy is banished from this photograph. The light flowing in from the left gives the figure strength and power.

193

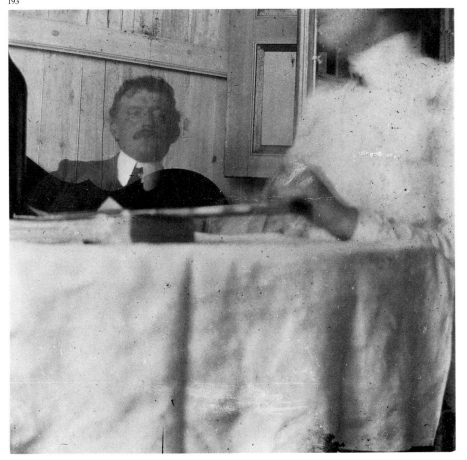

There is another self-portrait taken on the same veranda (193). It can be interpreted as a comment on the bitter series *The Green Room*, paintings on which Munch was working during this summer. He is photographed with his housekeeper, who has probably been seated during the whole of the exposure. The housekeeper seems to hold an object in her hand, which she might have used to cover the open lens while Munch came in and sat down.

This would explain the crystal clear, transparent figure of the artist, whilst the woman, who must have moved when covering the lens, is blurred. Munch has probably set the exposure for a very long time – perhaps as much as a minute.

As in the painting *Desire* (191) there is a bottle of wine on the table in front of the couple. Another photograph shows the housekeeper, stiff and erect, alone at the table (192). Her attitude also relates to *Desire*, in which the woman is almost 'frozen', more occupied by the bottle on the table than by the man.

According to a letter from Berlin of 18 August 1907, Munch sent this photograph to his aunt Karen Bjølstad:

Here is my house (where the arrow is pointing) and I and my housekeeper at the dining table – on the glass covered veranda. She has now left – as I had to go to Berlin for a time – She was, by the way, a really magnificent specimen.

The photograph of 53 Am Strom with 'the arrow' has been preserved, plus two more prints of this subject. Munch stayed in the house with the many small windows to the left in the photograph.

The photographs from the veranda in Warnemünde have a wide-angle effect which was obtained by directing the lens at close quarters on to the table in the foreground with the people in the background becoming relatively small. In the series *The Green Room*

194–6. The photograph shows Munch's model Rosa Meissner, a professional model from Berlin. The fair, ghostlike figure to the left must be her sister, Olga, as the photograph was not a double exposure. The photograph was probably taken in the women's hotel room in the Hotel Rôhne, which had such wallpaper, and where the Meissner sisters presumably were living during their stay in Warnemünde in the autumn of 1907. The photograph was surely a basis for the painting *Weeping Girl*, 1907 (194). A contemporary drawing (195) shows that he already by then had the same idea for the sculpture of the subject, which was cast in bronze in 1932.

197–9. Edvard Munch and Rosa Meissner on the beach at Warnemünde. In (199) Munch seems to have been experimenting deliberately with photographic effects. He probably obtained the double exposure by letting Olga Meissner take two exposures without advancing the film. Munch developed both a correct and a reverse image of this photograph. Also notice his fingerprints, which might be considered his signature.

195

194

(196). There are clothes hanging against the loud wallpaper, and a chamber pot under the bed. To the left is another woman seen faintly; she is dressed in light-coloured clothing and stands with one hand in front of her mouth and the other at her side. The blurring to the left of the nude is best explained by the clothed woman having moved about during exposure, which would indicate that it is a deliberate effect sought by Munch. One of the women is most likely Rosa Meissner,[19] a professional model whom Munch had used in Berlin in 1906 and whom he brought to Warne-

196

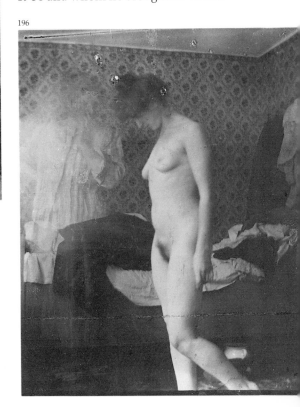

the perspective is defined in the same way, as if Munch had studied the subject through a wide-angle lens. In this manner he found a way to bring the viewer as close as possible to the unpleasant group. The series is probably from a room in the Hotel Rôhne in Warnemünde. The interiors can be seen illustrated on contemporary writing paper. The photographs (taken with an exaggerated wide-angle lens) show that this hotel had the same kind of wallpaper as in *The Green Room*.

Also from this period comes the photograph which has most in common with the already discussed Spiritualist photographs. The subject is a nude woman with bent head, standing in front of an unkempt bed

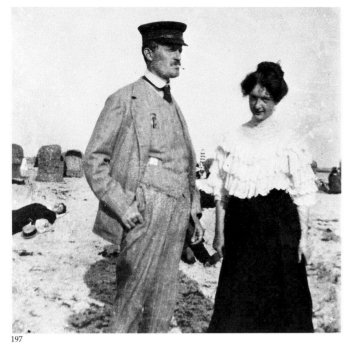

197

198

199

200

münde in August 1907. The other woman is presumably her companion and sister, Olga. The similarity of feature in the two faces can give the illusion of a woman contemplating herself. This photograph evokes an intense atmosphere which makes it one of Munch's major photographic works.

The theme of a woman in front of a bed with bold wallpaper patterning in the background was employed by Munch in the painting *Weeping Girl* (194). In the first version the wallpaper is brown with a greenish area in the same position occupied by the translucent figure in the photograph.[20]

Weeping Girl was also included in the series *The Green Room* together with the painting *Amor and Psyche,* painted using the same technique. *Amor and Psyche* is a rendering of the myth of the woman forsaken by her lover when she betrayed his trust; a theme of both mythical and personal reference. In this context *Weeping Girl* can be seen as the mythical Psyche, obsessed by her love, suffering and distraught in the agony of separation.

As Professor Hans Petter L'Orange has pointed out (in his article 'Amor and Psyche: Eros and Soul'),[21] the figure of Psyche was used as a symbol on Roman sarcophagi, an 'angel of Death'. Munch's first sketch (195) for the sculpture *Weeping Woman*, which was cast in 1932, was probably made in 1907, and it may be seen as a study

for his own tombstone! Because of ill health Munch felt he was dying and wrote several times in his notes sentences such as 'As I am now soon going to die . . .' However, we have to ask which came first, the sketch for the sculpture or the photograph? At any rate the photograph with its ghost-like figure is much more evocative than the similar, but heavy-handed, versions in painting, graphics and sculpture.

Rosa Meissner can be identified in a pair of photographs of the artist and his model on the beach in Warnemünde. In one of these Munch is standing, his thumb stuck in his trouser pocket and a cigarette in his mouth, with Rosa Meissner, shy and demure, by his side (197). Munch's damaged hand is clearly visible; the fact that it appears here as his right hand shows that the photograph is reversed. Munch and Rosa Meissner

130

201. Warnemünde could be described as a German Åsgårdstrand in the years before the First World War. Munch arrived there in 1907 and rented the house to the left in the photograph. The broad main street, Am Strom, where the house was situated, was a promenade for the holidaymakers as well as the people of the town, who were employed in fishing, shipping or the tourist business. In the companion pictures, *Mason and Mechanic* (209) and *The Drowned Child* (210), the background is Am Strom, where we recognize the trees and the characteristic covered verandas.

202. Munch in the hallway of 53 Am Strom. Here he has used the by-now typical effect of transparency in a symbolic manner: the paintings are seen clearly through the figure of the artist. Such a deliberately symbolic representation may have been done with publicity in mind. Showing the artist among his works was in fashion, and Munch had been asked to send pictures of himself at work to the English art magazine *Studio*, and the previous year Karl Scheffler had urged Munch to write down his thoughts about art, life and religion for *Das Kunstblatt*.

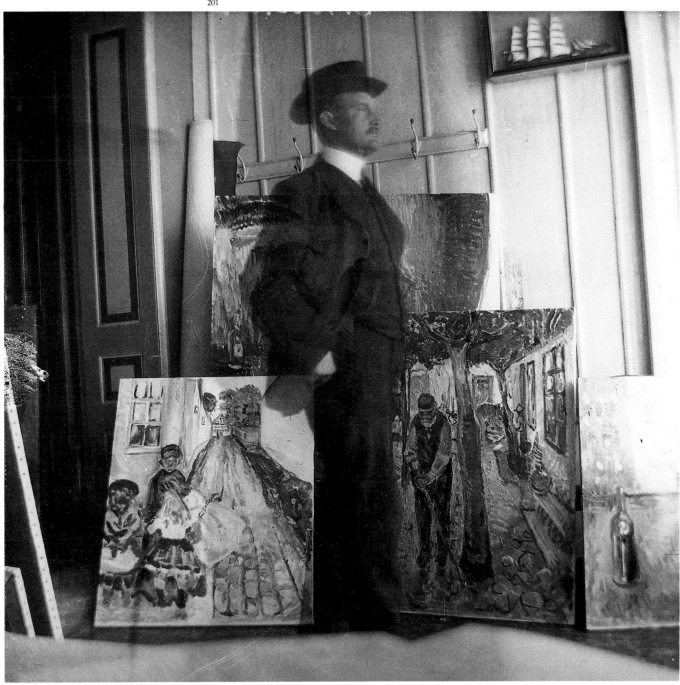

201

202

203

204

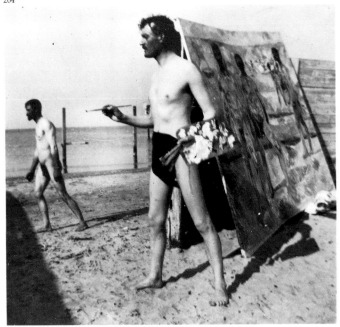

205

206

203–6. Studies in the nude, from the nudist beach in Warnemünde of Munch and one of the attendants who acted as a model for *Bathing Men* (203).

207. A close-up of Munch, here dressed, taken at the same beach in Warnemünde where he painted *Bathing Men*.

208. *Bathing Men*, painted on the beach in Warnemünde in the summer of 1907. The following year Munch had some plans for expanding this painting into a pentych, with two paintings of respectively *Youth* and *Old Age* on either side. The idea was never quite realized, and the result was a triptych. The main painting is today at the Ateneum Taidemuseo in Helsingfors. The transparent figure to the left with his back turned towards the viewer – that figure was, by the way, not yet painted on the canvas when Munch photographed himself at work at the beach (204) – brings to mind the effect of double exposure from photography. A similar style of painting can be seen in the manner in which the dog and the horse have been painted in *The Drowned Child* (210).

appear in another photograph in a slightly altered pose; they appear 'double', which gives the photograph a dreamlike quality. Munch was at this time especially interested in the split personality of man, which will be discussed later on. The double exposure is presumably quite deliberate; he has printed the photograph in both straight (198) and reverse versions (199), clearly fascinated by the possibilities of the subject.

Another photograph, at first glance a failure, has been preserved from the beach at Warnemünde, showing two women sitting on the sand, presumably again Olga and Rosa Meissner (200). They are cropped at mid-torso. This is the only example among all Munch's preserved photographs of such a format. And considering that this was taken by a creative artist of such obvious skill and instinct in calculating composition it is most likely that the framing was intentional.

One of the best-known self-portrait photographs dates from the summer of 1907 in Warnemünde (202). Munch is standing in the entrance hall of 53 Am Strom between the paintings *Children in the Street* (1907), a subject from the alley by the side of the house, and *Old Man in Warnemünde* (1907), painted in the picturesque back garden. Behind him is a newly begun version of the subject *The Sick Child*, a commission from his Swedish patron Ernest Thiel. Here Munch has utilized the effect of transparency in such a way that his

208

perhaps most personal subject is seen obscurely through the translucent figure of the artist. The artist's identification with his subject which the photograph expresses is articulated by Munch in a letter to Theil sent from Lübeck on 6 August 1907: 'The Sick Child is being painted by a sick painter.' Munch's right hand is resting in his trouser pocket. The damaged left hand is not seen, but judging from the attitude it covers the exact point in *Sick Girl* where the models, repre-

senting his dead mother and sister, are holding hands to comfort each other. Does this overlapping of images relate to Munch's own words?

In the same chair as I painted the sick child both I and all my loved ones – from my mother onwards – sat through long winters – sat longing for the sun – until death took them.[22]

This photograph can also be interpreted in another fashion: Munch, in

209. *Mason And Mechanic*, 1908. The light and the dark male figures were from then on to become a fixed symbol in Munch's art. The surroundings are Am Strom where Munch stayed in the summers of 1907 and 1908.

his prime, though marked by life's experience, is standing between childhood and old age, represented by the two paintings, *Children in the Street* and *Old Man in Warnemünde*. This symbolism of the ages of man reappears in the triptych *Bathing Men*, begun in Warnemünde in the summer of 1907, in which the side panels, painted the following summer, show respectively youth and old age.

While working on the massive central panel Munch took a number of photographs of himself and his models, probably as studies for the bathing scene. Two of the photographs are full-length nudes of himself, seen from the front and the back (205–6). In a third he is standing next to the canvas, his brushes in his hand (204). The 'loin cloth' was earlier interpreted as retouching, but a closer look at the photograph shows that it is tied at his hip.

He directs his models, the bathing attendants, as a stage director does. (Munch had worked on stage design for Max Reinhardt at his new Kammerspiel Theatre in Berlin in the winter of 1907.) Whereas *Bathing Boys* from 1904 was painted in a somewhat formalized Art Nouveau fashion, *Bathing Men* from 1907 stands out as realistic and direct, a Nietzsche-like apotheosis of the vital man (208).[23]

The photographs in which the naked bodies stand like sculptures on the beach may well have contributed to Munch's new style. And his exper-

iences from double exposure may as well have influenced his manner of painting. The figure at the left-hand bottom corner, with his back turned, is looking into the picture space towards the three, rigidly frontal, men who have just emerged from the water. He is quite transparent and therefore relates to Munch's experiments with double exposure photography. His body is almost dissolved in the sunshine, appearing as immaterial in contrast to the others, who are filled with substantial power and vitality.

As when he worked on the large bathing scene at Åsgårdstrand in 1904, a close-up photograph of Munch outdoors was also taken in Warnemünde (207). Wearing his painting clothes on the beach in full daylight he looks as vital as the models in his powerful *Bathing Men*.

In contrast to the 1890s when Munch sought to express both optimistic and pessimistic moods through the same theme, he now splits them up into respectively positive, optimistic themes and negative, hate-filled themes. He himself was just like that: now high-spirited, now melancholic and bitter, sometimes shaking from fear, which he deadened and reinforced with alcohol.

In the time leading up to his nervous breakdown in the autumn of 1908 in Copenhagen, Munch increasingly suffered from what he himself called his 'insane nervous illness'. What

Munch regarded as attacks of incipient insanity were auditory and visual hallucinations: 'What I believe are visions – get mixed up with what really happened.' The sensations of a split personality had occupied him for many years. And in Warnemünde it was reinforced by a feeling of 'walking next to yourself', as he expressed it. A short time after his stay at the clinic for nervous disorders he summed up his experiences as follows:

Under the influence of alcohol the split mind or soul was brought to the

209

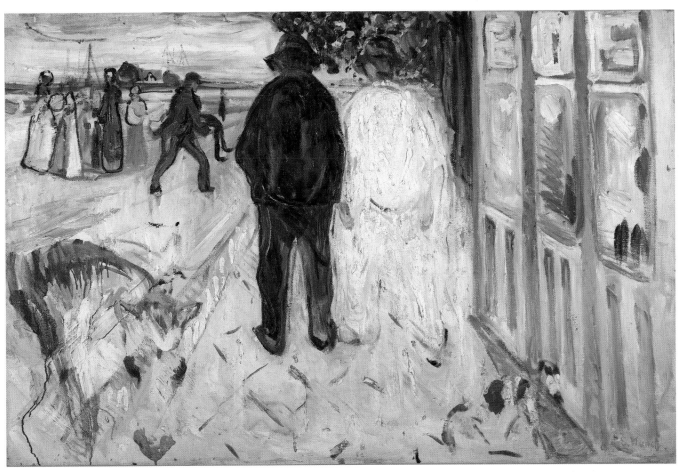

210

outermost edge – where those two conditions were struggling like two wild birds tied together to escape in opposite directions, threatening either to break the chain or to destroy themselves – During the forceful fission of these two states of mind the inner tension increased more and more – a terrible inner struggle – a terrible fight in the cage of the mind.[24]

He also regarded his split mind as hereditary forces and he tried, accord-

ing to Ravensberg's diary note from 7 May 1909, 'constantly to unite the two split halves, the vicar and the sailor'. The sailor meant the part inherited from his mother; the vicar, from his father.

The split mind, the struggle between the light and the dark forces of the mind, is expressed in two complementary paintings from the Warnemünde period, *Mason and Mechanic* (1908) and *The Drowned Child* (1908), which

carry an ominously dense atmosphere expressed by the monumental contrast between the two male figures in each. In *The Drowned Child* (entitled *Mechanic and Peasant* when it was exhibited in Stockholm in 1913) it can be observed how Munch audaciously added a horse's head and a small dog, in the left and right bottom corners, to the already finished scenery by squeezing paint directly from the tube (210). These transparent shapes can

135

211

212

213

211–12. At Dr Jacobson's Clinic in Copenhagen, 1908–9. The cloud of smoke around Munch's head in (211) is not just due to the cigar in his right hand, but also to the fact that he has moved in order to finish the exposure. The crippled finger of the left hand, which had become a trauma for him, a part of the traumatic complex which Dr Jacobson would help him to overcome, is clearly viewed here.

213–14. At Dr Jacobson's, 1908–9. The effect of transparency is more obvious here than in the other photographic self-portraits from the clinic, which contributes to a touch of non-reality in this photograph. Munch is sitting in the same way as shown in *Self-Portrait from the Clinic*, 1909 (214), and the photograph may have served as support for his painting.

be understood as analogous both to shadows left on the cornea as well as to the effects of double exposure in photography. The main theme is expressed by means of the two figures, their backs turned, walking side-by-side into the picture space. One is a light radiant figure, almost immaterial, the other is dark and in deep contrast.[25]

Thematically, these are the light and dark forces that are fighting to dominate the artist; they are the split personality of Faust from Goethe's classic work. The two animals, the horse and the dog, which have important, although diffuse, positions in the painting, also relate to the demonic powers in Goethe's *Faust*; the dog represents the poodle that constantly bustles about Faust and his companion, and the horse is the force by means of which they travel from place to place.

Mason and Mechanic (209) immediately seems to represent two kinds of artisans. The fact that the painting was earlier entitled *Baker and Chimney Sweep, Baker and Blacksmith* and *Mason and Butcher* indicates that Munch did not intend to present two specific artisan types, but that, as in the previously mentioned *Fisherman in a Green Meadow* (162), he wanted to generalize a personal experience.

The two solid figures are walking towards the viewer in an aggressive manner, which gives the painting depth and intensity. The theme is the

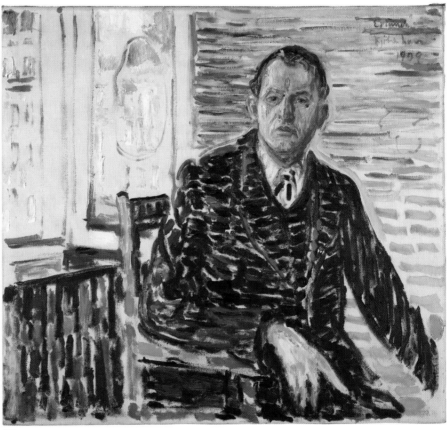

214

contradiction between the light and the dark forces of the mind, the dilemma of Faust. The scene is the same as in *The Drowned Child*, the promenade in front of Munch's house on Am Strom in Warnemünde. The two figures in *Mason and Mechanic* are leaving the picture space at exactly the same spot as they are entering it in *The Drowned Child*. In this sense the paintings can be said to be companion pieces.

As for the theme of Goethe's *Faust*,

Munch may well have had the following quotation by Mephistopheles in mind:

There is a law among ghosts and devils that we must continue along the path we started on. One is a free choice, the other law and judgment![26]

In 1908 in Warnemünde Munch was visited by the young philosopher Eberhard Grisebach, and he was highly stimulated by their long conversations

215. This photograph, showing Munch lying next to the bathtub, bears the title *Marat in the Bath*. The forceful foreshortening reflects the many depictions of himself 'à la Marat' in his works. Munch has been looking into the lens at close range, creating an aggressive, foreshortened perspective which breaks up the foreground; a style we recognize in such apparently different subjects as *John Gabriel Borkman, Dead* (248), *The Yellow Tree Trunk* (253) and *Workers Returning Home* (249).

216. A nurse, keys in her belt, her hands behind her head, is lightheartedly posing as the sensual Maya from Munch's *The Three Stages of Woman*.

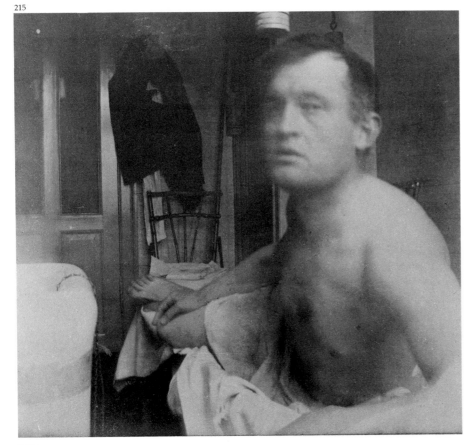

216

on topics such as determinism and the primeval light. Many years later, in 1932, Grisebach visited Munch at Ekely, outside Oslo. Munch then painted his portrait along with a peculiar painting entitled *The Split Personality of Faust* (224), in which the model – Grisebach – is split into a real figure and an 'astral' shadow, which is a composition not unlike that of *Mason and Mechanic*.

In October 1908 Munch was finally admitted to Dr Jacobson's private clinic on Kochs Vej in Copenhagen in order to put an end to his nervous and alcoholic problems. The last of the photographs Munch called 'Fatal Destiny Photographs 1902–1908' were taken there. Three of these relate quite clearly to the painting *Self-Portrait from the Clinic* (214).

In one of these Munch is sitting, turned away from the camera, facing the recently begun painting (211). The damaged, left hand lies on the arm of the chair, whilst the right hand is holding a cigar in front of his face, just as in the lithograph entitled *Self-Portrait with Cigarette*, also completed at the clinic. Between the artist and his portrait stands, tray in hand, a smiling nurse, one of 'the angels' as Munch called them. The atmosphere at Dr Jacobson's is revealed in a letter from Munch to his younger colleague Thorolf Holmboe:

It is a strange feeling being ordered about all day – so one no longer has one's own will – one feels like a child again when a young beautiful nurse with black eyes says to the elderly man – who is walking up and down the floor, a cigarette in his mouth – Are you smoking, Mr Munch, have you been allowed to? – I have to tell the doctor – it is my duty.

In another photograph Munch is sitting alone in profile, a cigar in his right hand, his left resting on his thigh (212). It is printed in two versions, one of which has a light spot resulting from the printing. The photograph shows a new inner tranquility and an extroverted attitude, which also can be observed in the painting *Self-Portrait from the Clinic*.

According to Ludvig Ravensberg's diary, Munch said himself that he 'no longer sees inwards, but outwards from the room'. The faint 'halo' around Munch's head in both of these photographs was probably caused by his turning towards the camera in order to stop the exposure.

215

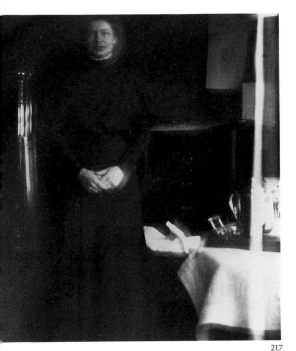

217. The nurse, dressed in dark clothes in Munch's room at the clinic, stands out in an almost Rembrandtesque chiaroscuro. In a strange way, this picture is reminiscent of several of Munch's Impressionist female portraits from 1890–2.

218. The nurses, dressed in respectively dark and light clothing, are posing for Munch in his room at Dr Jacobson's clinic. To the right is a portrait of Emanuel Goldstein, a friend from Munch's youth. The print is taken from the same plate as two caricatures in which the friend is transformed into a panther. In one of the caricatures it wanders about in the jungle and in the other it is pondering on 'borrowed thoughts', according to Munch's inscription. During his stay at the clinic, Munch very often visited the zoo and made many studies of wild animals in captivity. He depicts himself as a tiger in a lithograph in the series *Alpha and Omega*.

219. The painting *On the Operating Table* photographed in Dr Linde's house in Lübeck, 1902–3. The incidents which gave rise to the subject were the beginning of what Munch – in another connection – would call his 'Passion Story', which came to an end as a result of his stay at Dr Jacobson's clinic. The picture, painted shortly after the famous shooting incident, in August 1902, is the first example of Munch's foreshortening technique, which was developed in the Marat theme.

In the third photograph Munch is sitting and staring straight into the camera lens (213). He is holding the thumb and index finger of his right hand as if in a sign, whereas his shortened middle finger points out into the room. The pose is the same – although reversed – as in the painting *Self-Portrait from the Clinic*. He seems to radiate light – not unlike the effect seen in the lithograph *The Sick Child* on the wall behind him, next to the portraits of Dr Jacobson and Helge Rode. The artist is completely transparent, and the chair is seen through his figure.

The other photographs taken by Munch's camera from this period seem to be more humorous, some even self-deprecatory, such as the

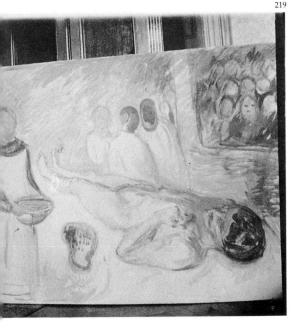

photograph of himself in exaggerated foreshortening in the bathroom (215), a paraphrase of one of his main themes, *Marat's Death*. The photograph was printed in a brown and a green version. Munch is looking directly into the camera lens which, judging from the angle of the light, was placed on the window sill. He himself is not lying in the bathtub, as Marat, but next to it.

J. A. Schmoll gen. Eisenwerth draws special attention to this photograh in

his article 'Munch's Photographic Studies' in *Edvard Munch: Problems, Research, Theses*:

His expression is difficult to describe: the half open mouth and the heavy seriousness. Purifying introspection, the deliberate gaze of self-control from the psychiatric patient in the bathroom ... The camera becomes here a means of control for self-analysis, more than for anybody else during these years. This photographic document is a personal

220

document of the most profound effect ... Here the photograph is such an independent document that it could not be replaced or surpassed by any other medium.[27]

Munch was probably quite aware that this photograph marked an end to the epoch in his life that had started with *On the Operating Table* (219) in 1902. In both the painting and the photograph he lies naked and stretched out – as in the traditional representations of Christ after the deposition from the Cross. The irony and humour which are sensed in the portrait photograph are also seen in another photograph where one of the nurses is posing, coquettish and inviting, hands behind her neck (216), as a humourous version of the central female figure in *The Three Stages of Woman*.

One of the photographs from Dr Jacobson's clinic is quite special: a nurse in dark uniform is standing like a statue with an obscure vibrating light flowing around her (217). The light was probably caused by a technical trick: perhaps Munch moved in front of the lens during exposure. The photograph relates, in a strange manner, back to Munch's first portraits of women, made in an Impressionist fashion in the early 1890s.

Another photograph that also conveys a psychologically relaxed attitude is of two nurses standing in Munch's room as a smiling paraphrase of the dark and the light women in Munch's art (218).[28] The one clad in a white dress is also in another photograph, in which she is sitting in front of some of Munch's paintings (220). This photograph shows her from the same angle as in Munch's fine etching *The Nurse* (221). The portrait of the nurse marks the first occasion since the 1880s that Munch depicts a woman as uncomplicated, serene and kind. The model is Sigrid Schacke Andersen, twenty-two years of age and recently qualified as an assistant nurse, a Solveig-figure in the middle-aged Munch's life. At this time he was rereading *Peer Gynt*, while planning to return to Norway. As he wrote in a draft letter to Jappe Nilssen on 27 December 1908: 'I am reading Ibsen again and reading him as myself – did we not earlier pay attention to the young Peer Gynt alone – the naughty rascal – and with admiration?' Peer Gynt's exile and return made Munch see Peer as himself, at a certain ironic distance. The day before leaving the clinic Munch entered the author Anders Holm's room, dressed in a black frock coat, white tie, top hat and his recently awarded St Olav medal (which he had been given that winter) saying: 'This is Peer Gynt who has come to say good-bye to the poet Holm before returning to Norway.'[29]

In many drawings throughout his whole life Munch constantly depicted himself as Peer Gynt, whereas his friends were 'given' some of the other parts. Albert Kollmann with his Mephistopheles-like face had to 'lend' some of his features for the Button Moulder, alias the Thin Man. This intriguing person confronts Peer Gynt with death, which is also the theme of Munch's and Kollmann's photographs from 1902 from a stonemason's yard in Berlin. In the last act of *Peer Gynt* the Thin Man philosophizes over the identity of mankind by using metaphors from photography:

There are two ways in which a man can be himself. / A right way and a wrong way. / You may know that a man in Paris / Has discovered a way of taking portraits / With the help of the sun. Either one can produce / A direct picture, or else what they call a

221

222

223

negative. / In the latter, light and dark are reversed; / And the result, to the ordinary eye, is ugly. / But the image of the original is there. / All that's required is to develop it. / Now if a human soul, in the course of its life, / Has created one of these negative portraits, / The plate is not destroyed. They send it to me. / (I give it treatment, and by suitable means / Effect a metamorphosis.) I develop it. / I steam it and dip it, I burn it and cleanse it / With sulphur and similar ingredients, / Till the picture appears which the plate was intended to give. / (I mean, the one known as the positive.) / But when a soul like you has smudged himself out, / Even sulphur and potash can achieve nothing.[30]

In Dr Jacobson's clinic for nervous disorders the existential question for Munch was whether a purification of body and soul would prove that he, in Ibsen's words, had 'smudged himself out' and thus was finished as an artist.

After travelling along the coast of southern Norway during the early summer of 1909 Munch decided to rent the property called Skrubben at Kragerø, where there was an excellent view over the fjord and the skerries. Here he was to find most of his subjects both for the University Festival Hall murals and for a number of landscape paintings in the following years.

He lived a quiet and regular life and saw only old friends, such as Torvald Stang, Jappe Nilssen, Christian Gierløff and Ludvig Ravensberg, who kept him company in turn besides helping and supporting him. At Kragerø he painted his friends in substantial full-length paintings; he himself called them 'the Guardians of my art'. The portraits represent explosions of creative power, made without any preliminary work, neither sketches, lithographic studies nor photographs.

There are, however, a number of photographs, taken with Munch's camera, showing Munch or his friends next to their respective portraits when they were largely finished. The models pose in the same fashion as in the paintings. A few of these photographs can be dated to 11 July 1909. On that day Ravensberg left Skrubben, and he wrote in his diary that Munch 'showed

224A

224B

225. At the entrance staircase of Skrubben, Christian Gierløff is standing in front of the portraits of Jappe Nilssen (to the left and right), the one of himself and that of Ludvig Ravensberg.

226. Torvald Stang, a bon vivant, in front of Skrubben. The blurred right side of the photograph is difficult to expain. Even though he did not himself drink alcohol during these years, Munch treated his friends to the best quality champagne, burgundy and brandy.

225

226

227. The house in the background is Munch's property, Nedre Ramme in Hvitsten. The dog, called Boy, is seen as a shadow on the top of the hill in the foreground.

228–9. Photographic studies from the harbour at Kragerø.

227

228

up in a white tropical suit' to see him to the boat. A photograph shows Munch in this same white outfit between the portraits of Jappe Nilssen and Ludvig Ravensberg (222). Ravensberg also wrote in his diary that Munch had painted his portrait in three days: the 7th, 8th and 10th of July. The sunlight casting rather long shadows from the east indicates that it was early in the day. It was presumably Ravensberg who took the photograph.

Another photograph, in which Ravensberg is standing next to Munch's portrait of him, must have been taken by Munch (223). Munch sent him the photograph on the 22nd of the same month with these words by Christian Gierløff:

This is the photograph; it shows, as they say in certificates for writing courses: This is how I looked before I came to Munch's at Skrubben (so thin, flat, and undernourished, and this is how I looked after only 6 weeks' stay at Munch's (so powerfully healthy and fresh). (Munch has also had to add a little to the portrait as well; he painted the whole figure over, so now it has more resemblance with your present body.)

When Ravensberg visited Munch the next time at Skrubben in December of the same year, he thought that this overpainting, which consisted of many dots and strokes applied spontaneously on and around the model,

had spoiled the painting. Two photographs from Munch's studio at Skrubben indicate why the overpainting was done. One shows Munch with the brushes in his hands between the portraits of Gierløff and Ravensberg (224A). The dots of colour and the quick brushstrokes are clearly visible on both portraits. Munch obviously wanted to match the paintings.

In the other photograph Munch is looking at his work (224B). On the floor and along the walls are his studies for the decoration of the University Festival Hall in Kristiania and to the right of Jappe Nilssen's portrait is a subject from Åsgårdstrand.

There is as well a photograph taken outdoors at Skrubben where Christian Gierløff is posing, with open coat, next to a dashing full-length portrait of himself painted in radiant colours (225). Behind him at the well are the portraits of Ludvig Ravensberg and Jappe Nilssen.

The portrait of Torvald Stang, a lawyer from Kristiania, is a major work among the portraits. He was a *bon vivant*, which Munch has not at all expressed in the portrait, but which is clearly seen from a humorous photograph in which Stang, with his small pipe cheerfully thrust into the corner of his mouth, his hat cocked over one ear and his silver-mounted cane held elegantly under one arm, is carrying a tray of champagne glasses, and a bottle in the ice bucket (226). He is photographed from below, which

229

143

230

231

emphasizes the sense of his move-ment forward with the filled tray. This joyful snapshot is quite unique as a portrait showing a different side of Torvald Stang's character than the serious figure, weary of life, in the psychologically deep, full-length portrait on the canvas.

Munch, who had been cured of his alcoholism at Dr Jacobson's clinic, used to serve good champagne and burgundy to his visitors, but he himself enjoyed wine only through 'transmission, sublimated through the medium of friends', as Gierløff expressed it.

Two photographs from the harbour basin at Kragerø show the harbour with the small islet at the harbour entrance, taken from two different angles. In the distance in one of the photographs is a small steamboat listing in the water, surrounded by rowboats containing tiny people (228). The foreground is dominated by the massive wharf and a pile of planks. Lower down, a moored boat describes a marked line in the composition.

In the other photograph the wharf dominates the foreground, the strong perspective lines opposed by the parallel lines of the repeated gangways (229). A good number of the landscape paintings from Kragerø carry such strictly organized compositions which emphasize Cubist, sculptural shapes – compositions Munch had used already at the end of 1880s in, for example, *The Arrival of the Postboat*.

The inspiration for most of these paintings from Kragerø undoubtedly came from Cézanne. Munch's reflec-tions of the work of this foremost landscape artist is most obvious in some of the lesser known subjects, but also visible in the following major paintings such as *Winter at Kragerø* (1912) and *Spring in the Skerries* (1910). The severe almost classic build-up of the picture space, with precedents among Renaissance painters such as Giotto and Masaccio,

anticipates the massive canvas *History*.

A comparison with the art of Pablo Picasso at the same time shows quite significantly how two contemporary artists went different ways from an analogous starting point. In the summer of 1909 Picasso photographed the roofs of the houses in the Spanish village Horta de San Juan. In contrast to Munch's realistic photographs from Kragerø, Picasso's camera captured the abstract interplay of lines and planes

232

144

233

230–1. The final version of *History*, photographed by Munch at an earlier stage (230), together with *Alma Mater* (*The Researchers*) (231), today hangs in the lecture room of the Munch Museum, along with the earlier version.

232. *Irene and the Nursing Sister in the Park*, a study for Ibsen's play *When We Dead Awaken*, where Munch seems to paraphrase his photograph of the light- and dark-clothed nurses from the clinic (218). Munch maintained that the author had been inspired by his painting *The Three Stages of Woman* for his principal female characters in the play: Maya, Irene and the Nursing Sister. Munch did a series of studies in the 1920s for the play, where he used the portraits of Ingse Vibe (175–7) as a model for Irene.

233. Munch's handy man, Børre Eriksen, who was sitting as a model for *History*. Photograph by A. F. Johansen on Kragerø.

234. Drawing of an unfinished sculpture, intended as a national monument, from one of Munch's sketch books. The theme is formally connected to *Two Women on the Beach*. Munch varies the cone-like shape of the sculpture in many of his paintings, from *Women on the Bridge*, 1903, to *Alma Mater* (231).

235. Munch next to the sculpture showing, according to himself, 'Old Mother Norway with her Great Son', in the studio at Skrubben on Kragerø.

reflected in his contemporary Cubist landscape paintings from Horta.[31]

Munch also took two landscape photographs from the hill between the township of Hvitsten and the property he bought there in 1910. The property is seen in the centre of both pictures. In one the foreground is filled out with a massive rock on which Munch's setter, Boy, is seen, indistinctly, waiting for his master (227). In the other photograph the dog is jumping into the picture space, which makes the contours indistinct, but integrates the dog with his surroundings as a shadow more than a figure.

Munch's horse, Rousseau, carrying an unknown rider, is in another photograph so integrated with its surroundings that it merges into the wood. These snapshots of animals may be seen as Munch's attempts to integrate animals and humans into the verdant natural surround, which

234

235

was a major theme in his paintings and graphic works from Hvitsten during the following years.

In a sketchbook from the early part of his Kragerø period Munch made the following reflection:

I saw a nun – I think – could a photograph not help – I tell myself – The photograph would not tell me what I think, seeing the nun – A photograph would separate the nun from the surrounding nature – I see the nun in relation to and in the middle of the surrounding nature.[32]

We can obviously interpret this extract in relation to Munch's effort to merge humans and animals in the surrounding nature. The nun can,

145

236. Munch is working on the underlayer for the painting in the Festival Hall of the University. A closer analysis of *The Sun*, which appears to be a realistic painting, shows that it consists of a concentration of the ideas of mysticism surrounding light and linked to theosophy and occultism; for instance the idea that geniuses are born in the rays of the sun. Some of the protest against Munch's murals may be explained by the fact that public display of such phenomena was banned. The photograph was taken by A. F. Johansen, and the original negative is today in the Berg-Kragerø Museum.

however, also refer to Ibsen's play *When We Dead Awaken*. There is a watercolour showing Munch's concept of the first act with Irene and the nun – according to Ibsen's stage directions – in a 'park-like place with fountains, groups of big old trees, and bushes' (232).

The nun in dark dress, 'Irene's shadow', has been painted as a materialized figure, whereas Irene is depicted as a transparent shadow. The tension between the nun and 'the surrounding nature' has something of the unreal atmosphere of a dream, and Irene's lighter figure is attached to her 'shadow'. The women appear like the double exposure Munch had explored at the beach at Warnemünde, in which both he and Rosa Meissner are seen doubled.

In the spring of 1910 Munch again used his camera, this time to document the progress of his work in his open-air studio at Skrubben on the *History* and *Alma Mater* murals intended for the Festival Hall of the University in Kristiania. Munch sent a photograph showing a study for *History* (230) to Gustav Schiefler on 11 May 1910 with the words: 'As you see I have finished the large mural, the History – The subject is still a bit romantic, but it will do.'

The photograph of *Alma Mater* (231) shows clearly that the mother and nursing child are painted together in a sculptural cube-like shape, a form Munch had developed from 1903

when, as referred to in a letter to Dr Linde in Lübeck, he started working in sculpture. The many sculptural elements in the murals for the University, from the Early Renaissance-like rocks in *History* to the shape of the woman and the group of children at play in *Alma Mater*, can be explained by the fact that Munch had begun to sculpt again.

As Gerd Woll has shown, Munch saw Meunier's sculpture *Mother and Child* in Copenhagen in 1908, when it was exhibited in the Glyptoteket. In his letter to Gustav Schiefler dated 11 May, Munch enclosed a photograph (235) in which he is seen working on a sculpture. According to Munch this was a study for a national monument:

You see I have also started sculpting – this is meant as a monument for Old Mother Norway with her Great Son (Norway's recent independence).

The photograph was taken at very close quarters, from below, and has a concentrated Munch-like structure that recalls some of his earlier self-portraits. The impression of activity and vitality has probably been made by Munch's movement away from the field of vision during exposure. He seems to have wanted to express the opposite of the symbolism of the Fatal Destiny Photographs. Negative passivity has been turned into meaningful activity.

Munch also had a professional

236

photographer, A. F. Johansen, take a longer series of photographs of himself working at studies for the University Festival Hall murals on Skrubben. (They are today in the Berg-Kragerø Museum.) These photographs were probably used as documentation at the exhibition of sketches and studies which, according to the catalogue, was held at the Diorama in August 1911.

The same photographer also took

146

237. Poster, 1910, made for Munch's own exhibition in the Diorama in March 1910. The vertical lines of the façades of the houses, traditionally drawn using parallel lines, are here drawn as perspective lines with their vanishing point at the bottom corner on the left, while the horizontal lines have their vanishing point at the level of the eagle's eye. With a touch of self-irony, Munch remarked that the eagle looked rather like an accidentally shot crow.

238–9. Picture postcards taken from a balloon, of the Palace (1905) and the University in Krisitiania (1906), from the collection of the Oslo Bymuseum.

237

the view from Skrubben where Munch found the subject for *The Sun*, as well as the model for *History*, the old-age pensioner Børre Eriksen, sitting on a chair in the same pose as in the painting (233). Eriksen, looking like a figure from primeval times, was Munch's handyman and an important model during the Kragerø period.

A year later, at a time when almost

238

239

all hope of fulfilling the Festival Hall decoration had collapsed, Munch sent another photographic message to Gustav Schiefler with the comment, 'The Builder Solness has packed up'. The photograph, also taken by the photographer Johansen, shows Munch on the steps of a ladder working on a study for *The Sun* (236). Referring to Ibsen's tragic hero Solness, Munch sees his own situation as 'a very triumphant defeat'.

The poster for Munch's exhibition in the Diorama on Karl Johan Street in March 1910, which also included studies for the University murals, appealed to the audience by showing a golden eagle flying high above the Royal Palace and the University, seen in an exaggerated bird's-eye view (237). The eagle is flying with broken chains around his feet, and blood dripping from his left wing. The text, *Edvard Munch's Exhibition of Paintings and Graphic Works*, stands out like a big banner in the sky. Down below is a group of animals and misshapen people, as in many of Munch's caricatures, aiming at the eagle with guns.

The closest inspiration for the poster is probably Honoré Daumier's famous caricature from 1862 of Nadar photographing Paris from the gondola of a balloon, the title of which – *Nadar Raising Photography to the Level of Art* – must have appealed to Munch. But, whereas Daumier and for that matter Nadar in his balloon aimed at a natural perspective, Munch drew the street and the people in an exaggerated bird's-eye perspective. The scene is composed in such a manner that the vanishing point is at the level of the eagle's eye. It must be noted that Munch may have been inspired by two aerial photographs, which were for sale as postcards: one of the Palace taken in 1905 (238), and one of the University taken in 1906 (239).

The use of two different photographs could explain why the Palace and the buildings of the University have been drawn as if they were much closer together than in reality. Another case of Munch abstracting from a postcard photograph was seen in the background of the Nietzsche portrait, in which there is a similar tension between the figure and the landscape far below (117).

Such an audacious use of bird's-eye perspective as in Munch's poster is not known elsewhere in art. The fact that aerial photographs could supply the artist with 'new environments' was first suggested in an article by Kasimir Malevich in 1913, and the first known use of a balloon is Robert Delaunay's abstract view of the Champ de Mars in Paris, painted in 1922 from a photograph taken in 1908.

Photographic Reflection in Munch's Art

240

240. Edvard Munch in front of *The Sun* in his outdoor studio on Kragerø, 1910. Photographer A. F. Johansen. The original negative is in the Berg-Kragerø Museum.

MUNCH'S DRAWINGS ON POSTCARDS

During Gustav Schiefler's visit to Munch in Warnemünde in 1908 Munch and Schiefler sent a postcard to Mrs Schiefler of a landscape photograph from Warnemünde, on which Munch had drawn an airship and a figure somersaulting down a cliff (242). The drawing is almost like a child's scribbles. Similarly there is a postcard, presumably from c.1900, on which James Ensor has scribbled a similar figure among the photographed holiday-makers at Ostende.

Otherwise it was not until 1921, to my knowledge, that another artist, George Grosz, did something similar when he drew a fisherman on a beach scene, with an airship floating above, also in a childish fashion. Gerhard Wietek has interpreted Grosz's illogical composition as an expression of the concepts of Dadaism, which distorted reality in a 'magical' fashion and constituted a break from Expressionism.

It was quite likely that it was Schiefler who inspired Munch to pursue this kind of doodling. Being a collector of personal postcards from artists, he probably wished to include Munch in his collection. Whereas Kirchner, Schmidt-Rottluff, Heckel, Pechstein and Nolde made an effort to send Schiefler interesting postcards, Munch's first contributions were some scribbles on postcard photographs of quite banal subjects.

After his stay at the clinic in Copenhagen Munch sent many such postcards to Gustav Schiefler. The first, dated 1 May 1909, was written on his way home from Denmark to Norway. The photograph shows a field in which a peasant is ploughing with horses.

The postcard is entitled *The Ploughman* (243), and Munch's inscription to Schiefler was 'A Norway Traveller'. In the horizon Munch drew himself with his hand under his chin, greatly oversized in comparison with the landscape, clearly inspired by the fashion in which Nietzsche's portrait, as previously discussed, was inserted on the postcard photograph of his house (114). Munch seems to have used the subject as a humourous comment on his own hopes for the future. The subject, a man ploughing with a pair of horses, was one Munch was to paint in numerous versions throughout the coming years, and, as will be seen, although apparently simple, it is charged with symbolism.

When Munch was finally invited to participate in the competition for the decoration of the Festival Hall of the University, he sent to Schiefler on 23 August 1909 another optimistic postcard containing a drawing (244). The original subject in the postcard is a ski-jumper in the air at the Holmenkollen ski jump above a crowded spectator stand. Munch placed broad brushes and a palette in the hands of the jumper and a paint box on the skis. Is it possibly an image of himself

floating in the air heading towards new tasks and wondering about the landing? A short while ago a similar card with a drawing appeared, a 1912 New Year's greeting to Thorolf Holmboe, on which Munch has drawn himself between two girls going skiing, perhaps as a humorous comment on the healthy life he was by now leading (245).

Another postcard, sent on 23 July 1912, illustrates the market square at Kragerø. Munch has drawn himself, paint box in hand, in violet ink, accompanied by his white horse, Rousseau, a rider and two of his dogs, Boy and Fips (246). And in March 1913 he sent an amusing postcard of the University on which he has drawn Alma Mater enthroned on the roof in the sun, surrounded by her children, while the historyteller is sitting on the Domus Media (247). This is again a comment on his own situation. At this time it was still uncertain whether he would receive the commission for painting the Festival Hall of the University.[1]

After finishing the Festival Hall murals Munch started populating his own paintings with figures in a style not unlike that on the postcards. Such drawing can be seen in a number of subjects from Moss and Ekely, often added several years after the painting itself was finished; and in *The Murderer in the Avenue* (1919) a scribbled figure is seen as the main subject in the foreground.

242–7. These six picture postcards give an impression of how Munch used postcard photography for humorous 'comment'. The self-portrait on the horizon of *The Ploughman* (243) was the basis of a long series of drawings where Munch varies the theme 'hand under chin', resulting in his only painted self-portrait from the Kragerø perod, *Self-Portrait with Hand under Chin* from 1911. The ploughman with the two horses seems to be the start of many of Munch's paintings of horses.

242

En Pløjemand

243

244

245

246

Universitetet, Christiania.

A NEW PERSPECTIVE IN MUNCH'S ART

Munch's photographs from Dr Jacobson's clinic are clearly a climax of expressive depictions of himself and his surroundings leading from melancholy to irony and humour. During the following years he did not take his camera with him 'in Heaven and Hell'. The hell was defined by Strindberg in the Danish edition of *Black Flags* (1908) as 'not a place, but a state of mind which changes everything around oneself into an Inferno'. At the clinic Munch read both *Black Flags* and *The Glacier* (1908) by Johannes V. Jensen. *The Glacier* describes in the form of a heroic myth how the Scandinavian people of prehistoric times were hardened by their rough living conditions. This book marked a breakthrough in Scandinavia for a vitality in art that had been prevalent for some years in European art and literature.

Munch's own outlook on life, as well as the attitude to life he expressed through his art, had changed from a negative, introverted bitterness to a positive, extroverted optimism. This change in outlook is expressed fully in the painting *Self-Portrait from the Clinic* (214) in which Munch is sitting at the open window, bathed in sunlight, which casts aside all pessimism and melancholy. This vitality contrasts markedly with the melancholy he felt and expressed in a note written just before his admission to Dr

Jacobson's clinic: 'to me life is the window of a cell – never, never shall I reach the wonderful, lovely life'.[2]

In a similar manner Munch also reinterpreted the bitterness and suffering of the many versions of *Marat's Death* in his ironic comments on the earlier self-portrait photograph from the bathroom at the clinic (215), which has been mentioned before. The exaggerated foreshortening of his naked body is rather sensational considering the fact that the photograph was taken with so simple a camera. From this photograph onwards his art was influenced by new attitudes which both changed the subject-matter and at the same time literally gave it a new perspective.

The exaggerated foreshortening which gives the upper part of his body a peculiar solidity is also seen in many of Munch's drawings from 1910 illustrating Ibsen's play *John Gabriel Borkman* in the last act of which Borkman is sitting, covered with snow, hunched up and dead on a bench in the garden (248). In these drawings Munch is so close to the subject that the massive figure almost falls – or, perhaps better, leaps – out of the picture space, creating its own disquieting dynamics, dynamics which may be considered Munch's answer to the magical movement the Italian Futurists cultivated in their paintings.

This is continued and elaborated in the master work *Workers on their Way Home* (1913), in which the street

is crammed full of workmen swarming towards us (249). The men in the foreground shoot out of the picture space, almost like projectiles. The foreshortening technique with the enlarged torsos is the same as in the drawing of John Gabriel Borkman.

Munch's technique for rendering transparency is most obvious in the foreground figure to the left, whereas the centre figure's legs are seen moving in a primitive fashion, almost detached from the ground. The red and green mask-like faces, the stiff gazes and the stillness evoke an atmosphere of unreality and a poignant dream-like state of fear.

In Munch's collection of press-cuttings is an item from *Allers Familie Journal* of September 1911, in which his study for *Alma Mater* (*The Researchers*) is shown next to a photograph from the disturbances associated with the General Strike in London (251). The General Strike during the autumn of 1911, which affected all of England's industrial cities, was also reported in the Norwegian press, in both articles and pictures. The photograph shows a strike-breaker driving a pair of horses and a heavy coal wagon at full speed along the street, escorted by a number of mounted police.

In order to capture the fearful atmosphere of the situation the photographer has taken his position at relatively close quarters, an effect Munch developed by similar means in

153

248. *John Gabriel Borkman, Dead*, 1910. The drawing was formerly dated 1920, but Ludvig Ravensberg's diary mentions that it already existed in January 1910, which also makes sense of the technique used in the drawing. A comparison with the photograph *Marat in the Bath* (215) explains visually how Munch used the foreshortening technique from his photographic self-portrait.

249. *Workers on their Way Home*, 1913–15. The painting is a study of movement. Both the viewpoint of the subject and the main figure's distorted proportions, with its large torso and radiant face, are reminiscent of the movement and distortion achieved in motion pictures, which probably inspired it.

248

249

power in the way the horse's head is thrown to one side and by his radical use of foreshortening. The driver, who, in both photograph and painting, is holding the reins in his left hand and the whip in his right, is far smaller in the painting, in relation to the horse, than in the photograph.

A closer look at *Galloping Horse* reveals two male figures to the left,

one clad in light clothing, the other in dark clothing. They recall the two contrasting figures in other works such as *Mason and Mechanic* (209) and *The Drowned Child* (210). To the right in the painting two children are pressing against the rock wall to avoid the speeding horse. When the painting is taken out of its frame the seemingly purposeless ochre blotches in the

Workers on their Way Home. Both the vantage point and the distorted body of the central figure in this painting provide references to the movement and distortion of cinema.

Munch was indeed a keen cinema goer; and effects such as people, animals and trains which were, so to speak, bursting head on out of the screen had a striking effect on the audience of the period. A street crowded with workmen was, moreover, the archetypal image of strikes or social disorder. It must thus be concluded that Munch was influenced by both media – cinema as well as still photography.

The newspaper photograph from London strongly recalls *Galloping Horse* (250). The conventional dating of this painting is 1911–12, and in this case the photograph may well have provided the basis for the painting. If the photograph is seen reversed the horses appear to have striking similarities with the horse in *Galloping Horse*. Furthermore, Munch emphasizes the expression of erupting

154

250. *Galloping Horse*, 1910–12. When the painting is stretched out is is obvious that the short brush strokes to the right and left create a totally transparent man's leg and part, presumably, of a woman's skirt, both fleeing to avoid the dark figure of the horse, which has been whipped into a gallop.

251. A newspaper cutting from *Allers Familie Journal* of September 1911, from Munch's archives. The photograph shows an incident during a transport strike in England, where strike-breakers are being escorted by police.

252. *A Pair of Horses in the Snow*, 1923. For more than a decade Munch painted a long series of portraits of a pair of light and dark coloured horses, accompanied by a worker. The model for both horses was probably his own horse, Rousseau, which he acquired in 1910 or 1911, and kept until it was thirty-five years old. In these paintings Munch uses the same extreme foreshortening technique as in *Galloping Horse* (250) and *Workers Returning Home* (249).

251

bottom right- and left-hand corners create the figures of a man and a woman, who are throwing themselves aside to avoid being trampled by the horse.

Horses were from now on to become central images in Munch's art, which in a sense go back to the previously discussed postcard Munch sent to Gustav Schiefler in 1909 of a pair of plough horses. A group of paintings

250

shows a pair of horses in front of a plough, driven by a peasant coming towards the viewer, painted with a similar use of foreshortening to *Galloping Horse*. The horses were generally painted one light and one dark. The light horse is pulling to its left and raising its head, the dark one is pulling to its right with its head bent (252).

Another group of paintings shows a pair of horses from behind walking into the picture space. This group of paintings uses a similar use of foreshortening, which now seems exaggerated. The horses' rumps contrast with their tiny heads, creating an especially dynamic sense of

252

movement. In this way Munch constantly uses movement in and out of the picture plane to create compositional variety. It is, however, natural power which interests him, never mechanical.

These subjects have traditionally been considered farming landscapes. But a closer look reveals a thematic basis from the famous parable which Plato ascribed to Socrates in the dialogue *Phaedrus*. Here the soul is seen as two horses, one dark and one light, pressed on by their driver; the dark horse is pulling downwards, while the light one is attempting to pull upwards. The soul's rationality is under the control of the driver, who

253

maintains balance and harmony in this three-dimensional image. The following description of his own split personality before his admission to the clinic for nervous disorders indicates that Munch knew of Plato's famous parable: 'My soul is like two wild horses tearing me apart from either side.'[3]

According to the entry in Ravensberg's diary dated 28 December 1910, Munch referred to Plato around the time he began to paint horses, and he 'was pleased that they had reached the same result'. Munch considered Plato an instinctive philosopher, contrary to Aristotle, whose realism demanded proof and rationality. In a contemporary depiction of Parnassus, in which he included all the great personalities of world history, he positioned Socrates (Plato's spokesman) next to Nietzsche and Ibsen.

Munch also used the horse as a symbol of uncontrolled power in a drawing in which two children in the foreground cling to each other gazing fearfully ahead while the horse runs past behind them (257). The drawing is made in a close and compact fashion. This was characteristic of several Cubist and Futurist-inspired works executed after his visit to the Sonderbund Exhibition in Cologne in 1912, where Modernism made its definitive breakthrough. However, Munch never left his particular vital point of view.

The subject of *The Yellow Tree Trunk* (1912), made in a number of

different versions, has its basis in a strange watercolour with a greatly foreshortened composition, which goes back through the many versions of *Marat's Death*, in painting and graphic works, to the previously discussed photograph from the clinic. On the forest floor of the watercolour, wet with snow, two naked, yellowish bodies lie stiffly, indicating that they are dead (254). On such a forest floor in his large paintings, Munch depicts yellow tree trunks in the same manner (253).

254

A thematic comparison between the painting and the watercolour indicates that in this apparently realistic landscape Munch wanted to express how death follows life and how death becomes a precondition of new life. Munch expressed similar ideas in a more pessimistic manner in his subjects of material transfer dating from the turn of the century.

In the painting *The Yellow Tree Trunk* the subject also has a dynamic motion that relates to the cinema; if one passes in front of the painting at a

253. *The Yellow Tree Trunk*, 1911–12. The painting is an example of Munch's ability to create a broad field of vision for the eye on the canvas, like a wide-angle camera lens, and this brings about the intensified perspective.

254. *Forest Floor with Human Bodies*, c.1910. Watercolour. The subject is best interpreted as a version of the theme *Material Transfer*, which Munch treated in a series of works before the turn of the century, i.e., trees feeding on bodies rotting in the soil. In this respect, the theme of *The Yellow Tree Trunk* can be interpreted as an expression of the cycle of life.

255. *Man and Woman II*, 1912–15. Munch has focussed on the woman. The man to the left in the field of vision – his alter ego – stands out as a dynamic blurred shadow. In photographic terms, the man was standing too close to the camera, and then moved.

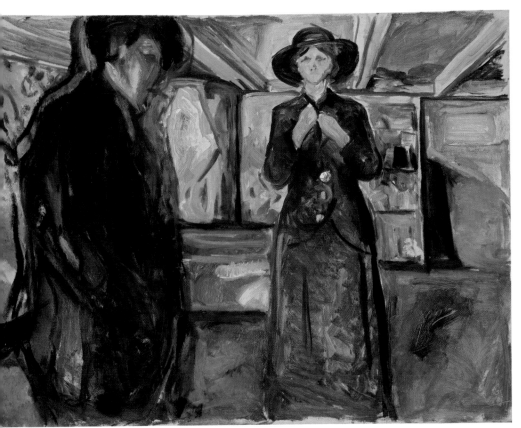

255

Hall of the University, murals that would be seen from below, as the paintings were to be mounted approximately two metres above floor level. Munch must again have thoroughly studied the treatment of perspective by artists such as Giotto, Masaccio, Michelangelo and Puvis de Chavannes, artists who had modified the construction of perspective in order to integrate murals into a given architectural space. *History* and *Alma Mater*, each over eleven metres long, were to be seen at relatively close quarters and demanded that Munch in a real sense had to work with an expanded depiction of nature.

In paintings such as *Galloping Horse*, *The Yellow Tree Trunk* and *Man and Woman II* Munch's treatment is simple and realistic, even if it stretches to the limit applications of one-point perspective.

Munch can in this sense be said both to preserve the use of one-point perspective in painting and to break it up. For a short period after his exposure to the enormous Exhibition of Modern Art in Cologne in 1912, Munch experimented with a perspectiveless, flat painting style, which was, in its way, his answer to the kind of Cubism and Expressionism exhibited there.

A small number of paintings among Munch's art effects were earlier considered unfinished and unsuccessful, but upon closer analysis they seem to be the result of a deliberate

certain distance the perspective seems to change in a peculiar way as the gaze is drawn in along the tree trunk towards the facing line of the trees.

A similar dynamic can be observed in the painting *Man and Woman II* (1912–15). All the orthogonal lines lead to a woman who is undressing in front of a bed (255). The male figure to the left, the alter ego of the artist, is seen at extremely close quarters. The contours of the male figure are blurred as if Munch had observed the subject

through a lens, so that the woman is in focus and the man out of focus, and he has given the male figure volume and weight by making no detail recognizable and the room around him indistinct. In this manner Munch shows the subjects in an expressive fashion which we might see as a potent expression of photography.

The strongest motivation for Munch's experiments with new perspectival effects was, however, the painting of the murals for the Festival

157

256–8. *Women Bathing*, c.1913, *Galloping Horse and Two Frightened Children*, 1913, and *In the Kennels*, c.1913. Munch left a small number of almost 'disorderly' works, which until now have been totally ignored. As a reflection of his experiments with the effects of blurring caused by movement and double exposure, the use of transparancy is understandable.

256

experiment with the effect of double exposure in photography. The best example is of an apparently chaotic scene of a number of women bathing (256). A female figure enters the picture space from the left; she is unnaturally large and appears transparent compared to the other bathing women.

Similarly, there are experiments in overlapping figures among Munch's drawings from around 1912, such as that of the scared children in front of a galloping horse (257).

Another example is the portrait of Munch's big St Bernard dog, Bamse, surrounded by his other dogs barking and prancing about (258). To the left is, from the dog's perspective, a transparent leg and foot, which we can assume to be the artist's. In contrast to the heavy body of the St Bernard, the other dogs appear as lightweight prancing shadows. It is Bamse's experience of the situation that is the main subject of the painting. In this connection Munch liked to take Bamse to the cinema in Moss, and he thought that if Bamse barked during the performance the film was not worth seeing!

Munch's experiments with overlapping images have an obvious parallel with the photography of Anton Giulio Bragaglia, which was of great importance to the development of Italian Futurism. Giacomo Balla cooperated regularly with Bragaglia from 1910. Bragaglia's photographs were a

development of Etienne-Jules Marey's chrono-photographs, which earlier had influenced Munch in some of his works from Berlin in 1893–5, as previously mentioned. Bragaglia used a long exposure time on moving objects and by means of a succession of exposures created a picture space filled by transparent shadow-like shapes. One of Bragaglias best-known photographs from 1912, showing Giacomo Balla next to his painting *Movement of a Dog on a Leash* (1912), was well known through reprints in several international art magazines dating from January 1913.

In spite of all the differences, Munch's paintings of the smaller dogs jumping around Bamse constitute the same subject – a dog in motion and a man's leg and foot. Bragaglia's photographs were forgotten after a while and were not rediscovered until recently. The same fate befell many other experimental photographers in this period. One of those, the Italian Luigi Cantù, was best known for his double exposures of people in the bath. His photographs however, have, disappeared, but could they, perhaps, be preserved through Munch's paintings of bathing women, mentioned earlier?

In a letter to the philosopher Eberhard Grisebach, written at Grimsrød in Moss on 15 November 1912, Munch wrote about his newest experiments; he had by then started to use more paint and less solvent:

Because I work more on creating depth and will do more experiments with the problem of light and shade. Something grotesque and disturbing will surely come out of these different experiments – but I believe it will get me further.

Munch's interest in the problem of light and shade makes it most likely that the following can be attributed to this period; the remark was quoted in Christian Gierløff's book *Edvard Munch Himself* (1953):

Movements? To profess to a movement in painting is for a painter the same as nailing himself to a wall. It is not 'movements'. That is the wrong word. It is objectives. The new goals they treat. For the time being it is light and shade. For Realism it was detail; for Impressionism, character. Now it is light and shade – and their dynamics – and the painting problems they represent. The

257

158

258

259. *Death of the Bohemian*, 1915. Munch was absent when Hans Jaeger died, but he painted the picture according to his friend Jappe Nilssen's recollection. In an attempt to get close to the subject, he rented a studio in the same street in Kristiania in which Jaeger had died in 1910.

light and shade a prisoner sees in a goal.
The strange grey stripes of shadows.
They recede and approach. They slide
away and join again. Bend and burst.[4]

A work that sums this up is *The Bohemian's Death* (1915–18), which refers to the death of the author and anarchist Hans Jaeger in 1910 (259). Munch himself was not present when Jaeger died, but Jappe Nilssen would have been able to relate to Munch in detail what had happened. In order to revive the incident in his imagination Munch rented, in the summer of 1915, a room in the street where Jaeger had lived and died. Here he completed his substantial painting of the incident.

To the left in the picture lies Hans Jaeger, his head resting on a white pillow against a scarlet headboard which contrasts with the green that fills the room. A woman dressed in blue sits on the edge of the bed, while another woman – also in blue – has thrown herself crying across the foot of the bed. Two melancholy men sit at a table. Judging from the number of empty bottles, the hours of waiting have been long. The man in the foreground is Jappe Nilssen, seated in profile. In front of him is a peculiar shadow of the same shape. The knee and a hand are quite distinct, whereas the head and the upper part of his body are quite transparent.

In a literal sense the scene is viewed through Nilssen's shadow. This is a version of the double-exposure technique from Munch's own photographs at Warnemünde. And the condensed atmosphere relates to similar effects in the Fatal Destiny Photographs, where he sits hunched up in dimly lit room.

259

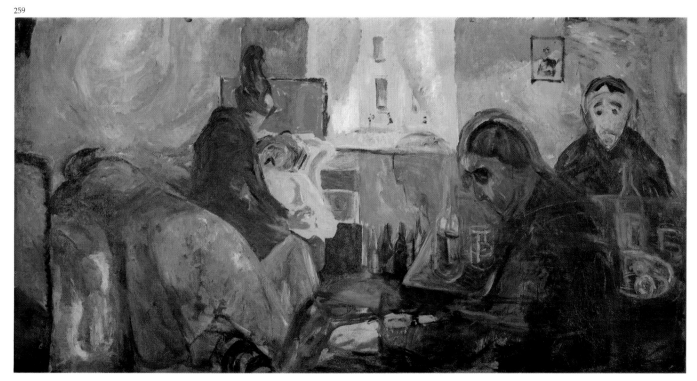

Munch's Experiments as an Amateur Photographer 1926–1932

260. Edvard Munch, 1926, Photographed by Inger Munch.

After Munch took his last photographs with the Kodak camera at Kragerø and Hvitsten, fifteen years were to pass before he again took up photography. From New Year's 1927 until 1932 he was again, periodically, intensely occupied with photography, and at the same time he continued to use professional portrait photography as a basis for his portraiture. In contrast to his first phase as a photographer, he neither developed nor printed his photographs himself. He used several different cameras, but never again his small Kodak from 1902. Moreover, he acquired a cinema camera, presumably during a trip abroad in 1927.

Munch's second phase as a photographic artist paralleled his sister Inger's active interest in photography, and it concluded at the time she published her life-work, *The River Aker*, at Christmas 1932. *The River Aker* is a purely photographic book, a documentary book on the natural and industrial environment along the river, which was the vital nerve of Oslo, from the source of the river at Mariedalen to the mouth at Nyeland, a stretch she and her brother had known from childhood.

Inger's ambition in photography was mentioned for the first time in a letter to her brother (of 8 September 1917) after a visit to Ekely with her sister Laura and aunt Karen, while Munch himself, characteristically, was not present: 'I wish I could photograph. Next summer I hope I

shall learn it thoroughly.' It was presumably her brother's eccentric home she wished to photograph.

But it was not until nine years later that she started her career as an amateur photographer, clearly at the instigation of her brother, who might have thought that his sister needed preoccupation other than her piano teaching, which had become painful because of rheumatism in her fingers. At any rate she wrote to him much later: 'When you acquired the nice camera for me, you brought me lots of pleasure and usefulness at the same time.'

Inger's knowledge of the medium was clearly limited when she received the camera, for Munch noted, laconically, on a picture postcard of *Girls on the Bridge*, stamped 23 September 1926: 'It is possible to photograph in cloudy weather.'

A month later Inger was cultivating her new interest, and the following letter, dated 11 November 1926, reached Munch in Zurich:

I have taken so many pretty photographs. The one of you outside the house is very good, but you look a little tired after the trouble of packing. I was not lucky. I have taken a wonderful photograph of the view here, and several interiors with our aunt, all very good. The camera is excellent.

This photograph of Munch has been identified (260). He is standing, hands behind him, in front of the stairs at the

southern end of Ekely. The photograph has a rather low vantage point, probably caused by Inger's holding the camera at stomach-level and looking down into the view finder – the way she was seen photographing for her own book, *The River Aker*. The oblong format (8.3 × 13.5 cm) was originally a special format for producing postcard photographs, which could be a lucrative occupation in the case of popular subjects.

When Munch returned from his travels abroad at Christmas 1926 he himself took a series of photographs with a new camera. The photographs have the format 9 × 14 cm and mainly depict his own paintings in his studio at Ekely.

In a sketchbook are several notes from different photographic tests, along with preparatory notes for another trip abroad made in the spring of 1927. He has briefly noted the exposure time, the conditions of light, the subject, and whether he considered every subject a success or a failure. On the back of eight preserved copies are similar notes (262–4). For instance, the exposure time in the sunshine outdoors was a fifteenth of a second compared to 30 seconds in the darker interiors.

The photographs are obviously camera tests, completely devoid of artistry. The series might simply be the result of Munch's wanting to brush up his skills in order to instruct his sister Inger better.

The portrait of Rolf Stenersen, which Munch probably painted in 1925, placed on an easel in one of the many studies of Ekely. This photograph is one of a series of ten which are the only ones known to have been taken by Munch with this camera (265). On the back of the photographs he has noted the conditions of light and the different exposure times, probably trying out the possibilities of the camera. In this case is written, 'Sunshine – with circa 10 seconds'.

263–4. *The Wedding of the Bohemian*, 1925, and *Street in Kragerø*, c.1911, photographed by Munch in 1927 in the garden of Ekely. On the reverse side of the photographs he has noted, respectively, 'Out in the sunshine – House in shadow at the rear – Painting in shadow' and 'Outside, half sunshine – seconds 25 or 1'.

262

None of the negatives from this first series has been preserved, but there are two negatives of a quite different, experimental character, of the format 4 × 6.3 cm, which would give the print the size 9 × 14 cm. They are probably from the Kodak Vest Pocket Camera which today is preserved in the Preus Fotomuseum (265).[1]

In one of these photographs Munch sits in his big cane chair at the foot of a bed (266). Before him is an enlarged projection of his cheek, chin and mouth. The camera did not have an automatic release, and the effect has most probably come from Munch's getting up and looking into the lens at close quarters before ending the exposure, which was similar to the procedure used for his self-portrait photographs of twenty years earlier.

Munch is sitting in the cane chair that can be recognized in a set of paintings of the ageing artist and his model painted from 1919 to 1921. The bed looks like a hospital bed and suggests thoughts of illness and death. The other small negative of the format 4 × 6.3 cm shows a woman, most likely Munch's housekeeper, standing in front of a doorway leading into a brightly lit room with another door (267).

This formal build-up – a room leading to another room, which is lighter than the first room – is repeated in the paintings of the series *The Artist and his Model* (1919–21). The peculiar glow of light around the

263

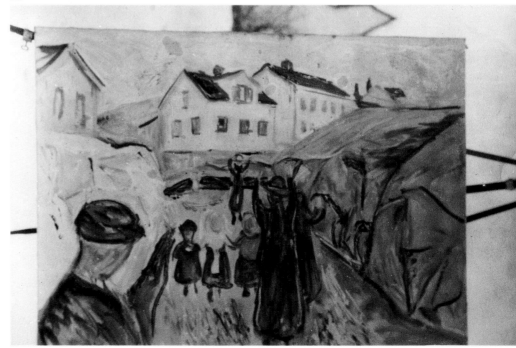

264

265

265. Edvards Munch's camera, a Kodak Vest Pocket Camera, which he used for a series of photographs in 1927. The camera is today at the Preus Fotomuseum, Horten.

266. The technique Munch used for his photographic self-portraits is here clearly demonstrated. Here it is not, as in earlier photographs, just a blurred shadow showing that he has got up and left the frame of the picture. It is obvious that part of the face, including the cheeks, the mouth and the chin, is reproduced as an enormous shadow on the wall where the portrait study *The Assyrian* is hanging. As in one of his Fatal Destiny Photographs from *c.*1906 (182), he photographed himself against a bed, which invariably leads to thoughts of illness and death.

267. The apparently unsuccessful photograph of the housekeeper may have been intended as a companion picture to the photographic self-portrait. See also (285) and (286).

housekeeper has a faint resemblance to the lighting in the photographs of the nurses in Munch's room at the clinic in Copenhagen. Even if the result is not quite successful, there is the question of whether this is not a deliberate repetition of a photographic experiment. Judging from the preserved photographs Munch seems never to have used this camera again.

The following note may indicate that Munch made experiments with another camera, but neither prints nor negatives have been found to fit such a camera:

The subject, right and flowing, on the glass plate – Mind the weather – mind the distance – mind the size of the lens – (the smaller the lens, the longer the time). Mind the plate being put in – Mind the lens being closed – Mind replacing the plate after taking – then out with the film.[2]

It was quite a surprise when a moving picture camera was brought to the

266

267

268–80. Edvard Munch's moving picture camera, together with a selection of the films he made in the summer of 1927 in Dresden and Oslo and at Ekely using his small Pathé-Baby camera which he probably acquired in Paris that same year.

268

269

271

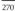

270

Munch Museum several years ago. It was a so-called Pathé-Baby with a 9.5 mm film cassette and a projector in a specially made traveller's case (268). The advanced amateur camera was said to have belonged to Edvard Munch, a fact confirmed by a viewing of the four accompanying films, which had originally been developed at Nerlien's in Oslo. A small plate inside the camera is inscribed: 'Exportation de cet appareille hors de France et colonies est formellement interdite',[3] which would indicate that Munch either bought the camera in Paris and smuggled it out or acquired it illegally outside France.

In connection with Munch's Exhibition of Honour at the National Gallery in Berlin in the spring of 1927 he went on an extended trip to the Continent, during which he also visited Dresden before returning to Oslo in May. One of the cassette films was taken in Dresden, the other three in Oslo and Aker. All the shots seem to be from that summer.

The film from Dresden can be identified from the shots from the Schlossplatz overlooking the river Elbe and of the equestrian statue of the Saxon King Albert. This is obviously Munch's first experiment in cinema; and the film consists mainly of brief sequences from the centre of the city. Munch seems to have been fascinated by the street life. The camera has captured tramways, cars (272) and horsedrawn carriages running in all

272

273

274

directions, dwelling on the crowd of people passing in the street, and focussing on a man and woman laboriously shifting a cart (269–71). It is characteristic of the reel that most people have their backs turned, suggesting that they were unaware of being filmed; Munch probably sought out places from where he could film in secret.

The next film was mainly taken in the garden of Ekely, where Munch's old terrier is lying in the sunshine (273). Munch thought, according to Christian Gierløff, that 'the soul of an old wise man had taken its place in the dog'. The film sweeps over the landscape and captures a building in the neighbourhood (274).

The next scene is of Dronning-parken, and then from in front of the Palace, but most of the film was taken at and around Karl Johan Street, where Munch was again fascinated by the busy traffic and, just as he had lingered on the couple with the cart in Dresden, this time he followed a couple of sturdy women, who were working in the park, for a longer time.

In Studenterlunden he put down the camera, started filming and moved into the picture space himself. He moves towards the camera to stop the film, but fumbles with the camera, which seems to have turned over.

In the third film he moved to the eastern side of Karl Johan Street, where he stood outside Kirkeristen filming the busy street life (275).

275

276

277

Munch filmed people rushing about and cars passing by, panning through 180 degrees. He seems to have wanted to capture the pulse of life by moving the camera. He also created contrasting scenes: he stops at a menu-card at the entrance of a restaurant (276), just as he stops at an oil and colour shop to film the display through the window (277).

The fourth film shows, in sweeping movements, parts of Solveien at Nordstrand, where his aunt and his sister lived. Inger's statuesque figure is seen and in a brief moment the head of his aunt fills out the whole picture. A longer close-up sequence of a fence rail is taken with an 'Impressionist' approach.

The last part of the film is of Munch himself at the foot of the stairs at Ekely. Munch enters from the right, approaches the lens, bends down and gazes directly into the lens (278–9). After this he gets up and walks slowly out of the picture. Parts of his body – for instance, a longer shot of his jacket with his handkerchief in the pocket – fill out the picture, giving the scene the sense of a radical experiment (280).

Such short close-ups had been discussed by Fernand Léger the previous year in his article 'A New Realism – The Object: Its Plastic and Cinematic Value'.[4] However, the closest source of inspiration is probably experimental film, which Munch must have been exposed to during his many travels abroad in the years 1925–7.

168

278

279

280

The Russian film artist Dsiga Werthoff was very much in vogue in this period, having already, in a manifesto in 1922, launched a new kind of documentary film: instead of using a plot the artist should convey impressions of reality through a new kind of rhythm like that of a musical composer. One of Werthoff's best-known works, *The Man with the Cinema Camera*, was built up through street scenes, deliberate blurring through movement, double-exposure effects, such as shots through windows, and stopping at, for instance, a poster to give the effect of a still life.

Munch seems to have tried out exactly the same kind of effects, and his camera was especially good for such sequences. Werthoff was the first film artist introduced in *Das Kunstblatt* (May 1929); perhaps his style was viewed in unison with the programme of The New Objectivity.

From the exchange of letters between brother and sister it can be seen that Inger became increasingly interested in photography. She participated in the competition for amateur photographers arranged by the Kodak importer Nerlien, in the late winter of 1927, with photographs taken outside Akershus. Her ambitions had obviously increased. Half a year later, in the autumn of 1927, Munch wrote to her: 'You ought to photograph a couple of pictures from Pilestraedet – Olaf Schous Plads, and also from Fossveien.'

169

281

Many photographs taken by Inger from places where the family had lived during her childhood have been preserved. A few of these were chosen by Jens Thiis for his 1933 biography of Munch, but without naming the photographer. One was from 7 and 9 Fossveien, and the other from Schous Plass. Jens Thiis also chose one of Munch's photographs from the entrance to 30 Pilestredet, where the family lived during the years 1868 to 1873. Munch's more intense photograph distinguishes itself from Inger's rather matter-of-fact photograph.

As a postscript to the letter mentioned above from the autumn of 1927, Munch wrote: 'Sometime you should come out here and teach me photography –.'

The sister may well have been pleased with the invitation to come out to Ekely and visit her brother, who otherwise kept her at a safe distance. Whatever happened, Munch acquired another camera, and this time the format of the negative was 8.3×10.8 cm. He took many photographs with it during the following years. The first were of Ekely after a heavy snowfall around New Year's 1928. These photographs show a refined sensitivity to nature.

Two of the photographs are complementary, in the sense that Munch must have stood in approximately the same spot in front of the house at Ekely and photographed in two different directions. One shows the

170

gardener's red lodge and the birdhouse to the left in the foreground. The afternoon light gives a shining depth to the picture, as if it had been taken against the light. The other subject is a view towards the main building with the studio in the background. Munch has moved a few steps so that the birdhouse is here seen to the right. And the camera was held somewhat lower, obtaining a more interesting vantage point. Munch had the two photographs copied as postcards and sent one to Inger in January 1928 (281) with the following words: 'Here you see the gardener's house at Ekely in the snow – You can make such postcards yourself. They cost 30 øre apiece.' The other postcard, on which Munch has drawn himself with a cigarette in his mouth with one of his dogs playing in the snow, was intended for Ottilie Schiefler (282).

His old terrier is depicted in two photographs from the glass-covered veranda, one of which shows the seventeen to eighteen-year-old terrier in an exaggerated close-up view, the long-haired old dog gazing at its master with sad eyes.

A third winter subject, which also reveals experimental composition and lighting, is a close-up of the veranda from the garden side of the house (283). These three landscape photographs are marked by a lyricism which is also seen in some peculiar, luminous, watercolour-like paintings from the same vantage point.

Two other photographs of a more experimental character may also have been taken during this winter. In one of the photographs Munch can vaguely be distinguished in a room dominated by a big door, drawings hung on the walls, a mirror and an easel bearing a canvas of a still life of vegetables (286). The photograph reinterprets the earlier, melancholic Fatal Destiny Photographs. The drawings are seen through his transparant head; his presence seems rather unreal in the room. However, Munch does not

282

283. The covered veranda of Ekely in the snow. The staircase is the same as the one seen behind Munch in (260).

284. *The Human Mountain* in the open-air studio, photographed by Munch. In the years 1926–9 Munch was working on a monumental version of *The Human Mountain* – a continuation of *Towards The Light*, which was the first study he sent to the Jury for the murals for the Festival Hall of the University in 1910. A series of photographs taken by Ragnvald Vaering documents how Munch built up a monumental subject by means of a peculiar patch technique. Many of the 'patches' became independent paintings. One may wonder if Munch did not plan a photographic, thoroughly well-illustrated autobiography in which he would explain his working methods in detail.

284

appear to have been motivated to continue his experimental photography; and five years were to go by before he again created a coherent series of self-portrait photographs at the time of a serious eye disease.

The other photograph depicts the housekeeper in a doorway (285). Her shadow is cast on the door and her head and upper body are reflected in the polished surface of the table. The woman's simple and trustworthy appearance in the photograph may relate to the photography of August Sander, whose portraits of everyday people were published in 1929 under the title *Anlitz der Zeit*.

In the New Year Munch wrote in a longer letter to Inger:

I will very soon bring you some German magazines filled with photographs – It is considered a kind of art . . . – You have become an excellent amateur photographer and you can progress much more. Everybody to whom I have shown your photographs thinks that they are are so well done.

283

The magazines which Munch planned to show his sister were probably copies of the German periodical *Das Kunstblatt*, to which Munch had subscribed for years. Whereas it at one time used to deal only with experimental photography by advanced artists such as Man Ray, in 1929 it opened itself up to more naturalistic photography, and this was presented as an independent art-form on a par with other pictorial arts.

The New Objectivity had its breakthrough at this time in Germany, a movement which was the first to put photography on the same footing as painting. A major theme in this new, objective style of photography was the recording of industrial scenes and workers. Several exhibitions with such documentary photographs, for instance from the Ruhr district, went from one major museum to another in Germany in 1929. It was probably the many features on that theme in *Das Kunstblatt* that encouraged Munch's sister to explore her straightforward photography of the industrial surroundings of the river Aker.

Another central theme, which appeared in *Das Kunstblatt*, was the relation between photographic and painted portraits, such as in a special thematic issue in March 1929, in which the introduction, written by the painter Ludwig Meidner, was illustrated by the works of Otto Dix and Edvard Munch.

Approximately one year later *Das*

285. A disarming photograph of Munch's housekeeper in the doorway reflects the famous photographer August Sander's portraits of everyday people. At the same time as being the subject of a portrait, she is – just like the people in Sander's portraits – a representative of her class. Munch has used the reflection of the table, perhaps recently polished by the housekeeper, to draw attention to the subject.

286. A transparent, shadowy Munch in front of one of his many colourful still lifes from this period. The photograph may have been intended as a companion picture to (285).

Kunstblatt arranged its own exhibition on the theme of art versus photography, which resulted in a special issue in which a graphic work or a drawing was illustrated next to a photograph of the same model. Several of the most prominent artists of the time were represented, among them Edvard Munch, whose etching of Gustav Schiefler was juxtaposed to a very similar portrait photograph of him (122). On the opposite side was Otto Dix's portrait photograph of his daughter Nelly, along with two of his etchings of her.

It was most probably this special issue that led Munch to pen a longer memorandum about portraiture and photography, in which he also refers to Otto Dix. The memorandum

285

was intended for *Kunst og Kultur*, the Norwegian equivalent to *Das Kunstblatt*:

I suggest that you debate the question: portrait photographs – portrait paintings – The first condition is that it must become art – the second condition for a portrait is that it should not look like the model – I ask him to go and see a photographer – Then resemblance is permitted – I add, it is quite difficult for an artist to avoid resemblance . . . I can therefore understand and admire Dix who must be looking for artistic resemblance – The mechanical portraiture by a cautious hand can give fine results –
The answer is always – No, I want a work of art –
– Well, then you will have to find a work of art –
– But that is not done – The painter is supposed to see like a camera –
– You ought to see the model just as he sees himself – just as, in a thousand secret moments during the span of a year, he has seen himself – as his tailor has seen him – and wanted to make of him –
– as his loved one has seen him – (as his mother has seen him) and as his many cousins have seen him . . .
– He must appear as the people have seen him on the platform – if he is a well-known official man – Not just as the artist sees him – Not just as the image resulting from the first immediate glance which is the first condition for making a work of art at all – What would be said if the poor painter wanted to paint a flock of geese – and they all of

286

a sudden cried out that they did not want to be painted like that –
– Or imagine a painter who while enthusiastically painting a red house in the countryside suddenly hears the house calling out through its gate – I do not look like that – I have finer lines and colours – I do not look like that.[5]

In the extensive exhibitions of Munch's art, first in Munich in 1926, later in Berlin and Oslo in 1927, his recent works were prominent, and the

287. *Self-Portrait with Brush and Palette*, 1925.
The painting shows a symbolic version, in the New
Objectivity style, of the artist with his brushes and
palette, in front of his studio on his own estate. This
traditional building was replaced in 1929 by a brick
building which Munch called his winter studio.

288. Munch photographed by Ragnvald Vaering in
the autumn of 1933. Munch was pretending to paint.
In the centre of the photograph is the portrait of the
former Prime Minister, Otto Blehr. The big staircase
to the right led to the newly built winter studio at
Ekely. Munch added another studio to the side of
this building, the outer wall of which is seen in the
background. Here he hung his paintings, to be aired
by wind and weather.

288

portraits attracted attention, as they
were fine reflections of the new,
radical, objective style which was the
leading movement in German art
until Hitler's assumption of power.

The most prominent paintings were
Self-Portrait with Brush and Palette,
from 1925, and the double-portrait of
Jappe Nilssen and Lucien Dedichen
(1925–6), the latter being a painting
with an obvious photographic ap-
proach, both in composition and in its
overall grisaille. The painting almost
represents a programme for the new
objective style. In *Self-Portrait with*

287

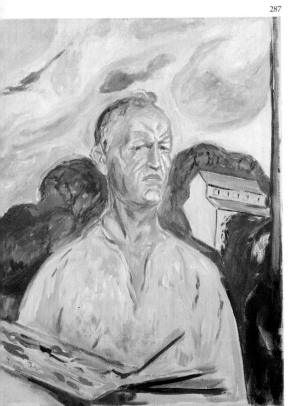

Brush and Palette (287) Munch stands
outdoors, energetic and natural in the
sunshine, wearing an unbuttoned
shirt. He is dazzled by the sun, while
the blue sky with floating clouds and
the fresh green trees are seen behind
him. The brush and palette relate to
the manner in which the New Objec-
tivity shows people and their tools in
their working environments. Behind
the artist's figure stands the charac-
teristic studio building, which three
years later was replaced by the winter
studio.

After the exhibition this painting
was purchased by the Kunsthalle at
Mannheim, the institution where the
new movement had established itself
at an exhibition in 1925. At this
exhibition the most prominent
painters were George Grosz and Otto
Dix, artists with a clear affinity to the
new objective photography, presented
by August Sander.[6]

In this connection it can be men-
tioned that Sander's famous double-
portrait photograph of Otto Dix and
his wife (1928) must have been
inspired by Munch's lithograph of
Walter Leistikow and his wife from
1902. Otto Dix also 'quoted' Munch's
previously mentioned self-portrait
when painting his *Self-Portrait with
Brush and Palette* in 1931. Munch was
again popular in Germany, which is
most easily explained by the New
Objectivity having refocussed the
emphasis on Munch's art.

A new objective style can also be

observed in the portrait of the former
Prime Minister Otto Blehr, which was
commissioned from Munch on the
occasion of the Prime Minister's
birthday, on 17 February 1927.

The newspaper *Dagbladet* reported
that friends in politics would honour
Blehr 'by having his portrait painted
by Edvard Munch, which probably
would end up in the gallery of Nor-
wegian politicians in the Parliament'.
However, Munch went away to the
Continent in order to be present at the
extensive exhibition of his works in
Berlin, and work on the painting was
not continued until May, some time
after he had returned. Blehr wasted
away and died, so seven years were to
pass before the painting was placed in
the gallery of Stortinget.

The portrait of Otto Blehr (290) is
characterized by a down-to-earth
heartiness; he stands broad and jolly,
mouth open and a cigar in his hand, far
from the elastic vitality which chara-
terized the portraits of Thiel and
Rathenau, painted twenty years
earlier. Something new has been
added, related to the new trends in
art represented by Otto Dix, a matter-
of-fact realism.

A comparison between Munch's
portrait and August Sander's photo-
graphy shows to what extent the
portrait represents an approach to the
New Objectivity movement. Both
carry the same relaxed attitude,
deprived of all pomposity.

Even if Blehr is known to have sat

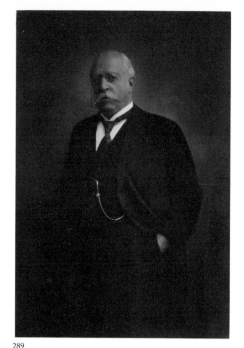

289

289–90. Munch possessed two photographic portraits of the Prime Minister, Otto Blehr, both taken a few years before 1927, when he was commissioned by Blehr's political friends to paint a portrait to be hung in Stortinget. However, seven years would pass before the painting was finished.

for Munch several times, two photographs exist which Munch undoubtedly used as aids (289), first for a lithograph of Blehr's head, then for the transfer to canvas. In this way he retained the resemblance he sought through a masterful process of simplification. On the occasion of a trial hanging in Stortinget, Munch wrote about the portrait:

If it lacks in resemblance it has the breeze of salt sea and fresh air from a blue sky which surrounded him and so many of the men from 1905 – Michelsen is quite a good portrait but it seems monstrously large up on the wall – In the other room are the black paintings from the Inquisition in Spain, the judges on one side, the tortured victims on the other – The salty green blue colours in my painting ventilate the room well – I am always afraid of hanging in rooms with such collections – they seem to me like mortuaries with all those portraits on the wall –.[7]

In a photograph, presumably from 1932, which was also used as a postcard, Blehr's portrait is placed outside together with other paintings against the high walls of the winter studio (288). This painting was probably also exposed to Munch's 'horse cure': the paintings were hung outdoors in order to obtain a certain patina, in this case, perhaps, to diminish 'the breeze of salt sea and fresh air from a blue sky', so that it would fit in with the other paintings in Stortinget.

174

Munch's new realism derived from the New Objectivity style may have made him reflect on the relations between painting and photography. He differed greatly in his use of photography from the painters of the New Objectivity who submitted their painting to photography, giving it a photographic appearance. It was then he made his famous statement:

The camera cannot compete with brush and palette – as long as it cannot be used in Heaven or Hell.

This statement is taken from his booklet *On the Creation of the Frieze of Life* (1929), but it was printed in different versions, and one of these Munch dated to Berlin *c.*1904. All the preserved drafts can, however, be dated to 1927–9, when Munch collected and edited his own notes, intending to publish them.

This was, however, never carried out, as a blood vessel burst in Munch's right eye in May 1930 and caused a reduction in his eye sight. His left eye was already very weak. When the eye improved in August, Munch recorded the further progress of his eye disease in a set of peculiar drawings (291–7). The results are partly concentric circles, often painted in bright watercolours, but the spot of the eye also develops into a death's head and an enormous vulture, indicating how fear dominated his perception of subjective vision.

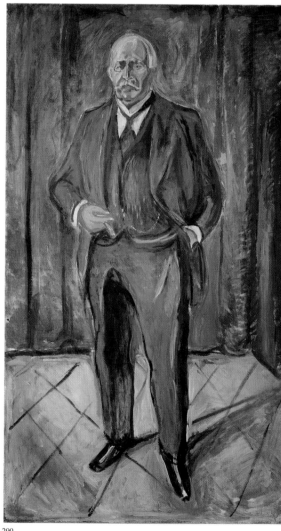

290

According to Munch's own notes on some of these drawings, he worked very systematically. First he covered his damaged eye for some time, after which he stared at a piece of paper, often wearing glasses of varying strengths, and eventually blue lenses.

291–7. Watercolours and painting showing Munch's optical illusions after his eye disease in 1930. Among other things, he projected the picture of his damaged cornea directly on to the paper using the lenses of his own eye as a magic lantern. The results are the abstract figures, such as those of (291), and the caustic, threatening figures with the heads of birds. (292), (294) and (295) also show how Munch covered his left, sound eye in order to visualize the inside of the damaged eye.

292

291

293

The distance from the paper, the kind of light (sunshine, shadow or electric light) were noted. Or he would stare at a specific object (a telephone pole, a group of people, or just some object in his room) on which the projection of his damaged cornea would show up as a three-dimensional shape.

In this manner such paintings of an apparently non-figurative image arose, with elements of irrational figures and shapes, but in contrast to most abstract art, this is clearly seen by the living eye. One motivation for Munch to create these paintings might have been a wish to describe his symptoms for the benefit of his eye specialist, Professor Johan Raeder, but the results are peculiar and imaginative works of art.

A longer note makes it clear how analytical and reflective Munch was in describing his own disease:

There are dark spots which show up like small flocks of crows far up when I look at the sky – Can they be blood clots which have been resting in the periphery of the damaged circular part – which by a sudden movement or by the effect of sharp light are moved from their origin – When they suddenly disappear it looks as if they fly down to their first place – Can it be caused by the liquid of the circle having absorbed or replaced them – The black object which seems to spring from the iris can be a group of black particles, which takes ten minutes to disappear.

When the particles are elsewhere on

176

294

The watercolours (293) and (296) were painted on the same day, 20 September 1930, according to Munch's own inscription. He also made the following notes: 'After covering damaged eye, 20th September 30. At a distance of half a metre from the white door. Electric light.' In other cases he also noted the distance between the eye and the paper, plus the type of spectacles. The methodical procedure is similar to the manner in which Munch tried out a camera at approximately the same time (see 262–4). In (296) the optical illusions are shown as a floating, transparent circle above the roof of a house. In the circle there is a figure resembling the Phoenix. In the painting (294) the artist is standing in the background, naked with his back turned to the window, between the clock and the bookshelf in his studio, whilst the optical visions have become a threatening shadow with a bird's head, in the foreground.

296

the periphery the circle seems clearer and redder, or the beak and the body of the bird are seen clearer.[8]

As related earlier, Munch had already suffered from disturbing visions when painting *The Sick Child*. Approximately a decade later Strindberg made notes of some unusual visions as a basis for an essay entitled 'Confused Impressions'. Some of these are as follows:

I get up, look at the white marble fireplace and visualize there a net of blood-red threads. Those are the retina of my own eye, which is projected enlarged there – is this a discovery nobody has made before me?

I dose off for five minutes, and when I open my eyes again I see a begonia with red and white quivering flowers . . .

What was that?

The blood vessels of the cornea together with the red and white blood corpuscles seen at a distance in an enormous magnification . . .

Is it not the tears and their corroding salts which have prepared my cornea so that it was possible for me to see my own blood vessels projected as in a magic lantern?[9]

295

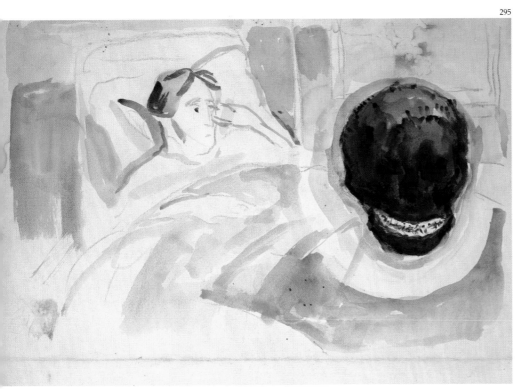

297

177

299

300

298–304. Photographic self-portraits from the garden of Ekely, taken by Munch holding the camera in his outstretched arm.

During his convalescense after the eye disease, perhaps at the same time as he worked with the projections of his damaged eye in watercolour, Munch took a set of self-portrait photographs in the autumn of 1930 and the following year in and around his house at Ekely, in which he poses with or without hat or glasses. The photographs generally convey the image of a vital and self-assertive artist. Most of them were taken in very close proximity – the outdoor photographs mostly by holding the camera in his outstretched arm, which has resulted in a fairly low perspective and more or less unfocussed features (298–304).

The photographs taken outdoors in the sunshine are peculiar, concentrated self-portraits. As in his Kragerø period after his stay at Dr Jacobson's clinic, he meets the sun as a life-giving force after a long and serious illness. In a way Munch again assumes the same kind of vitality that characterized his *Self-Portrait with Brush and Palette* from 1925. He acts in front of the lens, throws his head back, enjoying the sun, with his eyes closed and with a faint smile. His chin is protruding and it gives him a forceful and somewhat arrogant expression.

The special presence conveyed by the photographic medium makes the photographs personal documents which distinguish them from the self-portrait paintings. This is best seen by comparing the photographs with the lithograph *Self-Portrait with Hat*,

which Munch made at the same time. Concentrating on the eyes and the mouth the lithograph conveys both rejection and shyness; in contrast to the close-up view in the photographs the lithograph expresses a solid distance from the subject.

Whereas the series of photographs taken in the sunlight are deprived of any iconographic symbolism, the contemporary self-portrait photo-graphs from indoors, in which Munch posed against his works of art, are clearly symbolic (305–11). In one of these he sits, hand under chin, in front of a large watercolour, the so-called *Family Tree*, the fruits and branches of which are withered. The fruits are symbolic portraits of his parents, sisters and brothers and himself. While moving in order to finish the exposure, Munch has created a double-exposure effect, so that the tree seems to shine through him.

This series of self-portrait photo-graphs has an intensity which indi-cates that Munch again wanted to experiment with photography as a means of artistic expression, as in the earlier Fatal Destiny Photographs. Perhaps it was caused by his fear of not being able to paint because his eyes were so weak. He concealed his bad

303

304

eyesight from his friends, but from his notes it can be seen how anxious he was not to lose his eyesight. His peculiar kind of photography did not even demand scrutinizing the subject, and as such did not tire his eyesight.

That Munch was inspired by the modern portrait photographs of the time, often taken from radical angles and deliberately unfocussed, cannot be ignored. Those were varied, from Moholy-Nagy's famous portrait of Mayakovsky (1926) entitled *Big Shape against Light Background*, a photograph of fascinating similarity with Munch's self-portrait wearing a hat (298), to Hemar Lorski's many well-known portrait photographs, published in *Das Kunstblatt*. Munch may have thought that such techniques of photography as he used in his early experiments had now become a modern means of expression to which he again could contribute.

An interview with Munch by the Danish author Hans Tørsleff, until now ignored, which was published in the German magazine *Die Dame* in November 1930, throws new light on Munch's last phase as a photographer. Tørsleff asks if the young German painters, such as Nolde, Nacke and Pechstein, are influenced by him. Munch answers:

What do I know! They have most probably learnt from me. But have I not, on the other hand, learnt from them? As a whole we have all learnt from one another. One can learn from the most peculiar things.

I have, for instance, learnt much from photography. I have an old box with which I have taken many photographs of myself. It often produces surprising effects. When I am old and have nothing better to do than work on my autobiography, all my self-portrait photographs will see the light of day.

Presumably, 'the old box' Munch mentions is one of the cameras he acquired in 1926. At this time Kodak had a box-camera on the market of the same size as Munch's. It is in line with Munch's whole artistic production, such as it is known from paintings and graphic works, that he used the simplest tool to capture the most convincing expressions.[10]

The fact that Munch mentions an eventual autobiography with photographs makes one wonder if all his photographs were not taken and preserved with that intention, whether he was the photographer or not. There is, for instance, a set of photographs of different stages of the massive *Towards the Light*, which clearly demonstrates his working methods, very suitable for illustrating a book about his own life as an artist.

A smaller number of photographs of an oblong format are most likely from Inger's camera, taken in the period

310

305–11. Self-portraits in the interior of the studio show the then seventy-year-old artist in front of a number of his works, including *Marat's Death* (307), a study for *Alma Mater* (308), a scene from Karl Johan Street (308), *A Childhood Memory* (with his mother) (309), and *Youth on the Shore* (from the Linde Frieze) (309). altogether a kind of cross section of his life's work.

1931–2. The pictures of relatively overfilled studios, intriguingly framed, create a dense spatial effect.

In one of these photographs Munch's jacket is seen as he is passing the field of view of the camera (312). It is unlikely that the matter-of-fact Inger was responsible for such a composition; Munch had probably wanted to experiment with the camera.

Among these photographs is also one that is difficult to interpret, which must have been taken by means of a double or perhaps triple exposure (314). It is similar to an expressive self-portrait in which Munch is standing in front of his painting, placed against the wall of the winter studio (313). Standing under *Material Transfer*, Munch appears indistinct and out of focus, the lens having focussed on the wall behind him. His translucent face acquires a demonic force. The result is a self-portrayed showing that there still is youth and energy in the ageing artist.

Another subject shows the artist in his cane chair; behind him is a reflective wooden screen with a watercolour painted during the time of his eye disease. The watercolour shows the artist lying with a hand over one eye. A death's head seems to be a projection from his inner eye. The watercolour also seems to shine through him. Whereas such effects in the earlier Fatal Destiny Photographs reflected the artist's feelings of melancholy and alienation, Munch

311

312–14. Three photographs, taken with his sister Inger's camera, but probably shot by Munch himself. These are from the big central room in the winter studio. Some of the paintings from the earlier Friezes of Life are hanging on the wall as a frieze, and on the floor are, among others, *Mother with Child*, from c.1907, and *Self-Portrait with Hand under Chin*, from 1911. Otherwise, the quantities of paint (313) show that Munch was working comprehensively, and the electric heater indicates that this was taken during the winter months. (313), where Munch is standing in front of *Material Transfer*, is one of the most peculiar and expressive of his later photographic self-portraits. The same painting is seen on the wall in the almost 'abstract' photograph (314). It is probably Munch's head that fills most of the space.

312

here seems to show how much he identifies with his artistic work.

Munch's series of self-portraits at Ekely has a counterpart – of a more conventional character – in a series of six preserved photographs of engineer Fritz Frølich, studies of minute

differences in pose and facial expressions, which Munch took in connection with a portrait. Frølich sits in the same cane chair as Munch did in his self-portrait photographs.

Judging from Frølich's clothes the photographs were taken at two

different times (315–16). It was mainly the position of the hand which was varied in the photographs: he sits with a match in his left hand and points to it with his right. Munch probably wanted to emphasize that Frølich was the director of a match

313

314

315–16. Fritz Frølich sitting for Munch in a corner of the winter studio. To the left on the wall behind him is the large painting *The Sacrament*, showing the Rev. Horn at the death of Munch's father (46).

317. *Match Manufacturer Fritz Frølich*, 1930–2. The painting was photographed several times by Munch while being painted, and is thus one of the few examples showing the development of one of his works. In the background of the painting are flasks, fizzing with sulphur which, together with the match Frølich is holding, indicate his profession.

317

factory. Munch likewise varied the positions of the hands in the woodcut he made of the director. One of the woodcuts was transferred to a canvas, which became the basis for at least one of the portrait paintings.

The series of portrait photographs of Frølich is in itself unique in Munch's work as a photographer, since from the basis of his photographs he first created a colour woodcut, then transferred it directly to the canvas as a basis for further painting. The series of portrait photographs therefore also marks a step forward in the artistic development of Munch, who – at the age of seventy – was attempting to revitalize his portraiture in such a manner.

Similar to Blehr's portrait, a pair of late portraits have their basis in professional photographs. In these cases Munch obviously instructed the photographer Ragnvald Vaering to photograph the models in the exact pose and surroundings he wished to use for their portraits. This was the case for bank director Nikolai Rygg (1938), who was photographed at Munch's work-table, his arms in front of him on the table (318–19); and for the art dealer Rolf Hansen, who was shown seated on a bench in the garden at Ekely (320–1). In Inger's last photograph of her brother, when he was lying dead in his coffin in his studio, this unfinished painting was on the easel in the background.

Apart from a couple of self-portrait

318–19. Ragnvald Vaering took two photographs of Nikolai Rygg in 1938 at Munch's table at Ekely, which Munch undoubtedly used for his portrait of him. Nikolai Rygg was a chief executive for Norges Bank when he was painted by Munch. He wrote an article on the hours he sat for Munch, in which he tells how they exchanged many thoughts about politics, religion, life and death. Munch quoted in German, from Goethe's *Faust*, the main character of which he compared with Don Juan from Kierkegaard's *Diary of a Seducer*, thinking of their respective seductions of an innocent girl. Besides this, Munch showed a particular interest in Socrates from Plato's Dialogues.

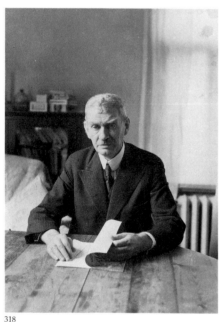

318

photographs taken indoors, nothing indicates that Munch was experimenting during these years. Experiments with double exposure, which had been extremely radical in his early photographs, were now standard techniques in photography. He took photographs of many of his paintings and watercolours, such as the subjects that were intended for the Town Hall in Oslo, and the study for *The Split Personality of Faust* (324) with the philosopher Eberhard Grisebach as Faust and his new lovely model Hanna Brieschke as Gretchen.

After his eye disease Munch returned to sculpture: there were new studies for the National Monument which he worked on at Kragerø in 1909, as shown in a photograph (235),

319

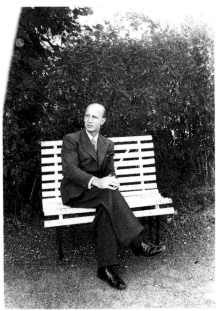

321

320

plus a new version of himself sitting on a chair among books and notepaper. This subject had for a long time occupied him in his sketchbooks. In two photographs, taken by Inger's camera, it can be observed how Munch used a normal wooden kitchen stool as a base for the clay figure. On one of the photographs Inger has written 'Edvard Munch', indicating that she ascribed the photograph to him.

Later in the autumn of 1932 Munch took two more photographs, with his own camera, showing the seated clay figure for the sculpture, now lying on a box tied up with wire. In one of the photographs the back wall of the winter studio is seen, which, together with the long shadows, contributes to

322. *Dr Schreiner*, 1932–3, photographed by Munch. The photograph is a collage representing a dissection, in which Dr Schreiner, the professor at the Anatomical Institute, is dissecting the artist. According to Dr Schreiner, Munch asked to see the mortuary at the Anatomical Institute, though he would have Schreiner posing afterwards in the humid basement of Ekely, with its 'Rembrandtesque light'.

323. *The Split Personality of Faust*, photographed by Munch in his outdoor studio, probably in the autumn of 1932. The painting is a collage in 'monumental' format. The model for the two identical men is the German philosopher Eberhard Grisebach, Munch's friend from Warnemünde in 1908, who visited Ekely in 1932. Munch used his young model Hanna Brieschke as Gretchen, who is holding a clergyman's ruff in her hand, exactly as described in the stage directions for the scene, The Garden. The pitch-black poodle, which constantly accompanies Faust and Mephistopheles, is here made by a paper cut-out.

324. *The Split Personality of Faust I*, 1932–5. The final version of the theme, where the split personality of man is painted, uses an almost too clear technique of 'double exposure'. The man and woman behind the double image of Faust probably illustrate Mephistopheles and Martha.

the intensity in the photograph (325). This is not unlike the effects Munch obtained in his photographs from the back yard of 20 Pilestredet in 1902. In the other photograph the figure is lying down as if frozen in rigor mortis (326). This impression is reinforced by the dramatic lighting, as well as by the exaggerated diagonal composition. This diagonal pose relates, once more, to the theme of *Marat's Death*, by which he was still occupied, and to the new death theme of himself on the autopsy table (322) in *Dr Schreiner Performs a Post-Mortem Examination* (1932–3).[11] Behind the sculpture is, as a contrast, the plaster cast for *Workers in the Snow*, which was cast in bronze that same autumn.

Finally, there are three more photographs which seem to have been taken

322

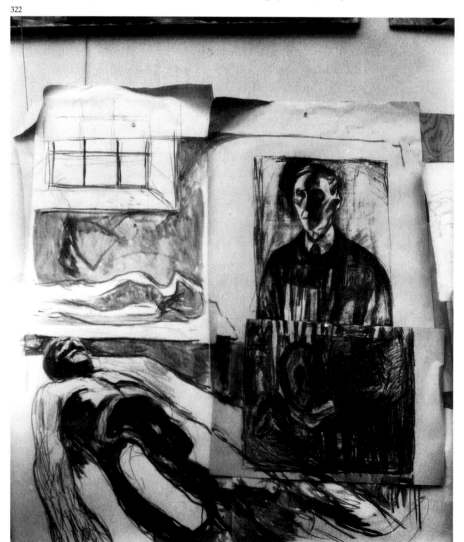

323

324

325–6. The sculpture was originally seated in a chair, and was probably supposed to illustrate Munch reading and writing, just as he had depicted himself in many drawings. By reclining the sculpture, Munch probably wanted to indicate that he had abandoned the completion of the work. At this time he also abandoned the idea of publishing his own literary works. The sculptures, *Workers in the Snow* and *Weeping Girl*, were cast in bronze that autumn, but the rest of his sculpture projects were hidden away.

327. Munch in front of the sculpture of himself in the garden of Ekely.

327

with Munch's camera, showing Munch among his sculptures in the garden (327). One, known from a postcard sent to Gustav Schiefler in February 1933, shows him posed between the sculptures of himself and the one of *Workers in the Snow*; in the next he is looking at his study for the National Monument. It is, however, difficult to see if Munch has set the scenes up himself.

325

326

189

Epilogue

328. Munch in a cane chair on the veranda in front of a drawing on canvas of the portrait of Henrik Bull, taken just before Munch's seventy-fifth birthday.

The manner in which Munch presented himself throughout his life in official photographs is a good supplement to his self-portrayal in drawings, graphic works and paintings, in which he, Argus-eyed, observes himself. For the last decade of his life he registered the process of ageing, laying bare his human condition, often with an ironic touch.

It has already been noted how melancholy and resigned his image was in his photographs around the turn of the century. Later, in his Kragerø period, on the contrary, he acted with vitality, always actively painting either children in the street or the huge canvases which were to decorate the new Festival Hall of the University. Munch seemed indefatiguable in his creativity, and this is how he presented himself both in interviews and in photographs.

A photograph taken by the photographer Johansen in Kragerø shows Munch, in profile, sitting on a stool in the sunshine with a part of his painting of the sun vaguely visible in the background: the artist and his art are integrated (240). From that time onwards Munch was, at regular intervals, photographed surrounded by his paintings, often pretending to be working on them. The most popular subject seems to have been Munch wandering about in the snow in his various open-air studios, first at Kragerø and later at Ekely. After the winter studio was built in 1930 this

329

330. *Self-Portrait Between Clock and Bed*, 1940–4.
When Munch painted this painting, he probably had
Christian Krohg's last self-portrait in mind, in
which Krohg painted himself sitting by a clock
without hands, a worn-out body waiting for death.
As with their respective paintings of the sick-girl
theme, Munch could be said to have quoted his
teacher again. But, as in the first case, he shows the
particular characteristics of genius which
distinguish him from the clever Krohg.

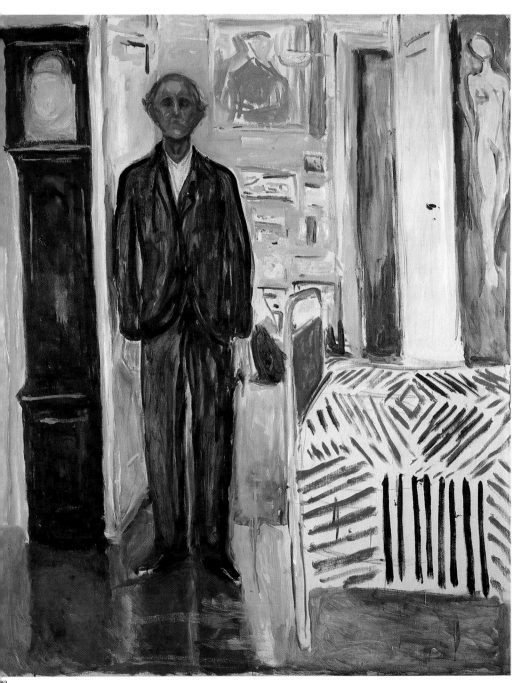

became the scene for new versions of the theme of the artist integrated with his art, often taken in connection with the artist's various birthdays.

In one of the photographs on the occasion of his seventy-fifth birthday in 1938 the artist is seen in a corner of the winter studio in front of the arched door-frame (329). On the floor are some of the paintings from the originally rejected Linde Frieze, on the wall behind him is *Death in the Sick-Room*, and to the right in the back-ground is the sculpture *Workers in the Snow*. The ageing Munch stands in a characteristic pose – feet turned slightly outwards, right hand held over the damaged left hand, and head thrown a little back – an erect and proud man ready to receive homage for the fulfilment of his life's work.

This photograph has unarguable visual similarities with *Self-Portrait Between Clock and Bed* (1940–4). The erect figure has some of the same sense of pride in both portraits. In this painting (330) Munch reflects for the first time what had been a major theme in his self-portrait photographs, the artist against a background of his own works.

A closer comparison between paint-ing and photograph reveals interesting differences. In contrast to the well-dressed man in the representative studio, the figure of Munch in the painting is standing in his private bedroom, casually dressed, without a collar, and with his arms hanging

331. In his studio, eighty years old. It was probably
this photograph which revealed his 'fatal hand'
which Munch decided should be put together with
the other Fatal Destiny Photographs, 1902–8.

loosely. The symbolism seems
obvious. He has placed himself in the
doorway between his studio and his
bedroom. To the left is a clock with-
out hands and to the right is his bed
made with a colourful bedspread. The
studio behind him is painted in a
golden light, filled with sketches and
studies and with a painting on the wall
above the table, just as the interior is
known from photographs.

But even if the background is auth-
entic, it functions here as a symbol of
his life and his life's work. The
bedroom, which is a narrow space in
the foreground of the composition, is
painted in a cool bluish atmosphere
evoking a presentiment of death. The
clock has no hands: time has come to
a standstill. The bed, which had been a
major prop in Munch's death and love
themes, looks forbidding with the
almost ritual black and red bedspread,
as if it were made for the last time; it
relates almost to a sarcophagus.

Above the bed is the lovely blue-
coloured nude, which has been
entitled *Kotkaia* (after the woman
who committed suicide in Dostoyev-
sky's short story *The Confession*). The
subject is the last version of the many
female nudes which were started in
1907 by *Weeping Girl* (194) from
Munch's evocative photograph of Rosa
Meissner in front of a bed in Warne-
münde; and it might therefore as well
have been entitled *Psyche*. The
upright nude in the painting seems to
float in the liquid atmosphere.

In the self-portrait she has, how-
ever, more the character of a small
blue flame. The model is painted
reversed compared with the original,
which is characteristic of *Self-Portrait
Between Clock and Bed*, indicating
that Munch had studied himself and
his surroundings in a mirror. The old
symbol of death, announcing its
arrival by a stationary clock, is also in
the death scene in Goethe's *Faust*,
where Mephistopheles announces the
death of Faust with the words, 'The
clock has stopped', to which the
chorus answers, 'Stands still. Silent as

the midnight watch. Its hands fell off'.

Inspired by his own experience,
Munch had earlier illustrated two
identifiable scenes from *Faust*, which
he entitled *The Split Personality of
Faust I* and *II*. One of the paintings,
which was later entitled *The Fight*,
illustrates the scene in which Faust
kills Gretchen's brother. The other, in
which Munch made a double image of
the philosopher Eberhard Grisebach
through a real and an astral figure,
illustrates the scene in which Faust
reflects over his love for Gretchen,
who in Munch's painting, just as in

331

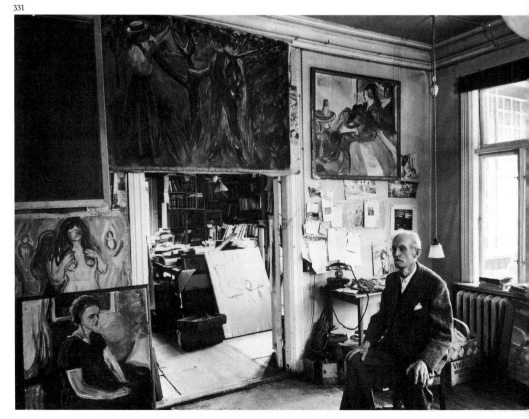

194

Goethe's text, stands with a clergyman's ruff in her hand.

So it is only natural that Munch once again found some inspiration from Goethe's *Faust*, creating a symbolic work such as *Self-Portrait Between Clock and Bed*. Analogous to the fate of the Faust figure, Munch can be said to have depicted himself against the background of his creative life, in the same way as the hands of the clock fell off just before the final scene in which the fight over Faust's soul starts between the winged Psyche and Mephistopheles. Faust's last words can be made Munch's:

The imprint of the years of my earthly life will not be erased in thousands of years. Facing such anticipated happiness I now enjoy the beauty of the moment.

The last photograph taken of Munch was probably the one he wanted 'added to the Fatal Destiny Photographs', showing him sitting on a stool (331). Here he is also surrounded by his artistic works, mainly subjects of women, hanging on the wall and standing on the floor.

In the studio next door, filled up with books and papers, is a sketch on a canvas for the recently begun portrait of the art dealer Rolf Hansen, a painting on which Munch worked until the day he died. The background is more or less the same as in *Self-Portrait Between Clock and Bed*, but reversed.

On the floor behind Munch is a mirror, which he might have used for the reversed painting. His lean old face is gazing straight ahead, while his hands are resting on his knees, showing his damaged finger for the first time in an official photograph. The grim expression is the same as in *Self-Portrait at the Window*, and *Self-Portrait with Shadow* and especially as in the watercolour *A Quarter Past Two in the Morning* (332).

He is half sitting up in his chair, his body weak, while gazing towards the light. The moonlight shines on his skull which already carries the mark of death. Behind the chair is a shadow, which, just as in a double-exposure photograph, is attached to him as a fragment of his own ego, the Angel of Death which, according to Munch, guarded him at birth and followed him as a shadow throughout his life. In Plato's words from the seventh book in 'The State', he seems to portray himself in the moment he 'breaks the chains' and 'directs his soul towards that which is the source of light, leaving behind him shadows and reflections'.

332

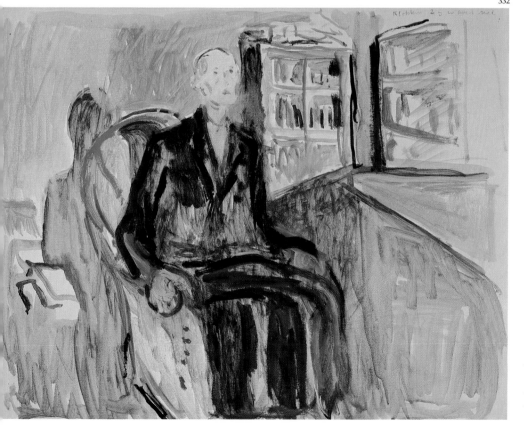

333

Oslo was the name of the Norwegian capital until 1624, when it became *Christiania* (after the Danish King Christian IV). In 1877 the Spelling was changed to *Kristiania*, and on 1 January 1925 it became again *Oslo*.

Unless otherwise stated the quoted extracts and letters (or copies of letters) are preserved in the Munch Museum, Oslo.

PREFACE

1. See Hans Tørsleff's interview with Munch, p. 181.

CHAPTER 1 (pages 9–21)

1. Laura Cathrine Munch received a photograph album as a present from her husband six months after the birth of Edvard. She thanked her husband for the present in a letter, written at Engelshaug on Whit Monday in 1864: 'I thank you with all my heart for the album, which I filled yesterday, and yet there are still many gaps left over … it was so sad that you could not participate in the pleasure of filling it.'

This album, which probably was an album for carte-de-visite photographs, has not been preserved. Another photograph album, nicely leatherbound, gilt-edged and with metal fitting, donated to the Munch Museum by Munch's sister Inger, includes places for both carte-de-visite photographs and cabinet photographs. It must have been acquired after 1866, which was the year the cabinet photograph was standardized.

2. Published in *Søren Kierkegaards efterladte Papirer* [S. K.'s posthumous writing], Copenhagen 1909–48, vol. 11, part 1, p. 80.

3. Published in *Hans Christian Ørsteds samlede og efterladte skrifter* [H. C. Ø.'s collected and posthumous works], Copenhagen 1851–2, vol. 3, p. 193.

4. Lorentz Dietrichson, *Det Skönas Verld* [The world of aesthetics], Stockholm 1873, p. 205.

5. Hippolyte Taine, *Kunstens filosofi* [The philosophy of art], Copenhagen 1873, pp. 38–41.

6. *The Pencil of Nature* (1844–6) is a collection of calotypes developed and published by the inventor of the process, William Henry Fox Talbot, with a description of the invention and some suggestions for its applications. This is one of the first books illustrated with the first mass-produced photographs.

7. The letter was dated Iselingen, 11 August 1862. Published in Georg Brande, *Julius Lange — Breve fra hans Ungdom* [J. L. – Letters from his youth], 2nd ed., Copenhagen 1898, p. 89. I have earlier discussed Lange's ideas in 'Studier i nordisk kunstteori pa 1800–tallet', thesis in art history, University of Oslo 1968, pp. 83–91.

8. *Dagbladet*, 16 March 1875. The author has also discussed Lorentz Dietrichson's importance in Norwegian cultural politics in the nineteenth century in 'Lorentz Dietrichson som kunstpolitiker under naturalismens frembrudd', *Kunst og Kultur*, 1981, vol. 3, pp. 132–59.

9. *Aftenposten*, 26 February, 11, 12 & 13 March 1880.

10. *Aftenposten*, 3 April 1880.

11. *Aftenposten*, 27 July 1983.

12. In Lorentz Dietrichson's autobiography *Syunde Tider*, vol. 2, Kristiania 1899, pp. 236–7, he discussed Knut Bergslien and his painting *The Wounded Bear Hunter*, remembering a visit to his studio in Düsseldorf in 1860: 'The immense influence which photography was later to have on painting was quite unthinkable, and I can remember that Bergstrom drew my attention to its usefulness. He said, "I have not been able to make any model pose in the right manner, then it occurred to me the other day to have myself photographed in the proper folk costume in that particular pose, and now I have captured what I intended". That was quite a new

and surprising procedure at the time. Later photography has had a revolutionary influence in art. [Hans] Gude, too, was in this period very interested in photography – he photographed formations of clouds in particular.'

(I am very obliged to Robert Meyer for having shown me this quotation. Such a clearly recognized influence of photography on Norwegian art during the period 1860 to 1880 has hardly been considered worth mentioning in later Norwegian art historical accounts.)

13. When in 1880 Munch painted his grandfather Andreas Bjølstad, who was dying (M 1094), the feeble, but very sceptical model referred to a photograph of himself, according to one of Munch's contemporary notations. In the photograph he looked as he wished to appear for posterity. In another note his grandfather 'acquired some of the same expression as in the photograph, where he was so energetic' (T 2781). A photograph of Andreas Bjølstad in which he appears firm and energetic is preserved in the photograph album, but there is no reason to believe that Munch used this photograph as a basis for the portrait.

In 1881, while Munch attended drawing classes at the Royal Academy under the supervision of the sculptor Julius Middelthun, another sculptor, Christopher Borch, published a booklet: *Optegnelser efter nogle Foredrag om Kunsten* [Notes in addition to some lectures on art], in which he maintains in the chapter entitled 'Fotografi og maskiner' [Photography and machines] that the use of photography will invariably result in distorted drawings that will not bear a likeness to the portrait drawn from life. The manner in which Munch learned to compensate for this when painting a portrait from a photographic model could be the subject of a separate study. Niels Lauritz Høyen dealt with the exhibited photographs at the World Exhibition in London (pp. 400–1) in 'Femten Forelaesninger om Kunstens Forhold ved de store Industri- og konst-Udstillinger i 1851' [Fifteen lectures on the conditions of art at the large exhibitions for industry and art in 1851], given at the Foreningen for Nordisk Kunst in the winter of 1851–2 and published in his writings, vol. 3, 1876. He thought that photography would become as important to painting as plaster casting of various parts of the body was to sculpture. Sets of photographs, taken in different lighting, of slightly changed poses could be of use to any artist.

14. The photograph was published in Oscar Thue's article 'Albertine i politilaegens ventevaerelse' [Albertine in the police doctor's waiting room], *Kunst og Kultur*, 1957, p. 97.

15. In Aaron Scharf's well-known book *Art and Photography*, London 1968, pp. 33–4, he writes about the use of photography as a foundation for painting in the chapter 'Photography on Canvas'. From the early 1860s this process was called photopainting. Scharf mentions that a common advertisement in the 1870s would sound like this: 'Enlargements made direct upon canvas at moderate prices'. Later the process was called 'linografi' and was as such introduced in *Fotografisk Tidskrift*, March 1889, a translation of a lecture originally published in *Eders Jahrbuch für Photographie*. 'Linografi' was there defined as a canvas on which a photograph was printed in order to be 'the ground under the oil painting'. It was furthermore explained that an earlier yellowish tone was due to the photograph on the canvas being waxed, which could be avoided by using gelatin. In his book Scharf also mentions another method called 'photo-sciagraphy', which was developed towards the end of 1860s, whereby a portrait photograph could be projected on to canvas or paper while the artist was working.

CHAPTER 2 (pages 25–37)

1. Andreas Aubert, 'En impressionist', *Aftenposten*, 21 December 1883 (originaly submitted in March the same year, but refused the first time).

2. *Dr Meidell's norske Maanedskrift*, no. 3, 1883. Also printed in Lorentz Dietrichson, *Fra Kunstens Verden* [From the world of art], Copenhagen 1885, pp. 193–4.

3. M. J. Monrad, *Kunstretninger* [Movements in art], Copenhagen 1883, pp. 56–7.

4. Julius Lange had already discussed the relationship between the treatment of the same subject by photography and art, which was the major topic of his influential art theory. (See Eggum, work cited in note 7, chap. 1). Lange's theory was also cited in Lorentz Dietrichson's art theory, such as in 'En abnorm Kunstner', *Fra Kunstens Verden* ['An abnormal artist', From the world of art], 1885. One of Dietrichson's main points is expressed in the following reflection about photography as the art of the sun: 'Well – let us assume that the sun could give us both form and colour. The sun finishes the picture in a flash, whereas the artist, who has to work progressively, in a sense never finishes the same image, which the sun captures in a moment. Just try to compare a picture postcard and a painting of the same view, and you will realize how the artist gets the worst of it. It cannot be denied. There are many details which the artist does not include in order to seize a compendium of nature, whereas photography seizes it in its entirety showing every stone in the field, every branch and every leaf on the tree.'

5. Munch was probably inspired to experiment with his technique of scraping the oil paint surface of *Study* with knife, spatula and thumb, by Gustave Courbet's painting. Courbet was said to improvise from memory. See Meyer Schapiro, 'Courbet and Popular Imagery', *Journal of the Warburg and Courtauld Institutes*, vol. 4, 1941, pp. 164–91.

I have earlier written a thorough analysis of *Study (The Sick Child)*, as well as discussed the reception by the public of it: first in the article 'The Theme of Death' in the catalogue for the Munch Exhibition at the National Gallery of Art, Washington, 1979, *Edvard Munch: Symbols and Images*; then in a revised and enlarged form in the catalogue for the exhibition *Edvard Munch: Liebe, Angst, Tod* [E. M.: Love, angst, death] at the Kunsthalle, Bielefeld 1980.

6. Robert James Bantens, *Eugène Carrière: His Work and his Influence*, Ann Arbor 1983, p. 49.

7. Jens Thiis, *Edvard Munch og hans samtid* [E. M. and his contemporaries], Oslo 1933, p. 134.

8. At the same time that the World Exhibition took place in Paris in 1889 a world-wide Spiritualist conference was held. In the report *Compte Rendu du Congrès Spirite et Spiritualiste International de 1889*, Paris 1890, pp. 340–1, the secretary of the Spiritualist Society in Norway, Carl Sjøsted, writes that the Norwegian Spiritualist Society was founded on 9 January 1888 and reports on some public Spiritualist séances in Kristiania. In the article 'Spiritismen i Norge' [Spiritualism in Norway], in the Swedish periodical *Efteråt?*, July 1892, it was mentioned that a 'Spiritualist circle' was already functioning in Kristiania in the 1850s as 'a flame which soon died out'. It was also mentioned that Spiritualism was recruiting devotees mostly from 'the lower classes'.

9. In *Morgendaemringen* of 7 November 1886, no. 2, it was reported that Slade had made a 'medium painting' during a trance without having any 'drawing or painting skills'; he could also play the piano 'fortissimo' and sing while in a trance. The séances took place at the home of the editor of the magazine *Morgendaemringen*, B. Torsteinson, 2 Drammensveien. In a longer article on such a séance with Mr Slade, signed J. V., in *Aftenposten* of 27 September 1886, it was reported that an 'Album with Spiritualist photographs' was available in one of the other rooms. The most popular spirit photograph was William Mumler's photograph of Abraham Lincoln's 'spirit' behind the seated Mrs Lincoln. Published in *Incunabula of British Photographic Literature, 1839–1875*, London 1986, p. 81.

10. In 1965 Victor Hellern wrote a doctoral thesis (University of Oslo) on E. F. B. Horn, in which his

involvement with Spiritualism was not mentioned at all. For this reason the account of Horn's isolated position within the Norwegian Church became incomplete and somewhat misleading in an otherwise excellent study.

11. MS Munch Museum T 2704, p. 24. Gustav Schiefler wrote about Munch in his diary in the middle of July 1907: 'He talked about the way he sees a person, imagining his personality. To him the figure often seems to be surrounded by an "aura", which envelops it as a colourless flame.'

The theory that hypersensitive individuals were able to see radiation which normal people could not see and which furthermore could be photographed was discussed in Eduard von Hartmann, *Der Spiritismus*, Leipzig and Berlin 1885: 'Es scheint, dass man es dabei in vielen Fällen mit Aetherschwingungen zu thun hat, welche erst im Auge des Sensitiven (oder durch das Medium zeitweilig sensitiv Gemachten) in Lichtschwingungen umgewandlet werden. Diess wird bestätigt durch die Experimenten Photographen Beattie, welcher verschiedene Lichterscheinungen auf den Platten erhielt, die ihm und seinen Genossen unsichtbar waren, deren Formen aber mit den Beschreibungen der Medien über die während der Aufnahme von ihnen an bestimmten Orten gesehenen Lichterscheinungen übereinstimmen.'

12. It has been maintained (by Rolf Stenersen, *Naerbilde av et geni* [Close-up of a genius], Oslo 1946) that Munch had an unusual visual memory: he could draw precisely what he had seen earlier without having any models. Munch's uncle, the historian P. A. Munch, was known for his ability 'to photograph' whole pages of books and manuscripts in his memory. However, Munch says very little about this possible ability. During his stay at Dr Jacobson's clinic Munch told Emanuel Goldstein about having the image of the dead author Holger Drachmann sitting on his inner eye as on a photographic plate. He also mentioned that he could hear his voice clearly. Munch wrote in a note: 'The image is still on the eye as on a photographic plate – fresh as if he had just left. – In my ear I hear his voice – just as distinctly as if the words were spoken – as by a phonograph' (T 2785, p. 53).

13. The Austrian literary critic and author Hermann Bahr, who knew Munch and his art from Berlin in the 1890s and who introduced him to the Austrian public, dedicated half of the chapter 'Das Auge des Geistes' [The eye of the soul] to Francis Galton's *Inquiries into Human Faculty* in his *Expressionismus*, Munich 1916.

14. T. A. Ribot, *Hukommelsens Sygdomme* [The diseases of memory], Copenhagen 1892, p. 50.

15. Harald Høffding, *Psykologi*, Copenhagen 1882, p. 180. This example of 'a print on the closed eye' disappeared in later editions of Høffding's *Psykologi*. In collaboration with Mygind he worked out a questionnaire in 1884 for his students in order to examine their recollections. Most characterized their memories 'as photographs', as 'faded', 'subdued', 'matt photographs' and as 'pictures in dusk'.

16. Høffding, *Psykologi*, p. 177.

17. In *Norsk kunstdebatt ved modernismens terskel. Fra 'erindringen kunst' til 'det dekorative'* [Norwegian art debate at the threshold of modernism: From the 'art of recollection' to the 'decorative art'], Kunst og Kultur Series No. 1, Oslo 1985, Magne Malmanger sees Munch's ideas about the importance of recollection for his art in relation to Julius Lange's much debated article 'Studiet i marken. Skildreriet. Erindringens kunst' [The outdoor study. The painting. The art of recollection], *Nordisk Tidskrift för Vitenskap, Konst och Industri*, 1889, pp. 141–52. Malmanger wrote, 'If we relate this programmatic article to contemporary art and further development, Munch's art of the '90s seems to be the obvious answer to Lange's hopes'. However, I consider Lange as a very conservative art historian (even his friend Harald Høffding said that Lange would not accept any art after 1880), and I think that Lange attached his otherwise interesting art theories to the very popular ideas of recollection. In so doing,

he stated an idealistic and reactionary concept of art, which was also the concept of him among his contemporaries.

CHAPTER 3 (pages 41–51)

1. More and more Scandinavian paintings from the 1880s are discovered to have had a photographic basis without carrying a photographic touch. A new example was pointed out by Hanne Westergaard in the catalogue for the exhibition *1800-årene i nordisk maleri* [The 1800s in Nordic painting], Oslo etc. 1965–6, p. 178: P. S. Krøyer used a photograph, taken by the German painter Stoltenberg in 1884 for his famous painting *Hip, hip, hurra!*, which was not finished until 1888 after many thorough studies. Westergaard also relates that both Krøyer and Michael Ancher photographed themselves and used photographs for model studies, as well as for the bases for compositions.

2. *Aftenposten*, 13 November 1886.

3. *Dagen* (4 November 1886) thought that it was 'the light and dreamy poetry of the Norwegian summer's night which has been captured on the canvas' in such a manner that one is lured into the picture space. The critic of *Dagbladet* (28 October 1886) wrote: 'One can just stay there, at the foot of the tree, enjoying the refined light through the green leaves' and Andreas Aubert in *Aftenposten* (2 November 1886) wrote: 'It is as if we could go up and rest our arms against the tree, rest our head in our hands and gaze down into the depths, lost in the awakened dream of the night.' H. S. of *Christiania Intelligentsedler* (25 October 1886) goes even further by expressing his feelings as follows: 'Look! this is water! One feels like dipping the hand in it — or better, undress, jump and splash around in its crystal clear depths.' In this manner *Summer Night* becomes an example of Naturalistic work in the tradition of Gustave Courbet, a poem of nature, in the contrast to Pierre Puvis de Chavannes's idealistic and very stylized chalk-like murals or his painted studies and sketches. In her article 'Fra den hellige lund til Fleskum' [From the holy grove to Fleskum] in *Kunst og Kultur*, 1977, no. 2, pp. 69–92, Marit Lange maintains another opinion on *Summer Night*. She places it in an anti-naturalistic, idealizing tradition of European painting, especially referring to Puvis de Chavannes's painting *Bois sacré*. Lange maintained that the musical atmosphere of the painting distinguished it from the Naturalistic tradition, and further that Andreas Aubert should have indicated this by the use of musical metaphors. This was again contradicted by Sverre Krüger, who stated that Aubert had already used musical metaphors to describe purely Naturalistic *plein air* paintings in 1884. See Sverre Krüger, 'Maleri og Musikk' [Painting and music], thesis in art history, University of Bergen 1985, pp. 77–8.

4. Lorentz Dietrichson, *Det skönas Verld*, Stockholm 1973, p. 79.

5. Eilif Peterssen sent a photograph of *Summer Night* to Hans Gude, who answered: 'The birch and the foreground as a whole seem to be excellently painted, it looks as if it were a photograph of nature.' Gude also mentioned that he himself had painted several paintings with such a high horizon, because he had worked a great deal with reflections in water, but, as he wrote, 'the worst is that those paintings cannot be hung low enough on the wall, neither at exhibitions nor in private, without giving a bad impression'. Quoted from Harald Aars, 'Pa Fleskum i Baerum 1886', *Kunst og Kultur*, 1942, pp. 93–110.

6. Emerson cooperated, otherwise, with the landscape painter F. T. Goodall in his first famous series of photographs from Norfolk, published under the title *Life and Landscapes on the Norfolk Broads* (1886). Goodall's only well-known painting in public collections, *Bow Net* (1886) in the Walker Art Gallery, Liverpool, is very similar to the photograph of the same title in the series. In Goodall's painting the horizon is placed higher than seen in the photograph, creating a similar intimate picture space as in

Gathering Water-Lilies, and for that matter in Eilif Peterssen's *Summer Night*.

7. The Photographic Society in Kristiania was founded in 1881. In 1888 the chairman was L. Szacinski, the vice-chairman C. G. Rude and the secretary H. Abel. The Society of Amateur Photographers was also founded in that year. Similar associations, for both professionals and amateurs, were founded in the years 1888 and 1889 in the other Scandinavian capitals, and in Göteborg as well. The inter-Scandinavian magazine *Fotografisk Tidskrift*, published in Stockholm, was a common voice for the associations for both professionals and amateurs. The exhibition in Copenhagen was thoroughly reviewed by A. Jonason in *Fotografisk Tidskrift* (1888, no. 4), in which there were also advertisements for reproductions of well-known works of art in the form of carbonprints. In the catalogue for the works of art acquired by the Nasjonalgalleriet, *Katalog over kunstvaerker indlemmede i Nasjonalgalleriet efter Hovedkatalogens Udgivelse i 1886*, Kristiania 1893, 321 sheets of carbonprints are listed. There is also a large collection of such photographs arranged by country and genre in the archives of the Nasjonalgalleriet (Oslo).

8. Johan Rohde, 'El Greco', *Kunstbladet*, 1st year 1888, p. 280.

9. MS Munch Museum N 94.

10. MS Munch Museum N 39.

11. MS Munch Museum T 2761.

12. Karl Madsen, *Japansk Malerkunst* [Japanese painting], Copenhagen 1885, p. 137.

13. MS Munch Museum T 2785, p. 73.

14. Ludwik Szacinski was also very preoccupied with Spiritualism and the occult. As a younger man in Poland he had performed as a medium in Spiritualist séances, and he worked as a hypnotist in Kristiania in 1886 and 1887. When Munch's friend from the Berlin period, the occultist Stanislaw Przybyszewski, visited Kristiania with Munch in 1893, he also made contact with Arne Garborg and Ludwik Szacinski. In his autobiographical book *Erinnerungen an das literarische Berlin* [Memories from literary Berlin], Munich 1965, Przybyszewski gives a short biography of Szacinski. Szacinski's Spiritualist interests and his preoccupation with hypnosis are also described by Kristian Hosar in *Norsk Fotohistorisk Årbok 1981/82*, Oslo 1982, pp. 50–60. A further analysis of Szacinski's documentary photograph of the military band on Karl Johan Street and Munch's painting of the same subject should therefore reveal other relations between a work of art and a photographic equivalent than is usually recognized.

15. There is preserved a photograph showing the participants at this summer meeting, taken by C. G. Rude in Oscarshall on Thursday afternoon, 20 June 1889. (The photograph was published in an article entitled 'Norges Fotografforbund 90 år' by Jac. Brun in *Norsk fotohistoriisk Årbok 1983/84*, but dated incorrectly.) The circumstances and festivities surrounding this meeting are vividly described in an article in *Fotografisk Tidskrift*, July 1889, signed by A. Jonason.

16. MS Munch Museum T 2760.

17. The information about Munch's painting *Rue Lafayette* (1891) having inspired the photographer Puyo is taken from Helmut Gersheim, *The History of Photography*, London 1964, p. 465. Gersheim refers to the photographer's own information in Robert Demachy and Emile Puyo, *Les Procédés d'art en photographie*.

18. Quoted from Christian Skredsvig, *Dager og netter blandt kunstnere* [Days and nights among artists], 3rd ed., Oslo 1943, p. 152.

19. MS Munch Museum T 2760.

20. MS Munch Museum N 59.

21. Christian Krohg, *Kunstnere* [Artists], Kristiania 1892, 2nd ser., pp. 21–5.

22. MS Munch Museum N 29.

23. Francis Galton, *Inquiries into Human Faculty*, London 1883, p. 98.

24. Edvard Munch, *Livsfrisens tilblivelse* [On the creation of the Frieze of Life], Oslo [1929], p. 13. It is not certain if Munch knew at that time of Fernand

Khnopff's peculiar painting from memory of his sister, *Memoires* (1889), for which he used a series of photographs as models. That Munch was interested in the artist is demonstrated by the letter of introduction he had received from his teacher and relative Fritz Thaulow in 1894 for the Belgian artist. The stiff, dream-like atmosphere which is characteristic of Fernand Khnopff's art and which is also central to the painting *Death in the Sick-Room* makes it relevant to assume that there are lines of influence from the Symbolist Khnopff to Edvard Munch.

CHAPTER 4 (pages 55–63)

1. Jens Thiis, *Edvard Munch og hans samtid* [E. M. and his contemporaries], Oslo 1933, p. 205.

2. Richard Dehmel, *Gesammelte Werke* [Collected works], Berlin 1921–8, vol. 9, pp. 152–5.

3. The basic information about Strindberg as an amateur photographer is taken from Per Hemmingsson, *August Strindberg som fotograf* [A. S. as photographer], Stockholm 1963.

4. See Sven Lundwall, 'Fotografering utan objektiv' [Photography without lenses], *Fotografisk Tidskrift*, 1893.

5. Published in Göran Söderström, 'Strindbergs måleri' [Strindberg's painting], in *Strindbergs måleri. En monografi*, ed. Torsten Måtte, Malmö 1972, p. 98.

6. John Ruskin, *Modern Painters*, 2nd ed., Orpington & London 1898, vol. 4, p. 65.

7. Söderström, 'Strindbergs måleri', p. 112.

8. *Aftenposten*, 14 September 1892.

9. Etienne-Jules Marey's experimental photography was the big sensation in Paris when presented in connection with the fiftieth anniversary of photography. There was a clear description of his method and working conditions in *Fotografisk Tidskrift* of September 1889 in the article 'Från fotografiske kongressen i Paris' [From the Photography Congress in Paris], signed J. Petersen. The article was based on a visit to Marey's studio. Marey displayed a collection of his photographs and the famous bird sculpture, composed by means of a series of photographs taken simultaneously from different angles, at the World Exhibition of 1889; which Munch visited several times. He himself exhibited the painting *Morning* (1884) there.

10. In Munch's sketchbook (T 132), which was being used by the end of 1892 in Berlin, are two sketches for the lithograph *Tingel-Tangel*. The lines indicating the kicking legs of the dancer create the same pattern in both sketches as in the final lithograph. In the same sketchbook between the two sketches is a portrait drawing of Strindberg, which shows that the idea arose at the time Munch and Strindberg met each other.

11. Respectively in *Barmer Zeitung*, 10 March 1893, and in *Die Post*, 7 June 1893.

12. Stanislaw Przybyszewski, *Erinnerungen an das literarische Berlin* [Memories from literary Berlin], Munich 1965, p. 222.

13. Among Strindberg's papers in the Kungliga Biblioteket, Stockholm, is an article torn out from *La Revue des Revues*, April 1886, 'La Photographie transcendentale' by Jean Finot, in which a reversed print of ill. 38, *Madame et la main mysterieuse*, appears.

14. The photograph of the dead Paul Verlaine has been published in Söderström, 'Strindbergs måleri', p. 98.

15. Munch's *Self-Portrait with Lyre* (c.1897) also has characteristic abstract shapes, as if the lyre created such a flowing aura. (Or could it be a harp he is playing? The harp was described as the most spiritual instrument in the occult book *Anatomie et physiologie de l'orchestre*, Paris 1894, by Frederick Delius and Papus (pseud. for Gérard Encausse).) The shapes relate to many of the colourful depictions of auras around the body in C. W. Leadbeater, *Man Visible and Invisible*, London 1902. The illustrator, Count Maurice Prozor, who had translated Ibsen

into French and whose translations of *Peer Gynt* and *John Gabriel Borkman* were performed in Paris in 1896 and 1897, for which Munch made the posters, met Munch for the first time in Stockholm in 1894. As late as 1906 and 1907, during Munch's stay in Weimar, he was still in contact with the colourful Polish-French diplomat. See also Sixten Ringbom, 'Art in the Epoch of the Great Spiritual', *Journal of the Warburg and Courtauld Institutes*, vol. 29, 1966, in which Ringbom discusses the importance of the occult to the development of modern art.

16. Reprinted in *Annalen der Physik und Chemie*, new ser., vol. 64, 1898, No. 1, pp. 1–17.

17. Quoted after Hemmingsson, *Strindberg som fotograf*, p. 107.

18. Published in August Strindberg, *Prosabiter från 1890-tallet*, Stockholm 1917.

CHAPTER 5 (pages 67–91)

1. *La Revue Blanche*, 1896, pp. 525–6.

2. MS Munch Museum N 222.

3. Quoted after Antoine Terrasse, *Degas et la photographie*, Paris 1983, p. 39.

4. Quoted after Erhard Göpel, *Edvard Munch*, Munich 1955, p. 39.

5. MS Munch Museum N 178.

6. See Marcel Réja, *L'Art chez les fous*, Paris 1908, fig. 4. Among the illustrations in the book are several prints of drawings made by insane people, such as a drawing in India ink, fig. 19, *Dessin métaphysique. Représentation d'un animal synthetique*, which might as well have been conceived by Paul Klee, and an abstract watercolour, fig. 12, *Aquarelle décorative. Chaos de lignes et de coleurs*, of an intriguing resemblance to Kandinsky's most progressive style. Another illustration depicts a flattened female figure, fig. 14, *Déformations systematiques*, which relates to the early Cubist period of Picasso, Braque and Maillol. Marcel Réja wrote a thorough critique of Munch's art, 'Symbolism pictural', *La Critique*, 1900, no. 118, pp. 9–11.

7. MS Munch Museum N 231.

8. Ludvig Ravensberg's diary, 1910. Munch Museum.

9. Concerning the background for Munch's lithographic portraits it is also obvious to refer to Carrière's portraiture, which was very popular in the period, made by combining lithographic pen and India ink on a rough surface. Through a varied technique of nuanced tones and indistinct contour against the dark background Carrière achieved a transparent effect, like that achieved by Munch.

10. See note 7, Chapter 3.

11. Quoted after Hugo Perls, *Varför är Kamilla vacker?* [Why is Camilla so lovely?], Stockholm 1965, pp. 33–4.

12. Whereas before his death Munch let Professor Kristian Schreiner have his so-called literary diaries for reading and eventual 'dissection', his huge collection of letters went to his sister Inger. Inger systematically went through the letters and sent them to director Johan H. Langaard in portions. Before she destroyed some of the letters she made some 'witnessed copies', which were also sent to Langaard and the Munch Museum. The quoted letters exist only in these copies.

13. In Lucy de Knupffer, 'Eva Mudocci and Bella Edwards: Music and Friendship or Two Artists of Life or On Wings of Music' (unpublished and undated manuscript), the author relates that Eva Mudocci had great success as an infant prodigy under the name of Rose Lynton, and that she made her first international tour at the age of sixteen with her 'treasured Stradivarius'. The violin was then called 'Emiliano d'Oro', which is said to be one of the six most valuable violins built by Antonio Stradivari.

14. *Photographische Rundschau*, 1902, p. 124.

15. MS Munch Museum T 195, p. 94.

16. MS Munch Museum, 'Tilbakeblikk 1902–8', p. 14.

17. In her book *Ernest Thiel och hans Konstgalleri* [E. T. and his art gallery], Stockholm 1969, Brita Linde has proved that the originator of the commission of the portrait was Elisabeth Förster-Nietzsche. Brita Linde quotes from a letter written by the poet-philosopher's sister to Ernest Thiel on 3 July 1905: 'As I, unfortunately, have to economize in these years and as you during your last visit expressed your wish to have a painting done by Munch, I had the thought that you might wish to commission a portrait of my brother by him.'

18. Elisabeth Förster-Nietzsche, *Das Leben Friedrich Nietzsche* [The Life of F. N.], Leipzig 1904, vol. 2, part 2, pp. 681–2.

19. See Paul Westheim, 'Gezeichnet oder geknipst?' [Drawn or shot?], *Das Kunstblatt*, 1930, no. 2, pp. 33–56.

20. MS Munch Museum T 2785, pp. 18–19.

21. As for the portrait of Felix Auerbach, see Ruth Kisch-Arndt, 'A Portrait of Felix Auerbach by Munch', *Burlington Magazine*, March 1964.

22. Quoted from Rolf Stenersen, *Edvard Munch. Naerbilde av et geni* [E. M.: A close-up of a genius], Oslo 1946, p. 59. Medical journals which might have been able to clarify Dr Jacobson's diagnosis of Munch's nervous disorder are lost. In one of his books (*Sindsyg – Ikke Sindsyg?*, Copenhagen 1918, pp. 22–9), Jacobson describes geniuses such as Michelangelo, Goethe and Søren Kierkegaard as melancholics, probably with an implicit reference to Munch's case, who could not be characterized as insane even if they temporarily would suffer from a 'manic-depressive psychosis'.

CHAPTER 6 (pages 95–147)

1. *Malerei nach Fotografie* [Painting after photography] (catalogue), Münchner Stadtmuseum, Munich 1970, p. 16.

2. Eisenwerth's dating of Munch's photographs differs very much from mine. Eisenwerth ascribes photographs to Munch that he probably did not take, such as the photographs of Mrs Linde and the four sons (published in *Edvard Munch. Probleme – Forschungen – Thesen* [E. M.: Problems – Research – Ideas], ed. Henning Bock and Günter Busch, Munich 1973, p. 202), Edvard Munch with brushes (ill. 109), and the portrait of Mrs Förster-Nietzsche (ill. 120). The author's comment on the dating is wrong. The greatest difference is in the dating of the photograph (ill. 178), which he dates to c.1935 and I date to the autumn of 1904.

3. Judging from the preserved original negative it can be stated that the camera must have been a roll film camera, according to photographer Svein Andersen.

4. There is no reason to believe that the model should be Munch's ex-fiancée Tulla Larsen, such as Eisenwerth maintains. Munch had hardly any contact with Tulla Larsen at that time, but could, of course, have chosen the model because she resembled Tulla Larsen.

5. MS Munch Museum T 2789.

6. See *Edvard Munch. Alfa og Omega* (Catalogue), Munch Museum, Oslo 1981. Norwegian, English and German editions. See also Arne Eggum, 'Det gröna rummet', in *Edvard Munch* (catalogue), Liljevalchs and Kulturhuset, Stockholm 1977.

7. *Verdens Gang*, 28 December 1902.

8. *Photographische Rundschau* (Halle), 1902, p. 115. See also Helmut Gersheim, *The History of Photography*, London 1964, pp. 466–7; and Peter Pollack, *Die Welt der Photographie*, 1962, p. 257.

9. Munch sent ills. 170 and 173 to Ravensberg in a letter dated 23 June 1904. The photographs were later acquired by the Munch Museum.

10. Christian Gierløff, *Edvard Munch selv*, Oslo 1953, p. 156.

11. G. B. Shaw, 'Preface to Catalogue of an Exhibition of the Work of Alvin Langdon Coburn at the Liverpool Amateur Photographic Association', 1906. Quoted after *Photography: Essays and Images: Illustrated Reading in the History of Photography*, ed.

Beaumont Newhall, Museum of Modern Art, New York 1980, p. 200.

12. The two companion photographs, ills. 178 and 179, plus ill. 174, can all have been initiated by a request from Georg Brøchner, dated 15 July 1904, who asked for photographs 'of your, as far as I have understood, rather peculiar home at Aasgaardstrand for an article in *The Studio* on Norwegian Artists' Homes – mind you, those of interest'.

Published in Graham Ovenden, *Alphonse Mucha Photographs*, London 1974. Erika Billeter writes, without further documentation, in the catalogue *L'Autoportrait à l'âge de la photographie en dialogue avec leur propre image*, Musée des Beaux-Art, Lausanne 1985, that Pierre Bonnard also took self-portrait photographs with an automatic release in 1903. The main source for expressive self-portraits in photography is, probably, Hippolyte Bayard's well-known *Self-portrait as a Drowned Man* from 1840.

14. MS Munch Museum T 2731.

15. MS Munch Museum T 2704, p. 51. In Arne Garborg's *Traette Maend* [Tired men], 1894, p. 237, is a similar scene, in which the alter ego of the artist trying to contact a dead friend cries out in the room: 'Dear unhappy friend, if it possible for you, if no spiritual or natural laws are in your way, then appear for me, now, in this very moment . . . Answer me by a sign . . . Are we alive after death?'

Garborg and Munch were friends during the years 1885–9, when the plot of this novel takes place, and the theme of *Traette Maend* is the idea which is closest to what Munch wanted to express in the *Frieze of Life* in the 1890s. *Traette Maend* is based on the pattern of Goethe's *Faust*: the alter ego of the author, Gabriel Gram, has the part of Faust and Georg Jonathan that of Mephistopheles.

16. Edvard Munch, *Livsfrisens tilblivelse* [On the creation of the Frieze of Life], Kristiania [1929]. Dr Gösta Svenaeus has pointed out in *Im männlichen Gehirn* [In the human brain], Lund 1973, that there are similarities between Munch's writing and Albert Aurier's Symbolist programme from 1892, in which the French author maintained that the artist should find his themes in Heaven and Hell. From Stanislaw Przybyszewski, *Erinnerungen an das literarische Berlin* [Memories from literary Berlin], Munich 1965, p. 223, it is also known that Munch read Swedenborg's *De Coelo et Inferno* with great enthusiasm in 1892–3.

17. MS Munch Museum N 170.

18. Munch acquired a certain experience in judging professional photographs when he collected photographs from Vaering and Worm-Petersen for the illustrations of Hermann Esswein's book on Munch in the series *Moderne Illustratoren* in 1905. Commenting on an article Jens Thiis sent to Munch a short time afterwards, Munch wrote that it was a shame that the standard of photography and printing was so bad in Norway.

19. Eisenwerth maintains in *Edvard Munch*, p. 218, that the woman is a prostitute. According to a letter to Munch, Rosa Meissner charged 10 marks for having posed for five hours in Berlin, which indicates that she was a professional model. In Gustav Schiefler's diary of 17 September 1907, it is related that Munch had hired two models in Berlin and brought them to Warnemünde.

20. Munch may have got the idea of letting such loud wallpaper signify brothel surroundings from André Derain's painting *Bal de Suresne* (1903), which shows a dance scene in a brothel. Derain had

used a photograph as a basis for this subject. (See Van Deren Coke, *The Painter and the Photograph: From Delacroix to Warhol*, Albuquerque 1975, p. 94.)

21. Published in *Tradisjon og fornyelse. Festskrift til A.H. Winsnes*, Oslo 1959, pp. 61–75. The manner in which the woman in Munch's sculpture bends her head forward relates to a Greco-Roman statue of Psyche in the National Museum in Naples, shown in L'Orange's article. Munch's sculpture (cast in plaster in 1914 and in bronze in 1932) has, however, more similarity in pose and surface treatment with Strindberg's sculpture *Crying Boy* (1891), the creation of which he describes in the article 'Slumpen i det konstnärlige skapandet' (1894), published in *Strindbergs måleri. En Monografi*, ed. Torsten Måtte, Malmö 1972.

22. MS Munch Museum N 45.

23. According to Gustav Schiefler's diary of 30 October 1907 the models for *Bathing Men* were the assistants at the nudist beach at Warnemünde. When Munch was working on the stage design for *Ghosts* and *Hedda Gabler* for Max Reinhardt, he had photographs sent from Ludvig Ravensberg and Åse Nørregaard of typical Norwegian homes to help him in his work.

24. MS Munch Museum T 2789.

25. In Wilhelm Kaulbach's etching, published in *Goethes sämmtliche Werke*, vol. 2, Stuttgart 1860, Faust is shown wearing white clothes, whereas Mephistopheles is an apparition in dark clothing.

26. Quoted after Johan Wolfgang Goethe, *Faust*, part I, 'the Studio'.

27. *Edvard Munch. Probleme – Forschungen – Thesen*, ed. Henning Boch and Günter Busch, Munich 1973, p. 197.

28. The light-clothed nurse is probably Sigrid Schacke Andersen: the nurse in dark clothing is probably Linke Jørgensen, who had a close relationship with Munch and continued to write to him until 1917.

29. Quoted after H. P. Rohde, 'Edvard Munch på klinikki København' [E. M. at the clinic in Copenhagen], *Kunst og Kultur*, 1963, p. 270.

30. Michael Meyer's translation from Henrik Ibsen, *Plays: Six: Peer Gynt, The Pretenders*, Methuen's World Dramatists, London 1987, pp. 175–6. Munch himself used metaphors which played on the photographic words 'negative/positive'. In Paris in 1896 when making the poster for *Peer Gynt* he wrote: 'How are you my negative image – where my soul fits in.' The expression is written in connection with a wish to meet a woman and to find a kind of love which 'does not tear parts of my heart' (T 2782 ba).

31. See also Paul Hayes Tucker, 'Picasso, Photography, and the Development of Cubism', *Art Bulletin*, June 1982.

32. MS Munch Museum T 134, p. 20.

CHAPTER 7 (pages 151–159)

1. There is preserved a photograph of a trial hanging of *The Researchers* in the Festival Hall of the University on which Munch has marked some changes: the group of trees to the right and hills in the background; as such the photograph seems to document the stage from version 1 to version 2 of this subject.

2. MS Munch Museum T 2736, p. 17.

3. MS Munch Museum T 2784, p. 40.

4. Christian Gierløff, *Edvard Munch selv*, Oslo 1953, pp. 226–7.

CHAPTER 8 (pages 163–189)

1. Leif Preus states in his article 'Edvard Munchs fotografiapparat' [E. M.'s camera], *Fotoforum*, no. 2, 1980, that the negative size produced by the camera was 40 × 65 mm. He is, however, wrong in thinking that the self-portraits from the 1930s were taken with that camera. Some original negatives preserved from this camera measure 80 × 108 mm.

2. MS Munch Museum T 205.

3. The Pathé-Baby cinema camera was the first amateur camera that was really popular. It was produced in 1923, first with a crank, later with a spring, as in Munch's camera. As the 9.5 mm had a centre perforation the real negative was 8.5 × 6.5 mm which was more or less the same as a 16 mm film with perforation at the sides. The lens had a strength of 1 : 3.5f = 20 mm with the possibility of dimming to f11. The film was bought in rolls of 8 metres, which could be installed as a cassette.

4. Fernand Léger, 'A New Realism – The Object: Its Plastic and Cinematic Value', *Photography. Essays and Images. Illustrated Reading in the History of Photography*, ed. Beaumont Newhall, Museum of Modern Art, New York 1980, pp. 231–3.

5. MS Munch Museum (not reg.).

6. See also Hans Gotthard Vierhuff, *Die Neue Sachlichkeit. Malerei und Fotografie* [The new objectivity: painting and photography], Cologne 1980.

7. MS Munch Museum (not reg.). In a commentary on the portrait Munch wrote, prompted by the information in Wilhelm Keilhau, *Det norske folks liv og historie*, Olso 1938, about Blehr being a good bridge player, 'Blehr was also a man of sarcastic remark – That is what he is doing here' (N 162).

8. MS Munch Museum T 2167.

9. Originally published in *Le Figaro*, September/October 1894, later printed in *Prosabitar från 1890-talet* [Prose bits from the 1890s], Stockholm 1917.

10. The following shows that Munch was using the old camera at that time: '3 self-portraits with the old camera with close-up, lens $1\frac{1}{2}$ m/140 seconds'. The expression 'the old camera' indicates that he owned two cameras at that time. The 'new camera' was probably the Kodak Vest Pocket Camera, which today is preserved at the Preus Fotomuseum, Horten.

11. Besides being professor in anatomy at the Anatomical Institute of the University of Oslo, Kristian Schreiner was interested in phrenology and had collected a large number of skulls. Schreiner relates the following in his chapter entitled 'Memories from Ekely' in the book *Edvard Munch som vi kjente ham. Vennene forteller* [E. M. as we knew him: Told by his friends], Oslo 1946: 'One day he [Munch] said: – Here we are, we two anatomists, together, the anatomist of the body and the anatomist of the soul. I understand that you would like to dissect me. But beware, I have also got my knives. My interest in "dissecting him" was expressed in the lithograph, where he has shown himself at the autopsy table with me standing next to him.' The subject-matter can also be seen in connection with Munch's Faust theme; an ironic comment on selling one's body and soul to Mephistopheles. Even if Munch did not give Schreiner his body for study, he did give him most of his literary drafts for reading with carte-blanche to burn what he considered inappropriate for posterity.

The technical specifications of the photographs have been supplied by Wlodek Witek.

1. E. MUNCH WITH WATERCOLOURS OF HIS EYE DISEASE, 1930. Modern print from original negative in O. Vaering's archives. Self-portrait.

2. EDVARD MUNCH, 1864. A detail of ill. 3.

3. LAURA CATHRINE MUNCH WITH EDVARD, 1864. Later copy of carte-de-visite photograph. 215 × 130 mm. Photographer: H. Lunde.

4. EDVARD 18 MONTHS OLD, 1865. Yellow-toned albumen paper. Carte-de-visite. 90 × 54 mm. Photographer: J. Lindegaard.

5. LAURA CATHRINE MUNCH, 1865. Yellow-toned albumen paper. Carte-de-visite. 90 × 55 mm. Photographer: J. Lindegaard.

6. AT THE DOUBLE BED, 1891–2. Charcoal drawing. 307 × 218 mm. T 2358.

7. THE DEAD MOTHER AND THE CHILD, 1899–1900. Oil on canvas. 100 × 90 cm. Kunsthalle, Bremen.

8. SOPHIE MUNCH 3 YEARS OLD, 1865. Yellow-toned albumen paper. Carte-de-visite. 90 × 45 mm. Photographer: J. Lindegaard.

9. LAURA CATHRINE MUNCH WITH HER CHILDREN, 1808. Albumen paper. Carte-de-visite. 55 × 95 mm. Photographer: J. Lindegaard.

10. CHILDHOOD MEMORY, c.1895. Charcoal drawing. 480 × 627 mm. T 2266.

11. GAMLE AKER CHURCH, 1877. Watercolour and pencil drawing. 128 × 153 mm. T 2547.

12. THE LIVING ROOM AT 7 FOSSVEIEN, 1878. Watercolour and pencil drawing. 148 × 174 mm. T 2574.

13. THE BOYS' ROOM AT 7 FOSSVEIEN, 1878. Watercolour and pencil drawing. 153 × 175 mm. T 54.

14. DESK WITH FRAMED PHOTOGRAPHS, c.1879. Watercolour. 140 × 111 mm. T 2616.

15. THE LIVING ROOM AT 7 FOSSVEIEN, 1879. Watercolour. 163 × 167 mm. T 2608.

16. EDVARD'S LEFT HAND, 1878. Watercolour. 160 × 154 mm. T 2729.

17. EDVARD'S FIRST CARTE-DE-VISITE PHOTOGRAPH, 1879. Albumen paper. Carte-de-visite. 90 × 53 mm. Photographer: J. Lindegaard.

18. THE HILL AT ST OLAV'S CHURCH, 1881. Oil on paper. 22 × 27.5 cm. M 1059.

19. CHRISTIAN KROHG. THE NET MENDER, 1879–80. Oil on canvas. 93.5 × 65.5 cm. Nasjonalgalleriet, Oslo.

20. AT DAWN, 1883. Oil on canvas. 96.5 × 66 cm. Private collection.

21. PORTRAIT STUDIES OF KAREN BJØLSTAD, 1883. Oil on canvas. Back of ill. 20.

22. CHRISTIAN MUNCH, c.1885. Albumen paper. Carte-de-visite. 60 × 90 mm. Photographer: C. G. Rude.

23. THE ARTIST'S FATHER, c.1885. Oil on cardboard. 46 × 34 cm. Private collection.

24. CHARLOTTE (MEISSE) DÖRNBERGER, 1889. Oil on canvas. 47 × 35 cm. Private collection.

25. CHARLOTTE (MEISSE) DÖRNBERGER, c.1889. Albumen paper. Carte-de-visite. 60 × 90 mm. Photographer: Theodor Larsen.

26. EDVARD MUNCH 22 YEARS OLD, 1885. Albumen paper. Carte-de-visite. 93 × 61 mm. Photographer: unknown.

27. RAINY DAY ON KARL JOHAN STREET, c.1883. Oil on canvas. 38 × 55 cm. Private collection.

28. SKATERS ON THE ICE OUTSIDE AKERSHUS, 1882. Pencil drawing. 81 × 164 mm. T 2560.

29. SKETCH FOR THE PAINTING 'FUN AT DANCING', 1884–5. Drawing in Indian ink. 108 × 189 mm. T 1972.

30. SKELETONS DANCING, 1884–5. Pen drawing. 93 × 22 mm. Rolf Stenersen donation 382.

31. KARL JOHAN STREET, c.1886. Oil on canvas. 35 × 41 cm. Private collection.

32. KARL JOHAN STREET, c.1880. Photographer: unknown (Johannes Holmsen print). Oslo Bymuseum.

33. KARL JOHAN STREET, c.1885. Photographer: unknown (Johannes Holmsen print). Oslo Bymuseum.

34. KARL JOHAN STREET, 1890. Light-print. Postcard. 95 × 148 mm. Photographer: unknown. Oslo Bymuseum.

35. SELF-PORTRAIT, 1886. Oil on canvas. 33 × 24.5 cm. Nasjonalgalleriet, Oslo.

36. PHOTOGRAPH OF 'THE SICK CHILD (STUDY)', from exhibition in Berlin, 1892–3. Albumen paper. 155 × 152 mm. Photographer: Atelier Marshalk.

37. THE SICK CHILD, 1886. Oil on canvas. 119.5 × 118.5 cm. Nasjonalgalleriet, Oslo.

38. 'TRANSCENDENTAL PHOTOGRAPH', 1881. Light-print. 140 × 103 mm. Photographer: N. Wagner, St Petersburg. Published in A. Aksakow, *Animismus und Spiritismus*, vol. I, 1890, pl. 5.

39. CHRISTIAN KROHG. SICK GIRL, 1880–1. Oil on canvas. 102 × 58 cm. Nasjonalgalleriet, Oslo.

40. INTERIOR WITH SICK GIRL. Genre-photograph. The print probably dates from the 1890s. Collodion printing-out paper. 165 × 220 mm. Photographer: unknown. Oslo Bymuseum.

41. SPIRITUALIST PHOTOGRAPH, March 1872. Photographer: Mr Hudson. Published as a light-print in Georgiana Houghton, *Chronicles of Spiritual Beeings and Phenomena*, 1882.

42. SPIRITUALIST PHOTOGRAPH, March 1872. As 41.

43. SPIRITUALIST PHOTOGRAPH, March 1872. As 41.

44. SPIRITUALIST PHOTOGRAPH, March 1872. As 41.

45. VICAR E. F. B. HORN. Later re-photographed cabinet photograph(?) Photographer: unknown.

46. THE SACRAMENT, c.1915. Oil on canvas. 120 × 180 cm. M 416.

47. FADING AWAY, 1858. Albumen paper. 245 × 395 mm. Photographer: Henry Peach Robinson. Royal Photographic Society, Bath.

48. SPRING, 1889. Oil on canvas. 169 × 263.5 cm. Nasjonalgalleriet, Oslo.

49. EDVARD MUNCH, ÅSE AND HARALD NØRREGAARD, c.1889. Albumen paper. Carte-de-visite. 92 × 62 mm. Photographer: Frøling & Co., Kristiania.

50. THE SCREAM, 1893. Tempera and pastel on plate. 91 × 74 cm. Nasjonalgalleriet, Oslo.

51. GATHERING WATER-LILIES, 1886. Print after photogravure. 270 × 360 mm. Photographer: Peter Henry Emerson.

52. EILIF PETERSSEN. SUMMER NIGHT, 1886. Oil on canvas. 133 × 151 cm. Nasjonalgalleriet, Oslo.

53. INGER ON THE BEACH, 1889. Oil on canvas. 124.5 × 161.5 cm. Rasmus Meyer collection.

54. EDVARD MUNCH, c.1888. Albumen paper. Carte-de-visite. 92 × 60 mm. Photographers: Levarin, Kristiania.

55. EDVARD MUNCH AT THE EASEL IN ÅSGÅRDSTRAND, 1889. Albumen paper. 170 × 228 mm. Photographer: C.T. Thorkildsen.

56. SKETCH FOR 'EVENING AT KARL JOHAN STREET', from Munch's Illustrated Diary, 1889. Pen drawing. 210 × 165 mm. T 2761–29.

57. CHRISTIAN KROHG AND HANS JAEGER AT KARL JOHAN STREET. Drawing. 241 × 343 mm. T 436.

58. THE MILITARY MUSIC IS ARRIVING, 1880s. Albumen paper. 131 × 195 mm. Photographer: L. Szacinski. Oslo Bymuseum.

59. THE MILITARY BAND ON KARL JOHAN STREET, 1889. Oil on canvas. 100.5 × 141 cm. Kunsthaus, Zurich.

60. KARL JOHAN STREET, Kristiania c.1887. Light-print. 96 × 145 mm. Printed: Copyright H. Abels Kunstforlag. Oslo Bymuseum.

61. SPRING DAY ON KARL JOHAN STREET, 1890. Oil on canvas. 80 × 100 cm. Bergen Billedgaleri.

62. VIEW FROM EKEBERG OVER KRISTIANIA, c.1890. Gelatin printing-out paper. 169 × 238 mm. Photographer: unknown (Johannes Holmsen print). Olso Bymuseum.

63. DESPAIR, 1892. Oil on canvas. 92 × 67 cm. Thielska Galleriet, Stockholm.

64. DEATH IN THE SICK-ROOM, 1893. Oil on canvas. 134.5 × 160 cm. M 418.

65. EDVARD MUNCH, 1890–2. Modern, enlarged copy. Photographer: unknown.

66. AUGUST STRINDBERG, Berlin 1893. Self-portrait. Original in Kungliga Biblioteket, Stockholm.

67. MUNCH'S EXHIBITION IN EQUITABLE PALACE, Berlin 1892–3. Albumen paper. 145 × 205 mm. Photographer: Atelier Marschalk.

68. MUNCH'S STUDIO IN BERLIN, 1894. Collodion paper. 91 × 124 mm. Photographer: unknown.

69. AUGUST STRINDBERG. SOLITARY FLOWER ON THE BEACH, 1893. Oil on what is said to have been Munch's palette. Private collection.

70. MOONLIGHT ON THE SHORE, 1892. Oil on canvas. 62.5 × 96 cm. Bergen Billedgalleri.

71. STREET SCENE IN BERLIN I, 1893. Ink drawing. 178 × 113 mm. T 1257.

72. STREET SCENE IN BERLIN II, 1893. Ink drawing. 230 × 298 mm. T 1259A.

73. TINGEL-TANGEL, Berlin 1893. Pencil, ink and watercolour. c. 206 × 365 mm. T 490.

74. AUGUST STRINDBERG, 1886. Albumen paper. Carte-de-visite. Self-portrait.

75. SELF-PORTRAIT WITH A CIGARETTE, 1895. Oil on canvas. 110.5 × 85.5 cm. Nasjonalgalleriet, Oslo.

76. STARRY NIGHT, 1893. 135 × 140 cm. Getty Museum, Malibu.

77. ATTRACTION, 1895. Etching. 314 × 240 mm. G/r 16–1.

78. MAN'S HEAD IN WOMAN'S HAIR, c.1896. Hand-coloured lithograph. 651 × 501 mm. G/l 219–19.

79. PORTRAIT OF AUGUST STRINDBERG, 1896. Lithograph. 651 × 501 mm. G/l 219–19.

80. ILLUSTRATION OF AN 'AURA'. Published in Albert de Rochas, *L'Extériorisation de la sensibilité*, Paris 1895.

81. GEOMETRICAL 'AURA' SHAPES. Published in *Neue Metaphysische Rundschau*, 1901.

82. THE KISS, 1897–8. Woodcut. 591 × 457 mm. G/t 577–4.

83. THE KISS, 1902. Woodcut. 447 × 447 mm. G/t 580–4.

84. MELANCHOLY, 1896. Woodcut. 377 × 460 mm. G/t 571–8.

85. EDVARD MUNCH, c.1906. Gelatin printing-out paper. Postcard. 89 × 57 mm (extract). Photographer: probably R. Sudermann, Berlin.

86. DOUBLE-PORTRAIT OF EDVARD MUNCH AND TULLA LARSEN, 1899. Ferrotype. 90 × 63 mm. Photographer: unknown.

87. STÉPHANE MALLARMÉ, 1896. Lithograph. 605 × 380 mm. G/l 221–5.

88. STÉPHANE MALLARMÉ, 1895. Copy from original in Fotografiska Museet, Stockholm. Photographer: Paul Nadar.

89. STÉPHANE MALLARMÉ, 1896. Etching. 175 × 141 mm. G/r 164.

90. MARCEL RÉJA, c.1896. Platinotype. 130 × 95 mm. Photographer: unknown.

91. MARCEL RÉJA, 1896. Woodcut. 390 × 326 mm. G/t 691–7.

92. HENRIK IBSEN, c.1896. Albumen paper. Cabinet photograph. 140 × 99 mm. Printed: Bertrand Jensens Forlag.

93. POSTER FOR THE PERFORMANCE OF 'JOHN GABRIEL BORKMAN' IN PARIS, 1897. Lithograph. 320 × 208 mm. G/l 721–2.

94. MATERIAL TRANSFER, 1888–1903. Oil on canvas. 172.5 × 142 cm. M 419.

95. See ill. 86.

96. E. MUNCH AND A PORTER WITH BEER MUGS, 1902–4. Gelatin printing-out paper. Postcard. 90 × 138 mm. Printed: F. Lippens. Postkarten-Photographie, Berlin. Friedrichstrasse 15.

97. E. MUNCH (CASTING A SHADOW) AND TWO OTHER MEN, 1902–4. Gelatin printing-out paper. Postcard. 90 × 138 mm. Printed: Brevkort. Photographer: E. Munch (?)

98. E. MUNCH WEARING A SILK HAT, 1902–4. Gelatin printing-out paper. Postcard. 90 × 138 mm. Printed: Postkarten Photographie, Berlin. Passage. Laden 15.

99. E. MUNCH (SMOKING A CIGAR) AND TWO MEN, 1902–4. Gelatin printing-out paper. Postcard. 90 × 138 mm. Printed: Rud. Suderman. Berlin. Centralhotel Laden 26.

100. E. MUNCH WEARING A HAT, 1902–4. Gelatin printing-out paper. Postcard. 90 × 138 mm. Printed: F. Lippens. Postkarten-Photographie, Berlin. Friedrichstrasse 15.

101. THE VIOLIN CONCERTO, 1903. Lithograph. 480 × 560 mm. G/l 254–22.

102. THE ARTIST COUPLE EVA MUDOCCI AND BELLA EDWARDS, 1902. Gelatin printing-out paper. Inscribed with pen: January 1902. 445 × 300 mm. Photographer: Harald Patz Successor Copenhagen.

103. EVA MUDOCCI WITH HER 'EMILIANO D'ORO'. Gelatin printing-out paper. 155 × 82 mm. Photographer: L. Forbech, Kristiania.

104. SALOME, 1903. Lithograph. 396 × 310 mm. G/l 256.

105. DOUBLE-PORTRAIT OF THE PAINTER HENRIK LUND AND HIS WIFE, GUNBJØR, 1905–6. Oil on canvas. 67 × 57 cm. M 617.

106. TWO PHOTOGRAPHS OF THE SAME PERSON. Published in *Photographische Rundschau*, 1902, p. 124.

107. ELLEN WARBURG AND HER PORTRAIT, 1905. Modern copy from Kunsthaus, Zurich. Photographer: Gertrude Margrethe Warburg.

108. E. MUNCH AND HIS PORTRAIT OF ELLEN WARBURG, 1905. Modern copy from Kunsthaus, Zurich. Photographer: Gertrude Margrethe Warburg.

109. E. MUNCH IN HERBERT ESCHE'S LIBRARY, Chemnitz 1905. Gelatin printing-out paper. Photographer: unknown.

110. SELF-PORTRAIT WITH BRUSHES, 1904. Oil on canvas. 197 × 91 cm. M 751.

111. HERBERT ESCHE'S CHILDREN, 1905. Oil on canvas. 147 × 153 cm. Private collection.

112. HANS AND ERDMUTE ESCHE, Chemnitz 1905. Gelatin printing-out paper. 172 × 122 mm. Photographer: unknown.

113. VAN DE VELDE AND E. MUNCH AT ESCHE'S HOUSE, 1905. Gelatin printing-out paper. 166 × 113 mm. Photographer: unknown.

114. FRIEDRICH NIETZSCHE AND HIS HOUSE IN WEIMAR. Rephotographed postcard. Photographer: unknown.

115. SKETCH FOR THE PORTRAIT OF FRIEDRICH NIETZSCHE, 1905. Pastels and charcoal on cardboard. 73 × 101 cm. M 254.

116. FRIEDRICH NIETZSCHE, 1899. Copy from original in Goethe and Schiller Archives, Weimar. Photographer: Hans Olde.

117. FRIEDRICH NIETZSCHE, 1907. Oil on canvas. 201 × 160 cm. Thielska Galleriet, Stockholm.

118. RUDELSBURG AND SAALECKSBURG AT THE RIVER SAALE. Light-print. Postcard. 90 × 137 mm. Photographer: R. Krause, Bad Kösen.

119. E. MUNCH IN FRONT OF A TAPESTRY PROP OF THE SCENERY OF RUDELSBURG AND SAALECKSBURG, 1906–7. Ferrotype. 80 × 65 mm. Photographer: unknown.

120. ELISABETH FÖRSTER-NIETZSCHE, 1907. Collodion printing-out paper. 148 × 102 mm. Photographer: unknown.

121. ELISABETH FÖRSTER-NIETZSCHE, 1907. Oil on canvas. 163 × 101 cm. M 378.

122. GUSTAV SCHIEFLER, 1905. Etching. Published with contemporary photograph of G. Schiefler in *Das Kunstblatt*. Photographer: R. Dührkoop, Hamburg.

123. OTTILIE SCHIEFLER, 1905. Platinotype. 145 × 104 mm. Photographer: unknown.

124. OTTILIE SCHIEFLER, 1907. Etching. 388 × 267 mm. G/r 125–7.

125. PROFESSOR FELIX AUERBACH, 1906. Gelatin printing-out paper. 165 × 113 mm. Photographer: Anna Auerbach.

126. PROFESSOR FELIX AUERBACH, 1907. Oil on canvas. 83 × 76 cm. Private collection.

127. E. MUNCH AND DR JACOBSON AT THE CLINIC ON KOCHS VEJ, Copenhagen 1909. Gelatin printing-out paper. 140 × 82 mm. Photographer: unknown.

128. E. MUNCH WEARING A LIGHT HAT, presumably *c.*1902. Ferrotype. 85 × 57 mm. Photographer: unknown.

129. ROSA MEISSNER IN THE HOTEL RÔHNE, Warnemünde 1907. Toned gelatin printing-out paper. 87 × 73 mm. Photographer: E. Munch.

130. E. MUNCH ON HIS TRUNK AT 82 LÜTZOWSTRASSE, I, Berlin 1902. Collodion printing-out paper. 80 × 80 mm. Self-portrait.

131. E. MUNCH ON HIS TRUNK AT 82 LÜTZOWSTRASSE, II, Berlin 1902. Collodion printing-out paper. 80 × 80 mm. Self-portrait.

132. E. MUNCH IN HIS STUDIO FLAT AT 82 LÜTZOWSTRASSE, Berlin 1902. Collodion printing-out paper. 80 × 80 mm. Self-portrait.

133. MODEL IN MUNCH'S STUDIO I, Berlin 1902. Collodion printing-out paper. 84 × 84 mm. Photographer: E. Munch.

134. MODEL IN MUNCH'S STUDIO II, Berlin 1902. Collodion printing-out paper. 90 × 88 mm. Photographer: E. Munch.

135. NAKED WOMAN, 1902. Oil on canvas. 120 × 49.5 cm. M 496.

136. SIN, 1902. Lithograph. 495 × 396 mm. G/l 241–30.

137. MARTA SANDAL IN MUNCH'S STUDIO, Berlin 1902. Collodion printing-out paper. 88 × 90 mm. Photographer: E. Munch.

138. THE WIECK BROTHERS IN MUNCH'S STUDIO, Berlin 1902. Collodion printing-out paper. 89 × 92 mm. Photographer: E. Munch.

139. ANNA AND WALTER LEISTIKOW, 1902. Lithograph. 522/4 × 368 mm. G/l 243.

140. WALTER LEISTIKOW IN HIS STUDIO, 1902. Collodion printing-out paper. 91 × 89 mm. Photographer: E. Munch.

141. E. MUNCH IN FRONT OF TOMBSTONES, Berlin *c.*1902. Collodion printing-out paper. 94 × 89 mm. Photographer: Albert Kollman with E. Munch's camera.

142. ALBERT KOLLMAN IN FRONT OF TOMBSTONES, Berlin *c.*1902. Collodion printing-out paper. 84 × 81 mm. Photographer: E. Munch.

143. MUNCH'S LEFT HAND, 1902. Print from an X-ray photograph. Kristiania Roentgen Institut.

144. MUNCH'S EXHIBITION AT BLOMQVIST'S, KRISTIANIA, 1902. Collodion printing-out paper. 93 × 96 mm. Photographer: E. Munch.

145. MUNCH'S EXHIBITION AT BLOMQVIST'S, KRISTIANIA, 1902. Collodion printing-out paper. 93 × 96 mm. Photographer: E. Munch.

146. E. MUNCH'S EXHIBITION AT BLOMQVIST'S, KRISTIANIA, 1902. Caricature by Ragnvald Blix, published in *Tyrihans*, 1902, no. 42.

147. E. MUNCH IN BED, presumably 1902. Collodion printing-out paper. 98 × 100 mm. Self-portrait.

148. THE YARD OF 30B PILESTREDET, presumably 1902. Collodion printing-out paper. 120 × 89 mm. Photographer: E. Munch.

149. THE FAÇADE OF 30B PILESTREDET, presumably 1902. Collodion printing-out paper. 89 × 118 mm. Photographer: E. Munch.

150. 30A AND 30B PILESTREDET, presumably 1902. Collodion printing-out paper. 89 × 97 mm. Photographer: E. Munch.

151. CHILDHOOD MEMORY: IN THE BACK GARDEN, *c.*1935. Watercolour and pencil. 700 × 860 mm. T 567.

152. FROM THE BACK GARDEN OF 30B PILESTREDET, *c.*1902, Collodion printing-out paper. 88 × 81 mm. Photographer: E. Munch.

153. MUNCH'S AUNT KAREN BJØLSTAD AND HIS SISTER INGER IN FRONT OF NO. 2 OLAF RYES PLASS, *c.*1902. Gelatin printing-out paper. 91 × 99 mm. Photographer: E. Munch.

154. TWO WOMEN ON THE BEACH, 1898. Woodcut. 455 × 508 mm. G/t 589–9.

155. AUGUSTE RODIN, 1901. Light-print from rubberprint. Photographer: Edward Steichen. Published in *Photographische Rundschau*, 1902.

156. EDVARD MUNCH. Bookcover from Max Linde, *Edvard Munch und die Kunst der Zukunft*, 1902. High-print. Photographer: unknown.

157. E. MUNCH IN DR LINDE'S GARDEN, Lübeck 1902. Modern print. Photographer: unknown.

158. SELF-PORTRAIT WITH BRUSH AND PALETTE, 1901. Light-print after rubberprint over photogravure. 207 × 153 mm. Photographer: Edward Steichen. Published in *Photographische Rundschau*, 1902.

159. DR LINDE'S HOUSE IN LÜBECK, 1903. Collodion printing-out paper. 89 × 86 mm. Photographer: E. Munch.

160. DR MAX LINDE, 1903. Collodion printing-out paper. 55 × 55 mm (photograph has been cut down). Photographer: presumably E. Munch.

161. DR LINDE IN SAILING OUTFIT, 1903. Oil on canvas. 133 × 81 cm (painting was later shortened by Munch; here shown original length). Rolf Stenersen donation.

162. PAUL CASSIRER'S EXHIBITION ROOMS, BERLIN, 1903. Gelatin printing-out paper. 88 × 89 mm. Photographer: E. Munch.

163. PORTRAIT OF HARRY GRAF KESSLER ON THE EASEL, 1904. Yellow-toned collodion printing-out paper. 84 × 112 mm. Photographer: E. Munch.

164. IN THE SAILBOAT AT ÅSGÅRDSTRAND, 1903. Collodion printing-out paper. 89 × 89 mm. E. Munch's camera.

165. E. MUNCH IN THE GARDEN AT ÅSGÅRDSTRAND, 1903. Gelatin printing-out paper. 111 × 88 mm. Photographer: E. Munch.

166. E. MUNCH, NAKED, Åsgårdstrand 1903. Gelatin printing-out paper. 86 × 82 mm. Self-portrait.

167. SELF-PORTRAIT IN HELL, 1903. Oil on canvas. 82 × 60 cm. M 591.

168. E. MUNCH, NAKED, HALF-FIGURE, presumably 1904. Collodion printing-out paper. 86 × 87 mm. Self-portrait.

169. E. MUNCH, NAKED, Åsgårdstrand, presumably 1904. Modern, cut-down print from original negative in O. Vaering's archives. Self-portrait.

170. LUDVIG RAVENSBERG, Åsgårdstrand 1904. Yellow-toned collodion printing-out paper. 89 × 90 mm.

171. E. MUNCH WITH RAVENSBERG AND AN UNIDENTIFIED MAN, Åsgårdstrand 1904. Yellow-toned collodion printing-out paper. 80 × 80 mm. Self-portrait.

172. E. MUNCH IN A WORKSHIRT, Åsgårdstrand 1904. Yellow-toned collodion printing-out paper. 88 × 95 mm. Photographer: presumably L. Ravensberg with E. Munch's camera.

173. THE PAINTING 'BATHING BOYS' IN THE GARDEN, Åsgårdstrand 1904. Yellow-toned collodion printing-out paper. 89 × 89 mm. Photographer: E. Munch.

174. E. MUNCH IN PROFILE, INDOORS, Åsgårdstrand, presumably 1904. Gelatin printing-out paper. 88 × 94 mm. Self-portrait.

175. INGSE VIBE, 1903. Oil on canvas. 160 × 70 cm. M 272.

176. INGSE VIBE, presumably 1903. Modern copy provided by her family. Photographer: unknown.

177. INGSE VIBE WITH FRIENDS, Åsgårdstrand 1903. Collodion printing-out paper. 105 × 86 mm. Photographer: E. Munch.

178. E. MUNCH WITH AN UNKNOWN YOUNG WOMAN, 1904. 85 × 86 mm. Gelatin printing-out paper. Self-portrait.

179. PAINTINGS FROM THE LINDE FRIEZE IN THE GARDEN, Åsgårdstrand 1904. Gelatin printing-out paper. 87 × 90 mm. Photographer: E. Munch.

180. THE BEACH AT ÅSGÅRDSTRAND, presumably 1904. Modern print from original negative. 86 × 86 mm. Photographer: E. Munch.

181. OSVALD, 1920. Hand-coloured lithograph. *c.* 390 × 500 mm. G/l 421–1.

182. E. MUNCH SOMEWHERE ON THE CONTINENT I, presumably 1906. Gelatin printing-out paper. 90 × 90 mm. Self-portrait.

183. E. MUNCH SOMEWHERE ON THE CONTINENT II, presumably 1906. Reversed version of ill. 182. Gelatin printing-out paper. 83 × 87 mm. Self-portrait.

184. THE SON. 1902–4. Oil on canvas. 70 × 89 cm. M 215.

185. MUNCH ON HIS TRUNK I, *c.*1906. Gelatin printing-out paper. 89 × 95 mm.

186. MUNCH ON HIS TRUNK II, *c.*1906. Gelatin printing-out paper. 83 × 81 mm. Self-portrait.

187. SELF-PORTRAIT WITH WINE BOTTLE, 1906. Oil on canvas. 110.5 × 120.5 cm. M 543.

188. MUNCH'S EXHIBITION AT PAUL CASSIRER'S IN BERLIN, 1907. Gelatin printing-out paper. 80 × 85 mm. Photographer: E. Munch.

189. MUNCH'S EXHIBITION AT PAUL CASSIRER'S IN BERLIN, 1907. Modern print from original negative. 86 × 87 mm. Photographer: E. Munch.

190. E. MUNCH ON THE VERANDA OF 53 AM STROM, 1907. Modern print from original negative. 86 × 87 mm. Self-portrait.

191. DESIRE, 1907. Oil on canvas. 85 × 130 cm. M 552.

192. MUNCH'S HOUSEKEEPER, Warnemünde 1907. Collodion printing-out paper. 89 × 89 mm. Photographer: E. Munch.

193. E. MUNCH AND HIS HOUSEKEEPER, Warnemünde 1907, Collodion printing-out paper. 89 × 89 mm. Self-portrait.

194. WEEPING WOMAN, 1906–7. Oil on canvas. 121 × 119 cm. M 689.

195. WEEPING WOMAN, 1906–7. Pen drawing. 210 × 165 mm. T 2784–25.

196. See ill, 129.

197. E. MUNCH AND ROSA MEISSNER, Warnemünde 1907. Collodion printing-out paper. 86 × 83 mm. Self-portrait.

198. E. MUNCH AND ROSA MEISSNER, Warnemünde 1907. Collodion printing-out paper. 86 × 79 mm. Self-portrait.

199. E. MUNCH AND ROSA MEISSNER, Warnemünde 1907. Reversed version of ill. 198. Collodion printing-out paper. Self-portrait.

200. ROSA AND OLGA MEISSNER ON THE BEACH, Warnemünde 1907. Collodion printing-out paper. 88 × 118 mm. Photographer: E. Munch.

201. 53 AM STROM IN WARNEMÜNDE, 1907. Collodion printing-out paper. 89 × 89 mm. Photographer: E. Munch.

202. E. MUNCH IN THE HALLWAY OF 53 AM STROM, 1907. Gelatin printing-out paper. 89 × 92 mm. Self-portrait.

203. MALE MODEL ON THE BEACH, Warnemünde 1907. Collodion printing-out paper. 79 × 87 mm. Photographer: E. Munch.

204. E. MUNCH ON THE BEACH WITH BRUSH AND PALETTE, 1907. Collodion printing-out paper. 83 × 88 mm. Self-portrait.

205. E. MUNCH, NAKED, I, Warnemünde 1907. Collodion printing-out paper. 85 × 82 mm. Self-portrait.

206. E. MUNCH, NAKED, II, Warnemünde 1907. Collodion printing-out paper. 88 × 119 mm. Self-portrait.

207. E. MUNCH IN PROFILE, Warnemünde 1907. Collodion printing-out paper. 88 × 118 mm. Self-portrait.

208. BATHING MEN, 1907. Oil on canvas. 206 × 227 cm. Ateneum Taidemuseo, Helsingfors.

209. MASON AND MECHANIC, 1908. Oil on canvas. 90 × 69.5 cm. M 574.

210. THE DROWNED CHILD, 1908. Oil on canvas. 85 × 130 cm. M 559.

211. E. MUNCH AT THE TABLE AT DR JACOBSON'S CLINIC, 1908–9. Modern print from original negative. 86 × 87 mm. Self-portrait.

212. E. MUNCH IN HIS ROOM AT DR JACOBSON'S CLINIC, 1908–9. Yellow-toned gelatin printing-out paper. 88 × 119 mm. Self-portrait.

213. E. MUNCH SITTING ON A CHAIR AT DR JACOBSON'S CLINIC, 1908–9. Gelatin printing-out paper. 90 × 90 mm. Self-portrait.

214. SELF-PORTRAIT AT THE CLINIC, 1909. Oil on canvas. 100 × 110 cm. Rasmus Meyer Collection.

215. E. MUNCH 'À LA MARAT' NEXT TO THE TUB, AT DR JACOBSON'S CLINIC ('MARAT IN THE BATH'), 1908–9. Gelatin printing-out paper. 81 × 93 mm. Self-portrait.

216. A NURSE, HER HANDS BEHIND HER HEAD, AT DR JACOBSON'S CLINIC, 1908–9. Gelatin printing-out paper. 88 × 89 mm. Photographer: E. Munch.

217. A NURSE DRESSED IN BLACK AT DR JACOBSON'S CLINIC, 1908–9. Modern print from an original negative. 86 × 88 mm. Photographer: E. Munch.

218. TWO NURSES, ONE IN DARK CLOTHES, THE OTHER IN LIGHT, AT DR JACOBSON'S CLINIC, 1908–9. Modern print from original negative. 86 × 88 mm. Photographer: E. Munch.

219. THE PAINTING 'ON THE OPERATING TABLE' (M22), PHOTOGRAPHED AT DR LINDE'S, Lübeck 1902–3. Gelatin printing-out paper. 91 × 98 mm. Photographer: E. Munch.

220. A NURSE DRESSED IN WHITE AT DR JACOBSON'S CLINIC, 1908–9. Gelatin printing-out paper. 121 × 83 mm. Photographer: E. Munch.

221. THE NURSE, 1909. Etching. 195/204 × 144/4 mm. G/r 130–2.

222. E. MUNCH BETWEEN THE PORTRAITS OF LUDVIG RAVENSBERG AND JAPPE NILSSEN, Kragerø 1909. Yellow-toned collodion printing-out paper. 90 × 90 mm. Photographer: L. Ravensberg with E. Munch's camera.

223. LUDVIG RAVENSBERG NEXT TO HIS PORTRAIT, 1909–10. Collodion printing-out paper. 87 × 88 mm. Photographer: E. Munch.

224a. E. MUNCH IN HIS STUDIO, Kragerø 1909–10. Modern print from original negative. 86 × 88 mm. Self-portrait.

224b. E. MUNCH IN HIS STUDIO AT SKRUBBEN, Kragerø 1909–10. Modern print from original negative. 86 × 88 mm. Self-portrait.

225. CHRISTIAN GIERLØFF, Kragerø 1909–10. Modern print from original negative in O. Vaering's archives. Photographer: E. Munch.

226. TORVALD STANG, 1909–10. Gelatin printing-out paper. 89 × 96 mm. Photographer: E. Munch.

227. VIEW OF MUNCH'S HOUSE, NEDRE RAMMEN, IN HVITSTEN, c.1910. Modern print from original negative in O. Vaering's archives. Photographer: E. Munch.

228. STUDY FROM THE HARBOUR AT KRAGERØ I, c.1910. Gelatin printing-out paper. 89 × 94 mm. Photographer: E. Munch.

229. STUDY FROM THE HARBOUR AT KRAGERØ II, c.1910. Gelatin printing-out paper. 82 × 86 mm. Photographer: E. Munch.

230. 'HISTORY' IN THE OPEN-AIR STUDIO, Kragerø 1910. Modern copy from original in Gustav Schiefler's collection of letters, Hamburg. Photographer: M. Munch.

231. 'ALMA MATER' IN THE OPEN-AIR STUDIO, Kragerø 1910. Collodion printing-out paper. 87 × 88 mm. Photographer: E. Munch.

232. IRENE AND THE NURSING SISTER IN THE PARK. Study for When We Dead Awaken. Watercolour. 500 × 650 mm. T 1537.

233. BØRRE ERIKSEN, MODEL FOR 'HISTORY'. Modern print from original negative in Berg-Kragerø Museum. Photographer: A. F. Johansen.

234. SKETCH FOR THE NATIONAL MONUMENT 'MOTHER NORWAY AND HER SON'. Pencil. 258 × 357 mm. T 149–22.

235. E. MUNCH WITH A STUDY FOR THE NATIONAL MONUMENT, Kragerø 1910. Gelatin printing-out paper. 89 × 99 mm. Self-portrait.

236. E. MUNCH PAINTS 'THE SUN' FOR THE NEW FESTIVAL HALL OF THE UNIVERSITY, 1911. Modern print from original negative in Berg-Kragerø Museum. Photographer: A.F. Johansen.

237. POSTER FOR MUNCH'S EXHIBITION IN THE DIORAMA, 1910. Lithograph. 1430 × 470 mm. G/l 728–1.

238. THE UNIVERSITY IN KRISTIANIA, PHOTOGRAPHED FROM A BALLOON, 1906. Gelatin printing-out paper. Postcard. 87 × 138 mm. Printed: Copyright Mittet & Co. (no. 6). Oslo Bymuseum.

239. THE PALACE IN KRISTIANIA, PHOTOGRAPHED FROM A BALLOON, 1906. Gelatin printing-out paper. 87 × 138 mm. Printed: Copyright F. B. O. Oslo Bymuseum.

240. E. MUNCH IN FRONT OF 'THE SUN', Kragerø 1910. Modern print from original negative in Berg-Kragerø Museum. Photographer: A. F. Johansen.

241. EKELY IN SNOW, THE HOUSE SEEN FROM THE WEST, presumably 1927. Postcard photograph with Munch sketch. Gelatin printing-out paper. 105 × 76 mm. Photographer: E. Munch.

242. BEACH AT WARNEMÜNDE. Postcard with Munch's ink drawing, sent 30 April 1908. 89 × 138 mm. Printed: Rheinische Kunstverlaganstalt, Wiesbaden. Property of A. Nerger. Gustav Schiefler's collection of letters, Hamburg.

243. THE PLOUGHMAN. Postcard with Munch's ink drawing, sent from Ålborg, 1 May 1909. 89 × 136 mm. Photographer: Knudstrup, Frederikshavn. Gustav Schiefler's collection of letters, Hamburg.

244. SKI-JUMPER AT HOLMENKOLLEN. Postcard with Munch's ink drawing, sent 23 December 1909. 88 × 138 mm. Printed: Kunstforlaget National. Copyright 1909. Gustav Schiefler's collection of letters, Hamburg.

245. SKIING. Postcard with Munch's ink drawing, sent presumably January 1915. 88 × 138 mm. Printed: Kunstforlaget National. Copyright 1907. Private collection.

246. THE MARKET PLACE AT KRAGERØ. Postcard with Munch's ink drawing, sent from Kristania, 23 June 1912. Printed: Kristiane Johnsen, Kragerø. Gustav Schiefler's collection of letters, Hamburg.

247. THE UNIVERSITY IN KRISTIANIA. Postcard with Munch's pencil drawing, sent 10 March 1913. Printed: E.A. Schjørn, Christiania. Gustav Schiefler's collection of letters, Hamburg.

248. JOHN GABRIEL BORKMAN, DEAD, 1909–10. Charcoal drawing. 480 × 650 mm. T 2116.

249. WORKERS ON THEIR WAY HOME, 1913–15. Oil on canvas. 200 × 228 cm. M 365.

250. GALLOPING HORSE, 1910–12. Oil on canvas. 148 × 119.5 cm. M 541.

251. MOUNTED POLICE IN LONDON, 1911. Newspaper cutting in Munch archives from Allers Familie Journal, September 1911. Photographer: unknown.

252. A PAIR OF HORSES IN THE SNOW, 1923. Oil on canvas. 134 × 180 cm. M 368.

253. THE YELLOW TREE TRUNK, 1911–12. Oil on canvas. 131 × 160 cm. M 393.

254. FOREST FLOOR WITH HUMAN BODIES, c.1910. Watercolour.

255. MAN AND WOMAN II, 1912–15. Oil on canvas. 89 × 115.5 cm. M 760.

256. WOMEN BATHING, c.1913. Oil on canvas. 72.5 × 100 cm. M 194.

257. GALLOPING HORSE AND TWO FRIGHTENED CHILDREN, c.1913. Drawing.

258. IN THE KENNELS, c.1913. Oil on canvas. 67.5 × 89.5 cm. M 328.

259. THE BOHEMIAN'S DEATH, 1915. Oil on canvas. 125 × 244 cm. M 377.

260. MUNCH IN FRONT OF THE VERANDA STEPS AT EKELY, 1926. Gelatin printing-out paper. Velox. 142 × 89 mm. Photographer: Inger Munch.

261. MUNCH IN PROFILE IN FRONT OF THE HOUSE AT EKELY, 1931–2. Gelatin printing-out paper. Lupex. 113 × 83 mm. Self-portrait.

262. THE CONSERVATORY AT EKELY WITH THE PORTRAIT OF ROLF STENERSEN, 1927. Gelatin printing-out paper. Velox. 145 × 98 mm. Photographer: E. Munch.

263. 'THE WEDDING OF THE BOHEMIAN' ON THE EASEL, garden at Ekely, winter 1927. Gelatin printing-out paper. Velox. 93 × 132 mm. Photographer: E. Munch.

264. 'STREET IN KRAGERØ' ON THE EASEL, Garden at Ekely, winter 1927. Gelatin printing-out paper. Velox. 145 × 96 mm. Photographer: E. Munch.

265. E. MUNCH'S KODAK VEST POCKET CAMERA. Preus Fotomuseum, Horten.

266. MUNCH SITTING IN A CANE CHAIR NEXT TO HIS BED, Ekely 1927. Modern print from original negative in O. Vaering's archives. Self-Portrait.

267. MUNCH'S HOUSEKEEPER IN THE DOORWAY, Ekely 1927. Modern print from original negative. Photographer: E. Munch.

268. E. MUNCH'S PATHÉ-BABY CINEMA CAMERA. Munch Museum, Oslo.

269. STREET SCENE: MAN AND WOMAN WITH PUSH CART I, Dresden 1927. Extract from Munch's film. 9.5 mm. Pathé-Baby, nitrate film, roll 1.

270. STREET SCENE: MAN AND WOMAN WITH PUSH CART II, Dresden 1927. As 269.

271. STREET SCENE: MAN AND WOMAN WITH PUSH CART III, Dresden 1927. As 269.

272. STREET SCENE: MAN HANGING ON TO LORRY, Dresden 1927. As 269.

273. MUNCH'S DOG IN THE GARDEN AT EKELY, 1927. Extract from Munch's film. 9.5 mm. Pathé-Baby, nitrate film, roll 2.

274. EKELY, 1927. As 273.

275. STREET SCENE: KARL JOHAN STREET SEEN TOWARDS KIRKERISTEN, 1927. Extract from Munch's film. 9.5 mm. Pathé-Baby, nitrate film, roll 3.

276. RESTAURANT MENU CARD IN THE CENTRE OF OSLO, 1927. As 275.

277. WINDOW DISPLAY IN THE CENTRE OF OSLO, 1927. As 275.

278. E. MUNCH FILMING HIMSELF IN FRONT OF THE STEPS AT EKELY I, 1927. Extract from Munch's film. 9.5 mm. Pathé-Baby, nitrate film, roll 4.

279. E. MUNCH FILMING HIMSELF IN FRONT OF THE STEPS AT EKELY II, 1927. As 278.

280. E. MUNCH FILMING HIMSELF IN FRONT OF THE STEPS

AT EKELY III, 1927. As 278.

281. THE GARDENER'S LODGE AT EKELY, SEEN TOWARDS THE WEST, 1927. Postcard photograph, Gelatin printing-out paper. 86 × 135 mm. Photographer: E. Munch.

282. EKELY IN SNOW, SEEN TOWARDS THE WEST, 1927. Postcard photograph with E. Munch's drawing. Gelatin printing-out paper. 131 × 86 mm. Photographer: E. Munch.

283. THE COVERED VERANDA IN SNOW, Ekely, presumably 1927. Modern print from original negative. Photographer: E. Munch.

284. STUDY FOR 'THE HUMAN MOUNTAIN', SHOWING MUNCH'S 'PATCHWORK' TECHNIQUE, Ekely, presumably 1927. Gelatin printing-out paper. Velox. Stamped: K 20. 112 × 85 mm. Photographer: E. Munch.

285. MUNCH'S HOUSEKEEPER IN THE DOORWAY, Ekely, presumably 1927. Gelatin printing-out paper. Stamped: B 049. 114 × 88 mm. Photographer: E. Munch.

286. E. MUNCH IN THE CONSERVATORY WITH STILL LIFE AND WATERCOLOURS, Ekely, presumably 1927. Gelatin printing-out paper. Stamped: B 149. 112 × 88 mm. Self-portrait.

287. SELF-PORTRAIT WITH BRUSH AND PALETTE, 1925. Oil on canvas. 90 × 68 cm. Private collection.

288. E. MUNCH IN HIS WINTER STUDIO AT EKELY, 1933. Published in *Oslo Nyheds & Avertissement Blad* and *Tidens Tegn*, December 1933. Also used as postcard. Gelatin printing-out paper. 89 × 142 mm. Photographer: Ragnvald Vaering.

289. PRIME MINISTER OTTO BLEHR. Coalprint. 225 × 165 mm. Photographer: Selmer Norland.

290. PORTRAIT OF OTTO BLEHR, 1927. Oil on canvas. c.190 × 108 cm. Stortinget (Parliament), Oslo.

291. ABSTRACT, OPTICAL ILLUSIONS FROM THE EYE DISEASE, 1930. Watercolour. 497 × 471 mm. T 2156.

292. THE ARTIST'S EYE AND THE THREATENING FIGURE OF A BIRD'S HEAD, 1930. Pastel. 502 × 315 mm. T 2152.

293. THREE OPTICAL ILLUSIONS FROM THE SICK EYE, 20 September 1930. Watercolour and pastel. 498 × c.325 mm. T 2165.

294. THE NAKED ARTIST AND THE THREATENING FIGURE OF A BIRD'S HEAD, 1930. Oil on canvas. 80.5 × 64.5 cm. M 341.

295. THE ARTIST WITH A SKULL: OPTICAL ILLUSION FROM THE SICK EYE, 1930. Watercolour and pastel. 320 × 500 mm. T 2157.

296. OPTICAL ILLUSION: THE PHOENIX, 1930. Watercolour and pencil. 324 × 500 mm. T 2150.

297. THREE OPTICAL ILLUSIONS FROM THE SICK EYE, 1930. Watercolour. 646 × 250 mm. T 2166.

298. E. MUNCH, WITH HAT, SEEN IN PROFILE FROM THE RIGHT SIDE, 1930. Gelatin printing-out paper. Velox. Stamped: A 51. 112 × 86 mm. Self-portrait.

299. E. MUNCH, HIS HEAD THROWN BACK, Ekely 1930.

300. E. MUNCH, WEARING HAT AND GLASSES, AT THE STAIRS TO THE WINTER STUDIO. Ekely 1930. Gelatin printing-out paper. Velox. Stamped: A 51. 112 × 85 mm. Self-portrait.

301. E. MUNCH, WITH HAT, SEEN IN PROFILE LOOKING TOWARDS THE SKY, Ekely 1930. Gelatin printing-out paper. Stamped: A 58. 112 × 86 mm.

302. E. MUNCH, CLOSE-UP, IN FRONT OF THE COVERED VERANDA, Ekely 1930. Gelatin printing-out paper. Velox. Stamped: H 24. 112 × 86 mm. Self-portrait.

303. E. MUNCH ON THE VERANDA I, Ekely 1930. Gelatin printing-out paper. Velox. Stamped: H 24. 112 × 86 mm. Self-portrait.

304. E. MUNCH ON THE VERANDA II, Ekely 1930. Gelatin printing-out paper. Agfa Lupex. 112 × 86 mm. Self-portrait.

305. E. MUNCH IN FRONT OF 'MARAT'S DEATH' I, Ekely 1930. Modern print from original negative in O. Vaering's archives. 114 × 77 mm. Self-portrait.

306. E. MUNCH IN FRONT OF 'MARAT'S DEATH' II, Ekely 1930. Gelatin printing-out paper. Velox. Stamped: A 53. 111 × 82 mm. Self-portrait.

307. E. MUNCH IN FRONT OF 'MARAT'S DEATH' III, Ekely 1930. Modern print from original negative in O. Vaering's archives. 105 × 78 mm. Self-portrait.

308. E. MUNCH IN FRONT OF 'THE FAMILY TREE', Ekely 1930. Gelatin printing-out paper. Velox. Stamped: A 53. 86 × 112 mm.

309. E. MUNCH IN PROFILE IN FRONT OF 'YOUTH ON THE BEACH' AND WATERCOLOURS MADE DURING HIS EYE DISEASE, Ekely 1930. Modern print from original negative in O. Vaering's archives. Self-portrait.

310. E. MUNCH IN FRONT OF 'MARAT'S DEATH' IV, Ekely 1930. Gelatin printing-out paper. Velox. Stamped: A 92. 105 × 78 mm. Self-portrait.

311. E. MUNCH, WEARING GLASSES, IN FRONT OF TWO WATERCOLOURS, Ekely 1930. Modern print from original negative in O. Vaering's archives. Self-portrait.

312. E. MUNCH IN THE WINTER STUDIO, IN FRONT OF PAINTINGS FROM 'THE FRIEZE OF LIFE', Ekely 1931-2. Gelatin printing-out paper. Velox. Stamped: 3387. 88 × 145 mm. Self-portrait.

313. E. MUNCH FACING THE CAMERA, IN FRONT OF 'MATERIAL TRANSFER', Ekely 1931-2. Gelatin printing-out paper. Agfa Lupex. Stamped: 3387. 112 × 83 mm. Self-portrait.

314. 'MATERIAL TRANSFER', PHOTOGRAPHED WITH SHADOW EFFECTS AND REFLECTION, Ekely 1931-2. Gelatin printing-out paper. Velox. Stamped: 3387. 88 × 145 mm. Self-portrait(?)

315. FRITZ FRØLICH IN DARK CLOTHES IN MUNCH'S STUDIO, Ekely 1930-1. Gelatin printing-out paper. Velox. Stamped: G 41. 112 × 85 mm. Photographer: E. Munch.

316. FRITZ FRØLICH IN LIGHT CLOTHES IN MUNCH'S STUDIO, Ekely 1930-1. Gelatin printing-out paper. Velox. Stamped: G 32. 111 × 83 mm. Photographer: E. Munch.

317. PORTRAIT OF FRITZ FRØLICH ON THE EASEL, Ekely 1930-1. Gelatin printing-out paper. Velox. Stamped: C 17. 110 × 82 mm. Photographer: E. Munch.

318. NIKOLAI RYGG, 1938. Gelatin printing-out paper. 224 × 159 mm. Photographer: Ragnvald Vaering.

319. PORTRAIT OF NIKOLAI RYGG. 1938. Oil on canvas. 95 × 82 cm. Norges Bank.

320. PORTRAIT OF ROLF HANSEN (unfinished), 1943-4. Oil on canvas. 109 × 80 cm. M 565.

321. ROLF HANSEN IN THE GARDEN AT EKELY, 1943. Modern print. Photographer: Ragnvald Vaering.

322. PORTRAIT COLLAGE OF DR KRISTIAN SCHREINER AS ANATOMIST, 1932-3. Modern print from original negative in O. Vaering's archives. Photographer: E. Munch.

323. 'THE SPLIT PERSONALITY OF FAUST' COLLAGE IN THE OPEN-AIR STUDIO, Ekely 1932. Gelatin printing-out paper. 230 × 171 mm. Modern print from original negative in O. Vaering's archives. Photographer: E. Munch.

324. THE SPLIT PERSONALITY OF FAUST I, 1932-5. Oil on canvas. 100 × 117 cm. M 553.

325. LYING SCULPTURE I, Ekely 1932. Modern print from original negative in O. Vaering's archives. Photographer: E. Munch.

326. LYING SCULPTURE II, Ekely 1932. Modern print from original negative. Photographer: E. Munch.

327. E. MUNCH NEXT TO HIS SCULPTURE, Ekely 1938. Gelatin printing-out paper. Agfa Lupex. Postcard. 140 × 89 mm. Self-portrait(?) with E. Munch's camera.

328. THE ARTIST, SEEN IN PROFILE, SITTING IN THE CANE CHAIR, Ekely 1938. Modern print from original negative in O. Vaering's archives. Photographer: Ragnvald Vaering.

329. E. MUNCH IN THE WINTER STUDIO, 75 YEARS OLD, Ekely 1938. Modern print. Photographer: Ragnvald Vaering.

330. SELF-PORTRAIT BETWEEN CLOCK AND BED, 1940-4. Oil on canvas. 149.5 × 120.5 cm. M 23.

331. E. MUNCH IN HIS STUDIO, 80 YEARS OLD, Ekely 1943. Modern print. Photographer: Ragnvald Vaering.

332. SELF-PORTRAIT, A QUARTER PAST TWO IN THE MORNING, 1943. Gouache. 515 × 645 mm. T 2433.

333. E. MUNCH, A DRAWING CHARCOAL IN HIS HAND, 1906. Modern print. Photographer: Anna Auerbach(?)

334. E. MUNCH IN HIS WINTER STUDIO IN FRONT OF 'THE SUN', Ekely 1943. Modern print. Photographer: Ragnvald Vaering.

Illustration numbers are italicized.